# ON THE BASIS OF ART

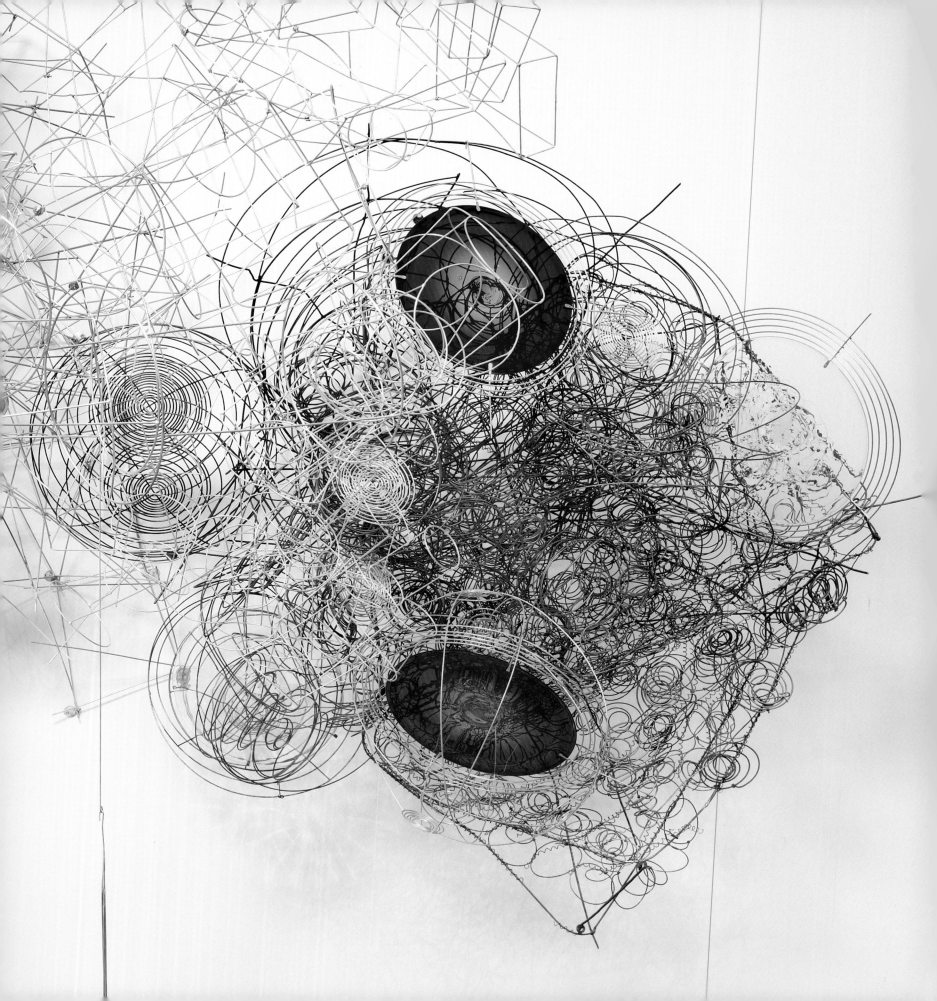

# ON THE BASIS OF ART

Introduction by
**Elisabeth Hodermarsky**

Essays by
**Helen A. Cooper, Linda Konheim Kramer, and Marta Kuzma**

And contributions by

Emily Arensman, Edi Dai, Judy Ditner, Carl Fuldner, John Stuart Gordon, Gavi Levy Haskell, Elisabeth Hodermarsky, Frauke V. Josenhans, Misty-Dawn MacMillan, Katherine Nova McCleary, Keely Orgeman, Leah Tamar Shrestinian, Sydney Skelton Simon, Molleen Theodore, Elissa Watters, and Laura Luís Worden

With research assistance by Edi Dai

**Yale University Art Gallery**
New Haven

**Distributed by Yale University Press**
New Haven and London

# 150 YEARS OF WOMEN AT YALE

Director's Foreword                6

Acknowledgments                   8

An Introduction                   12
Elisabeth Hodermarsky

Note to the Reader                19

**Part 1**
# 1869 to 1949

## No Longer "A Harmless Occupation for Girls"    22
Helen A. Cooper

Timeline: 1869–1949              36

Artist Entries                   40

**1880s**
Ellen Oakford                    40
Emma H. Bacon                    42

**1890s**
Josephine Miles Lewis            46

**1900s**
Mary Foote                       48
Irene Weir                       50

**1910s**
Mildred Cleora Jordan            54

**1940s**
Isabel Case Borgatta             56
Ellen Carley McNally             58

**Part 2**
# 1950 to 1968

## Modernism Comes to Yale       62
Linda Konheim Kramer

Timeline: 1950–68                76

Artist Entries                   80

**1950s**
Audrey Flack                     80
Jennett Lam                      84
Sheila Hicks                     86
Eva Hesse                        90

**1960s**
Barbara Chase-Riboud             96
Sylvia Plimack Mangold           100
Anna Held Audette                106
Janet Fish                       108
Nancy Graves                     112
Jennifer Bartlett                116
Judith Bernstein                 120
Howardena Pindell                122

# CONTENTS

**Part 3**
# 1969 to Present

The Yale School of Art:         128
A Legacy Revisited
Marta Kuzma

Photo Credits         307

Timeline: 1969–Present         154

Artist Entries         160

**1970s**

| | | | |
|---|---|---|---|
| Judy Pfaff | 160 | Holly Lynton | 242 |
| Louisa Chase | 164 | Rina Banerjee | 244 |
| Maria Porges | 166 | Marie Watt | 246 |
| Rosalyn Richards | 168 | Gail Albert Halaban | 248 |
| Elizabeth J. Peak | 172 | Sharon Core | 250 |
| Rona Pondick | 174 | Malerie Marder | 252 |
| Tabitha Vevers | 178 | Justine Kurland | 254 |
| Roni Horn | 180 | Victoria Sambunaris | 256 |
| | | Katy Grannan | 260 |

**1980s**

| | | **2000s** | |
|---|---|---|---|
| Nancy Friese | 184 | Shannon Ebner | 262 |
| Lois Conner | 186 | Lisa Kereszi | 264 |
| Maya Lin | 190 | Wangechi Mutu | 266 |
| Amy Klein Reichert | 194 | Kristin Baker | 270 |
| Susanna Coffey | 196 | Natalie Frank | 272 |
| Jan Cunningham | 200 | Elisheva Biernoff | 274 |
| Ann Hamilton | 202 | Mickalene Thomas | 276 |
| Jessica Stockholder | 206 | Angela Strassheim | 278 |
| Jocelyn Lee | 210 | Anna Collette | 280 |
| Lisa Yuskavage | 212 | Sarah Anne Johnson | 282 |
| Beverly Semmes | 214 | Leslie Hewitt | 284 |
| Fran Siegel | 216 | Erin Shirreff | 286 |
| | | Tala Madani | 290 |

**1990s**

| | | | |
|---|---|---|---|
| Marion Belanger | 220 | Rebecca Soderholm | 292 |
| Tanya Marcuse | 222 | Sam Contis | 294 |
| Mary Berridge | 224 | Suyeon Yun | 296 |
| Laura Letinsky | 226 | Jen Davis | 298 |
| Jennette Williams | 228 | Sasha Rudensky | 300 |
| Sarah Sze | 230 | Mary Reid Kelley | 302 |
| Donnamaria Bruton | 232 | | |

**2010s**

| | | | |
|---|---|---|---|
| Eve Fowler | 234 | Njideka Akunyili Crosby | 304 |
| An-My Lê | 236 | | |
| Erica Baum | 240 | | |

MARKING TWO IMPORTANT RECENT MILESTONES— the 150th anniversary of women's presence on Yale's campus (upon the opening of the Yale School of Art in 1869) and the 50th anniversary of women at Yale College—*On the Basis of Art: 150 Years of Women at Yale* celebrates the remarkable achievements in the visual arts of an impressive roster of women artists who have studied at the University over the last century and a half, earning degrees in the disciplines of Painting, Printmaking, Sculpture, and Photography. Drawn exclusively from the collection of the Yale University Art Gallery, the exhibition and catalogue document the stories of these women and the extraordinary work that they have produced over the fifteen decades represented here. The project also addresses the challenges they encountered in choosing to study at Yale and the obstacles they confronted in their later professional practice.

The title of the project alludes to the long history of women's suffrage in America, which reached a major breakthrough with the adoption of the Nineteenth Amendment to the U.S. Constitution on August 18, 1920, prohibiting states and the federal government from denying citizens the right to vote "on account of sex." Several pieces of U.S. legislation to further women's autonomy and end discrimination "on the basis of sex" followed this earlier law. In 1972, for example, the U.S. Congress passed the Equal Opportunity in Education Act (part of the Equal Employment Opportunity Act), denying federal funds to public colleges that discriminate against women. That bill, known as Title IX, remains one of the strongest pieces of legislation in

U.S. history to uphold gender equality. Opening just over one hundred years after the adoption of the Nineteenth Amendment, this exhibition, which was originally planned to be mounted in fall 2020 but was postponed when the Gallery closed due to the COVID-19 pandemic, also marks that milestone date.

In striving to tell the most accurate story, this project takes seriously the essential need to confront both historical and ongoing gender disparities and inequities. As Helen A. Cooper, M.A. 1975, PH.D. 1986, the Holcombe T. Green Curator Emeritus of American Paintings and Sculpture, explains in her essay in this catalogue, from its founding the Yale School of the Fine Arts (as the School of Art was then known) was envisioned as a place "for practical instruction, open to both sexes." Nevertheless, the mere presence of women does not imply equality, as Cooper's text and the subsequent essays by Linda Konheim Kramer, B.F.A. 1963, independent scholar and Executive Director Emerita of the Nancy Graves Foundation, and Marta Kuzma, the Stavros Niarchos Foundation Dean of the Yale School of Art, show.

The catalogue discusses and illustrates the work of nearly eighty women artists and is divided into three chronological sections, featuring essays, artist entries, and historical timelines that illuminate both the inequities and breakthroughs that women artists have experienced. Diverging from the catalogue's chronological approach, the exhibition is organized thematically, providing an opportunity to juxtapose works by artists across time and media, sparking rich and often surprising visual associations. Extensive oral history interviews with artists and

# DIRECTOR'S FOREWORD

faculty further inform the texts in the catalogue and the exhibition, as well as the robust audio guide.

Overseeing this timely and important project—presented on the heels of recent historic events such as the Women's March in Washington, D.C., and the #MeToo movement—was Elisabeth Hodermarsky, the Sutphin Family Curator of Prints and Drawings at the Gallery, who labored tirelessly to give voice to the artists whose work is included here. Lisa was joined by a team of curatorial and education colleagues at the museum, including Judy Ditner, the Richard Benson Associate Curator of Photography and Digital Media; John Stuart Gordon, the Benjamin Attmore Hewitt Curator of American Decorative Arts; Keely Orgeman, the Seymour H. Knox, Jr., Associate Curator of Modern and Contemporary Art; Sydney Skelton Simon, B.A. 2007, the Bradley Assistant Curator of Academic Affairs; and Molleen Theodore, Associate Curator of Programs. Former curators, current and former fellows, and students also contributed their time and talents to the publication. The authors' commitment to better understanding and capturing the triumphs and challenges of Yale's women artists has been inspiring to watch.

Our collective thanks are extended not only to these authors but also to the generations of collectors who have donated artworks or given funds for purchases, allowing us to share such a wide array of objects here. For their financial support of the exhibition and publication, we also thank Nancy D. Grover and those who established the following funds: the Janet and Simeon Braguin Fund, the Katharine Ordway Exhibition and Publication Fund, the Raymond and Helen Runnells DuBois Publication Fund, and the Wolfe Family Exhibition and Publication Fund. Our greatest thanks, however, go to the talented women artists who have made our world a more exciting, rewarding, and thought-provoking place through their art, and, especially, to the living artists who shared with us their experiences of their time at Yale and beyond.

At the time of this writing, all four of the University's visual-arts entities are directed by women: Deborah Berke, the first female dean of the Yale School of Architecture; Marta Kuzma, the first female dean of the Yale School of Art; Courtney J. Martin, PH.D. 2009, Director of the Yale Center for British Art; and me. Several women hold senior positions in the Provost's Office as well, and Carol LeWitt currently chairs the Gallery's Governing Board. This concentration of women in leadership positions with oversight of Yale's cultural collections makes it a thrilling time to be a woman on campus—and a fitting time to have undertaken this crucial project that marks a significant moment in Yale's history.

STEPHANIE WILES
The Henry J. Heinz II Director
Yale University Art Gallery

EXHIBITION AND PUBLICATION PROJECTS OF THIS scale and scope are always formidable undertakings. It is my great pleasure to acknowledge and thank the far-ranging roster of voices and expertise that have formed and informed this project. Delayed—and yet, oddly, also enriched—by the COVID-19 pandemic, this venture offered considerable and unprecedented challenges, but even greater rewards.

It is to the seventy-nine artists represented here that we owe the first and greatest thanks, for their extraordinary artwork as well as their generosity of voice and participation. This publication is dedicated to your talent, tenacity, brilliance, and strength.

This project is a coming together of many curatorial voices as well. I thank my core team of collaborators at the Gallery for their collegiality, exceptional work, and persistence: Judy Ditner, the Richard Benson Associate Curator of Photography and Digital Media; John Stuart Gordon, the Benjamin Attmore Hewitt Curator of American Decorative Arts; Keely Orgeman, the Seymour H. Knox, Jr., Associate Curator of Modern and Contemporary Art; Sydney Skelton Simon, B.A. 2007, the Bradley Assistant Curator of Academic Affairs; and Molleen Theodore, Associate Curator of Programs. The project has deeply benefited from their expertise and range of opinions and ideas.

My collaborators join me in thanking our three catalogue essayists, whose well-researched and beautifully written contributions both anchor and energize this publication: Helen A. Cooper, M.A. 1975, PH.D. 1986, the Holcombe T. Green Curator Emeritus of American Paintings and Sculpture at the Gallery; Linda Konheim Kramer, B.F.A. 1963, independent scholar and Executive Director Emerita of the Nancy Graves Foundation; and Marta Kuzma, at the time of this writing the Stavros Niarchos Foundation Dean of the Yale School of Art. The engaging historical timelines that punctuate and enliven this book were painstakingly researched and authored by Laura Luís Worden, M.A.R. 2019, former Graduate Curatorial Intern,

Department of Prints and Drawings, and Edi Dai, M.F.A. 2019, former Graduate Curatorial Intern, Department of Prints and Drawings, and Postgraduate Research Associate, Yale School of Art, with the additional research assistance of Antoinette Roberts, B.A. 2021, former Betsy and Frank H. Goodyear, Jr., B.A. 1966, Intern, Department of Prints and Drawings.

The artist entries that fill this publication were authored by the core curatorial team as well as by a broad-ranging group of curators, fellows, and graduate and undergraduate student interns, whose diverse contributions lend greatly to the catalogue's active voice. For their contributions, we thank: Emily Arensman, former Jock Reynolds Fellow, Programs Department; Edi Dai; Carl Fuldner, B.A. 2006, former Marcia Brady Tucker Fellow, Department of Photography; Frauke V. Josenhans, former Horace W. Goldsmith Associate Curator of Modern and Contemporary Art; Gavi Levy Haskell, PH.D. candidate, History of Art; Misty-Dawn MacMillan, former Postgraduate Fellow, Department of Photography; Katherine Nova McCleary, B.A. 2018; Leah Tamar Shrestinian, B.A. 2018; Elissa Watters, the Florence B. Selden Senior Fellow, Department of Prints and Drawings; and Laura Luís Worden.

The informative and illuminating exhibition labels were authored by the core curatorial team as well as a fantastic group of fellows and students, including: Jake Gagne, the Jock Reynolds Fellow in Public Programs, Education Department; Jenna Marvin, the Marcia Brady Tucker Fellow, Department of Photography; Katherine Nova McCleary; Kathryn Miyawaki, B.A. 2021, former Betsy and Frank H. Goodyear, Jr., B.A. 1966, Intern, Department of Prints and Drawings; Antoinette Roberts; Leah Tamar Shrestinian; and Elissa Watters.

To the magnificent Tiffany Sprague, Director of Publications and Editorial Services, we extend particular thanks for her epic patience, for her consummate expertise, and for keeping this publication train on the tracks in the face of the unquestionable

# ACKNOWLEDGMENTS

artists, and our historic roster of temporary exhibitions has primarily showcased the work of men.[6] Among national art museums, the Gallery is not unique on any of these fronts, but there remains much work to be done to balance the inequities.[7]

In our research into the history of women at the School of Art, we have found similar injustices: patriarchal attitudes in a school that, from its inception (per its foundational indenture), welcomed women to study, yet until relatively recently offered those women inadequate postgraduate professional assistance in securing gallery representation or teaching positions. Nor did the School of Art hire a woman as a full-time faculty member until as late as 1973—and only when forced to do so by the federal adoption of Title IX laws.[8] Acknowledging these historical and institutional underachievements, we realized early on that while we were setting out to celebrate the history of women in the visual arts at Yale, what we were finding was a history that was not, and is not still, something entirely celebratory.

The histories of the Yale School of Art and the Yale University Art Gallery are inextricably intertwined. The institutions cohabitated three historic buildings for nearly one hundred years, from 1869 until 1963.[9] They have even shared staffs—curators have regularly enjoyed adjunct appointments or served as critics at the School and, conversely, art faculty have served as curatorial advisors and collaborators.[10] The fact that these intertwined histories have been both dominated and documented by men, however, means that the stories that we continue to draw from and reference, all the way back to the 1860s, are ones that have been authored nearly exclusively by male voices—whether deans, professors, directors, curators, or students.[11]

For our curatorial team, this indeed presented a problem, given that our goal with this project has always been to tell *her*story—the history (note: his-story) of the visual arts at Yale from a female perspective. To do so, we made the decision early on to reach out to as many of the living artists whose work would be included in the exhibition as possible, as well as to select faculty and former faculty of the School of Art and the Department of the History of Art, and to delve deep into archival records, such as primary-source letters and documents, to gather testimonies from women—their insights into how gender shaped the Yale visual-arts campus over time, how it affected their Yale experiences, and, in the cases of the artists, how it has affected their practice post-Yale. Some graduates and faculty to whom we reached out declined to be interviewed; others were keen to tell their stories.[12] In the dozens of oral histories we gathered, what our team of curators, fellows, and student interns found has been a wide diversity of experiences, both positive and not, even within a single interview. We have treated and will continue to treat these shared histories with the utmost respect and discretion.[13]

IN THE OPENING ESSAY OF THE CATALOGUE, WHICH traces the years from 1869 through 1949, Helen A. Cooper writes of how Yale's art school was founded on the basis of its being "open to both sexes"—the instructions of the benefactors, Caroline Mary Leffingwell Street and Augustus Russell Street. Cooper notes that two of the three inaugural students matriculating at the School of the Fine Arts, as it was then called, were women and that this was a trend that would continue until the early twentieth century. Yet, the early history of women at the School remains largely buried.[14] This is in part due to poor record keeping in the early years, and in part due to the English standard of using male pronouns to describe persons of both genders. Even with deep research into Yale's Manuscripts and Archives it has been a challenge to find much mention of the presence of women in the early written accounts of the School of Art, and their presence is noted only rarely in letters written by professors or students or in faculty meeting minutes.[15] When there is mention of women, though, it is most often positive: as Cooper notes, female students who enrolled at the School during the early years regularly won the prestigious travel prizes, including Josephine Miles Lewis (cat. 3), who was also the first recipient of a B.F.A. degree, which inaugural dean John Ferguson Weir was proactive in establishing in 1891.[16] Paradoxically, upon Weir's retirement in 1913, only four B.F.A. degrees had been conferred on women and, in the decades that followed, female students increasingly became the minority.[17]

FOR NEARLY ITS FIRST ONE HUNDRED YEARS, THE School of Art remained trenchantly conservative, but by the mid-1900s, the stage was set for a major reassessment. As Linda Konheim Kramer chronicles in the second essay of this volume, a sea change occurred between 1950 and 1969 with the hiring in 1950 of Josef Albers as Chair of the newly reconfigured Department of Design and a subsequent curricular revolution, first under Albers and then under the chairs and deans who followed. Albers, who came to Yale from the artistically progressive Black Mountain College in North Carolina, arrived on campus to inherit a student body and faculty steeped in the study of

antiquated Renaissance techniques such as painting in egg tempera and sculpting in stone in a figurative mode. He set to work on not only hiring more modernist-facing faculty members but also actively recruiting a new wave of like-minded students. In so doing, he transformed both the philosophy and practice of teaching art at the University.

While Albers may have been modern in his teaching philosophy, however, he was old-fashioned in his social mores: Audrey Flack (cat. 9) recalls that Albers was appalled when he saw her in pants and instructed her to wear a skirt; Sheila Hicks (cat. 11) recounts that Albers regularly called her a "girl";[18] and Eva Hesse (cat. 12) remembers Albers openly referring to her rather pejoratively as his "little color studyist."[19] Despite Albers's old-school sexism and emphasis on female decorum, Kramer notes that over the course of his tenure the number of female students who became serious professional artists increased significantly.

That said, securing work was not without its struggles—and the School gave women artists little encouragement or employment advice. Janet Fish (cat. 16) recalls a male classmate sharing with her a "job book" in the School of Art office, only to have the department secretary snatch it away from her, saying, "That is not for you."[20] Judith Bernstein (cat. 19) notes that women were underrepresented during her School of Art years and that then dean Jack Tworkov openly told them, "'We cannot place women after they graduate,' a brusque way of conveying the reality that academic and other positions for women artists were woefully few, except as "gallery girls" and other menial jobs.[21] When Bernstein did receive a job interview from Connecticut College for Women, in New London, she was told by the search committee, "'Well, the only reason we'd even interview a woman or hire a woman [is] because we [want] women to model nude in the classroom." As Bernstein notes, "That was 1967. That was not *1867*, it was 1967."[22]

THE FINAL ESSAY IN THE CATALOGUE PICKS UP THE narrative in 1969, the year that marked the coeducation of Yale College and the incorporation of women undergraduates into the visual-arts curriculum. As Marta Kuzma describes, the 1970s were groundbreaking years for women in the arts at Yale on several fronts.[23] Most notably for women's presence in the School of Art was the passing in 1972 by the U.S. Congress of Title IX, which denied federal funds to colleges that discriminate against women. The University and its School of Art scrambled to comply. While there had been a handful of women instructors,

lecturers, and visiting critics at the School of Art prior to this period, there had never been any full-time female faculty hires.[24] In the fall of 1972, Samia Halaby joined the faculty as Visiting Lecturer in Painting and, in 1973, was appointed as the first full-time, tenure-track female Associate Professor of Painting. Her appointment was followed in 1973 by those of Inge Druckrey, as Assistant Professor of Graphic Design, and Gretna Campbell, as Associate Professor of Painting. In 1976 Winifred Lutz joined the Sculpture faculty as Assistant Professor. Yet, between 1972 and 1983 the number of full-time female professors never rose above four (and, by 1982, had been reduced to two), evidence that the commitment to building a more gender-balanced faculty was lukewarm at best. And, it would not be for another two decades following the adoption of Title IX laws that a woman would receive tenure at the School of Art, with the hiring of Sheila Levrant de Bretteville, B.F.A. 1963, M.F.A. 1964, in 1990.[25]

The women students at the School of Art were keenly aware of the School's patriarchal atmosphere. Howardena Pindell (cat. 20) recalls the sexist commentary prevalent in the legendary "pit crits" (so-named for the cement substructure in the Paul Rudolph–designed Art and Architecture Building, in which student critiques were held): "What I noticed was if a woman used red and white, it was called pink, and that was an outlawed color. But if a guy used red and white, it was called red and white, and not pink."[26] Marie Watt (cat. 53) also comments on the atmosphere, noting that when she entered the School in 1994 there was not a single female tenured professor: "They had just hired a woman, Rochelle Feinstein, . . . but that first year she was on probationary tenure. [The School] was very patriarchal. And I don't know if [my surprise at] that comes from [growing up in] the Pacific Northwest or coming from a tribe [Seneca] where we have matrilineal customs, but I was sort of shocked and I think even a little stifled by that."[27]

Women were not the only minority to be marginalized. Until the 1990s, the School's student body was overwhelmingly white and American, and the curriculum was decidedly Western-focused.[28] In the fall of 1982, following her firing from the School, Palestinian-born Samia Halaby led the charge to organize an exhibition titled *On Trial: Yale School of Art* at 22 Wooster Gallery, in New York, which challenged what was widely perceived by the student body to be the sexist, racist, and Eurocentric culture at Yale in the disciplines of art and art history. In a *New Haven Register* article, Halaby was quoted: "If your art doesn't have all of its roots in Renaissance and nineteenth-century French paint-

ing, it's considered practically unacceptable. We're sick and tired of painting nude females with pots and pans and bits of fruit the school says are 'realistic.'"[29]

During her graduate study at the School of Art in the mid-1990s, Indian-born Rina Banerjee (cat. 52) confronted not just sexist but also cultural biases. She describes a traumatic experience in a critique of her work that remains with her to this day:

> It was maybe the last semester, and my paintings, which were made of silk stretched on wood frames, were in what we called then the pit. . . . These few boys who were in the balcony area threw pepperoni at my work and stained it. . . . They thought it was funny, and they screamed out to me, "Stop making dresses!" That made such an impact—the fact that I'm using textiles instead of canvas. They had never thought that canvas, which they painted on . . . was fabric [too] . . . [T]he fact that I veered away from cotton duck into silk made it, I guess, a feminine painting, and therefore not a painting at all.[30]

In all fairness, the culture described by Pindell, Watt, Halaby, and Banerjee, and that is reflected in the challenges faced after the adoption of Title IX, was not unique to Yale or the School of Art. This was the reality at most elite universities nationwide, still heavily rooted in past patriarchal, Western traditions. At the School, it was once again a point in time for institutional self-assessment that would lead to further reforms and advancements in equity and inclusion. As Kuzma's essay attests, today there is relative parity among students as to gender and race, as well as a greater balance of national and international students. Still, there remains much work to be done in the expansion of opportunities for female-identifying artists. There is also enormous work to be done in the continued push toward gender balance in Yale's museum and library collections.

WHEN IT OPENED IN 1869—COINCIDENTALLY, THE same year that Susan B. Anthony and Elizabeth Cady Stanton founded the National Woman Suffrage Association—the Yale School of Art did so with a full commitment to training students in the visual arts regardless of gender. Since then, women have come to Yale to study art within its intellectually rich environment.[31] As all three historical essays in this volume and the vibrant artist entries and timelines reveal, across fifteen decades women artists have been drawn to Yale out of a passion and

dedication to create and to excel in their chosen profession. Thousands have gone on to serious careers as artists and art educators. Indeed, if this exhibition and publication attest to anything, it is to the extraordinary commitment and resilience of a roster of exceptional women artists who have come to Yale to study under great art professors and visiting critics, to be taken seriously for their work, to hurdle the historical and institutional obstacles of time and circumstance—and often of culture, finance, and family—on the basis of their art.

More than anything else, what we hope for this exhibition and catalogue is that they provide a statement—a marker—of this moment in time, and that in another 50, and 150, years the Yale canvas will be a very different one—one that reflects a more amplified, equitable, and diverse representation of artists' work across gender, ethnicity, race, nationality, and sexual orientation. Awareness and openness foster change, and we hope that this project is a harbinger of progress.

1. This has taken place not just at the Yale University Art Gallery, through this exhibition and catalogue, but also on the Yale campus as a whole. For more information, see the website 50WomenAtYale150, accessed March 1, 2021, https://celebratewomen.yale.edu/. The present exhibition, and many of the related events on campus, were planned to coincide with the anniversaries in 2019–20 but were postponed due to the COVID-19 pandemic.

2. The first woman to be hired at Yale as a fully tenured professor was Anne Coffin Hanson in 1970, in the Department of the History of Art. The first woman to be hired at the Yale School of Art as a fully tenured professor was Sheila Levrant de Bretteville, in Graphic Design, appointed in 1990.

3. The campus reflects a deep historic maleness, punctuated only here and there by a female presence—usually in the role of benefactor, rather than artist or subject. Two notable exceptions are Maya Lin's *Women's Table*—a study for which is included in the present exhibition (cat. 31, fig. 2)—installed in 1993 in front of Yale's Sterling Memorial Library, and Rona Pondick's *Granite Bed* (cat. 26, fig. 1), installed in 2018

in the courtyard of Baker Hall, Yale Law School. For an overview of public art on campus by women or engaging female themes, see "Women at Yale: A Tour," accessed April 24, 2021, https://visitorcenter .yale.edu/sites/default/files/files /Women_at_Yale_Tour.pdf.

4. In an effort to be as inclusive as possible in telling the stories of non-male-conforming artists at Yale, throughout this publication we use the term "women artists" to refer not just to those artists who identify as female but also to those who identify as nonbinary, gender nonconforming, and transgender female. We use the pronouns that each individual artist prefers.

5. This has been a challenge, as the records—particularly of the early years—are spotty. See the essay by Helen A. Cooper in the present volume.

6. For exhibition history, see https:// artgallery.yale.edu/exhibitions/past and Elise K. Kenney, "Exhibitions 1858–2001," in Susan B. Matheson, *Art for Yale: A History of the Yale University Art Gallery* (New Haven: Yale University Art Gallery, 2001), 271–94.

7. One has only to study the history and production of the feminist activist artist group the Guerrilla

Girls to understand this cultural truth. See the complete historical archive of the work of the Guerrilla Girls, *Guerrilla Girls' Portfolio Compleat 1985–2019*, in the Gallery's collection: inv. nos. 2009.43.1–.87, 2014.124.1–.16, and 2019.75.1.1–.27.

8. The distinction goes to Samia Halaby, who was hired as Associate Professor of Painting.

9. On the three buildings—Street Hall (1866), the Old Yale Art Gallery building (1928), and the Louis Kahn building (1953)—see the essays by Helen A. Cooper and Linda Konheim Kramer as well as the three timelines in the present volume.

10. In addition, it should be noted that the dean of the School of Art also served as the Gallery's director until 1940. See the essay by Helen A. Cooper in the present volume.

11. See, for example, Theodore Sizer, ed., *The Recollections of John Ferguson Weir, Director of the Yale School of the Fine Arts, 1869–1913* (New Haven: Associates in Fine Arts at Yale University, 1957); Theodore Sizer, "History of the Visual Arts at Yale, 1701–[1913]" (unpublished manuscript, 1957), Manuscripts and Archives, Yale University Library, New Haven; Irving Sandler, *20 Artists: Yale School of Art, 1950–1970*, exh. cat. (New Haven: Yale University Art Gallery, 1981); Sasha M. Newman and Lesley K. Baier, eds., *Yale Collects Yale*, exh. cat. (New Haven: Yale University Art Gallery, 1993); Matheson, *Art for Yale*; and Robert A. M. Stern and Jimmy Stamp, *Pedagogy and Place: 100 Years of Architecture Education at Yale* (New Haven: Yale University Press, 2016), to name just a few. Although *Yale Collects Yale* and *Art for Yale* were written by women, the histories and interviews that they reference are nearly exclusively those of male administrators, curators, and faculty.

12. Some of those who have declined interviews have done so because of excessive workload; others have stated that it is to avoid dragging up painful memories. Still others declined out of a desire not to engage in a project that they perceived to be a Yale promotional tool.

13. Transcripts of the oral history interviews that have been done for this project can be accessed in the Yale University Art Gallery Archives, New Haven. It should be noted that all of the artists interviewed for this exhibition and publication—across artistic disciplines—spoke of the tight bonds they made with fellow students in their varied programs of Painting and Printmaking, Sculpture, and Photography, and the ways in which these connections continue to sustain them. Nearly every artist interviewed also expressed the tremendous influence of particular members of the faculty—many of them women—both within the School of Art and in other departments across the Humanities. These bonds often crossed decades and forged into cross-generational chain-links of influence, as artists who had received their degrees years earlier returned to teach in either full-time or adjunct faculty capacities, and in turn influenced the next generation of artists. See the essays by Linda Konheim Kramer and Marta Kuzma in the present volume.

14. The history of women in the visual arts at Yale is a long one dating back to well before the founding of the Yale School of the Fine Arts in 1866, and the opening of its doors in 1869—the first college-affiliated art school in America. Harriet Trumbull, wife of Benjamin Silliman, Sr. (a renowned Yale chemistry professor who was integral in helping to bring the Trumbull Collection to Yale) took drawing lessons from her uncle, John Trumbull. Trumbull moved in with the Sillimans in 1837, and the Sillimans' daughters, Henrietta and Maria, would regularly attend Trumbull's lectures on his paintings in the Trumbull Gallery; see Matheson, *Art for Yale*, 21. Benjamin Silliman, Sr., was an early supporter of coeducation in the Ivy League and regularly allowed young women into his lecture classes. His efforts convinced Frederick A. P. Barnard (President of Columbia College and in whose name Barnard College was established in 1889)

that colleges should admit women: "The elder Silliman, during the entire period of his distinguished career as a Professor of Chemistry, Geology, and Mineralogy in Yale College, was accustomed every year to admit to his lecture-courses classes of young women from the schools of New Haven. . . . The results . . . were good; and they went far enough to make it evident that if the presence of young women in college, instead of being occasional, should be constant, they would be better." See Frederick A. P. Barnard, *The Higher Education of Women: Passages Extracted from the Annual Reports of the President of Columbia College, Presented to the Trustees in June, 1879, June, 1880, and June, 1881* (New York: N.p., 1882).

15. Cooper also reveals a little-known but disturbing fact: though the School of Art was intended to be coeducational from the laying of its cornerstone, the architect Peter Bonnett Wight did not include in his design any designated bathroom for female students.

16. Josephine Miles Lewis (cat. 3) won the first of the Ethel Childe Walker Prizes, in 1886, and Mary Foote (cat. 4) won the Alice Kimball English Travel Fellowship in 1874 as well as the William Wirt Winchester Prize in 1897.

17. Josephine Miles Lewis (1891), Lucy Parkman Trowbridge Ingersoll (1903), Mary Foote (1906), and Irene Weir (1906). The M.F.A. degree was established in 1927, and yet an M.F.A. would not be awarded to a woman until 1939. That distinction goes to Dorothy McIntosh Cogswell, who had previously received her B.F.A. at Yale, in 1933.

18. See the feature-length biography of Audrey Flack: *Queen of Hearts: Audrey Flack*, directed by Deborah Shaffer (2019), https://www.audreyflackfilm.com/. See also Audrey Flack and Sheila Hicks, in *Search Versus Re-Search: Recollections of Josef Albers at Yale*, directed and produced by Anoka Faruqee (July 1, 2016), https://www.youtube.com/watch?v=cC7671N76_Q&feature=youtu.be.

19. Eva Hesse, recalling her time at Yale in Cindy Nemser, "A Conversation with Eva Hesse (1970)," in Mignon Nixon, *Eva Hesse*, October Files 3 (Cambridge, Mass.: MIT Press, 2002), 5.

20. Janet Fish, oral history interview by Emily Arensman, April 9, 2019, transcript, Yale University Art Gallery Archives, New Haven.

21. Judith Bernstein, oral history interview by Emily Arensman, February 26, 2019, transcript, Yale University Art Gallery Archives, New Haven.

22. Ibid. Other students of Bernstein's generation, including Anna Held Audette (cat. 15), found rare employment opportunities at state colleges and universities nationwide. Audette was hired by Southern Connecticut State University, in New Haven, the year she received her M.F.A.

23. The year 1972 also marked a breaking of ground on a feminist front beyond Yale: this was the year that a group of women artists, fed up with the male choke hold on the New York art gallery system, boldly branched out on their own to found the A.I.R. Gallery in New York—an all-female cooperative art gallery that promoted work by women of all races who were tired of being overlooked for representation by New York gallerists. The A.I.R. Gallery was founded by Susan Williams and Barbara Zucker, who were joined by eighteen others: Dottie Attie, Rachel bas-Cohain, Judith Bernstein (cat. 19), Blythe Bohnen, Maude Boltz (M.F.A. 1964), Agnes Denes, Daria Dorosh, Loretta Dunkelman, Mary Grigoriadis, Harmony Hammond, Anne Healy, Laurace James, Louise Kramer, Rosemary Mayer, Patsy Norvell, Howardena Pindell (cat. 20), Nancy Spero, and Nancy Wilson-Pajic.

24. In a pejorative comment in the School of Art minutes of the April 27, 1972, report of the Appointments Committee, Al Held is paraphrased as saying, "The Search Committee has been interviewing candidates [and] they are primarily looking for a woman artist. However, they are

having difficulty finding one with the ideal qualifications who would be willing to move to New Haven."

25. Of the four women hired between 1972 and 1983, three—Halaby, Druckrey, and Lutz—were denied tenure (Campbell remained at the School until her untimely death in 1987); see the essay by Marta Kuzma and "Timeline: 1969–Present" in the present volume. Conversely, from 1972 to 1983 seven men had received tenure—four internal (Erwin Hauer, Richard Lytle, and Robert Reed) and three external appointments (William Bailey, Andrew Forge, Tod Papageorge, and David Pease). See the Yale School of Art Bulletins and other recorded documentation in the Dean's Office at the Yale School of Art. Despite the fact that today women make up more than 57 percent of all college students, women make up only 40 percent of full-time instructional faculty in American higher education. Only one in four full professors is a woman; less than 39 percent of associate professors are women; and only one-quarter of all college and university presidents are women. The average salary for a male full professor is 17 percent higher than that of a full-time woman professor. See "Celebrating Women's Progress in Higher Education and Exploring Issues of Gender Equity at U.S. Colleges and Universities," WIA Report, accessed April 24, 2021, https://www .wiareport.com/about/.

26. The critique structure dates back decades but took on a greater formalization in the post-Albers years of the 1960s. With the move of the School of Art to the newly constructed Paul Rudolph building in 1963, critiques became known familiarly as "pit crits." Though intended to encourage students to think and speak critically and articulately about their work, the harsh nature of the critique structure was often scathing and occasionally destructive—in some cases, putting an end to a student's pursuit of art as a career. Over the last three decades, as Kuzma notes in her essay, gradual reformations to the critique structure across disciplines have been set in place, largely pioneered by influential women faculty and Directors of Graduate Studies who have been instrumental in humanizing the critique structure, moving away from a power culture toward a less hierarchical, more conversant mode—as de Bretteville notes, "feminizing" the structure. See Sheila Levrant de Bretteville, oral history interview by Edi Dai, October 12, 2018, transcript, Yale University Art Gallery Archives, New Haven.

27. Marie Watt, oral history interview by Katherine Nova McCleary and Leah Tamar Shrestinian, May 20, 2019, transcript, Yale University Art Gallery Archives, New Haven.

28. Though from its opening the School of Art welcomed students regardless of gender, it clearly did not welcome students regardless of race, ethnicity, or nationality until more recently. Barbara Belle Johnson (Zuber) was the first Black woman to receive a B.F.A., in 1949, and Barbara Chase-Riboud (cat. 13) was the first Black woman to receive an M.F.A., in 1960.

29. Samia Halaby, quoted in Phil Blumenkrantz, "Dissidents to Put Yale School of Art on 'Trial,'" New Haven Register, December 16, 1982. The exhibition was on view from December 29, 1982, to January 8, 1983. It should be noted that this concept of a Western-centric curriculum extended to the History of Art program until the 2000s (with the exception of courses in Asian and African art). Most recently, in 2020, Tim Barringer, Chair of the Department of the History of Art, boldly announced that the History of Art faculty had made the decision to replace the traditional Yale survey course "Introduction to the History of Art: Renaissance to the Present" in favor of a more global model of course offerings, in response to both student and professor "uneasiness over an idealized Western 'canon'—a product of an overwhelmingly white, straight, European, and male cadre of artists." See Margaret Hedeman and Matt Kristoffersen, "Art History Department to Scrap Survey Course," Yale Daily News (New Haven), January 24, 2020.

30. Rina Banerjee, oral history interview by Edi Dai, March 25, 2019, transcript, Yale University Art Gallery Archives, New Haven.

31. What set Yale apart from other schools of art that admitted women (such as the National Academy of Design, in New York, and the Pennsylvania Academy of the Fine Arts, in Philadelphia) was the breadth of its intellectual rigor and offerings, a result of its position on a college campus—the first school of art of its kind. Nearly every artist interviewed spoke of the excitement of being on an academic campus that offered deep intellectual riches across disciplines.

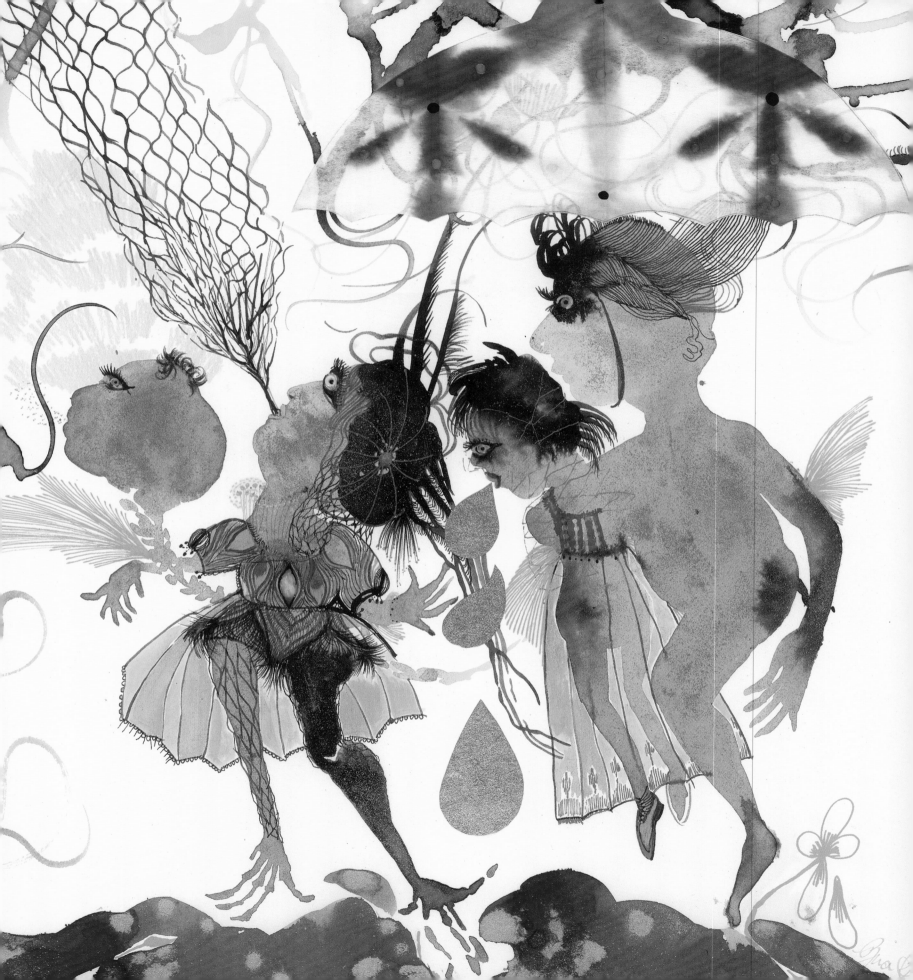

THROUGHOUT THE CATALOGUE, CIRCA (*CA.*) IS USED to denote that a work was executed sometime within or around the date given. For all objects, principal medium is given first, followed by other media in order of prevalence.

Dimensions are given in inches followed by centimeters in parentheses; height precedes width precedes depth. For drawings, dimensions are of the sheet; for relief, intaglio, and planographic prints, the matrix; and for screenprints and photographs, the image, unless otherwise noted.

Artist entries are roughly organized chronologically by degree year. All objects in the artist entries are in the collection of the Yale University Art Gallery, New Haven. Decades in the footers of the artist entries refer to graduation years.

The timelines in the catalogue, which were compiled by Laura Luís Worden, M.A.R. 2019, with the assistance of Edi Dai, M.F.A. 2019, Elisabeth Hodermarsky, and Antoinette Roberts, B.A. 2021, include major milestones involving women at the Yale School of Art, the Yale University Art Gallery, the Yale Center for British Art, and the Department of the History of Art. To further contextualize these events, key details related to the history of Yale, as well as important national and international milestones in the women's rights movement, are provided. Principal sources consulted for the timelines include:

Theodore Sizer, ed., *The Recollections of John Ferguson Weir, Director of the Yale School of the Fine Arts, 1869–1913* (New Haven: Associates in Fine Arts at Yale University, 1957).

*20 Artists: Yale School of Art, 1950–1970*, exh. cat. (New Haven: Yale University Art Gallery, 1981).

*Celebrating Women: Twenty Years of Coeducation at Yale College*, The Commemorative Journal (New Haven: Yale Women's Center, 1990).

Sasha M. Newman and Lesley K. Baier, eds., *Yale Collects Yale*, exh. cat. (New Haven: Yale University Art Gallery, 1993).

Susan B. Matheson, *Art for Yale: A History of the Yale University Art Gallery* (New Haven: Yale University Art Gallery, 2001).

Robert A. M. Stern and Jimmy Stamp, *Pedagogy and Place: 100 Years of Architecture Education at Yale* (New Haven: Yale University Press, 2016).

"Timeline," 50WomenAtYale150, https://celebratewomen.yale.edu /history/timeline.

CONTRIBUTORS

EA    Emily Arensman
ED    Edi Dai
JD    Judy Ditner
CF    Carl Fuldner
JSG    John Stuart Gordon
GLH    Gavi Levy Haskell
EH    Elisabeth Hodermarsky
FVJ    Frauke V. Josenhans
MDM    Misty-Dawn MacMillan
KNM    Katherine Nova McCleary
KO    Keely Orgeman
LTS    Leah Tamar Shrestinian
SSS    Sydney Skelton Simon
MT    Molleen Theodore
EW    Elissa Watters
LLW    Laura Luís Worden

# NOTE TO THE READER

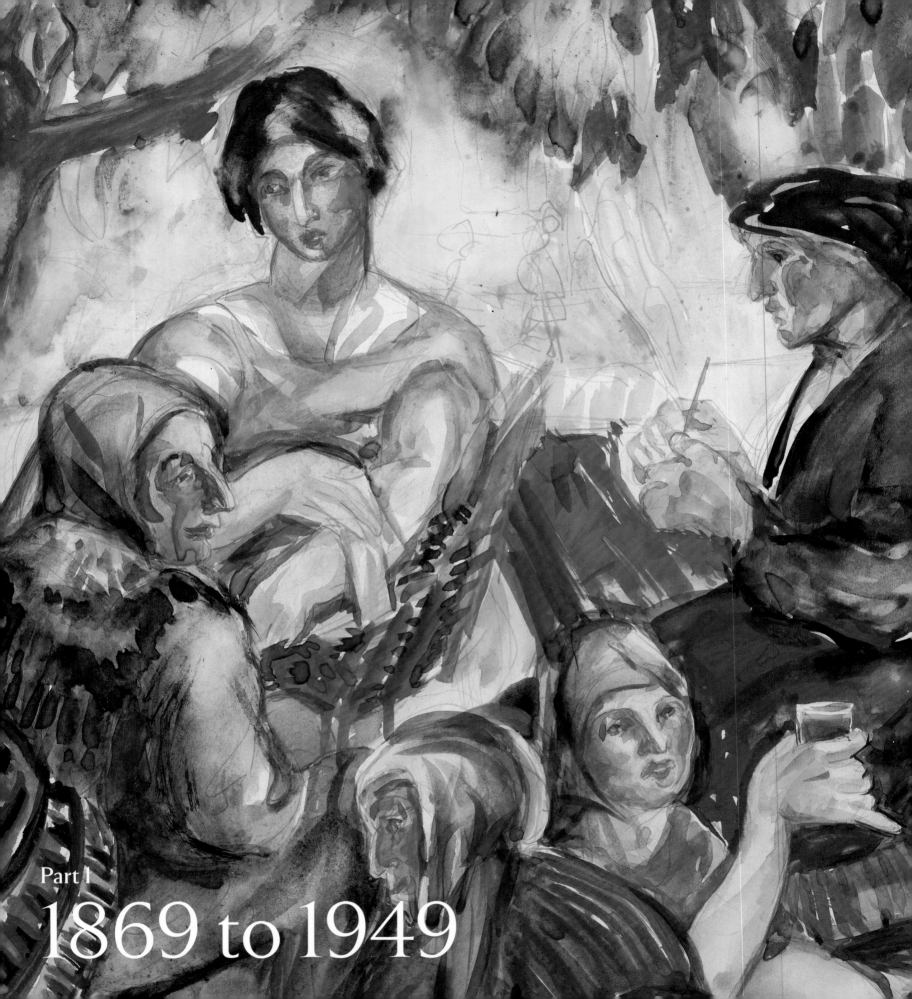

Part I

# 1869 to 1949

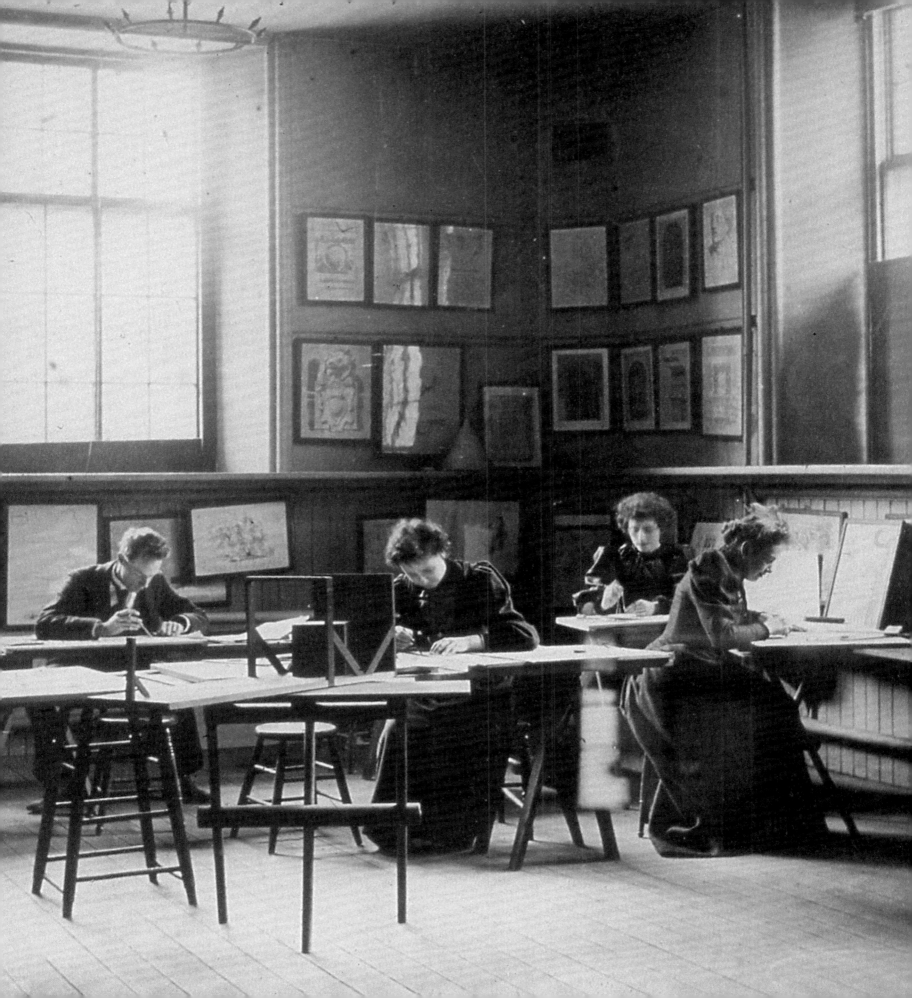

# No Longer "A Harmless Occupation for Girls"

Helen A. Cooper

AN ENLIGHTENED MAN, A DETERMINED WOMAN, and eight words in a will changed Yale forever.

In 1864 New Haven businessman and Yale graduate Augustus Russell Street (fig. 1) wrote to the president and fellows of Yale College to propose "the erection, at my sole expense, of a building on the college grounds, to be used for a school for the Fine Arts."[1] Street's will, drafted just a few months earlier, explained that the proposed art school, which came to be known as the Yale School of the Fine Arts, was:

> for the purpose of providing instruction in . . . the arts of drawing, designing, painting, sculpture, and other of the fine arts . . . *for the admission of pupils of both sexes* . . . to pursue either of the fine arts as a profession . . . and to awaken a taste for and appreciation of the fine arts, among the undergraduates of the college, and others.[2]

The independently wealthy Street cared deeply about his alma mater, his native city, and the state of art education in this country. Provincial, post–Civil War New Haven was an unlikely venue for such a forward-looking enterprise. Yet Street and his wife, Caroline Mary Leffingwell Street (fig. 2), however, were undeterred and knew exactly what they wanted: a professional art school on the campus of then Yale College that would be open to women as well as men. And while other Yale buildings turned inward, the will stipulated that the new building was to be as much for New Haven as it was for Yale, with an entrance on the college grounds and another, for the community, on Chapel Street.

Ground was broken on what today is known as Street Hall within the year, and the cornerstone was laid on November 16, 1864. The Streets were present, along with members of the Yale community and citizens of New Haven, as architect Peter Bonnett Wight handed the trowel to Yale president Theodore Dwight Woolsey to lay the cornerstone (fig. 3). Woolsey invoked a divine blessing and the Glee Club sang a specially composed hymn of praise. Edward Salisbury, Professor of Arabic and Sanskrit, spoke of the project's importance: that joining a school of fine arts with a college of higher learning recognized the place of art within all liberal studies, that the School would exert an influence on the refinement of taste, that artistic genius would be awakened, and that historical research would be enriched through the intimate connection between art and national values.[3]

Yale, in the first half of the nineteenth century, was primarily a literary institution where art, like science, was only mildly tolerated. Its presidents came from the clergy, and the intellectual

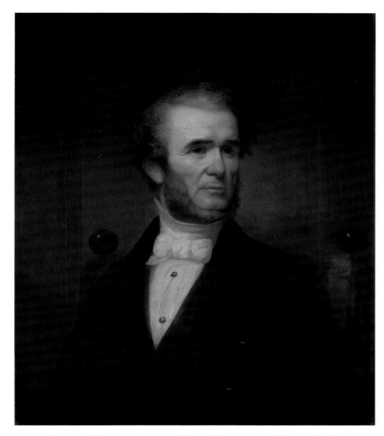

FIG. 1. Nathaniel Jocelyn, *Augustus Russell Street (1791–1866, B.A. 1812)*, ca. 1840–50. Oil on canvas, 30¼ × 25¼ in. (76.8 × 64.1 cm). Yale University Art Gallery, New Haven, Gift of Mrs. Augustus Russell Street Foote, 1918.1

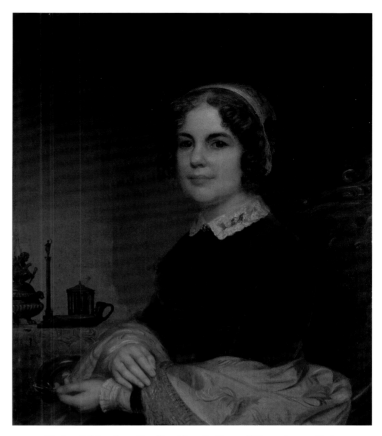

FIG. 2. Nathaniel Jocelyn, *Caroline Mary Leffingwell Street (1790–1877)*, ca. 1845. Oil on canvas, 30 × 25 in. (76.2 × 63.5 cm). Yale University Art Gallery, New Haven, Gift of Mrs. Augustus Russell Street Foote, 1918.2

climate was conservative. But a group of influential professors whose taste had been cultivated abroad believed that American society was at risk of becoming culturally inadequate in the face of rising commercialism and industrialization, and that the fine arts needed to be part of an enlightened person's (that is, a Yale man's) education.

The first major effort to encourage the fine arts on campus had occurred more than thirty years earlier, in 1831, when Professor of Chemistry Benjamin Silliman, Sr., negotiated for more than fifty paintings from patriot-artist Colonel John Trumbull, including Trumbull's renowned scenes of the Revolutionary War. The Trumbull Gallery, designed by the artist himself in the Greek Revival style, opened in 1832 as the first university art museum in America. One newspaper wrote, "Altogether, this Gallery must be considered the most interesting collection of pictures in the country. They are American."[4] The elderly Trumbull gave the college's first "art history" lectures—to seniors on Saturdays and sophomores on Wednesdays.[5]

By the late 1850s, the younger generation was no longer interested in Revolutionary heroes and rarely set foot in the Trumbull Gallery: the collections were neglected and the public was indifferent.[6] There was pressure to bring a wider range of art to campus. The expected arrival from Italy of two marble copies of antique busts of Demosthenes and Sophocles, by the late Connecticut sculptor Edward Sheffield Bartholomew, served as the impetus to organize a major loan exhibition.[7] Daniel Coit Gilman, the twenty-seven-year-old college librarian and Professor of Geology, undertook the task. In the summer of 1858, more than 250 paintings, sculptures, and watercolors by American, English, Flemish, French, German, Italian, and Spanish artists arrived in New Haven, some originals and many copies. They were installed in Alumni Hall; admission was twenty-five cents, plus an extra ten cents for the catalogue.[8] "Our principal object in forming this collection," Gilman wrote in the prospectus, "is to awaken and gratify a love of the fine arts, among the students of the College, and the residents of the town."[9] At the opening-night ceremonies on June 18, Judge C. J. McCurdy, a prominent

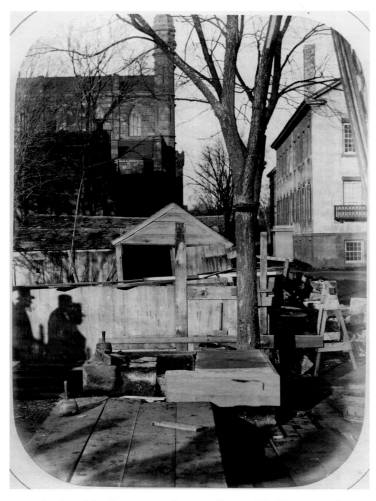

FIG. 3. Laying of the Cornerstone, Street Hall, 1864. Yale University Library, New Haven, Manuscripts and Archives, Pictures of Street Hall, RU 698

New Haven citizen, loftily declared that Yale should aim to be to the United States as Munich or Dresden was to Germany. The aged Professor Silliman spoke last, plaintively urging Yale students to cultivate other arts besides the art of moneymaking.[10] Close to seven thousand people visited the exhibition and attended lectures over its three-month run. The Boston *Congregationalist* presciently noted, "Since Yale has led off in this matter, why should she not also give the fine arts a recognized place among the studies of the curriculum, so that successive classes may have the means of learning the history and principles of art under the guidance of competent instructors."[11] The exhibition would be a turning point in the history of the arts at Yale and laid the groundwork for what is today the Yale School of Art.

The Streets' extended stays abroad and familiarity with the museums and art schools of Europe had reinforced their belief in the educational and cultural value of the visual arts; they had long been dismayed by what they saw as the artistic illiteracy of their countrymen. The success of the 1858 loan exhibition strengthened their ambitious intentions. Street's stunning stipulation that women be admitted was undoubtedly influenced by his wife, a "lady of remarkable vivacity and strength of mind," who oversaw the education of their seven daughters, all of whom were said to be "proficient with pencil and brush."[12] Schools of design in America had offered women instruction and employment in decorative arts and design since at least the 1840s, but beginning in the early 1860s, women began to enter traditional fine-art academies, such as the Pennsylvania Academy of the Fine Arts, in Philadelphia, joining men for academic training in painting and drawing in order to pursue careers. Together with their male counterparts, the women sought a new professionalism that stressed technical skills and meritocratic advancement through well-defined stages of academic art training, which would translate into exhibitions, sales, and reputations.[13]

From the first, the Streets wanted the School to have its own identity—beginning with the building itself. They rejected the colonial harmony of Yale's Old Brick Row and looked elsewhere for inspiration. Wight, the architect, was twenty-six years old and relatively unknown. He had recently won the commission for the New York Academy (today called the National Academy of Design), which he designed in the Venetian Gothic style promoted by the English theorist and critic John Ruskin and which immediately marked Wight as an architect of modern taste. His design for the exterior of the School at Yale was unapologetically Ruskinian in its asymmetry, irregularity, towers, turrets, arched windows, and multicolor stonework (figs. 4–5). As Street had specified, the building had an entrance on Chapel Street for the community and another on the college grounds for the students (fig. 6). The interior was divided into three floors. The basement and first floor held studios and classrooms for lectures on the history and criticism of art, and the second floor was home to thirty-foot-high, skylighted galleries that displayed paintings and sculpture and were open to the public (figs. 7–8).

Street, who had suffered ill health throughout his life, died just weeks before the building he had donated officially opened for commencement in June 1866. It was still unfinished, unfurnished, and largely unstaffed. The *New York Times* praised the architecture and congratulated Yale on creating the first collegiate building in America devoted exclusively to art, where "*young men* could receive an artistic training that would fit them for the actual work of their profession."[14] In New Haven, others were less complimentary: the Yale *College Courant* observed, "Yale College has lately come into possession of an elephant of the largest and most unmanageable kind, in the shape of an Art

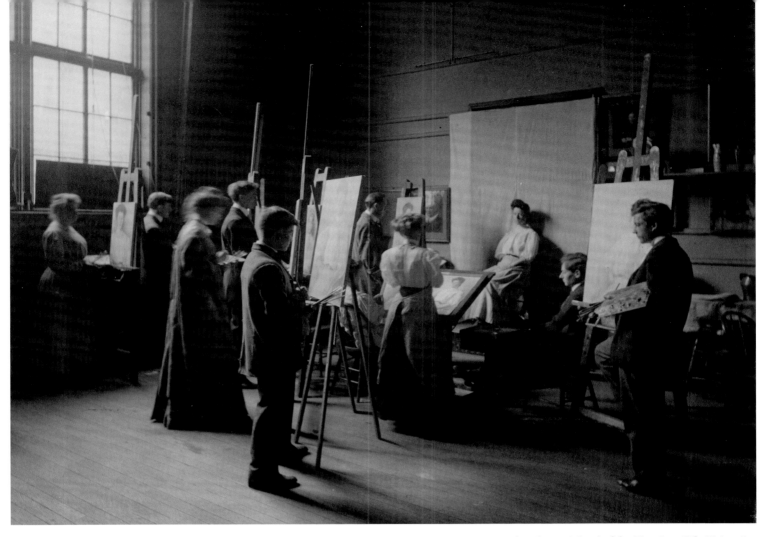

FIG. 11. Studio Painting Class, Street Hall, 1900–1920. Yale University Library, New Haven, Manuscripts and Archives, School of the Fine Arts, Yale University, RU 890

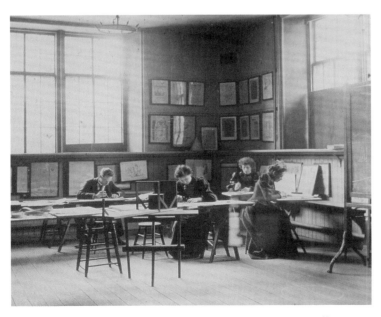

FIG. 12. Drawing Class, Street Hall, ca. 1911. Yale University Art Gallery Archives, New Haven

"fit-up a much-needed Ladies retiring room," provided that a suitable location could be found. The only available space was the large closet in Professor Eaton's office, which he refused to surrender. For months the Art Council tried to find alternative space and, finding none, voted to take the closet, optimistically believing that Eaton would concede. They were mistaken. Eaton submitted his resignation, and the bathroom was constructed.[26]

To be admitted to the School as a professional student, an individual had to be fifteen years of age or older, of good character, and able to pay tuition in advance—thirty-six dollars for three months. (Undergraduates in the College were charged half the usual rate.) Students began with basic drawing, then sketched from plaster casts and the live model, and finally advanced to painting in the third year (figs. 11–12). As time went on, Weir enlarged the faculty—which continued to be all male— with instructors in sculpture, anatomy, perspective, architecture, and lectures in the theory and history of art. In 1876 he formalized

the three-year professional course; beginning in 1878, upon successful completion of all coursework students received a Certificate of Completion.

Students required live models, but at first there were no regularly scheduled life-drawing classes. Weir thought New Haven was too puritanical for the nude and on this point, he and Eaton had agreed. "Drawing from the nude," said Eaton, "is something that may with difficulty be reconciled with Connecticut morals."[27] Later, the drawing and painting classes occasionally had a dressed or modestly draped male model (fig. 13). The rate was forty cents an hour; the School paid one half and the students paid the other. Male and female students were separated for classes with nude live models. The women's class got a young boy, for twenty-five cents. One of the students, Samuel Isham, donated a complete human skeleton.[28] With life drawing, the problem of sufficient heating became important, and when the stoves in various rooms were found to be inefficient, the always-pragmatic Caroline Street provided funds for a steam-heating apparatus.[29]

Caroline Street died in 1877. "It was from the mind and heart of Mrs. Street, not less than that of her husband, that the great munificence came," wrote the *Connecticut Herald and Weekly Journal*.[30] The influx of funds from her will led the *New York Evening Post* to pronounce, "Today the Yale School of the Fine Arts is the best equipped and most successful institution of the kind in the United States."[31] Weir's ambition to create a New Haven École was indeed successful; no other American art school so thoroughly emulated the Beaux-Arts academic teaching methods and philosophy as Yale.

But the School still struggled. Much of the Yale faculty ignored it, and the attitude among most undergraduates was one of humorous condescension. Art was "a harmless occupation for girls and weak-minded men," declared a campus publication, and the School merely "furnished light occupation to a large number of ladies residing in New Haven and the vicinity."[32] Some few allowed, grudgingly, that the presence of the women art students on campus might be a positive step toward making Yale a more cultured place. It was not until the 1890s that undergraduate men were regularly permitted to take art courses for credit.

Women students outnumbered the men for years after the School opened in 1869, but only the names of male art students appeared on the lists published in its annual catalogue. The only record of the early women in attendance is the handwritten registry of the School. The women complained, and in 1874— there were twenty women and two men in the class that year—the question concerning the insertion of their names in the catalogue came before the Yale Corporation. The board ordered that if any list of art students was printed it must include the names and residences of those students who were regular members of the School, whether they be male or female. Women's names appeared in print for the first time in the catalogue of 1876–77; of the sixteen students listed, twelve were women. The art school held its first documented commencement in 1878, and according to the handwritten register, six of the eight students who were awarded certificates for the three-year course were women. By 1882, of the fifty pupils in the School, thirty-eight were women.

By all accounts, Weir was a supportive and encouraging mentor to serious students of art, without regard to gender. Throughout the forty-four years of his incumbency, more than three-quarters of the thousand-plus students who enrolled as professional students were women. "The years spent in study there were the brightest and most promising of my life," wrote Mabel B. McIntosh.[33] The women came from socially prominent families in and around New Haven and included Weir's own daughters, Edith (Certificate of Completion 1898) and Louise, as well as his niece Irene (cat. 5). Most returned to their hometowns after completing their studies and are little known today, as is also true of the men. There were exceptions—those who were determined to continue their studies as far as their talent and ambition could take them, like Louise Rogers Jewett, who became an innovative art teacher at Mount Holyoke College, in South Hadley, Massachusetts. In 1891 the School of the Fine Arts awarded its first Bachelor of Fine Arts degree to the painter Josephine Miles Lewis, daughter of the mayor of New Haven (cat. 3). (Some waggishly suggested it might more properly be termed a "Maid of Arts."[34]) The B.F.A. was not a regular Yale undergraduate degree. Students could not register for it or acquire it through coursework; it was administered by Weir as a kind of honorary degree awarded only after the student became a professional artist. During Weir's tenure, women consistently won the School's most sought-after prizes. Some swept the field: Mary Foote (cat. 4), for example, entered the School in 1890, won the Ethel Childe Walker Prize for exceptional artistic development the following year, was awarded the Alice Kimball English Travel Fellowship in 1894, and in 1897 won the first William Wirt Winchester Prize for two years of study and travel abroad.

Women were not permitted to study at Paris's prestigious École des Beaux-Arts until the end of the nineteenth century, but the less prestigious Julian and Colarossi academies, also in Paris, opened their doors earlier, and women quickly took advantage of the classes taught by famous French academicians. (As at Yale, they were not permitted to draw the nude model

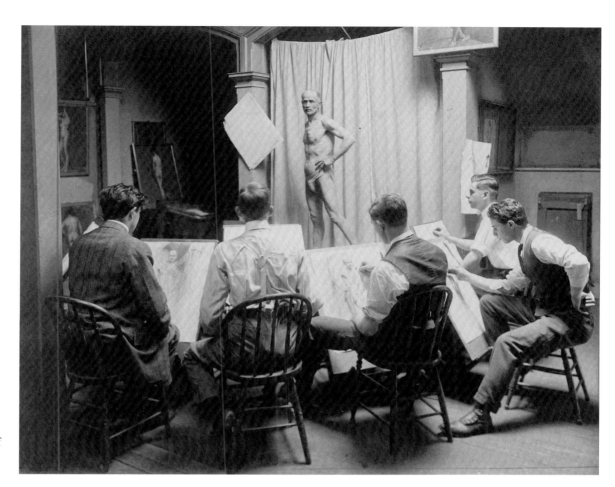

FIG. 13. Drawing Class with Male Model, Street Hall, early 20th century. Yale University Library, New Haven, Manuscripts and Archives, School of the Fine Arts, Yale University, RU 890

alongside their male peers.) The Yale women honed their technical skills and made the transition from student to professional. They returned home confident in their ability and artistic direction to encounter a booming market—for European art. Despite the appearance of Impressionism in the 1870s and Post-Impressionism a decade later, which subverted some of the absolute authority of academic art, the Yale women, like most American artists, remained committed to the academic tradition: their dedication to technical methods and styles steered them from art that startled or surprised. Many chose to specialize in realistic portraiture—Foote was among the most successful with her portraits of distinguished sitters—while others diverted their interest from painting to teaching or to the "lesser" media traditionally assigned to women, like miniature painting, pastel, and watercolor. Few women at Yale studied sculpture, and printmaking courses were rarely offered, despite an etching revival in America at the turn of the century. Magazine and book illustration offered an important avenue of employment for Yale women graduates. The four Cowles sisters—Genevieve, Maude, Edith, and Mildred, who studied at the School between

1886 and 1897—saw their work published in *The Century*, *Scribner's*, *Harper's Monthly*, and *Woman's Home Companion*. The sisters also collaborated on book illustrations (fig. 14).[35]

By the time of Yale's bicentennial in 1901, women art students were well established, but the administration's attitude toward them was paternalistic. The University planned an elaborate evening torchlight procession to celebrate the anniversary, and art students were encouraged to participate, dressed in costumes based on figures in Trumbull's Revolutionary War paintings. A month before the event, Professor John Schwab, a member of the University's organizing committee, said, "It will not be practicable to enlist the women students of the School," and explained their exclusion "on the ground of too great physical exertion required in the march."[36] Apparently, the women were strong enough to carry and install their own canvases, though, and their paintings were prominently featured in the celebratory exhibition.

In 1908 Sheffield Scientific School students were no longer required to take the drawing course, and the resultant loss of income to the art school was significant. Weir sent circulars to

FIG. 14. Maude Cowles and Genevieve Cowles, frontispiece from *The House of the Seven Gables*, vol. 2 (Boston: Houghton Mifflin), 1899. Bowdoin College Library, Brunswick, Maine, George J. Mitchell Department of Special Collections and Archives, M085

introduced as a course the year before. He lamented that "throughout the country, Art Schools in Universities have been hampered in their work because of the idea that architecture was science and not art."[37]

The heady ferment of modern art in the early twentieth century, with its repudiation of academic refinement and restraint, was not perceptible in New Haven. The School continued its quiet ways, its academicism comfortably in place. In February 1913, a huge exhibition of contemporary art opened at the Armory in New York, introducing Americans who were accustomed to realist art to the experimental styles of the European avant-garde—Cubism, Fauvism, Futurism. The show sent shock waves through the entire American art community, and some tremors were felt even in New Haven, at least by Weir, who was about to retire. In his valedictory speech that June, he seemed to be directly responding to the impact of the Armory Show: "We must not mistake novelty, eccentricity, for originality in art," he said. He defended the School's system of technical instruction as "based on methods in line with the great traditions of art, with standards of training and discipline tested by the experience of the past . . . in marked contrast with loose and superficial methods, if they can be properly termed as methods, that are prompted by caprice, or the varying fashions of the day."[38]

The appointment in 1913 of gifted painter William Sergeant Kendall as director (the designation was changed to dean in 1918–19) seemed to promise a new approach. He had trained under the "radical" Thomas Eakins at the Pennsylvania Academy of the Fine Arts, who believed that students should learn to draw directly in color and rejected the tradition of studying drawing from the antique. Yale students undoubtedly expected that Eakins's teachings would influence their curriculum, yet Kendall allowed Weir's academic philosophy to remain essentially unchallenged. He made some administrative changes—lecture courses now counted for credit, and the B.F.A. became a formal degree awarded for two years of advanced studies in the School; it required both a written thesis and original work in painting or sculpture. In 1915 the School awarded its first B.F.A. degrees in Sculpture and in Architecture. The catalogue boasted that the intellectual atmosphere at Yale, "where the three great branches, Architecture, Painting, and Sculpture, are studied side by side," offered greater advantages for the student than an art school limited to one of these professions alone.[39] Frustrated by his unsuccessful attempts to gain more space for the School—for offices, classes, and more—Kendall resigned in 1921 and went on to establish a significant career as a painter of genteel domestic subjects.

undergraduates, placed advertisements in newspapers, offered evening classes, and tried, unsuccessfully, to establish a summer school, all to bolster enrollment and income. There was some good news the following year, when a large sum of money was donated for the construction of a much-needed addition to the building. Weir, an amateur architect, followed Wight's original designs and drew up a scheme for extending the building on the High Street side. The addition provided new exhibition galleries and classrooms and expanded spaces for lectures and the library. But it was not large enough to accommodate adequate instruction in architecture, which Weir had

Everett V. Meeks (fig. 15), a wealthy, larger-than-life personality who succeeded Kendall as dean in 1922, broadened the School's curriculum while narrowing the student body. A Beaux-Arts-trained architect, he established the School's first chair of architecture—the one discipline at the School that excluded women. For the first time since the School's founding, women were no longer in the majority; in 1922, for example, there were thirty men in the Architecture course and seventy-five students in Painting and Sculpture, of which only eighteen were women.

Meeks expanded course offerings. Inspired by the Jarves Collection of early Italian paintings, he hired Eugene Savage to teach mural painting and Daniel V. Thompson, the translator of Cennino Cennini's *Craftsman's Handbook*, to teach traditional egg-tempera techniques. He integrated the study of architecture with painting and sculpture. He added the Department of Drama in 1924, and hired the School's first woman instructor, Evelyn Cohen, to teach costume design. In 1927 the Yale School of the Fine Arts awarded its first M.F.A. degree, granted by the Graduate School of Arts and Sciences. In his twenty-five-year tenure, Meeks enhanced the School's national and international reputation, primarily through his emphasis on architecture, which meant that women did not enjoy the same degree of mentorship. Yale men consistently won Beaux-Arts medals and competitions. Savage's influence at the School was so great that

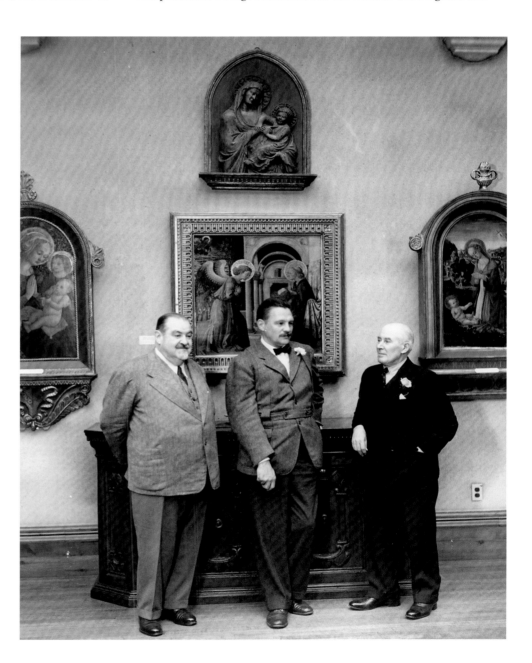

FIG. 15. Everett V. Meeks (left), Theodore Sizer (center), and Will Ashton (right, Director, National Gallery, New South Wales, Sydney), early 1940s. Yale University Art Gallery Archives, New Haven

a *Time* magazine article about the Yale men who, year after year, won the Prix de Rome fellowship, referred to their paintings as "Little Savages."[40] Women now rarely won the School's prizes. In the twenty-six years between 1921 and 1947, only two of the twenty-four winners of the Alice Kimball English Travel Fellowship were women, and of the twenty-two winners of the William Wirt Winchester Prize, only one was a woman. The Department of Architecture began to admit a few women in the 1940s, possibly to make up for the loss of male students to World War II. In 1949 Elvia Garwood and Nancy Yung-Chiu Pan (Nancy Pan Sun) were the first women to receive the M.ARCH. degree.[41] Nonetheless, it was very much a boys' club. The opinionated Meeks, nicknamed "The Big Bull Dean," had strong ideas even about women's clothing. Looking out his office window one day he saw a young woman student wearing trousers. Summoned to his office, she was informed that it was disrespectful to go out on the street dressed "that way."[42]

Meeks's tenaciousness served the School well in other areas. The collections were growing, but the building was not fireproof and the galleries were being used as classrooms, which meant that works of art were being sent to inadequate storage. Meeks persuaded President James Roland Angell that the School needed more space. On September 27, 1928, the new Gallery of Fine Arts opened.[43] Designed in Meeks's beloved Beaux-Arts style by Egerton Swartwout, it was connected to the art school by a bridge over High Street (fig. 16). The art was transferred to the new museum, and the emptied north and south galleries in the School were reconfigured as classrooms and studios. Meeks took on the dual role of dean of the School and director of the Gallery. In 1931 he hired the young art historian A. Elizabeth Chase (fig. 17) as docent. Chase was also Assistant Professor in the Department of the History of Art and the first woman to teach an undergraduate course at Yale College. She was a charismatic lecturer who, in her forty years as an educator, helped open the museum to broader audiences.

Meeks retired in 1947, and a new era began with the appointment of Charles H. Sawyer, former director of the Worcester Art Museum, in Massachusetts. A committed modernist, Sawyer brought fresh energy to the art school, promoting an openness to new ideas and engagement with the wider world. He brought together the Departments of Art, Architecture, and the History of Art, as well as the art library, uniting them all under a single administration and strengthening the disciplines within the University. The graduating class of 1949 included a significant first: the painter Barbara Belle Johnson (Zuber) became the first Black woman to receive the B.F.A. degree. Sawyer was instrumental in the University's decision to award the commission for a new building that would combine an art gallery with studio spaces to modernist Louis Kahn. Perhaps Sawyer's greatest achievement was his decision to persuade German-born, Bauhaus-trained Josef Albers to come to Yale in 1950 to chair the art school's newly established Department of Design, which

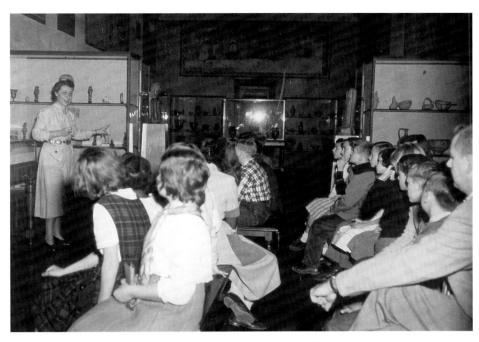

FIG. 17. A. Elizabeth Chase in Egyptian Collection, Gallery of Fine Arts, 1949. Yale University Art Gallery Archives, New Haven

included painting, sculpture, and graphic arts. It would be the beginning of the School's greatest years.[44]

When the barely completed Yale School of the Fine Arts optimistically opened its doors on an autumn day in 1869 to register three pioneering students—two of them young women who would be the first female students at Yale—no one could have foreseen the advent of undergraduate coeducation one hundred years later, or the amazing trajectory of the art school, from its beginnings as a barely tolerated Yale institution on the edge of an all-male campus to the preeminent position it holds today in the history of art education in America. It took time for Augustus and Caroline Street's radical vision to be fully realized, but the foundation was in place from the beginning.

1. Augustus Russell Street, March 24, 1864, Records of the Corporation, Yale College Register, March 29, 1864, YRG 1-A, RU 307, HM 49, Manuscripts and Archives, Yale University Library, New Haven.

2. Augustus Russell Street's will, September 25, 1863, copy in Treasurer's Records, YRG 5-B, RU 151, Manuscripts and Archives, Yale University Library, New Haven. Emphasis added.

3. "City News," Daily Palladium (New Haven), November 17, 1864.

4. Connecticut Journal (New Haven), November 6, 1832, 3.

5. Theodore Sizer, "History of the Visual Arts at Yale, 1701–[1913]" (unpublished manuscript, 1957), 49n31, Manuscripts and Archives, Yale University Library, New Haven.

6. In 1868 the paintings in the Trumbull Gallery were moved to Street Hall; the Trumbull Gallery building was converted to administrative offices and was eventually torn down, in 1901.

7. Sizer, "History of the Visual Arts at Yale," 54, 58.

8. After expenses, the exhibition netted $126.03.

9. Daniel Coit Gilman, "Art Exhibition in Yale College" (unpublished manuscript, 1858), Manuscripts and Archives, Yale University Library, New Haven.

10. Henry P. Becton, "The Founding of the Yale School of Fine Arts" (unpublished manuscript, 1965), 17, Yale School of Art Archives, New Haven.

11. "Art Exhibition at Yale," Congregationalist (Boston), July 13, 1858, quoted in Becton, "Founding of the Yale School of Fine Arts," 20.

12. Betsy Fahlman, "Women Art Students at Yale, 1869–1913: Never True Sons of the University," Woman's Art Journal 12, no. 1 (Spring–Summer 1991): 15–16.

13. Kirsten Swinth, Painting Professionals: Women Artists and the Development of Modern American Art, 1870–1930 (Chapel Hill: University of North Carolina Press, 2001), 5. According to the 1870 census, 414 women painters, sculptors, and teachers of art practiced their profession. Twenty years later, nearly 11,000 women were so identified.

14. "The Fine Arts: The Exhibition at Yale College," New York Times, July 19, 1867. Emphasis added.

15. Quoted in Betsy Fahlman, John Ferguson Weir: The Labor of Art (Newark: University of Delaware Press, 1997), 127.

16. Quoted in Becton, "Founding of the Yale School of Fine Arts," 81.

17. Minutes of the Yale Corporation, July 1865, quoted in Becton, "Founding of the Yale School of Fine Arts," 50.

18. Susan B. Matheson, Art for Yale: A History of the Yale University Art Gallery (New Haven: Yale University Art Gallery, 2001), 43.

19. Caroline Leffingwell Street, quoted in Becton, "Founding of the Yale School of Fine Arts," 52. This stipulation would have surprised future directors of the School.

20. Theodore Sizer, ed., The Recollections of John Ferguson Weir, Director of the Yale School of the Fine Arts, 1869–1913 (New Haven: Associates in Fine Arts at Yale University, 1957), 68.

21. Ibid., 70.

22. John Ferguson Weir, Fiftieth Anniversary of the School of the Fine Arts, Yale University (New Haven: Yale University Press, 1916), 23–24.

23. New York Times, October 8, 1869.

24. William Brownell, quoted in Swinth, Painting Professionals, 14–15. Emphasis in the original.

25. D. Cady Eaton, quoted in Sizer, "History of the Visual Arts at Yale," 104.

26. Ibid., 102–3, 120n9. The cost was $325.

27. D. Cady Eaton, quoted in Fahlman, John Ferguson Weir, 135.

28. Sizer, "History of the Visual Arts at Yale," 118n30. Isham may be best remembered as the author of The History of American Painting (1905).

29. Ibid., 101.

30. Quoted in Fahlman, "Women Art Students at Yale," 15.

31. New York Evening Post, June 14, 1879, quoted in Sizer, "History of the Visual Arts at Yale," 127.

32. Quoted in Fahlman, "Women Art Students at Yale," 15–16.

33. Ibid., 15.

34. Ibid., 16.

35. Ibid., 20.

36. Ibid., 21.

37. John Ferguson Weir, "Report to the President," 1906, quoted in Sizer, "History of the Visual Arts at Yale," 168.

38. Ibid., 172.

39. The Department of Architecture was founded the following year, in 1916. For more on this department, see the three timelines and the essays by Linda Konheim Kramer and Marta Kuzma in the present volume.

40. "Deane Keller Reminiscences" (unpublished manuscript, 1969), 7, Yale School of Art Archives, New Haven.

41. The history of the Architecture degree is unclear. The first B.F.A. in Architecture was awarded in 1915; at some point it became the B.ARCH. and then later the M.ARCH.

42. "Deane Keller Reminiscences," 18.

43. For an excellent description of the development of the Gallery and the extraordinary collections that came to it during this period, see Matheson, Art for Yale, 69–85.

44. For more on this period, see the essay by Linda Konheim Kramer in the present volume.

## 1701

The Colony of Connecticut approves an act to establish a "collegiate school" for young men. This school will become Yale College in 1718, when Elihu Yale donates funds, books, and a portrait of King George I.

## 1792

Sarah Pierce's Litchfield Female Academy, in Litchfield, Connecticut, begins instructing young women. Courses are offered in music, dancing, singing, embroidery, drawing, and painting.

## 1825

The New Haven Female Seminary begins to offer courses in fine needlework, landscape painting, music, perspective drawing, and painting on velvet.

## 1832

On October 25, the Trumbull Gallery opens at Yale College (on what is today Old Campus), becoming the first art museum on a college campus in the United States. Founded with funds appropriated by the Connecticut General Assembly, and designed by the patriot-artist Colonel John Trumbull, it is intended to house the growing collegiate collection as well as Trumbull's collection of paintings, including his depictions of major battles of the Revolutionary War—which had been accepted by the Yale Corporation (Yale's governing board of trustees) the previous year.

## 1842

The Wadsworth Atheneum Museum of Art is founded in Hartford, Connecticut; it opens to the public in 1844 and today remains the oldest continuously operating public art museum in the United States.

## 1848

On July 19–20, roughly three hundred women and men convene in Seneca Falls, New York, for what has come to be known as the first women's rights convention. There, one of the conference's organizers, Elizabeth Cady Stanton, sets forth a Declaration of Sentiments, modeled on the U.S. Declaration of Independence, in which she states, "We hold these truths to be self-evident: that all men and women are created equal." The declaration is signed by 68 women and 32 men, including Frederick Douglass, declaring the civil, social, political, and religious rights of women.

## 1850–60

Harriet Tubman, an escaped enslaved woman, is a pivotal "conductor" on the Underground Railroad, leading dozens of slaves to freedom before the U.S. Civil War.

## 1858

From June 18 to August 14, the Exhibition of 1858—the first loan exhibition at Yale—is held in Yale's Alumni Hall. Lent by local collectors to a "committee of gentlemen," according to the accompanying catalogue, the over 250 works on view in multiple media are chiefly by (or copied after) European Old Masters and by contemporary American artists. The catalogue states, "The object in forming the collection [of objects on view] has been to awaken and gratify a love of the Fine Arts among the citizens of New Haven, and the students of the College." Yet, while reviewing the exhibition, an unidentified reporter for the *Hartford Press* derisively responds to Sofonisba Anguissola's *Holy Family* (1592): "This is by one of the very few eminent female artists. And I confess that I have never seen any work by her, by Angelica Kaufman, or by any other woman, which was not feeble in comparison with good painting by men." Nevertheless, this exhibition elevates dialogue around artistic training in American colleges and universities.

## 1861–65

The U.S. Civil War is fought. An estimated four hundred women disguise themselves as men and enlist in the Union and Confederate armies.

## 1864

The Yale School of the Fine Arts is founded, funded by Augustus Russell Street and Caroline Mary Leffingwell Street. It is the first art school at an institution of higher learning in the United States. Peter Bonnett Wight is chosen as the architect of the new building, which is sited on the northeast corner of Chapel and High Streets. Ground is broken on August 13; on November 16, the cornerstone of the building is laid.

## 1865

In July, Yale College president Theodore Dwight Woolsey and Augustus Russell Street reach an agreement that the School of the Fine Arts is to be governed by a five-person Art Council.

## 1866

On June 12, Augustus Russell Street dies. His will specifies that the School of the Fine Arts is to provide "instruction in and of diffusing a knowledge of the arts of drawing, designing, painting, sculpture and other of the fine arts under such regulations, for the admission of pupils of both sexes . . . to provide for those desiring to pursue either of the fine arts as a profession . . . and to awaken and cultivate a taste for and appreciation of the fine arts among the undergraduates of the college and others." Caroline Street begins overseeing the funding that her husband had provided for the School.

In June, the School of the Fine Arts building (today known as Street Hall) nears completion and opens during commencement. The building contains studios, classrooms, and gallery spaces. In July, the Yale Corporation votes to transfer Yale College's art collections to Street Hall, including works from the overcrowded Trumbull Gallery (razed ca. 1901), portraits of Yale affiliates (namely, faculty) that had been scattered in various buildings on campus, sculptures and plaster casts, and copies of European Old Master paintings.

In December, Caroline Street writes to President Woolsey with concerns about Street Hall being underused, inadequately appreciated, and likely to be vandalized. She also calls for the artworks from the Trumbull Gallery, which had yet to be transferred, to move to Street Hall. The transfer of art is made in January 1867.

The Yale Peabody Museum of Natural History is founded. Construction begins in 1874, and the museum opens to the public in 1876.

## 1867

Early in the year, the painter Nathaniel Jocelyn moves into a studio in Street Hall and offers classes. He is charged by the Art Council to take care of "the art building and its contents," and he begins to arrange for students to rent studio spaces in the building.

The School of the Fine Arts' *First Annual Exhibition*, familiarly referred to as the Exhibition of 1867, is presented in Street Hall. Opening evenings take place on July 11 and 18; the exhibition closes on September 28. The exhibition (and other loan exhibitions, which follow until 1890) aims to raise money; since the School is a "professional school" within Yale College, it is required to provide its own funds. (The College covers costs for coal and a janitor.)

On December 4, the Prudential Committee of the Yale Corporation votes to authorize a loan of James Jackson Jarves's collection of paintings. The collection of 119 early Italian Renaissance paintings is exhibited in the School of the Fine Arts, beginning in May 1868. The paintings are purchased by the College on November 9, 1871.

## 1869

On October 15, the Yale School of the Fine Arts, Yale's first coeducational school, opens its doors. The School enrolls both men and women from prominent families who are able to afford the tuition. Alice and Susan Silliman, daughters of Benjamin Silliman, Jr., Professor of Chemistry at Yale College, enroll in the first class as two of the three inaugural students (a fourth name in the handwritten ledger listing enrolled students was erased). Students are awarded Certificates of Completion for successful concentrations and lengths of study (B.F.A. degrees will not be conferred until 1891). The curriculum is modeled on the École des Beaux-Arts in Paris. Classes are offered in drawing (after both plaster casts and live models), painting, sculpture, composition, perspective, anatomy, and the history and criticism of art. In the School's fledgling years, most faculty members donate their instruction in exchange for studio space.

# TIMELINE

# 1869–1949

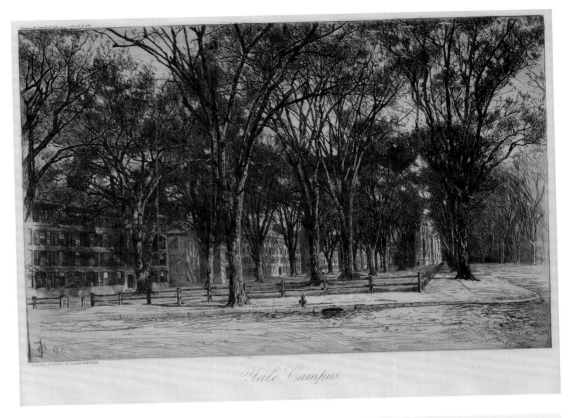

FIG. 1.  Ellen Oakford, *Yale Campus*, 1888. Etching, 12 × 15¹³⁄₁₆ in. (30.5 × 40.2 cm).
Gift to Pierson College, Yale University, 1949.129b

FIG. 2.  Ellen Oakford, *Yale College*, ca. 1898. Etching, 6⁷⁄₁₆ × 8 in. (16.3 × 20.2 cm).
Gift of the Reverend Anson Phelps Stokes, B.A. 1896, HON. 1900, LL.D. 1921,
1929.779.59

EMMA H. BACON'S LIFE BEGAN ON HER FAMILY'S farm in Middletown, Connecticut. Both her father, Albert, and her brother, Eben, worked the fields and orchard, while Lydia, Emma's mother, kept house.[1] Emma broke from familial tradition when, in 1874, at age twenty-six, she enrolled in the Yale School of the Fine Arts[2]—though perhaps this was not entirely a surprise; in 1869 a "very fine crayon sketch of horses" by one "Miss Bacon" was mentioned among the notable artworks exhibited in Middletown's annual fair.[3]

The thirty-four works by Bacon now in the collection of the Yale University Art Gallery, all of which appear to date to her student years, are either oil sketches or charcoal, ink, and pencil drawings, and include several figural studies, most based on plaster casts but some on live models (figs. 1–2).[4] Another exception is *Woman Seated at an Easel* (fig. 3); the model in the painting appears to be a classmate of Bacon's—one of the fifteen (or more) women who enrolled at the School of the Fine Arts during each year of her studies.[5] The scene is probably set in Street Hall, built in 1866 to house both the art school (the first on an American college campus) and Yale's collection of art. Likewise, *Young Girl Seated in a Chair* (fig. 4) shows a live model who had likely been hired to pose in the School's painting class, and it is also set in Street Hall. With a hesitant expression, the model sits uneasily in an oversize, high-back chair, while a large book props up her leg. The striped pattern of her stockings and the metallic trim of her tiered skirt are subtly echoed in the background by a spiral iron pole, the signature feature of a first-floor studio in Street Hall.

For at least one year during her time as a student, Bacon taught painting, perhaps at a local vocational school;[6] however, she did not officially receive her Certificate of Completion from Yale until 1885. That year, she and her fellow certificate recipients showed their work in an exhibition that coincided with the School's commencement activities.[7] Although on this occasion Bacon's contribution was not singled out as especially noteworthy, the extant examples of her figural drawings demonstrate a remarkable facility with line, suggesting that she had continued to build on her early talents.

Bacon returned home to Middletown—and to a life apart from the professional art world—soon after leaving Yale. She remained single, living with her brother and their two unmarried aunts on the family farm after her parents' deaths. When Eben died in 1934, Bacon appears to have taken over the farming duties; the town directory lists her as a "dairy [and] produce" farmer for the remainder of her life.[8]    KO

1. United States Census Bureau, "1870 U.S. Census Population Schedules," accessed May 6, 2019, https://ancestrylibrary.com/. For information on the Bacon family's orchard, see United States Census Bureau, "1880 U.S. Selected Federal Census Non-Population Schedules," Agriculture Schedule, Middletown, Middlesex Co., Conn., accessed May 6, 2019, https://ancestrylibrary.com/.

2. *Directory of the Living Non-Graduates of Yale University* lists Bacon's dates of enrollment as 1874 to 1885. Anson Phelps Stokes, Jr., ed., *Directory of the Living Non-Graduates of Yale University* (New Haven: Tuttle, Morehouse, and Taylor, 1910), 6.

3. "The Annual Fair," *Constitution* (Middletown, Conn.), October 13, 1869.

4. A few watercolor sketches depicting botanical specimens can be found in Bacon's sketchbook; see Yale University Art Gallery, New Haven, inv. no. 1972.64.34.

5. For the number of students in Bacon's class and others, see the *Catalogues of the Officers and Students of Yale College*; the first to mention Bacon is *Catalogue of the Officers and Students of Yale College, with a Statement of the Course of Instruction in the Various Departments, 1879–80* (New Haven: Tuttle, Morehouse, and Taylor, 1879). The subsequent academic years of the catalogues that refer to Bacon are 1880–81 (published 1880); 1881–82 (1881); 1882–83 (1882); 1883–84 (1883); 1884–85 (1884); 1885–86 (1885).

6. The 1880 United States Census cites Bacon's occupation as "teacher [of] painting" while she was living in New Haven. See United States Census Bureau, "1880 U.S. Census Population Schedules," New Haven, New Haven Co., Conn., accessed May 6, 2019, https://ancestrylibrary.com/.

7. "Yale Art School: The Graduating Exercises This Morning Held in Private," *New Haven Evening Register*, June 1, 1885.

8. "Middletown, Connecticut, City Directory, 1935," accessed May 6, 2019, https://ancestrylibrary.com/.

# Emma H. Bacon  CAT. 2

American, 1848–1942, Certificate of Completion 1885    1880s

FIG. 1. Emma H. Bacon, Untitled, ca. 1875. Charcoal on paper, 18⁷⁄₁₆ × 12 in. (46.8 × 30.5 cm). Mr. and Mrs. Joseph D. Schwerin, B.A. 1960, Fund, 1972.64.11

FIG. 2. Emma H. Bacon, Untitled, 1875. Charcoal on paper, 24 × 18⅛ in. (61 × 46 cm). Mr. and Mrs. Joseph D. Schwerin, B.A. 1960, Fund, 1972.64.30

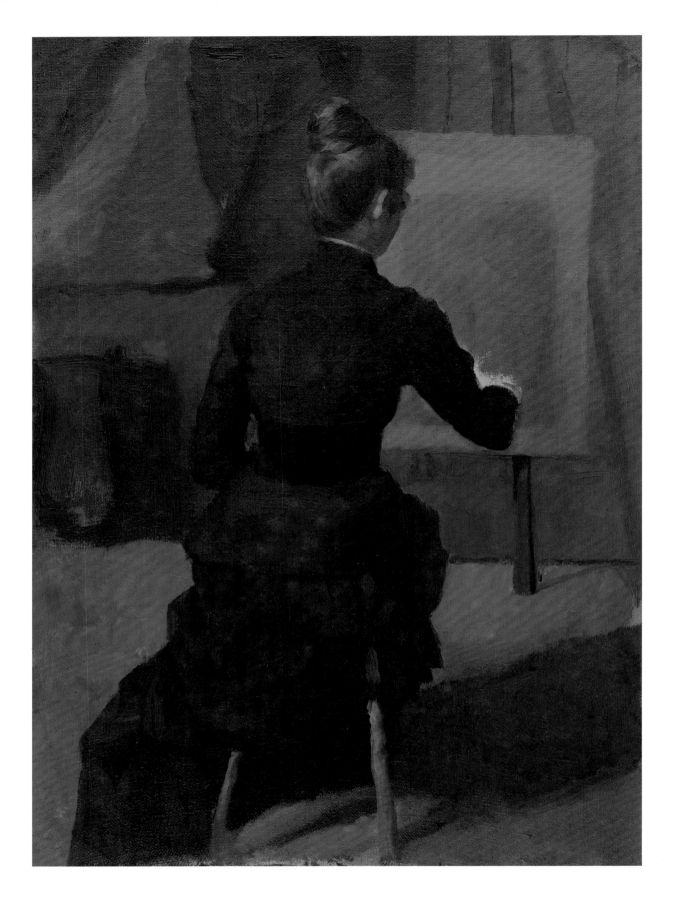

FIG. 3. Emma H. Bacon, *Woman Seated at an Easel*, ca. 1875–80. Oil on canvas, 13½ × 9¾ in. (34.3 × 24.8 cm). Mr. and Mrs. Joseph D. Schwerin, B.A. 1960, Fund, 1972.64.3

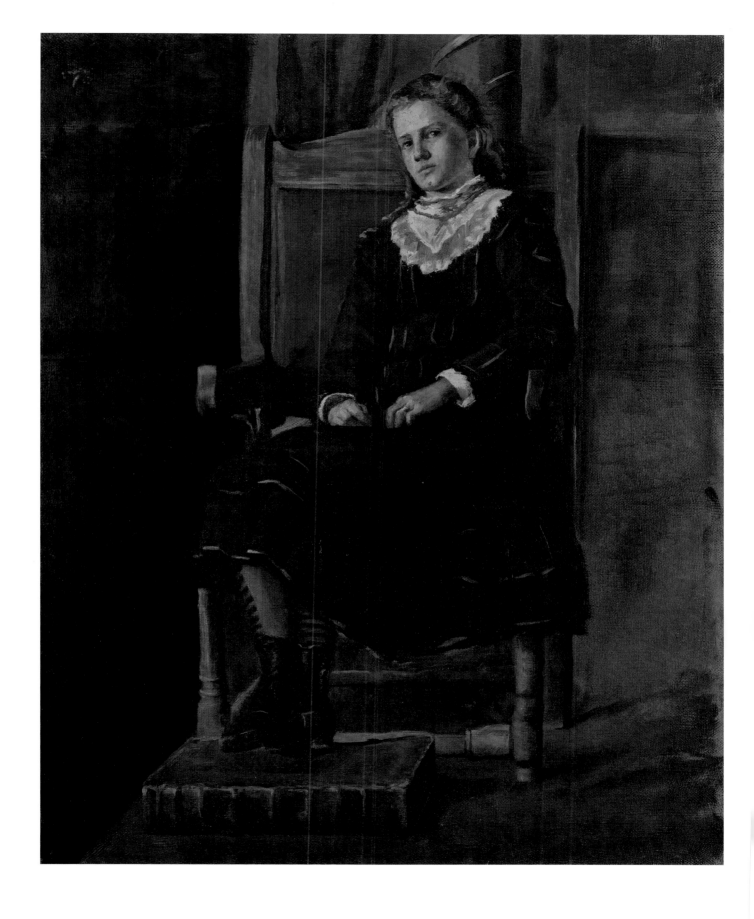

FIG. 4. Emma H. Bacon, *Young Girl Seated in a Chair*, 1878. Oil on canvas, 15⅞ × 12¾ in. (40.3 × 32.4 cm). Mr. and Mrs. Joseph D. Schwerin, B.A. 1960, Fund, 1972.64.2

JOSEPHINE MILES LEWIS WAS THE INAUGURAL recipient of a number of the long-standing honors conferred by the Yale School of the Fine Arts. She won the first Ethel Childe Walker Prize in 1886, and in 1891 she received the first B.F.A. that Yale awarded.[1] The latter made Lewis only the second woman granted a bachelor's degree by Yale.[2]

After attaining her degree, Lewis and her sister, Matilda—daughters of New Haven mayor Henry Gould Lewis—traveled to France from 1892 to 1897 for further study.[3] They continued to live and work together for much of their lives, wintering in New York and summering in Scituate, Massachusetts.[4] Their New York studio and apartment above Carnegie Hall put them in grand artistic company; both the dancer Isadora Duncan and the artist Charles Dana Gibson had studios in the same building.[5] Although both sisters were artists, Josephine had the more illustrious career by far, working professionally as a portraitist—especially of children—and winning numerous awards in her later years. The Yale B.F.A. degree originated as a distinction granted by John Ferguson Weir, Director of the School of the Fine Arts, based on his perception of an artist's career after Yale. Given Lewis's success as an artist, it is no surprise that she was the first to receive this honor.

Lewis painted *In the Orchard* (fig. 1) in 1922, at the height of her career.[6] With its thick brushwork and emphasis on light and shadow, the painting reveals the artist's interest in French Impressionism, which she developed during her time studying in Paris. Although she gave up her New York studio in 1943 and permanently moved to Scituate, Lewis continued to paint up until her death in 1959, at the age of ninety-five.[7]   GLH

1. *Catalogue of the Officers and Graduates of Yale University in New Haven, Connecticut, 1701–1892* (New Haven: Tuttle, Morehouse, and Taylor, 1892), 170.

2. Alice Rufie Jordan (Blake) was awarded a Bachelor of Laws degree in 1886. See *Catalogue of the Officers and Graduates of Yale University in New Haven, Connecticut, 1701–1901* (New Haven: Tuttle, Morehouse, and Taylor, 1901), 206.

3. "Josephine M. Lewis, 95: Portrait Painter of Children Exhibited Here and Abroad," *New York Times*, May 12, 1959.

4. United States Census Bureau, "United States Federal Census" (Washington, D.C., 1880), accessed November 6, 2018, https://www.ancestrylibrary.com/interactive/6742/4240017-00669; United States Census Bureau, "United States Federal Census" (Washington, D.C., 1900), accessed November 5, 2018, https://www.ancestrylibrary.com/interactive/7602/4114441_00366; New York State, "State Population Census" (Albany, 1905), accessed November 6, 2018, https://www.ancestrylibrary.com/interactive/7364/004518325_00291; United States Census Bureau, "United States Federal Census" (Washington, D.C., 1910), accessed November 5, 2018, https://www.ancestrylibrary.com/interactive/7884/4449360_00666; and United States Census Bureau, "United States Federal Census" (Washington, D.C., 1920), accessed April 9, 2019, https://www.ancestrylibrary.com/interactive/6061/4313935-00719.

5. New York State, "State Population Census" (1905); and United States Census Bureau, "United States Federal Census" (1910). Gibson lived elsewhere in the city but maintained a studio in the building.

6. Ronald Pisano, *One Hundred Years: A Centennial Celebration of the National Association of Women Artists*, exh. cat. (Roslyn Harbor, N.Y.: Nassau County Museum of Art, 1988), 66; and Carol Miles, "Josephine Lewis (1865–1959)," *Scituate Historical Society Newsletter* 3, no. 3 (October 1998): 4. In 1923 Lewis won first prize at the New Haven Paint and Clay Club exhibition. Miles suggests that this prize was for a painting titled *In a Garden*; given the similarity in date and title, the painting may in fact have been *In the Orchard*.

7. "Josephine M. Lewis, 95."

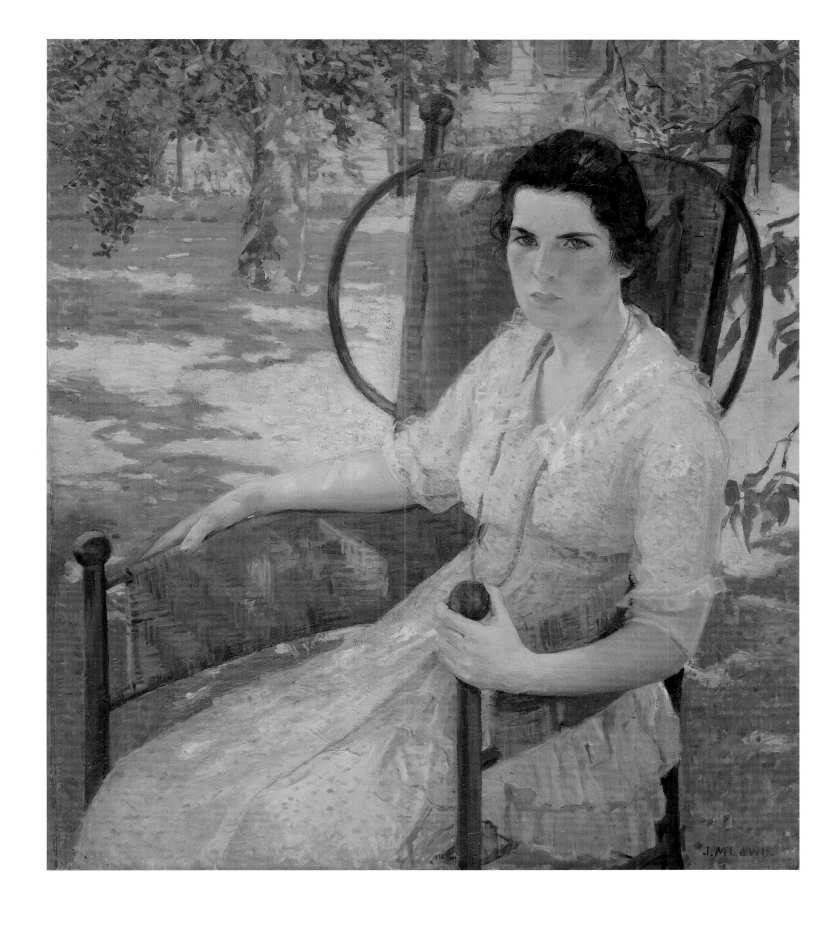

FIG. 1. Josephine Miles Lewis, *In the Orchard*, 1922. Oil on canvas, 36¼ × 33¾ in.
(92.1 × 85.7 cm). Gift of Mrs. James Finn, 1955.29.1

THE MUCKRAKING JOURNALIST LINCOLN STEFFENS wrote of the social gatherings hosted by the arts patron and writer Mabel Dodge that she "sat quietly in a great armchair and rarely said a word; her guests did the talking, and with such a variety of guests, her success was amazing."[1] Dodge entertained the cultural and intellectual elite at her Fifth Avenue– apartment salons in the early 1910s, around the time that this portrait (fig. 1)—notably, of Dodge seated in a gilded armchair— was painted by Mary Foote. At the time, Foote was pursuing her established practice as a portraitist, having opened her New York studio in 1901 and exhibited her work at the National Academy of Design, in New York, since 1903.[2] Her friend Dodge had more recently moved to the city, following several years of living in a villa outside Florence.[3]

Foote was raised in Guilford, Connecticut, in a farming family that had lost most of its wealth. After being orphaned as a teenager, she boarded with affluent relatives in Hartford. This turn of fortune afforded Foote the social status that would eventually place her in the company of famous artists. At the Yale School of the Fine Arts, where she enrolled in 1890, she won the prestigious William Wirt Winchester Prize, granting her two years of study in Europe, beginning in 1897, which she used to work with the American sculptor Frederick William MacMonnies in Paris and Giverny, France.[4] In 1907—a year after receiving her B.F.A. from Yale—she met expatriate John Singer Sargent when both artists were painting the Italian countryside in Tivoli, and the two often reunited during Foote's subsequent trips abroad.[5] Despite these important relationships, Foote enjoyed only modest artistic success and remained socially marginal within modernist circles. Gertrude Stein, for one, was said to have regarded Foote's distaste for Pablo Picasso as a "relic of the Stone Age."[6]

Like Dodge, who wrote in her memoirs about the personalities and interactions of her friends, Foote was adept at scrutinizing people.[7] Rather than writing about them, though, she translated her observations visually. Critics noted Foote's tendencies to "report social as well as individual tempers with precision" and to counterbalance the emotional intensity of her work by using a subdued palette. "Her color has a mellowness," one critic mused, "that takes off the edge of her incisiveness of characterization . . . as in the portrait of Mrs. Mabel Dodge, with its greens and grays."[8] Foote's portrayal of Dodge shows an alert sitter returning the artist's gaze, as if self-consciously engaged in the construction of her image.

Foote closed her studio in 1926, to travel first to China and then to Switzerland to seek psychoanalytic treatment from Carl Jung. Two years later, she permanently relocated to Zurich, where she stayed for nearly three decades, dedicating the rest of her professional life to studying Jungian psychoanalysis. Foote also transcribed Jung's lectures, an effort she largely financed with her money earned as a painter.[9]   KO

1. Lincoln Steffens, *The Autobiography of Lincoln Steffens* (New York: Harcourt Brace, 1931), 2:655.
2. Peter Hastings Falk, ed., *Who Was Who in American Art* (Madison, Conn.: Sound View, 1985), 208.
3. In her privately published book *Portrait of Mabel Dodge at the Villa Curonia* (Florence: Galileiana, 1912), Gertrude Stein memorialized Dodge's enchanted Italian home, which Dodge filled with paintings and frequently with parties that facilitated many an introduction between guests. Some acquaintances made were mutually influential, such as Stein and the photographer and critic Carl Van Vechten; other pairings were unequally matched, such as Stein and Foote—whose work was undeniably conventional by comparison to that of Stein, her avant-garde contemporary. Van Vechten's copy of Stein's book is in the collection of the Beinecke Rare Book and Manuscript Library, Yale University, New Haven.
4. Falk, *Who Was Who in American Art*, 208; and Betsy Fahlman, "Women Art Students at Yale, 1869–1913: Never True Sons of the University," *Woman's Art Journal* 12, no. 1 (Spring–Summer 1991): 19–20.
5. Sargent's painting *The Sketchers* (1913; Virginia Museum of Fine Arts, Richmond) depicts Foote in profile, standing at her easel, while she and another artist paint outdoors. See Richard Trousdell, "The Lives of Mary Foote: Painter and Jungian," *Journal of Analytical Psychology* 61, no. 5 (2016): 594, fig. 3.
6. Mary Foote to Mabel Dodge, September 12, 1911, Mabel Dodge Luhan Papers, Beinecke Rare Book and Manuscript Library, Yale University, New Haven, quoted in Edward Foote, "A Report on Mary Foote," *Yale University Library Gazette* 49, no. 2 (October 1974): 227.
7. Dodge devoted some of her multivolume autobiography to describing Foote's public persona at parties, characterizing Foote as "plain as a perch—yet a stylish perch." Mabel Dodge Luhan, *Intimate Memories*, vol. 2, *European Experiences* (New York: Harcourt Brace, 1933), 310. See also Trousdell, "Lives of Mary Foote," 598.
8. In this review of Foote's solo exhibition at M. Knoedler & Co., New York, the critic refers to the sitter as "Mrs. Mabel Dodge," as she was then married to Edwin Sherrill Dodge. They divorced in 1916, and Dodge married Antonio "Tony" Luhan, a Taos Pueblo, in 1923. See "Art Notes: Portraits by Mary Foote," *New York Times*, May 3, 1916.
9. Foote, "Report on Mary Foote," 230.

# Mary Foote   CAT. 4

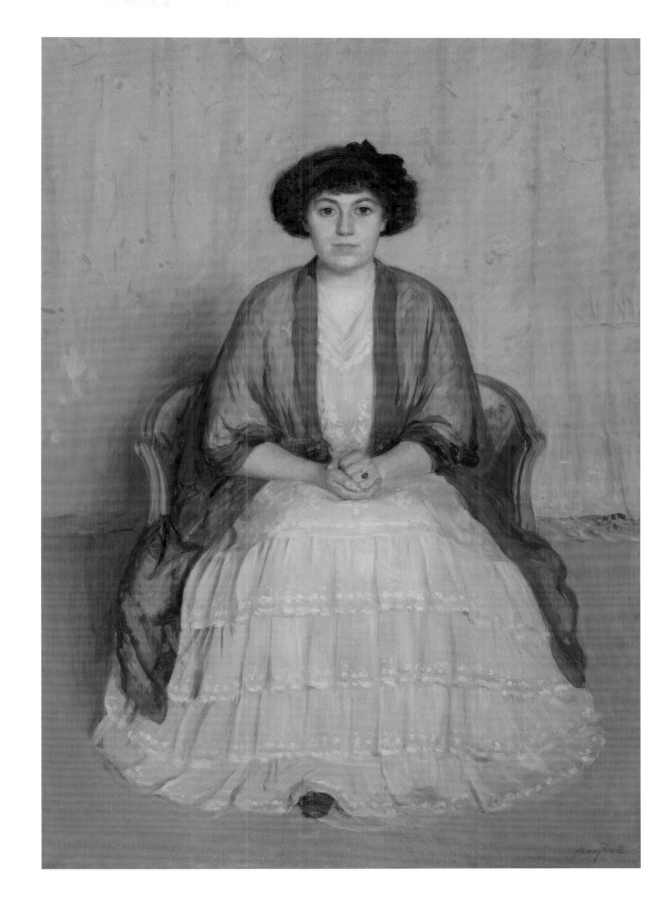

FIG. 1. Mary Foote, *Mabel Dodge (1879–1962)*, 1913–14. Oil on canvas, 57 × 42 in. (144.8 × 106.7 cm). Transfer from Beinecke Rare Book and Manuscript Library, Mabel Dodge Luhan Collection, Yale Collection of American Literature, 1973.95.9

IN EVERY PROFESSIONAL ROLE THAT SHE ASSUMED—artist, teacher, administrator, and writer—Irene Weir promoted the significance of cultural heritage. She especially advocated to instill this value in students of the arts by first training them in the basic elements of design and then testing their skills before actual artworks in museums, with Greek vases serving as her favorite examples.[1] Weir believed that visual literacy would allow these young novices to "claim a share in the rich inheritance of the ages."[2] Asserting her place in an esteemed lineage of her own, she never lost sight of the influence that the Weir family had on American art. Her grandfather—about whom Irene wrote a book-length biography—was Robert Walter Weir, a drawing instructor at the United States Military Academy, at West Point, in New York, for several decades (teaching such famous cadets as Ulysses S. Grant and James Abbott McNeill Whistler).[3] Both her uncles, John Ferguson Weir and Julian Alden Weir, the sons of Robert, enjoyed successful careers as artists. When Irene enrolled at the Yale School of the Fine Arts in 1881, staying for only a year, she became the pupil of John, then director of the School, and Julian, a prominent teacher there. After further pursuing instruction at the Art Students League of New York and at the Académie Colarossi, in Paris, Irene earned a Bachelor of Fine Arts degree from Yale in 1906.[4]

Education remained integral to Weir's life. Even during her tenure as the first director of the New York–based School of Design and Liberal Arts, from 1917 to 1929, she joined the inaugural class of 1923 at the École des Beaux-Arts at Fontainebleau.[5] Located outside Paris, Fontainebleau boasted a curriculum "designed as a sort of post-graduate school for advanced students, who . . . can benefit from their unique surroundings," which extended to the picturesque villages farther afield.[6] Four watercolors in the collection of the Yale University Art Gallery (figs. 1–4) were likely made during her visit to the historic commune of Chinon, where Fontainebleau students appear to have stopped on their trips to the Loire Valley. The works reveal that Weir was enchanted by everyday activities, particularly around the produce market, though she viewed this subject at a distance;[7] only the figures depicted in *The Blacksmith* and *The Noon Hour* are so closely observed as to record facial features and details of their clothing. These energetic studies call to mind two celebrated paintings of labor and leisure that Weir, with her vast art-historical knowledge, might have used as touchstones: Francisco Goya's *La fragua* (The Forge, 1815–20; Frick Collection, New York), with its pyramidal arrangement

of blacksmiths working a steel sheet, and Édouard Manet's *Le déjeuner sur l'herbe* (Luncheon on the Grass, 1863; Musée d'Orsay, Paris), a provocative gathering of a nude woman and clothed men dining outdoors.[8] The townspeople of Weir's playful scenes seem to refer to the archetypes in these iconic works of Western art, as if by recalling them she could "claim a share" of a grand artistic tradition—echoing the wish she had once made for her students.    KO

1. Weir wrote a popular book titled *The Greek Painters' Art* (Boston: Ginn, 1905) and, in a later article, explained her method of using the Greek vases in the collection of the Metropolitan Museum of Art, New York, to train students in visual analysis. See Irene Weir, "A Study of Museum Collections by Students," *Metropolitan Museum of Art Bulletin* 7, no. 9 (September 1912): 169–70.

2. Weir, "Study of Museum Collections by Students," 170.

3. For a discussion of Robert Walter Weir's students, see Marian Wardle, "Introduction: The Weir Family at Home and Abroad," in *The Weir Family, 1820–1920: Expanding the Traditions of American Art*, ed. Marian Wardle, exh. cat. (Provo, Utah: Brigham Young University Museum of Art, 2011), 6–9. Irene Weir's study on her grandfather was published posthumously. See Irene Weir, *Robert W. Weir, Artist* (New York: House of Field-Doubleday, 1947).

4. John Ferguson Weir bestowed the B.F.A. degree upon students not for coursework at Yale but for continued study or artistic achievement. See Betsy Fahlman, "Women Art Students at Yale, 1869–1913: Never True Sons of the University," *Woman's Art Journal* 12, no. 1 (Spring–Summer 1991): 16; and "Timeline: 1869–1949" in the present volume.

5. On Weir's many careers and published writings, see Fahlman, "Women Art Students at Yale," 16n22; and Heather Belnap Jensen, "Women of Substance: The Women of the Weir Dynasty," in Wardle, *Weir Family*, 146.

6. Fontainebleau Archives, *Fontainebleau Catalogue* (1923), 2, quoted in Isabelle Gournay, "Architecture at the Fontainebleau School of Fine Arts, 1923–1939," *Journal of the Society of Architectural Historians* 45, no. 3 (September 1986): 271. According to Gournay, the newly established Fontainebleau School appealed to "American artists and architects who had studied in Paris at the turn of the century [and] were anxious to re-establish and democratize pedagogic links with France." Weir, then director of a new art school, fit the mold of the type of student interested in learning methods of instruction not yet offered in the United States. Ibid., 270.

7. On the back of *View of the Market, Chinon, France* (fig. 3), Weir wrote: "From my window." *Women in Market Stalls, Chinon, France* (fig. 4) seems to have been made from a closer vantage point, but the women's faces are left blank and are thus devoid of individuality.

8. In the case of *The Blacksmith*, Weir also may have recalled the major painting on this theme by her uncle John Ferguson Weir, *Forging the Shaft* (1874–77; Metropolitan Museum of Art, New York), displayed in the 1878 Exposition Universelle, in Paris.

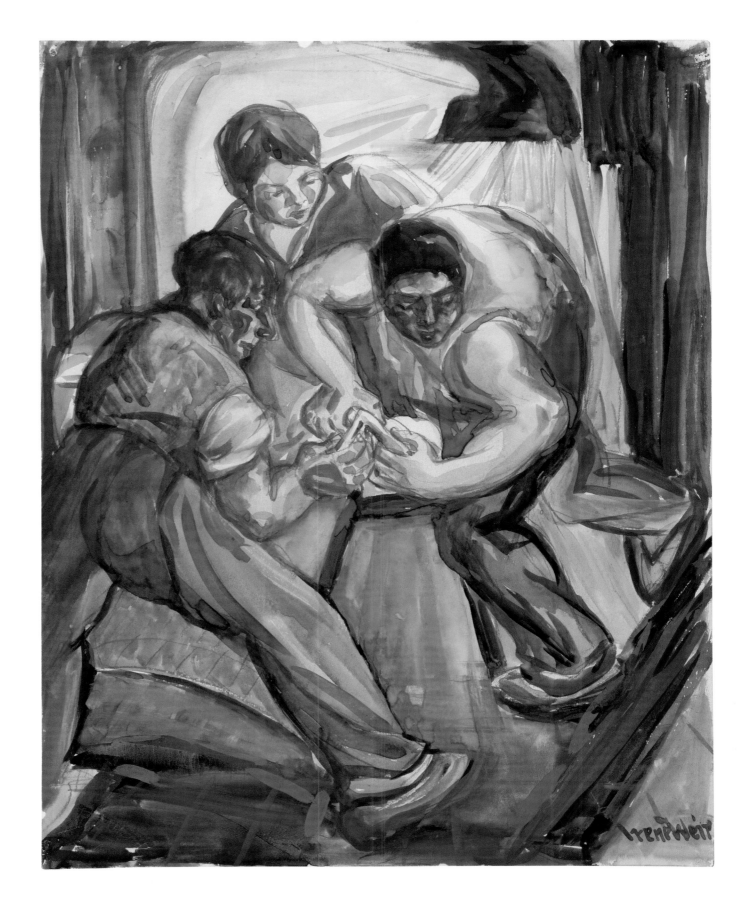

FIG. 1. Irene Weir, *The Blacksmith, Chinon, France*, ca. 1923. Watercolor on paper, 14¼ × 11¼ in. (36.1 × 28.6 cm). Gift of Irene Weir, B.F.A. 1906, 1931.102

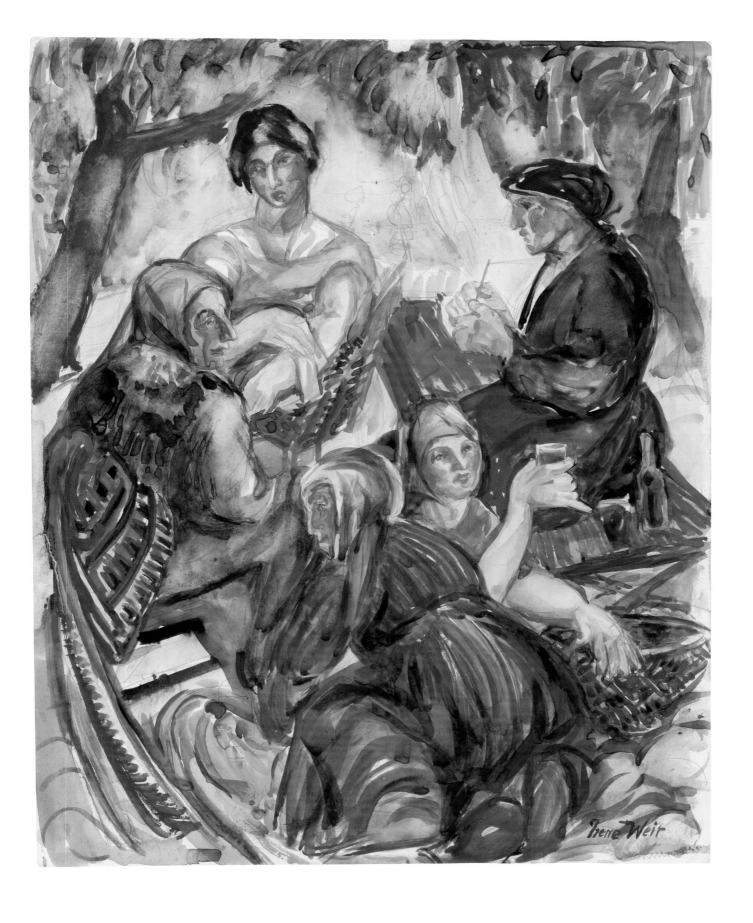

FIG. 2. Irene Weir, *The Noon Hour, Chinon, France*, ca. 1923. Watercolor on paper, 14¼ × 11¼ in. (36.1 × 28.5 cm). Gift of Irene Weir, B.F.A. 1906, 1931.103

FIG. 3. Irene Weir, *View of the Market, Chinon, France*, ca. 1923. Watercolor on paper, 7 × 4¾ in. (17.8 × 12.1 cm). Gift of Irene Weir, B.F.A. 1906, 1973.31.47

FIG. 4. Irene Weir, *Women in Market Stalls, Chinon, France*, ca. 1923. Watercolor on paper, 6⅛ × 4 in. (15.5 × 10.1 cm). Gift of Irene Weir, B.F.A. 1906, 1973.31.48

MILDRED CLEORA JORDAN'S EARLY LIFE FOLLOWED an unusual course for a student in the nineteenth century at the Yale School of the Fine Arts. Although her family remained together during her early years—moving from her birthplace of Portland, Maine, to Colorado before she turned five—her parents divorced while she was still a young woman.[1] Jordan then moved to New Haven with her mother and younger sister.[2] In 1891 she began her studies at the School of the Fine Arts, which she attended until 1900, despite receiving her Certificate of Completion in 1897.[3]

During her studies, Jordan's household was typical enough of a young woman at the turn of the century but unusual for the average, middle-class student at the School: in 1900 Jordan lived with her mother (a corset maker), her sister (a milliner), and a female boarder (a dressmaker).[4] By 1910 the household had two more boarders—a photographer and a doctor, both male.[5] Jordan's career was thriving; she had cofounded the New Haven Paint and Clay Club (which is still active today) in 1900, and she exhibited widely and painted portraits professionally, both on canvas and in miniature on ivory.[6] In 1914 she received her B.F.A. from the School of the Fine Arts in recognition of her artistic career beyond Yale.[7] That same year, she married a fellow Yale alumnus, a doctor named Charles Alling Tuttle. They may have met as early as 1900, when they lived a few doors down from each other on Whalley Avenue.[8] Although most of her surviving work dates to before her marriage, Jordan continued to paint and exhibit throughout her life.[9] After her husband's death in 1927, she traveled the world. She returned from a cruise mere months before her death in 1935.[10]

In 1907, before Jordan's marriage, George Dudley Seymour commissioned Jordan to paint a copy of the eighteenth-century artist Thomas Spence Duché's painting of the Reverend Samuel Seabury for Yale College (fig. 1). Although he had been a Loyalist during the American Revolution, Seabury became a formative figure in the Episcopal Church in the early United States. Jordan executed her copy at Trinity College, where Duché's original painting of Seabury then hung, working from the original and (in part because the original could not be cleaned) from an impression of William Sharp's engraving after the painting.[11] As she began the commission, Jordan wrote to Seymour that she "could not get easels heavy enough to hold the pictures, so [I] find them a bit awkward, but shall manage very well."[12] Jordan's copy blends the best of both Duché's painting and Sharp's engraving. She captured the soft, hazy landscape of the original, and the sitter's noble expression in it, but also the sharply geometric drapery delineated in the engraving.     GLH

1.  United States Census Bureau, "Colorado State Census" (Washington, D.C., 1885), accessed November 12, 2018, https://www.ancestrylibrary.com/interactive/6837/cot158_3-0179.1.
2.  United States Census Bureau, "United States Federal Census" (Washington, D.C., 1900), accessed November 7, 2018, https://www.ancestrylibrary.com/interactive/7602/4118740_00396.
3.  "Obituary Record of Graduates of Yale University: Deceased during the Year 1935–1936," *Bulletin of Yale University* 33, no. 3 (1936): 199. Jordan briefly interrupted her studies for a year in 1893.
4.  United States Census Bureau, "United States Federal Census" (1900).
5.  United States Census Bureau, "United States Federal Census" (Washington, D.C., 1910), accessed November 7, 2018, https://www.ancestrylibrary.com/interactive/7884/31111_4327343-00516.
6.  "Obituary Record of Graduates of Yale University," 199.
7.  On the B.F.A. during this period, see cat. 5n4 and "Timeline: 1869–1949" in the present volume.
8.  United States Census Bureau, "United States Federal Census" (1900).
9.  "Philadelphia," *Art News* 22, no. 8 (1923): 12.
10. "List of United States Citizens S.S. *Anna Maersk* Sailing from New York on a Round Trip, Dec. 12, 1934, Arriving at Port of New York, April 13, 1935," no. 1, p. 19, accessed November 12, 2018, https://www.ancestrylibrary.com/interactive/7488/NYT715_5630-0455.
11. William N. C. Carlton, letter to George Dudley Seymour, August 1, 1907, and Samuel Hart, letter to George Dudley Seymour, August 2, 1907, both George Dudley Seymour Papers, MSS 442, series 5, box 99, folder 1434, Manuscripts and Archives, Yale University Library, New Haven. The engraving was lent to Jordan by Samuel Hart, an administrator at Trinity College, at Seymour's request.
12. Mildred Cleora Jordan, letter to George Dudley Seymour, August 6, 1907, George Dudley Seymour Papers, MSS 442, series 5, box 99, folder 1434, Manuscripts and Archives, Yale University Library, New Haven. Judging by a letter from a librarian at Trinity College to Seymour, the "pictures" Jordan referred to were the original and her copy. See Carlton to Seymour, August 1, 1907.

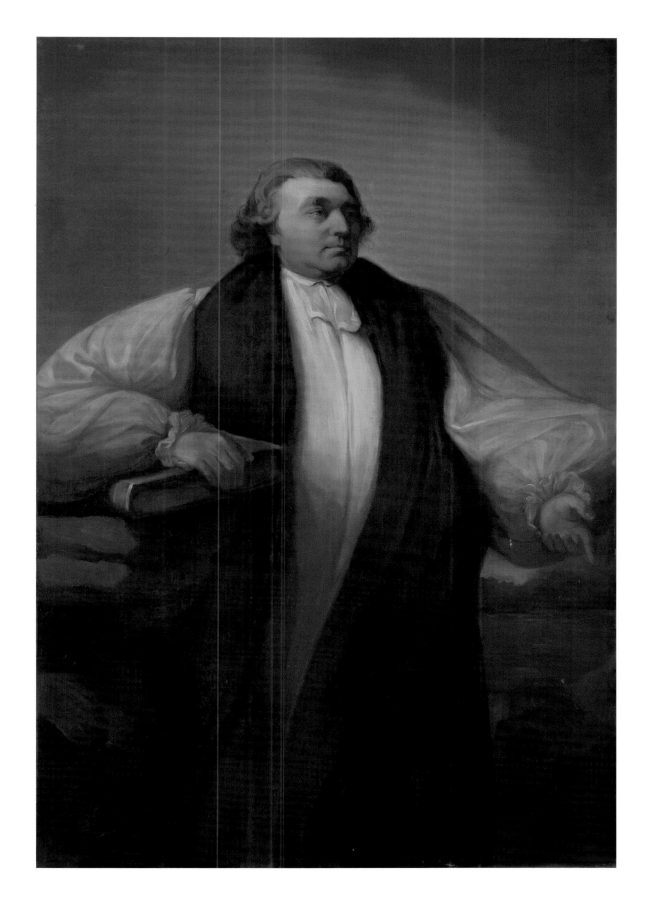

FIG. 1. Mildred Cleora Jordan, after Thomas Spence Duché, *Reverend Samuel Seabury (1729–1796, B.A. 1748, M.A. 1761)*, 1907. Oil on canvas, 63⅛ × 43 in. (160.3 × 109.2 cm). Gift of George Dudley Seymour, HON. 1913, 1907.4

ISABEL CASE BORGATTA WAS ONE OF THE FIRST female students to study sculpture at Yale, and her career spanned more than seventy-five years. She first attended Smith College, in Northampton, Massachusetts, and then went on to receive a B.F.A. from the Yale School of the Fine Arts in 1944. As a practicing artist and mother of three children, she was an advocate for advancing the status of female artists, and she was a founding member of the Women in the Arts Organization. In 1995 she became the first female artist to win the Alex J. Ettl Grant for lifetime achievement in American sculpture.

Although Borgatta worked mostly with stone throughout her career, recalling a long tradition of sculptors working directly with their materials that American artists had renewed in the 1920s and 1930s,[1] she created several wooden sculptures in the 1950s. Her later work was deeply influenced by ancient sculpture, which she had studied during numerous trips to Greece. Inspired by Greek mythology, she combined human figures and animals in several of her works. She was also interested in ancient Central and South American sculpture as an image source. "I am continually trying to distill and reduce form to the essence of whatever my subject might be," she said in an interview in 2005. "I carve directly without models or preliminary drawings with a vague idea of a concept, and I try to bring out the quality of the particular stone."[2]

Borgatta's main subject was the female figure taking on various forms, notably maternal, mythological, or biblical. In *Judith and Holofernes* (fig. 1), instead of showing Judith in the act of decapitating Holofernes, Borgatta focused on the woman herself, without any explicit iconography, instead portraying her strength. The roughly carved volumes of the sculpture reveal a solid, robust body, conveying a sense of calm, dignity, and monumentality.   FVJ

1. Patricia Hills and Roberta K. Tarbell, *The Figurative Tradition and the Whitney Museum of American Art: Paintings and Sculptures from the Permanent Collection*, exh. cat. (Newark: University of Delaware Press, 1980), 102.

2. Isabel Case Borgatta, quoted in Nina Costanza, "Simplicity of Form: A Conversation between Sculptor and Material," *Sculpture Review* 54, no. 3 (Fall 2005): 34.

# Isabel Case Borgatta   CAT. 7

American, 1921–2017, B.F.A. 1944   1940s

FIG. 1. Isabel Case Borgatta, *Judith and Holofernes*, ca. 1950–60. Wood, 29 × 8 × 8 in. (73.7 × 20.3 × 20.3 cm). Gift of Francesca Borgatta, Mia Borgatta, and Paola Borgatta, 2019.28.1

ON JUNE 22, 1945—FORTY-FIVE DAYS FOLLOWING THE Allied declaration of victory in Europe—Ellen Carley received her B.F.A. in Painting from the Yale School of the Fine Arts. As it was wartime, her graduating class was very small and very female, consisting of just seven painters (of which only one was a man) and one sculptor (a woman). Ellen, who went by "Nella," had received a full scholarship to the School in her first year and lived at the Faculty Club, where she served as hostess in exchange for room and board.[1] Her studies, principally under Lewis York, focused on the traditional techniques of egg-tempera painting, gold leafing, punching, and sgraffito.[2]

Following graduation, Nella returned to the New York of her childhood to marry George McNally. Atypical for her time, she embraced the holistic life of a working mother, balancing her career as a serious and prolific artist with her role at home as a wife and mother of three. Her skill in tempera technique and familiarity with ecclesiastical art—learned from her direct study of the early Italian paintings in the James Jackson Jarves Collection at Yale—positioned her to receive commissions for the altarpieces in churches across Europe and America, from the Panama Canal to Ireland, that were part of the postwar construction boom.

Painted in the early 1950s, *Sister Mary Margaret* (fig. 1) was commissioned by McNally's aunt Ruth, a close friend of the sister. Because accepting the portrait would have been considered vainglory, the sister's convent rejected the painting upon its completion. It is an interesting work on a number of levels, including in the apparent disconnect between the antiquated nature of its religious subject and use of egg tempera, and the startlingly contemporary style of its portrayal. Particularly odd yet delightful is the gender ambiguity of the sister, whose tight white wimple exaggerates her square jaw and hint of facial hair. The painting is a tour de force of tempera technique in its meticulous brushwork and built-up layers of tonalities, its exploitation of the white ground layer, and its playful use of sgraffito in the incised remarque at the upper left depicting the elementary school that the sister and Ruth attended.

In its hyperrealist depiction and disconcerting directness, *Sister Mary Margaret* is trenchantly modern; yet in McNally's use of tempera and sgraffito, the painting is grounded in the past. Here, it is representative of the last vestiges of Beaux-Arts teaching at Yale—a curricular methodology that would be turned on its head with the avant-garde revolution brought about by the appointment in 1950 of Josef Albers as chairman of the Department of Design.[3]     EH

1. All biographical information is from Ellen Carley McNally, oral history interview by Maura Cochran, Irma Passeri, and author, August 9, 2018, transcript, Yale University Art Gallery Archives, New Haven.
2. Lewis York was chairman of the Department of Painting at the Yale School of the Fine Arts from 1937 to 1950. He left in protest when the School was reorganized and Josef Albers was hired. York's tempera paintings provide the illustrations for the still-revered tome *The Practice of Tempera Painting: Materials and Methods* by Daniel V. Thompson (New Haven: Yale University Press, 1936).
3. Ellen Carley McNally died in July 2019 at the age of one hundred, just a little more than two years shy of the opening of the present exhibition. She continued to paint every day right up to her death, and egg tempera remained her favored medium.

FIG. 1. Ellen Carley McNally, *Sister Mary Margaret*, ca. 1950–55. Tempera on panel, sight in frame: 15¹⁵⁄₁₆ × 9⅝ in. (40.5 × 24.5 cm). Gift of the family of Ellen Carley McNally, B.F.A. 1945, 2019.16.1

Part 2
# 1950 to 1968

FIG. 7. Sylvia Plimack
Mangold, *Street Hall*, 1959.
Acrylic on canvas, 71⅝ × 48 in.
(181.9 × 121.9 cm). Yale
University Art Gallery, New
Haven, Gift of Sylvia Plimack
Mangold, B.F.A. 1961, and
Robert Mangold, B.F.A. 1961,
M.F.A. 1963, 2019.69.1

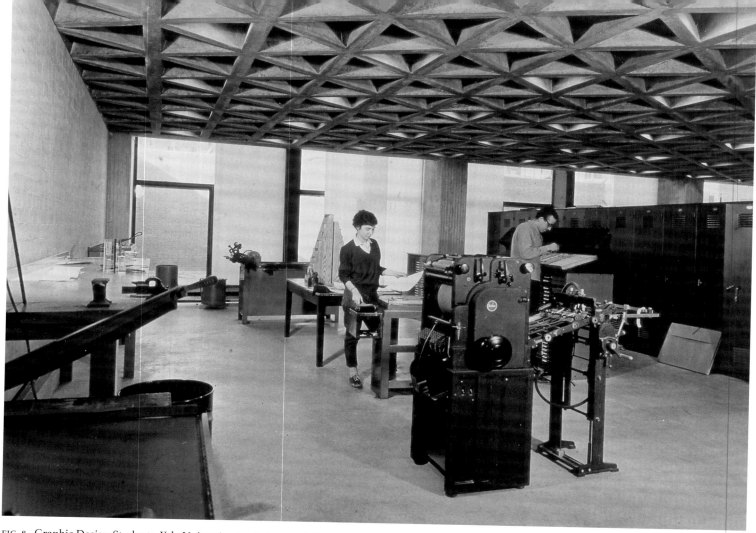

FIG. 8. Graphic Design Students, Yale University Art Gallery and Design Center, ca. 1954. Yale University Art Gallery Archives, New Haven

FIG. 9. Bernard Chaet, *Sun at Cathedral Rocks*, ca. 1981. Oil on canvas, 40⅜ × 56³⁄₁₆ in. (102.5 × 142.7 cm). Yale University Art Gallery, New Haven, Gift of the American Academy and Institute of Arts and Letters, 1982.10

encouraged a different relationship to work than I knew."[26] She liked the interaction between the art school, the Department of the History of Art, and the Yale University Art Gallery, which was down the block from Street Hall (where the painters and sculptors were still housed) and contained, in addition to the art collections, the Department of Graphic Design and Printmaking on the ground floor (fig. 8) and the Department of Architecture on the top floor.[27] Her teachers were Chaet, who painted expressive landscapes (fig. 9); Bailey, known for his clean, hard-edge still lifes (fig. 10); and the Abstract Expressionist Nicolas Carone (fig. 11). Soon after graduating, she was living in New York, painting urban landscapes, and married to the artist Robert Mangold, who had been a fellow student at Yale.[28] By 1967 she had begun to paint details of the parquet floors in her studio, a new and totally personal idiom that attracted the attention of the art world. Her parquet-floor imagery reflects an awareness of the geometry associated with Minimalism,

but it is also a realistic rendition of the floor, an example of the New Realist style that was emerging in reaction to Abstract Expressionism. One of these paintings was included in the exhibition *Realism Now*, organized in 1968 by a group of faculty and students for the Vassar College Art Gallery, in Poughkeepsie, New York, including the prominent art historian Linda Nochlin, known at the time for her studies of Gustave Courbet and nineteenth-century Realism (and later, famously, for her essay "Why Have There Been No Great Women Artists?").[29] Plimack Mangold's painting was selected for the cover of the exhibition catalogue.[30]

Just as Albers recruited students from Cooper Union, in the 1960s Chaet—perhaps seeking more female students—asked Leonard Baskin, who taught printmaking at Smith College, in Northampton, Massachusetts, to send promising students to Yale. Between 1960 and 1962, Baskin recommended five Smith graduates to Chaet. I know because I was one of them. I started at Yale as a painting student in the fall of 1961 and left in the summer of 1963 with a B.F.A. in Graphic Design and a new job in the curatorial department of the Solomon R. Guggenheim Museum, in New York. I became an art historian and a museum curator instead of an artist, but the other women from Smith—Anna Held Audette (cat. 15); Janet Fish (cat. 16); Patricia Tobacco Forrester, B.F.A. 1963, M.F.A. 1965; and Polly Mudge, B.F.A. 1962—all remained dedicated artists.

Although the permanent Painting faculty consisted primarily of Albers's students, who carried on his curriculum for the next few years, as far as I know Albers never returned to the School after his last year as a visiting critic. Outside influences and new ideas still came from other visiting critics. In the 1961–62 academic year, Alex Katz (who was hired briefly as faculty when Chaet was on sabbatical), Louis Finkelstein, and Philip Guston were among those who contributed to the Yale program. An exceptional number of the Yale art students of the early 1960s—both male and female—developed unique personal styles and became some of the most famous American artists of the 1970s and later; perhaps the absence of Albers's strong personality left room for this to happen.[31]

The artists from this period were, for the most part, ordinary art students when they started the program. Some tried painting in the popular Abstract Expressionist manner, and others made realistic still lifes or figurative works. In many cases, the students who started by trying abstraction ended up professionally as realists. Abstract Expressionism was still in the air, and most of these artists—called New Realists—never abandoned the formal lessons of abstraction. Some of the women at Yale in the early 1960s began to gain recognition in the art world in the late

FIG. 10. William Bailey, *Still Life—Table with Ochre Wall*, 1972. Oil on canvas, 47¾ × 53¾ in. (121.3 × 136.5 cm). Yale University Art Gallery, New Haven, Purchased with the aid of funds from the National Endowment for the Arts and the Susan Morse Hilles Matching Fund, 1972.115

FIG. 11. Nicolas Carone, *Night of the Yellow Eye*, 1956. Oil on paper mounted on canvas, 26 × 40 in. (66 × 101.6 cm). Yale University Art Gallery, New Haven, Richard Brown Baker, B.A. 1935, Collection, 2008.19.44

1960s and early 1970s. In addition to Plimack Mangold, among this group were my Smith compatriot Fish as well as Nancy Graves (fig. 12 and cat. 17) and Jennifer Bartlett (cat. 18).

Plimack Mangold became known for her already-discussed paintings of the parquet floors—and later, floors and mirrors (cat. 14, fig. 1)—of her loft. Fish burst onto the art scene in about 1968 with her tour-de-force paintings of fruit in glass jars or

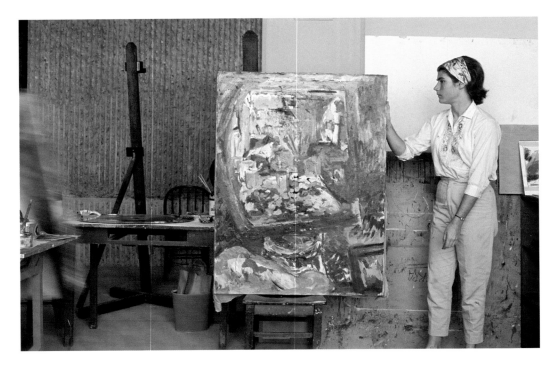

FIG. 12. Nancy Graves with *Vertical Still Life* (1963), Yale University, 1963. Nancy Graves Foundation, New York

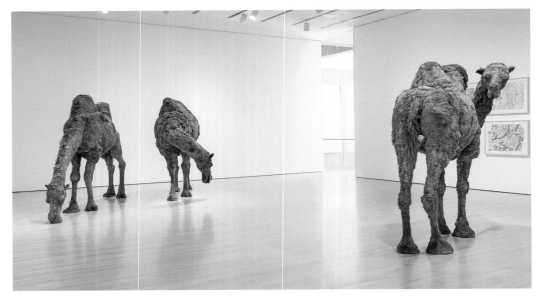

FIG. 13. Nancy Graves, *Camel VI, Camel VIII,* and *Camel VII,* 1969. Wood, steel, burlap, polyurethane, animal skin, wax, and oil paint, each (approx.) 8 ft. × 10 ft. 6 in. × 4 ft. (243.8 × 320 × 121.9 cm). Collection of the National Gallery of Canada, Ottawa, Purchased 1969, 15842; Gift of Allan Bronfman, Montreal, 1969, 15844; Gift of Allan Bronfman, Montreal, 1969, 15843

wrapped in clear plastic as in the supermarket (cat. 16, fig. 2), which examine the formal problems presented by the light reflections on the glass or cellophane. In 1969, when Graves was only twenty-nine years old, three of her sculptures of lifelike camels caused a sensation when they were exhibited at the Whitney Museum of American Art, in New York. Although she intended her camels to look realistic, she presented them equally as formal objects that focused on the visual effects of surface, volume, and shape (fig. 13). Bartlett, in 1968, settled on a style that combined Minimalism and Abstract Expressionism,

by painting Abstract Expressionist images on a series of regularly spaced, square, enamel-coated steel plates (cat. 18, fig. 1); soon she moved on to a succession of styles, including realism, still using the same square tiles.

A number of other women who attended the art school in the early 1960s and became respected professional artists also painted in a style that could be called New Realist. Good examples of these works are the large-scale still lifes painted by Harriet Shorr, B.F.A. 1962, and Nancy Hagin, M.F.A. 1964; the discarded industrial objects painted by Audette; and the

FIG. 14. Patricia Tobacco Forrester, *Guilford Woods*, 1965. Etching, sheet: 17⅝ × 23¹¹⁄₁₆ in. (44.8 × 60.2 cm). Yale University Art Gallery, New Haven, Emerson Tuttle, B.A. 1914, Print Fund, 1966.9.30

plants and landscapes painted by Janet Alling, B.F.A. 1962, M.F.A. 1964, and Forrester (fig. 14). Although very successful, the women artists at Yale during this time never achieved the same renown as their male counterparts. Some of the men, including Rackstraw Downes and Chuck Close, followed similar paths to their own kind of realism. Others like Robert Mangold, Brice Marden, and Richard Serra developed signature abstract styles. This period was still early in the rise of the 1960s feminist movement, and although the women were driven to succeed, they still tended to accept the traditional roles that were expected of them at the time—indeed, they often ended up marrying their male classmates.[32]

A new era at the art school began when the Abstract Expressionist painter Jack Tworkov became chairman of the Department of Art in the summer of 1963 and abandoned Albers's program completely (fig. 15). Tworkov was opposed to Albers's core curriculum, preferring independent, self-directed work supplemented by the exposure of the students to many different styles and ideas brought by visiting faculty and critics.[33] Indeed, the Visiting Critic program was the only aspect of Albers's legacy that Tworkov maintained—and he

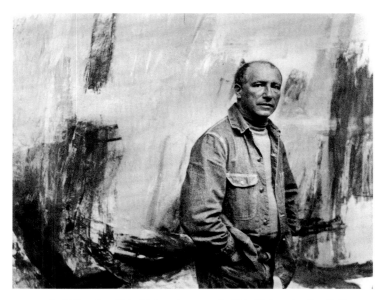

FIG. 15. Jack Tworkov, Yale University, ca. 1965. Yale University Art Gallery Archives, New Haven

actually expanded it to include more artists who each came to Yale for one day and others who participated in six-week seminars.[34] As Bailey observed, Tworkov made big changes; he brought the New York art world to the School, which Albers had cautioned against, calling it "the bandwagon."[35]

According to Andrew Forge, who became dean in 1975, Tworkov was considered by many to be a "wonderful teacher." He was well respected and clearly supportive of the women in the School. Bartlett has said that he was a "terrific teacher" who "was always interested." She acknowledged his open-minded approach to the variety of artists he brought from New York as visiting critics for six-week periods, citing as examples Jim Dine, Robert Morris, and James Rosenquist. "Jack was not threatened. He always tried to get the best people he could."[36]

It was also in 1963 that the new Art and Architecture Building, designed by Paul Rudolph to house all the art, design, and architecture students under the same roof, opened on the corner of Chapel and York Streets (fig. 16), across from the Yale University Art Gallery. It was an impressive structure, but one that did not work for either the students or faculty. There were many complaints, but the main problem was that the building was not large enough. A group of artists was sent to work in a brownstone a few blocks away. As Chaet recalled of that brownstone, "Yale had this big place on Crown Street, and that is where the famous classes of the early 1960s were all jammed together in rooms."[37] Ten students in their final year of the M.F.A. program, including Close, Downes, Serra, and Graves—the only woman of the group—worked there. For these students, it was a stimulating and competitive atmosphere that the art historian Irving Sandler believed may have contributed to the fame that many of the Crown Street artists achieved in later life.[38]

The activism of the late 1960s gave women new confidence. Two radical feminists who each earned an M.F.A. in 1967, Judith Bernstein (cat. 19) and Howardena Pindell (cat. 20), a Black artist, represent this new generation of activist-feminist artists. Both artists achieved some recognition in the 1970s but were, until recently, shunned by the art market. Bernstein and Pindell were among the founding members of A.I.R. Gallery, a pioneering, all-female, nonprofit cooperative gallery begun in New York in 1972 by a group of women seeking exhibition space for their work at a time when most commercial galleries rarely showed work by women—and showed even less work by Black women.

Tworkov's agenda worked well for Pindell. She had been trained as a figurative academic artist at Boston University and said that she was freed to work abstractly by the visiting artists that Tworkov brought to Yale, including one of the first women to be invited to Yale as a visiting critic, the Abstract Expressionist painter Helen Frankenthaler (fig. 17).[39] Pindell believed that

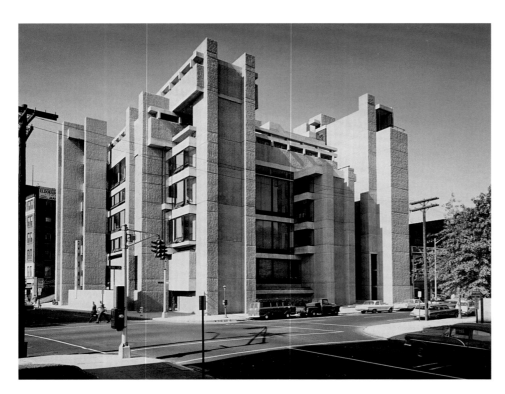

FIG. 16. Art and Architecture Building, Yale University, 1963. Yale University, New Haven, Visual Resources Collection, M0069-008

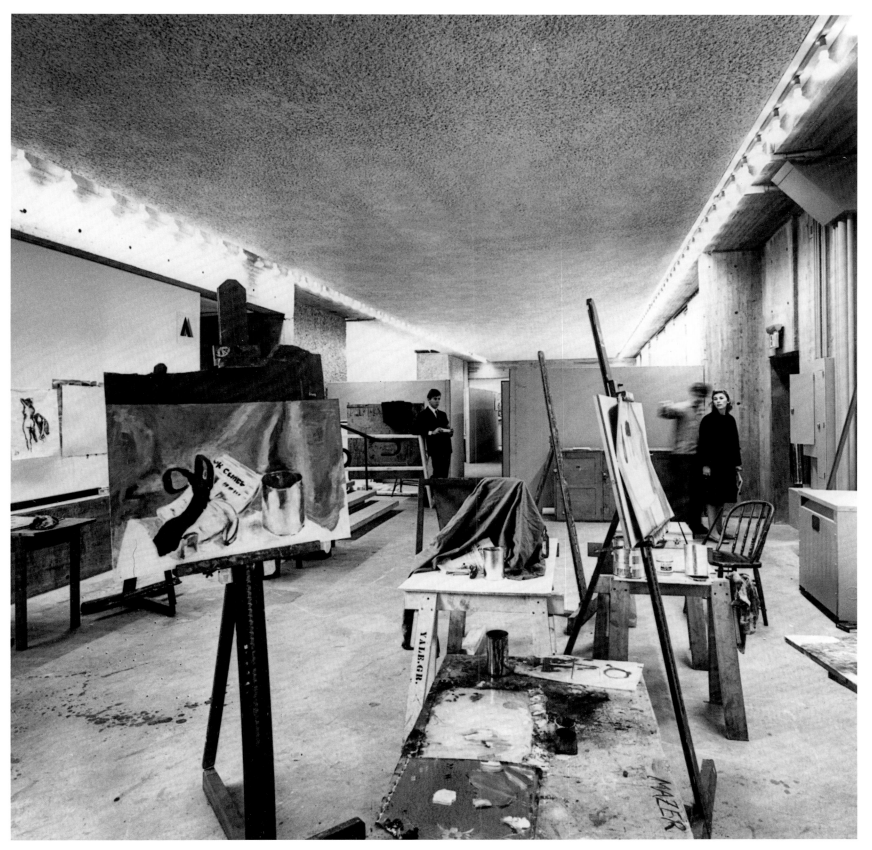

FIG. 17. Helen Frankenthaler, Art and Architecture Building, Yale University, ca. 1960. Yale University Art Gallery Archives, New Haven

FIG. 18. Howardena Pindell, *Memory Test: Free, White & Plastic (#114)*, 1979–80. Cut and pasted and painted punched paper, acrylic, watercolor, gouache, ink, thread, nails, mat board, spray adhesive, and plastic on cardboard, 20⅞ × 20⅞ in. (53 × 53 cm). Metropolitan Museum of Art, New York, Arthur Hoppock Hearn Fund, 1980, 1980.150

her noteworthy abstract paintings made of layers of punched-out paper circles were not well received in the 1970s because the Black community thought that her works were "pandering to the white world," and the white art establishment thought they were "inauthentic" (fig. 18).[40]

Meanwhile, Bernstein's provocative drawings of hybrid penis-screw imagery caused a sensation when they were removed from an exhibition in 1974 at the Museum of the Philadelphia Civic Center because they were considered pornographic. The artist has said that her crude, graffiti-like paintings of penises were inspired by the graffiti on the bathroom walls at Yale.[41] Despite these early unfavorable reactions, Bernstein and Pindell each were ultimately awarded significant recognition in their careers as artists, and they are now, in their seventies, achieving a new level of success.[42]

On June 14, 1969, a fire seriously damaged the fourth, fifth, and sixth floors of Rudolph's Art and Architecture Building, and alternative spaces needed to be found for the art students while the building was repaired (see Kuzma essay, fig. 1). The fire, along with the disruption of academic life on campus in this period caused by anti–Vietnam War and pro–civil rights protests at Yale (and at college campuses across the country), brought about the end of the Tworkov era. According to Chaet, there was little chance for teaching during this difficult period. Extensive renovations to the building were required, and the opportunity was taken to reorganize the structure and program of the School, with two deans, one in Art and one in Design and Planning.[43] The new character of the art school initiated by this reorganization was further affected by the coincidental decision of Yale University to begin accepting

female undergraduates in September 1969—a move that completely changed the relationship between men and women at Yale.

1. Sasha M. Newman and Lesley K. Baier, eds., *Yale Collects Yale*, exh. cat. (New Haven: Yale University Art Gallery, 1993), 11–12.
2. Charles H. Sawyer, letter to Josef Albers, February 12, 1948, Yale University Art Gallery Archives, New Haven.
3. Charles H. Sawyer, letter to Josef Albers, June 16, 1950, Yale University Archives, New Haven.
4. Ellen Carley McNally, oral history interview by Maura Cochran, Irma Passeri, and Elisabeth Hodermarsky, August 9, 2018, transcript, Yale University Art Gallery Archives, New Haven.
5. The Yale School of the Fine Arts was renamed the Yale School of Architecture and Design in 1955 and, subsequently, the Yale School of Art and Architecture in 1958. For more information, see "Timeline: 1950–68" in the present volume.
6. Newman and Baier, *Yale Collects Yale*, 18–19.
7. For more on this building, see "Timeline: 1950–68" in the present volume.
8. Newman and Baier, *Yale Collects Yale*, 19, 29 (inside flap). See also Josef Albers, report to A. Whitney Griswold, President, Yale University, 1951–52, Yale University Art Gallery Archives, New Haven.
9. Ibid., 18, 83–84.
10. Molly Glentzer, "Rice Professor Emerita Elinor Evans Whose Art Centered on Nature, Is Dead at 102," *Houston Chronicle*, August 29, 2016, https://www.houstonchronicle.com /entertainment/arts-theater/article /Rice-professor-Elinor-Evans -whose-art-centered-9191036.php; and Mark Yoes, "Elinor Evans: Some Truths from the Master," *Design Observer*, August 4, 2014, https://www.designobserver.com /feature/elinor-evans--some-truths -from-the-master/38540.
11. Society of Scribes, "Working with Color with Cynthia Dantzic, Saturday/Sunday, June 30 and July 1," accessed October 27, 2018, http://societyofscribes.org/10715 /working-with-color-satsun-june-30 -july-1/ (page discontinued).
12. Inter-Society Color Council, Munsell Centennial Color Symposium 2018, "Lois Swirnoff," accessed October 29, 2018, https:// munsell2018.org/swirnoff (page discontinued).
13. Obituary of Amy Genevieve Chapman, *New York Times*, March 30–31, 2015.
14. Society for Experiential Graphic Design, "Jane Davis Doggett," accessed October 29, 2018, https:// segd.org/jane-davis-doggett.
15. See Mildred Constantine and Jack Lenor Larsen, *Wall Hangings*, exh. cat. (New York: Museum of Modern Art, 1969), 8, nos. 8–10 (Hicks); 6, nos. 33–34 (Albers).
16. "Sheila Hicks Recalls Her Encounters with Anni Albers," in Briony Fer, Sheila Hicks, Duro Olowu, and Leonor Antunes, "Weaving Magic: Anni Albers at Tate Modern," *Tate Etc.* 44 (Autumn 2018): 57.
17. Helen A. Cooper, "Chronology," in *Eva Hesse: A Retrospective*, ed. Helen A. Cooper and Lesley K. Baier, exh. cat. (New Haven: Yale University Art Gallery, 1992), 21.
18. Ibid., 20.
19. Michael Rosenfeld Gallery, "Barbara Chase-Riboud, *Malcolm X: Complete*, September 9–November 4, 2017," http://www.michaelrosenfeldart .com/exhibitions/barbara-chase -riboudmalcolm-x-complete.
20. Fer, Hicks, Olowu, and Antunes, "Weaving Magic," 57.
21. Newman and Baier, *Yale Collects Yale*, 29 (inside flap).
22. Neil Rector, "Communicating in a Different Way: The Julian Stanczak Interviews," June 22–24, 2000, transcript, p. 79, Thomas J. Watson Library, Metropolitan Museum of Art, New York.
23. William Bailey, oral history interview by Laura Luís Worden, November 7, 2018, transcript, p. 1, Yale University Art Gallery Archives, New Haven.
24. Newman and Baier, *Yale Collects Yale*, 24.
25. Victoria Barr, oral history interview by Paul Cummings, January 11– February 18, 1977, transcript, Archives of American Art, Smithsonian Institution, Washington, D.C.
26. Newman and Baier, *Yale Collects Yale*, 79 (inside flap).
27. Ibid. For more on the history of the Yale University Art Gallery, see the timelines and the essay by Helen A. Cooper in the present volume; and Susan B. Matheson, *Art for Yale: A History of the Yale University Art Gallery* (New Haven: Yale University Art Gallery, 2001). Today, Street Hall is part of the Gallery.
28. Cheryl A. Brutvan, *The Paintings of Sylvia Plimack Mangold*, exh. cat. (Buffalo: Albright-Knox Art Gallery, 1994), 115–16.
29. Linda Nochlin, "Why Have There Been No Great Women Artists?," *Artnews* (January 1971): 22.
30. Cheryl A. Brutvan, "Collision: The Paintings of Sylvia Plimack Mangold," in Brutvan, *Paintings of Sylvia Plimack Mangold*, 18.
31. For thoughts on this phenomenon, see Irving Sandler, "The School of Art at Yale: The Collective Remi-niscences of Twenty Distinguished Alumni," in *20 Artists: Yale School of Art, 1950–1970*, exh. cat. (New Haven: Yale University Art Gallery, 1981), 9–21. Among the twenty artists Sandler selected were seven women, all of whom are discussed in this essay: Bartlett, Fish, Flack, Graves, Hesse, Pindell, and Plimack Mangold. The thirteen men include five "art stars": Chuck Close, Rackstraw Downes, Robert Mangold, Brice Marden, and Richard Serra.
32. Among those who married each other were Sylvia Plimack and Robert Mangold, Janet Fish and Rackstraw Downes, Nancy Graves and Richard Serra, Anna Held and Louis Audette, Polly Mudge and Neil Welliver, and Harriet Shorr and Eugene Baguskas.
33. Newman and Baier, *Yale Collects Yale*, 29.
34. Ibid., 28–29.
35. Bailey, interview by Worden, 8.
36. Michael Brenson, "Jack Tworkov: Painter and Art Teacher, Dead," *New York Times*, September 6, 1982, 32.
37. Newman and Baier, *Yale Collects Yale*, 32.
38. See Sandler, "School of Art at Yale," 20, for his analysis of why these classes produced so many famous artists.
39. Alex Greenberger, "Full Circle: Howardena Pindell Steps Back into the Spotlight with a Traveling Retrospective," *Art News*, February 6, 2018, http://www .artnews.com/2018/02/06/full-circle -howardena-pindell-steps-back -spotlight-traveling-retrospective/.
40. Hilarie M. Sheets, "Hailed after 70, Black Artists Find Success, Too, Has a Price," *New York Times*, March 24, 2019, 14.
41. See A.I.R. Gallery, "Judith Bernstein," accessed May 17, 2020, https://www.airgallery.org /judith-bernstein/.
42. Bernstein was given a solo exhibition at the New Museum, in New York, in 2012 and was profiled in 2015; see Julie L. Belcove, "Judith Bernstein, an Art Star at Last at 72," *Vulture*, May 5, 2015, https:// www.vulture.com/2015/05/judith -bernstein-isnt-afraid-of-dirty -words.html. A 2018–19 survey of Pindell's work traveled from the Museum of Contemporary Art, Chicago, to the Virginia Museum of Fine Arts, in Richmond, and to the Rose Art Museum, Brandeis University, in Waltham, Massachu-setts, and her profile appeared in *Art News*; see Greenberger, "Full Circle."
43. Newman and Baier, *Yale Collects Yale*, 34. For more information on this period, see "Timeline: 1969– Present" and the essay by Marta Kuzma in the present volume.

## 1950–53

The Korean War is fought. Active-duty women number 120,000, one-third of them healthcare workers. After the 1948 passing of the Women's Armed Services Integration Act, women are allowed to serve as members of the Army, Navy, Marine Corps, and Air Force for the first time in American history.

## 1950

On July 1, the Department of Design (encompassing painting, sculpture, and graphic arts) is founded at the Yale School of the Fine Arts, replacing the Departments of Painting and Sculpture, and Josef Albers is hired as chairman by Dean Charles H. Sawyer. This engenders a profound transformation in the philosophy and practice of the teaching of art at Yale. Albers's appointment results in the immediate resignation of Rudolph Zallinger, Instructor in Drawing and Painting, and Lewis York, Associate Professor of Drawing and Painting and chairman of the former Department of Painting, both of whom were steeped in the Beaux-Arts tradition. Those who remain on the faculty include Herbert Gute, Deane Keller, and Richard Rathbone.

Alvin Eisenman arrives as typographer at Yale University Press. Albers asks him to establish a program in graphic design at the School of the Fine Arts. Eisenman splits his time between the two organizations. During his tenure, Albers also hires Herbert Matter (in 1951), Norman Ives (1952), Bradbury Thompson (1955), Paul Rand (1955), and Armin Hofmann (1956), establishing the most eminent and vital graphic design faculty in the country.

Albers expands the Visiting Critic program, in which artists visit the School of the Fine Arts once a week for a semester or year. He often invites artists whose approach is quite different from his own. Among the early notable visiting critics are Willem de Kooning (1950–51), Stuart Davis (1951–52), and Ad Reinhardt (1952–53).

The five-year B.F.A. program is reduced to four years. Students who have completed three or four years of the five-year program prior to Albers's arrival are given the option of continuing their existing course of study or transferring to the new program. The School of the Fine Arts continues to award the M.F.A., which requires an additional two years of study beyond the B.F.A. At the end of his first year as chairman, Albers details the new curriculum and summarizes his philosophy of education in a report to Yale president A. Whitney Griswold: "All art studies, in the end, are studies of ourselves, in relationship to others. There is no objective measure in art. And art, I believe, cannot be taught directly."

Throughout the 1950s, Albers draws on male students who have recently graduated from the School of the Fine Arts for his new teachers, including Neil Welliver and William Bailey.

By the end of the year, the Gallery of Fine Arts' collection includes just under fifty thousand objects, with major holdings of American art, early Italian art, early twentieth-century European and American art, and art from the ancient Mediterranean world. There are also growing collections of Asian art, eighteenth- and nineteenth-century European art, and prints and drawings. Throughout the 1950s, two new fields of collecting—African art and art of the ancient Americas—expand the Gallery's collections.

## 1951

Under Josef Albers, there is no annual deadline for admission to the School of the Fine Arts. Prospective students are required to have completed two years of college or training at an art school, and Albers ultimately selects students based on viewing their work or an individual interview. He also looks to some of the leading art schools in the country to recommend students, such as Cooper Union, in New York (at the time, Cooper Union awarded only a three-year certificate). Albers selects each student's courses, but they all take foundation courses in color, drawing, and design, providing everyone with a shared language.

In July, Bernard Chaet is hired by Albers to teach courses in drawing and painting. He will become Critic in Painting in 1953 and thereafter continues to be promoted, eventually being named the William Leffingwell Professor of Painting in 1979; he teaches at Yale until his retirement in 1990.

## 1952

The Department of Architecture publishes the first issue of *Perspecta: The Yale Architectural Journal*, now the oldest student-edited architecture journal in the United States.

On December 15, the memorial exhibition *In Memory of Katherine S. Dreier, 1877–1952: Her Own Collection of Modern Art*, organized by the Gallery of Fine Arts Associate Director Lamont Moore, opens. It runs through February 1, 1953.

Bessie Lee Gambrill, in the Department of Education, becomes the first woman to receive tenure at Yale in a discipline other than Nursing.

## 1953

On November 6, the Yale University Art Gallery and Design Center opens, designed by Louis Kahn, who had been Professor of Architecture since 1950. Located at 1111 Chapel Street, adjacent to the 1928 Egerton Swartwout–designed building that housed the Gallery of Fine Arts, the Kahn building is the first modernist structure at Yale. The art collections of the Yale University Art Gallery (formerly the Gallery of Fine Arts) occupy the first and third floors and part of the second. The School of the Fine Arts occupies two floors: Graphic Design and Printmaking are on the ground floor, and Architecture is on the fourth floor. The Art Library moves from Weir Hall to the first floor of the Swartwout building (where it will remain until 1963); the collections also continue to be shown in parts of the Swartwout building. For the first time, Street Hall is devoted to the School, housing studios and classroom spaces for painting and sculpture. These three structures—the 1953 Louis Kahn building, the 1928 Egerton Swartwout building (now the Old Yale Art Gallery), and the 1866 Street Hall—make up today's Yale University Art Gallery.

John Marshall Phillips, director of the Yale University Art Gallery, dies unexpectedly. He is succeeded by Lamont Moore, who had been associate director from 1948 to 1953. Moore serves as director of the Gallery until 1957.

Gabor Peterdi is hired as Visiting Critic in Printmaking. With his arrival, studies in printmaking are incorporated into the Department of Design. Peterdi joins the permanent faculty in 1960 and teaches at Yale until 1987.

## 1954

The Yale University Art Gallery begins to mount commencement exhibitions for M.F.A. students in Painting, Sculpture, Printmaking, and Graphic Design. These are held through the mid-1960s.

## 1955–75

The Vietnam War is fought. Approximately eleven thousand Vietnamese women participate in the conflict. American women—the vast majority of them nurses—begin arriving in Vietnam in 1956, and by 1973 nearly five thousand women are stationed there.

## 1955

In the summer, the Yale School of the Fine Arts is renamed the Yale School of Architecture and Design. The Division of the Arts (which had been created in 1947 to unify the arts at Yale) is dissolved and replaced by the University Council on the Arts. The Department of Drama, until now part of the School of the Fine Arts, becomes a separate professional school, called the Yale School of Drama. The Yale University Art Gallery becomes a self-governing institution within Yale, separating from the art school.

Laura "Polly" Klotz Lada-Mocarski begins at the School of Architecture and Design as Instructor in Graphic Design, teaching bookbinding; later, she serves as Visiting Critic in Graphic Design.

On December 1, in Montgomery, Alabama, Rosa Parks refuses to give up her seat on a bus to a white man. The incident marks the beginning of the American civil rights movement.

## 1956

The Yale University Art Gallery exhibition *Pictures Collected by Yale Alumni* includes 250 works of art loaned by Yale alumni and Yale families. Many works will later be given or bequeathed to the Gallery.

Arthur Howe, Jr., the new Dean of Admissions at Yale, advocates for the admission of women to Yale College in order to raise the academic level of the student body, attract outstanding students who prefer coeducational schools, and reduce the disintegration of the Yale community on weekends as male students leave to visit women's colleges.

## 1957

Andrew Carnduff Ritchie begins as director of the Yale University Art Gallery; he serves until 1971.

In February, the Yale Divinity School opens Porter Hall (razed 2000). Designed by Douglas Orr, it is the first building on campus to be constructed as a residence for women.

## 1958

In January, Gibson Danes is appointed dean of the School of Architecture and Design and interim chairman of the Department of Art. Paul Rudolph, who had served as a visiting critic in 1957, is named chairman of the Department of Architecture, a position he holds until 1965.

In June, Josef Albers retires as chairman of the Department of Design. He continues to serve as a visiting critic until 1960.

In the summer, the Yale School of Architecture and Design is renamed the Yale School of Art and Architecture. It now includes studies in Painting, Sculpture, and Graphic Arts as well as Architecture and City Planning.

The four-year B.F.A. program is reduced to three years.

The School of Music becomes a separate graduate professional school.

Helen Hadley Hall, Yale's first residence for female students across the graduate and professional schools, is built; it is designed by Douglas Orr and named after the wife of Yale's thirteenth president, Arthur Twining Hadley. Before the opening of Helen Hadley Hall, women in the graduate and professional schools often found boardinghouse situations or lived in Yale buildings that had been converted into dormitories.

## 1959

In February, Bernard Chaet is named chairman of the Department of Art, taking over the interim duties from Dean Gibson Danes; he serves until 1962. Chaet regularizes the admissions process by working with three to four faculty members to review applicants' slides and conduct interviews.

The Yale Corporation and Yale president A. Whitney Griswold order that the Yale professional schools (including Art and Architecture, Drama, and Music) must cease to confer undergraduate degrees. The School of Art and Architecture gradually phases out the Bachelor of Fine Arts degree, awarding its final B.F.A. in 1975.

## 1960

Barbara Chase-Riboud (cat. 13) becomes the first Black woman to receive a Master of Fine Arts degree (in Sculpture) from the School of Art and Architecture.

Judith Chafee, the only woman in her class, receives a Master of Architecture degree from Yale. One year earlier, Chafee had been the first woman to win the annual Koppers Architectural Student Design Competition for her roof designs for a 150-bed hospital. Because the award ceremony was held at the men-only Quinnipiack Club, Chafee had to enter and exit through the kitchen to receive her award. After graduation, her first actualized home design, the Ruth Merrill Residence, in Guilford, Connecticut, lands on the cover of *Architectural Record* magazine, making Chafee the first woman architect to win the Record House Award cover.

Richard Lytle begins as Instructor in Painting at the School of Art and Architecture; he becomes Professor of Painting in 1966, a position he holds until 2002.

The Yale Norfolk Summer School of Art and the Yale Summer School of Music are combined into an eight-week program called the Yale Summer School of Music and Art.

## 1961

Alvin Eisenman is appointed Professor of Graphic Design at the School of Art and Architecture.

The Creative Arts Workshop—a nonprofit regional art center for children and adults, still in operation today—is founded in New Haven.

## 1963

On June 10, the Equal Pay Act is passed by the U.S. Congress, banning pay discrimination "on the basis of sex" for employees performing equal work.

In the summer, Jack Tworkov is appointed chairman of the Department of Art at the School of Art and Architecture; he serves until 1969. Like Albers, Tworkov believes that art schools are to encourage individualized development within a community of artists. Yet, Tworkov makes significant changes to the curriculum. Breaking an earlier pattern of having only one or two visiting critics each semester or year, Tworkov arranges a series of six-week seminars taught by various visiting professors as well as regular faculty. He thus extends the range of visitors and the scope of the course offerings.

On October 11, the Beinecke Rare Book and Manuscript Library—one of the world's largest rare book and manuscript libraries and the University's principal repository of literary archives, early manuscripts, and rare books—is dedicated.

The School of Art and Architecture moves from the Louis Kahn and Egerton Swartwout buildings into the new Art and Architecture Building, designed by Paul Rudolph and dedicated on November 9. In addition to housing the School, the Art and Architecture Building also contains the Art Library, the Art and Architecture Gallery (where critiques happen, and where student work is displayed for final theses), and the administrative offices of the School. The building is a critical success, but it also draws immediate complaints from the students and faculty for its inadequate facilities, such as constrained work spaces for sculptors. The Kahn building becomes solely dedicated to the Yale University Art Gallery; the Gallery retains spaces (along with the Department of the History of Art) in the Swartwout building.

## 1964

Mary Clabaugh Wright, Professor of History at Yale since 1959, becomes the first woman to receive tenure in the Faculty of Arts and Sciences.

On July 2, the Civil Rights Act of 1964 is passed, prohibiting discrimination in employment based on race, color, religion, sex, or national origin. The Equal Employment Opportunity Commission is created to enforce civil rights laws against workplace discrimination.

## 1965

Marie Boroff, PH.D. 1956, Professor of English at Yale since 1959, becomes the second woman to receive tenure in the Faculty of Arts and Sciences.

Pauli Murray, J.S.D. 1965, HON. 1979, becomes the first Black person—woman or man—to receive a Doctor of Juridical Science from the Yale Law School. In 2017 Yale will name one of its residential colleges in her honor.

On August 6, U.S. president Lyndon B. Johnson signs into law the Voting Rights Act of 1965. It is a landmark piece of federal legislation that prohibits racial discrimination in voting.

On September 24, President Johnson signs Executive Order 11246. It prohibits federal contractors from discriminating in employment decisions on the basis of race, color, religion, sex, or national origin.

## 1966

In March, the Yale Corporation announces that it is in favor of finding a women's "coordinate college" (i.e., a women's college with which to partner) to address the issue of coeducation.

Women are admitted to the Yale School of Forestry (now Yale School of the Environment), the last of Yale's professional schools to admit women. The school was originally founded in 1900 as the Yale Forest School.

The National Organization for Women (NOW) forms in Washington, D.C., to challenge sex discrimination in all areas of American society by means of lobbying, demonstrations, and litigation and to effect societal change. Betty Friedan is the first president of NOW, and Pauli Murray is one of the founding members.

## 1967

On October 13, U.S. president Lyndon B. Johnson signs Executive Order 11375, which amends Executive Order 11246 and prohibits all discrimination on the basis of race, color, religion, sex, or national origin. The amendment also requires affirmative-action plans to promote the full realization of equal opportunities for women and other minority populations.

In November, Antonina Uccello becomes mayor of Hartford. She is the first woman to become mayor in Connecticut and the first woman mayor of a U.S. state capital.

On December 8, an announcement is made regarding the sizable gift of art collector and philanthropist Paul Mellon to establish a center for British art and studies at Yale. (He is also responsible for the creation of a sister institution in London, the Paul Mellon Centre for Studies in British Art.) The Yale Center for British Art will open to the public in 1977.

# 1968

Jules D. Prown becomes the founding director of the Yale Center for British Art; he serves until 1975.

Ch'ung-ho Chang Frankel, who teaches calligraphy, is Lecturer in Graphic Design.

In September, Yale president Kingman Brewster, Jr., distributes a memorandum titled "Higher Education for Women at Yale" among members of the Yale Corporation and key faculty committees. The memorandum discusses the desirability of coeducation at Yale.

On November 4, Coeducation Week commences. The campus hosts 750 women from 22 colleges. In the middle of the week, students hold a spontaneous rally, marching to President Brewster's home to demand full coeducation. On November 9, the Yale Corporation approves coeducation for Yale College. On November 14, President Brewster announces his plan for coeducation to the faculty and then to the students. The next day, he makes a public announcement that the Planning Committee on Coeducation is to be chaired by Elga Wasserman, J.D. 1976, Assistant Dean of the Graduate School. Other members include Assistant to the President Henry Chauncey, Dean of Undergraduate Affairs John Wilkinson, Professor of English Marie Borroff, and Professor of Psychology Claude Buxton.

In December, Associate Director of Financial Assistance John Q. Wilson announces that, in terms of financial aid, Yale has a "basic commitment to men," and that men will be the first priority for receiving financial aid—meaning that women and men are not to be treated equally from a financial standpoint.

Shirley Chisholm becomes the first Black congresswoman, representing New York's Twelfth Congressional District in the U.S. House of Representatives. She serves for seven terms. Chisholm goes on to run for president in 1972—the first Black woman to do so.

AUDREY FLACK HAS DESCRIBED HER LONGING TO create works akin to the art of the European canon while making rebellious and avant-garde art as a student: "I was a wild abstract expressionist painter slinging paint from fifty feet away, hanging out with de Kooning, Kline, and Pollock, but in my heart . . . I always wanted to draw. And I always wanted to draw like an Old Master."[1] Flack was among the few women artists who worked within the masculine milieu of Abstract Expressionism prior to her arrival in New Haven as a transfer student from Cooper Union, in New York. "In my third year of Cooper Union," she has recalled, "I got called into the dean's office, thinking I was in trouble again, but on the contrary, Joseph [sic] Albers was sitting there waiting for me."[2] Albers, then chairman of the newly established Department of Design at the Yale School of the Fine Arts, offered Flack a scholarship to attend the School in 1951. She describes the recruitment of intrepid students, including herself, as one of Albers's energetic attempts to revolutionize the School following his arrival in 1950. But Flack has also recalled her many disagreements with him: "Albers wanted me to paint squares, as he did. There was no way that was about to happen."[3]

During her time at Yale, Flack maintained her traditional desire to sketch from life like the Old Masters, despite the School's push toward modernism and disinterest in realism, including a lack of live-model drawing. "So," she has recounted, "I would secretly copy Tintoretto, Raphael, Rubens, Michelangelo, and I had sketchbooks filled with them."[4] Upon graduation, she returned to New York to study art history at the Institute of Fine Arts, New York University, and anatomy at the Art Students League.

In the 1960s and 1970s, Flack was among the Photorealist artists employing projectors and airbrushes to create enlarged and highly detailed compositions. Yet, she views her work, naturalistic still lifes and portraits, as different from the banal images of cars and motorcycles that were popular among some of her Photorealist colleagues.[5] With optical fidelity, she made emotive images such as *Lady Madonna* (fig. 1). In this opulent lithograph, a tearful Virgin Mary gazes dejectedly ahead while wearing billows of lace, levitating jewels, and a gold halo. The image depicts a Baroque sculpture, *La Virgen de la Esperanza de Macarena* (Virgin of Hope of Macarena), that Flack had encountered on a trip to the cathedral of Seville in Spain. Drawing on this sentimental and pious subject allowed Flack to explore the complexities of her own identities as a woman, a Jew, a mother, and an artist.

Throughout her career, Flack has created theatrical works—both monumental public sculptures and smaller two-dimensional pieces—that reflect the experiences of women. *The Ecstasy of Saint Theresa* (fig. 2) is from a body of work featuring historically misrepresented heroines. Again, Flack was inspired by Baroque art; she sketched the climactic expression of the saint after Gian Lorenzo Bernini's famous mid-seventeenth-century sculpture. Her image also includes a flying, phallic lipstick and an erotic quotation, a double entendre of sexual and spiritual ecstasy, from Saint Theresa's autobiography. Describing the saint, Flack has written, "She is the antithesis of a middle aged de-sexualized nun, but rather a beautiful vibrant young woman in the throes of intense passionate feelings."[6] Both *The Ecstasy of Saint Theresa* and *Lady Madonna* reveal Flack's evolving interest in Christian iconography, which she encountered in a Yale course taught by A. Elizabeth Chase, an educator at the Gallery of Fine Arts and Assistant Professor in the Department of the History of Art.    LLW

1. Audrey Flack, quoted in Ira Goldberg, "Born to the Calling: An Interview with Audrey Flack," LINEA: Studio Notes from the Art Students League of New York, October 1, 2011, https://www .asllinea.org/art-students-league -audrey-flack/.
2. Ibid.
3. Audrey Flack, quoted in Sasha M. Newman and Lesley K. Baier, eds., *Yale Collects Yale*, exh. cat. (New Haven: Yale University Art Gallery, 1993), 29 (inside flap).
4. Flack, quoted in Goldberg, "Born to the Calling."
5. Audrey Flack, oral history interview by author, May 23, 2019, transcript, Yale University Art Gallery Archives, New Haven.
6. Audrey Flack, quoted in Andrea Bubenik, "Audrey Flack: *Ecstasy of St. Theresa* and *Une Bouchée d'Amour*," in *Ecstasy: Baroque and Beyond*, exh. cat. (Brisbane, Australia: University of Queensland Art Museum, 2017), 25.

# Audrey Flack  CAT. 9

FIG. 1. Audrey Flack, *Lady Madonna*, 1972. Lithograph, sheet: 34 × 24 in. (86.3 × 61 cm). Gift of Dr. and Mrs. Samuel S. Mandel, M.D., 1980.66.1

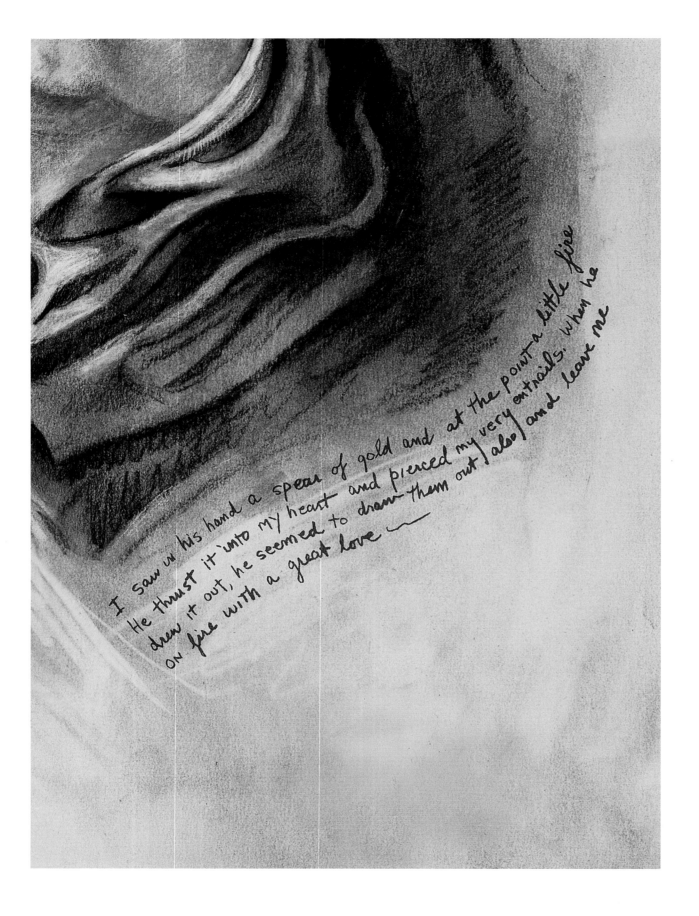

I saw in his hand a spear of gold and at the point a little fire He thrust it into my heart and pierced my very entrails. When he drew it out, he seemed to draw them out also, and leave me on fire with a great love

FIG. 2. Audrey Flack, *The Ecstasy of Saint Theresa*, 2012. Screenprint, 22½ × 16¹⁄₁₆ in. (57.2 × 40.7 cm). Gift of the Experimental Printmaking Institute and the Pennsylvania Academy of Fine Arts Press, 2014.50.1

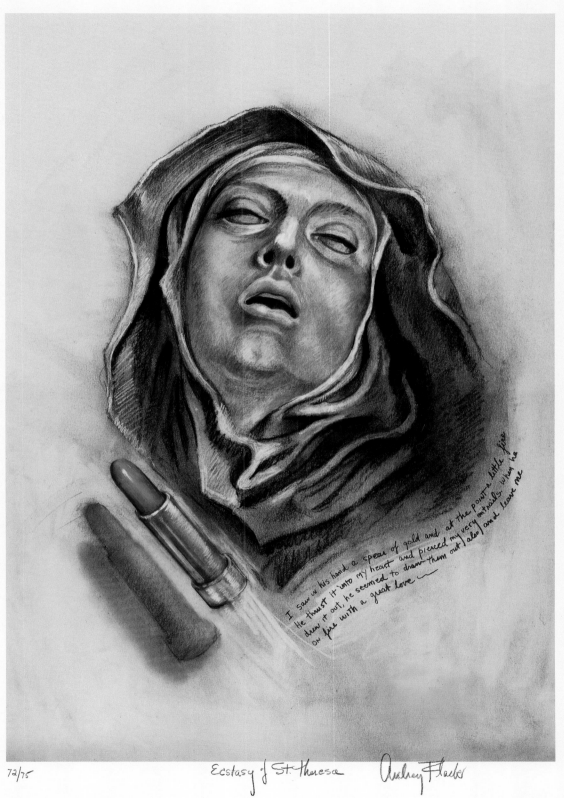

I saw in his hand a spear of gold and at the point a little fire
He thrust it into my heart and pierced my very entrails, when he
drew it out, he seemed to draw them out also, and leave me
on fire with a great love —

72/75          Ecstasy of St. Theresa          Audrey Flack

BORN IN ANSONIA, CONNECTICUT, IN 1911, JENNETT Lam studied at the Yale School of the Fine Arts during two distinct periods of her life—and in two distinct periods of the School's history. She first attended classes there as a young woman in the 1930s, and she briefly worked on a mural in New Haven for the Works Progress Administration, experiences she found dreary and uninspiring. It was not until she returned to the School almost twenty years later, in 1950, to study with Josef Albers and then with Bernard Chaet, that Lam found her footing as an artist. She received her B.F.A. in 1954—focusing especially on collage—and her M.F.A. in 1960. Just as Albers represented a sea change for the modernization of the art school, so too did he have an enormous influence on Lam's painting and on her approach to teaching. She taught in the art department at the University of Bridgeport, in Connecticut, from 1957 until her retirement in 1972.

In 1960 and 1961, Lam had fellowships at the MacDowell Colony, in Peterborough, New Hampshire, the oldest artists' retreat in the United States. There, she became interested in a charming feature of the colony's rustic decor: Victorian wicker chairs with floral cretonne covers. She painted a series of these chairs in an impressionistic style, conjuring the intimacy and atmosphere of a garden. The paintings caught the attention of the art critic and gallerist Colette Roberts, who organized four solo exhibitions of Lam's work in the early 1960s at the Grand Central Moderns Gallery, in New York, as well as an exhibition in 1965 at the Parisian gallery Le point cardinal.

Lam painted wicker chairs until 1962 when, on a trip along the Italian Riviera, she saw striped canvas chairs on the beach. These chairs, with their simple wooden structures and colorful canvas slings, would boldly inhabit her paintings for the rest of the decade. She recalled, "When I . . . discovered the canvas chair, it was to me the essence of the beach because it's weathered, it has the same quality, it's been in the sun, in the air, at the sea and on the sand and it's a beach object which is the essence of the beach."[1] Presented as icons in square- and diamond-shaped canvases, the unoccupied chairs became, in her words, "banners of absence" and testimonies to the complex relationships between people and objects.[2]

As Lam explored the rigid geometries of folding beach chairs, her painting style became increasingly hard-edged, entering into rich dialogue with Albers's abstract color study series, titled *Homage to the Square*, which he made from 1950 until his death in 1976. But even as she veered away from an obvious mimetic representation of the beach—as in *Port Royal* (fig. 1), with its deep red ground and brown sky—she never abandoned the narrative and affective qualities of figurative painting. Indeed, she delighted here in the evocation of a castle turret in the striped canopy of the chair.[3] When asked to reflect on the benefit of picking a single motif and exploring it in such depth, Lam recalled something that the artist Anni Albers had told her while Lam was studying at Yale: one needs constraints in art making. For Anni Albers, the limiting factor was the thread in her weaving; for Lam, it was the chair.[4]   sss

1. Jennett Lam, interview by Arlene Jacobowitz, July 26, 1966, Colette Roberts Papers and Interviews with Artists, 1918–1971, box 5, folder 29, transcript, Archives of American Art, Smithsonian Institution, Washington, D.C.
2. Lam's beach-chair paintings were presented collectively as *Banners of Absence* at her 1966 solo exhibition at Grand Central Moderns Gallery.
3. Lam, interview by Jacobowitz.
4. Lam recalled studying with Anni Albers in an interview with Colette Roberts. Jennett Lam, interview by Colette Roberts, April 11, 1968, Colette Roberts Papers and Interviews with Artists, 1918–1971, box 5, folder 30, transcript, Archives of American Art, Smithsonian Institution, Washington, D.C.

Jennett Lam   CAT. 10

FIG. 3. Eva Hesse, No Title, 1967. Acrylic, wood shavings, modeling compound, Masonite, and rubber, 12 × 10 × 2½ in. (30.5 × 25.4 × 6.4 cm). Gift of Robert Mangold, B.F.A. 1961, M.F.A. 1963, and Sylvia Plimack Mangold, B.F.A. 1961, in memory of Eva Hesse, B.F.A. 1959, and in honor of Helen A. Cooper, M.A. 1975, PH.D. 1986, 1998.53.1

FIG. 4. Eva Hesse, No Title, 1967–68. Mixed media, 14⅝ × 10¼ × 10¼ in. (37.2 × 26 × 26 cm). Promised gift of The LeWitt Collection, Chester, Conn.

94

BARBARA CHASE-RIBOUD'S WORK IS BORN OUT OF her deep engagement with issues of history, memory, identity, and place. In her sculpture, drawing, and writing, Chase-Riboud addresses historical erasures and voids, and suggests new perspectives by creating tension through the pairing of opposites. Bronze and silk, for example, are juxtaposed in abstract and expressive sculptures; drawings take on a monumental character; and specific references become symbols for universal ideas.

Chase-Riboud was born in Philadelphia and showed an early interest in art. After earning a B.F.A. at the Tyler School of Art, Temple University, in Philadelphia, she was awarded a fellowship to study at the American Academy in Rome. Her work was exhibited internationally, and she traveled to Egypt, a trip that profoundly influenced her. In September 1958, Chase-Riboud returned to the United States to attend the Yale School of Art and Architecture, where she studied with Josef Albers, Philip Johnson, Louis Kahn, and Vincent Scully, Jr., and where she met the artist Sheila Hicks (cat. 11) and the architect James Stirling. Chase-Riboud earned her M.F.A. from Yale in 1960— the first Black woman to do so.

Following graduate school, Chase-Riboud set up a studio in Paris and continued to travel. In 1985 she established a second studio in Rome. To this day, she continues to live in Paris and spends significant time in Italy and the United States. The artist's identity as outsider and expatriate is integral to her practice; in her work, she engages with figures "who exist outside of the hierarchy of power and in some ways influence this power,"[1] such as the minister and activist Malcolm X, the poet Anna Akhmatova (fig. 1), and the enslaved woman Sally Hemings. Chase-Riboud's first novel, *Sally Hemings* (1979)—a beautiful and tragic retelling of the relationship between Hemings and her enslaver, Thomas Jefferson—is a reflection on race, sex, and power in America.

In 1995 Chase-Riboud won a commission from the United States General Services Administration to create a sculpture to commemorate a burial ground for free and enslaved Africans that had recently been excavated at Foley Square, in Lower Manhattan (now designated the African Burial Ground National Monument). Installed in the lobby of the Ted Weiss Federal Building next to the African Burial Ground, Chase-Riboud's monumental bronze sculpture *Africa Rising* (1998) depicts an ark and a winged figure, evoking such references as the ancient Greek Nike of Samothrace and the Hottentot Venus. During this time, Chase-Riboud began her *Monument Drawings* series of works, which serve as suggestions for public monuments commemorating historical figures and sites. Each work begins with an impression on paper from two copperplates that includes two baseline elements: a loglike structure and a thin meandering line that can be read as rope or braids of hair. As the artist develops the piece, she adds drawn and printed elements to build up the overall composition. *The Foley Square Monument, New York* (fig. 2) features a receding entryway that suggests an ancient tomb or burial ground and the passage from life into death. The opening rests within a tall stack of braided cords.

Drawing, sculpture, and literature converge in Chase-Riboud's *Hottentot Venus* (2003), a historical novel about Sarah Baartman, a Khoisan woman of South Africa who was examined sexually and publicly by Europeans and is an example of colonial-era fascination with the female African body. *Hottentot Venus*, *Africa Rising*, and *The Foley Square Monument, New York*, exemplify the interdisciplinary, historically engaged, creative power of Chase-Riboud's practice across media.   MT

1.  Barbara Chase-Riboud, quoted in Suzette A. Spencer, "On Her Own Terms: An Interview with Barbara Chase-Riboud," *Callaloo* 32, no. 3 (Summer 2009): 739–40.

# Barbara Chase-Riboud <span>CAT. 13</span>   American, active in France and Italy, born 1939, M.F.A. 1960   1960s

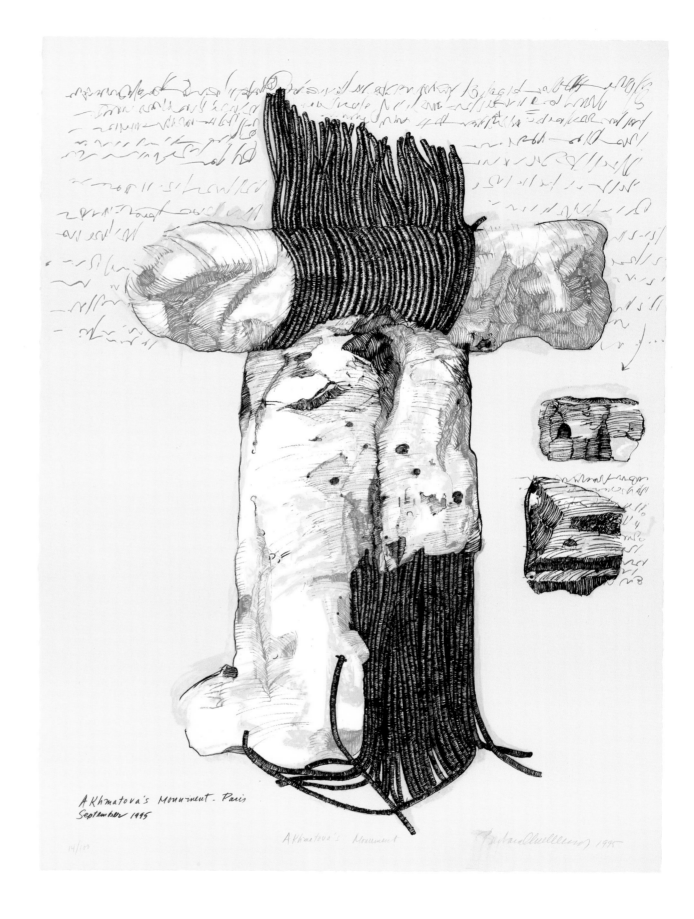

FIG. 1. Barbara Chase-Riboud, *Akhmatova's Monument*, 1995. Offset lithograph, sheet: 29⅞ × 21⁹⁄₁₆ in. (75.9 × 54.8 cm). Gift of Jean and Robert E. Steele, M.P.H. 1971, M.S. 1974, PH.D. 1975, 2009.82.5

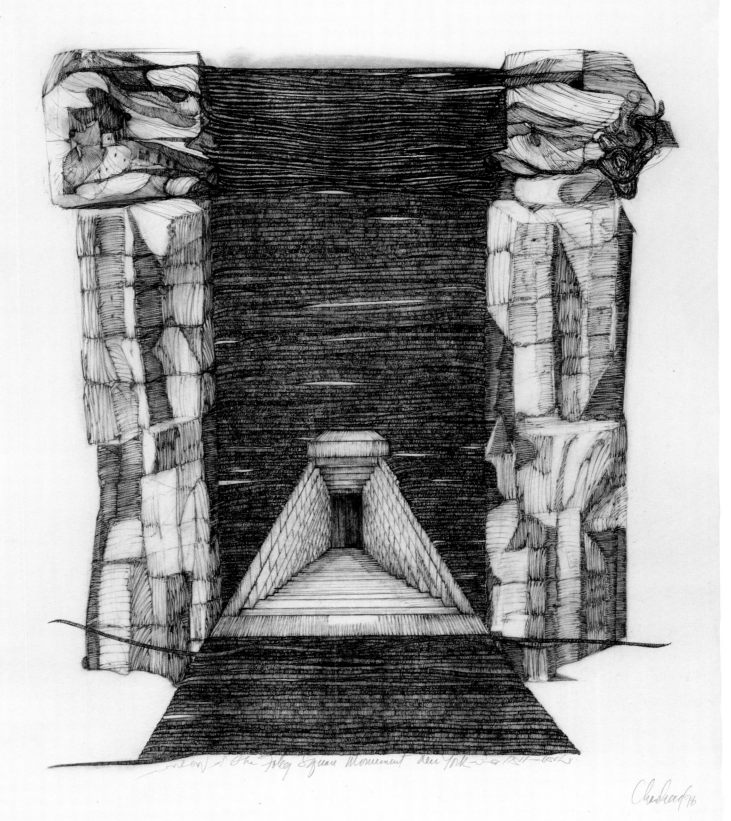

Interior of the Foley Square Monument, New York, 1981–1982

Chadwick '76

PAINTER AND PRINTMAKER SYLVIA PLIMACK MANGOLD is an acute observer of her surroundings. Her oeuvre is a visual diary of her environment, in which she aims to illustrate the process of looking, using illusion to draw the viewer into a work before they return to its formal qualities and material surface. The investigation of the relationship between illusion and reality, and between depth and surface, has preoccupied the artist for more than sixty years.

At the Yale School of Art and Architecture, Plimack Mangold studied with Bernard Chaet, who introduced her to different materials, and William Bailey, who "got [her] thinking about drawing and line and different ways of looking at form."[1] She also benefited from a class on medieval art taught by Sumner McKnight Crosby, in which she learned that you could "spend your whole life studying" a single subject, and from a critique with Josef Albers, who encouraged her to "only tell one story at a time."[2] After receiving her B.F.A. in 1961, Plimack Mangold lived with her husband and classmate, the artist Robert Mangold, and their growing family in New York, where she embarked on a series of floor paintings—focused, perspectival studies that capture both the geometry of the boards of the hardwood floor in her apartment and the organic grain of the wood. In 1971 Plimack Mangold and her family left New York, yet she continued her study of floors and her conceptual approach to realism. The meticulous, disciplined painting *Opposite Corners* (fig. 1) features a mirror that Plimack Mangold used to expand the illusion of space both into and beyond the picture plane, as well as a reflected corner of the opposite wall, which serves as a sculptural element.

The year 1977 proved a turning point for Plimack Mangold. She kept a diary chronicling both her process of painting and her experience as an artist, and she directed her attention to the landscape as a subject. Nocturnal and luminescent, *View of Shunnemunk Mountain* (fig. 2) reveals Plimack Mangold's experimental spirit as a printmaker. A complicated lithograph that plays with two- and three-dimensional illusion, this romantic image captures the gentle rise of the mountain on a low horizon, framed by trompe-l'oeil tape, beyond which the image extends. Similarly, *Valence with Grey Cloud* (fig. 3) captures the dramatic light at sunset in thin washes of color against a frame of painted tape.

Plimack Mangold's later subjects have included the individual trees on her property in Washingtonville, New York, as seen in *The Locust Trees with Maple* (fig. 4) and *The Pin Oak at the Pond* (fig. 5). The latter work—in drypoint, aquatint, and spit-bite—presents a tree in the eerie quiet of winter with a play of sharp and smudged lines. Painterly and carefully worked, *The Locust Trees with Maple* depicts a scene visible from the artist's studio window in a complex composition that engages each branch in a labored dialogue between illusion and reality. The close attention Plimack Mangold devotes to each branch and her low, steep vantage point, which has the effect of making the trees the sole focus of the work, reflect the lessons she learned during her time at Yale.    MT

1.  Sylvia Plimack Mangold, oral history interview by Elisabeth Hodermarsky and author, April 4, 2019, transcript, Yale University Art Gallery Archives, New Haven.
2.  Ibid.

# Sylvia Plimack Mangold  <span>CAT. 14</span>  American, born 1938, B.F.A. 1961  1960s

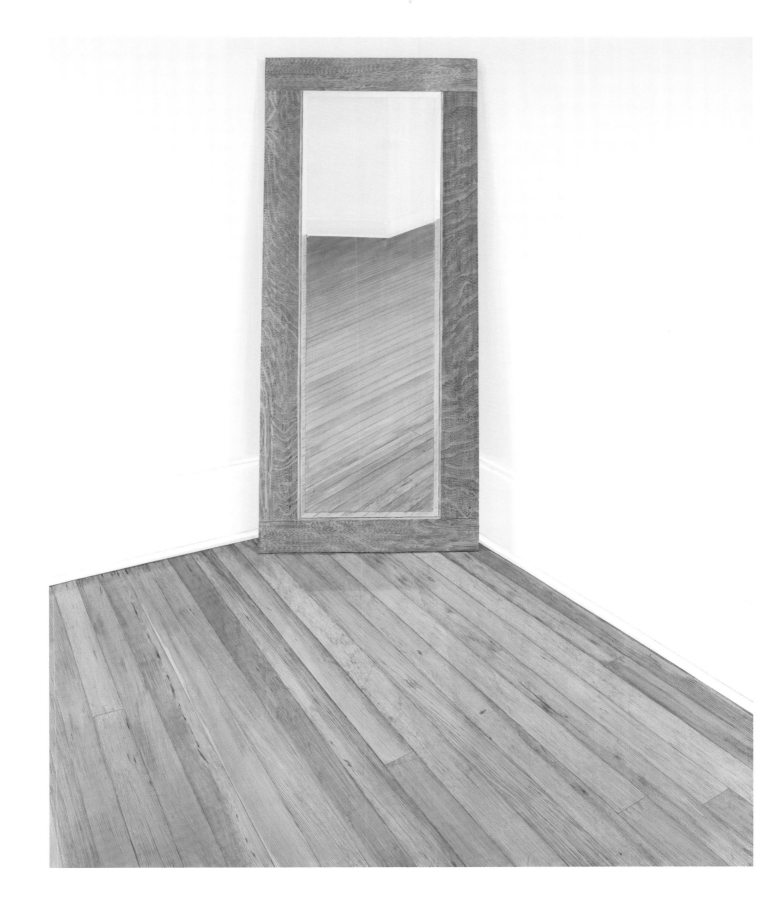

FIG. 1. Sylvia Plimack Mangold, *Opposite Corners*, 1973. Acrylic on canvas, 78⅛ × 64 in. (198.4 × 162.6 cm). Susan Morse Hilles Fund, 1974.18

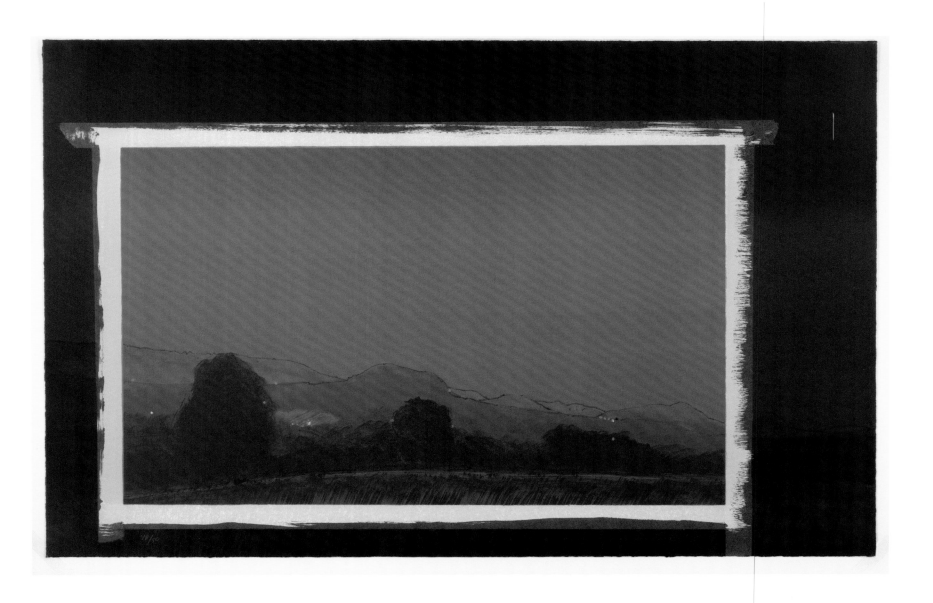

FIG. 2. Sylvia Plimack Mangold, *View of Shunnemunk Mountain*, 1980. Lithograph with hand-coloring in red and yellow ink, sheet: 20¹³⁄₁₆ × 32¹⁄₁₆ in. (52.9 × 81.5 cm). Purchased with the aid of funds from the National Endowment for the Arts and the Susan Morse Hilles Matching Fund, 1981.18

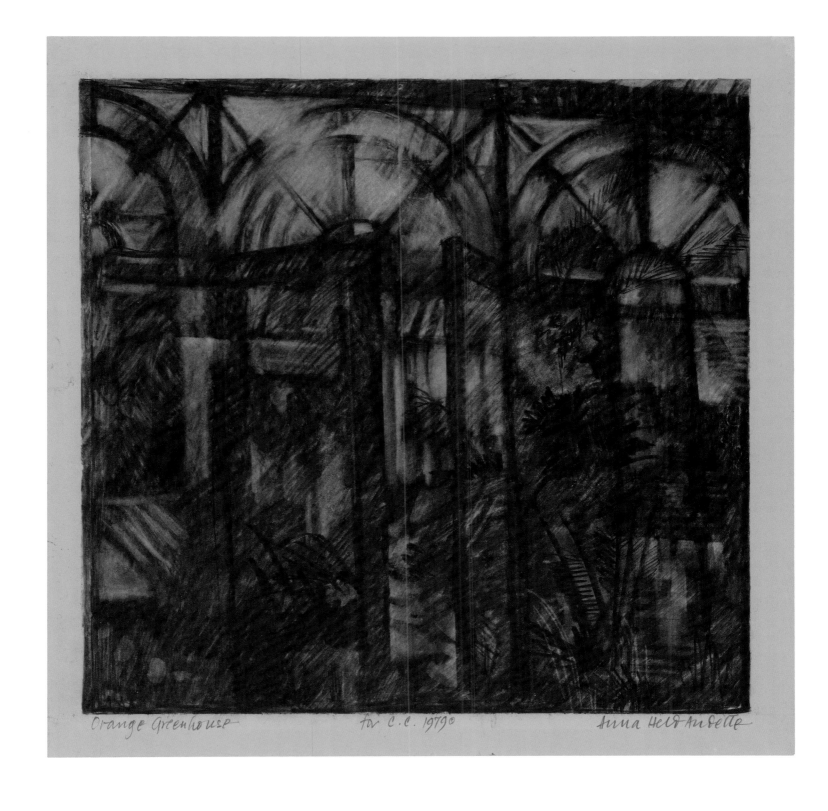

Orange Greenhouse     for C.C. 1979     Anna Held Audette

FIG. 1. Anna Held Audette, *Orange Greenhouse*, ca. 1979. Conté crayon on orange
paper, 12⅝ × 12¾ in. (32.1 × 32.3 cm). Gift of William Bailey, B.F.A. 1955, M.F.A. 1957,
2010.177.15

JANET FISH IS KNOWN FOR THE VIBRANT STILL LIFES that she began making in the 1960s. Her early work emerged from two distinct aims: a desire to realistically represent things she saw in the world and a formal commitment to gesture, surface, and materiality. As a student at the Yale School of Art and Architecture from 1960 to 1963, Fish admired many of her teachers, including Alex Katz and Philip Pearlstein, but she rebelled against the School's overwhelming focus on abstraction and opted to paint from life. "At that point," she later recalled, "all my teachers stopped talking to me. I guess there was nothing worse than a *girl* painting *still life* in the age of Abstract Expressionism."[1] For over fifty years, Fish—whose work does not neatly fit into any one particular artistic movement—has continued to evolve the tradition of still life on her own terms.

In *Six Vinegar Jars* (fig. 1), her choice of everyday subject matter could be aligned with Pop art, and the seriality of the jars evokes a Pop or Minimalist ethos. However, unlike Pop or Minimalist artists—many of whom were drawn to an object's newness or to its method of mass production—Fish delighted in the unique reflections on the jars and sought to capture the infinite variations in their repeating forms. At first glance, the painting seems to be straightforward; the Heinz labels are obscured but recognizable. Upon closer inspection, though, the illusion of mimesis breaks down to reveal a painterly emphasis on materials, echoing Abstract Expressionism. Fish has said, "I think that paint is a sensual medium. I am working with color and movement and texture and what I see. And it's important to me that the mark has a character to it."[2] Her focus on dynamism within the composition and her use of quotidian subjects to capture the substance and complexity of light remain hallmarks of her style.

Fish's interest in reflective surfaces began when she started painting produce wrapped in plastic in the mid-1960s. *Cut Limes* (fig. 2) reveals her technical virtuosity in the medium of pastel. Despite the drawing's impression of extemporaneity—limes spill from a shiny plastic bag, one cut so recently that its juicy membrane still sparkles with moisture—the composition is a taut arrangement. The textures of the fruit are differentiated, but the pattern of repeated oval forms provides a rhythm that moves the eye across the surface. The crinkly ripples of the bag and the acidity of the limes activate the senses of touch and even taste, but the real subject is warmth and light. Fish has said, "I see light as energy, and energy is always moving through us."[3]

Energetic light and pattern also appear in *Three Glasses* (fig. 3), in which Fish continued to fuse abstraction and close-up compositions with tropes of seventeenth-century Dutch still life, such as slightly skewed perspective and attention to texture and semitransparency. In this and Fish's later works, in which she incorporates an even broader spectrum of colors and environments, her still-life subjects at once emerge and dematerialize through complex patterns of light and color. Rather than life rendered still, Fish's paintings and drawings privilege change above all else.   EA

1. Janet Fish, quoted in Gerrit Henry, *Janet Fish* (New York: Burton, 1987), 14. Italics in the original.
2. Janet Fish, quoted in Robert Kushner, "Janet Fish: An Interview," in *Janet Fish*, exh. cat. (New York: DC Moore Gallery, 2000), 18.
3. Fish, quoted in Henry, *Janet Fish*, 86.

Janet Fish   CAT. 16

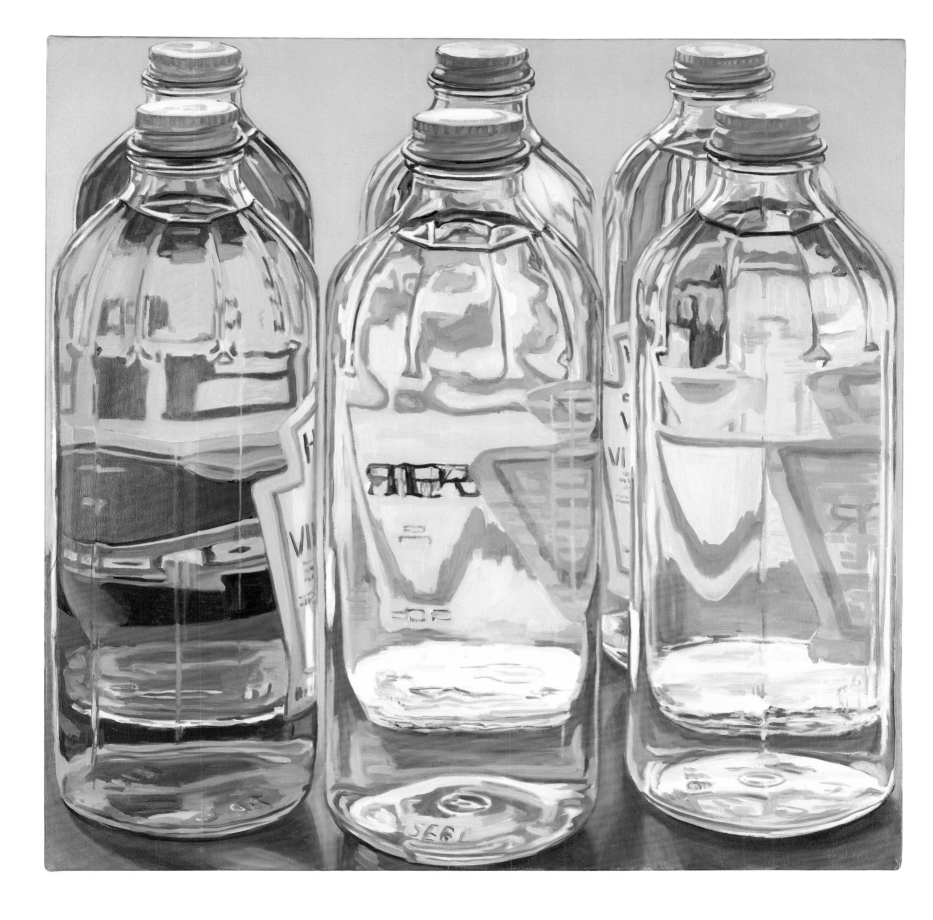

FIG. 1. Janet Fish, *Six Vinegar Jars*, 1972. Oil on canvas, 39¼ × 39¼ in. (99.7 ×
99.7 cm). Richard Brown Baker, B.A. 1935, Collection, 2008.19.553

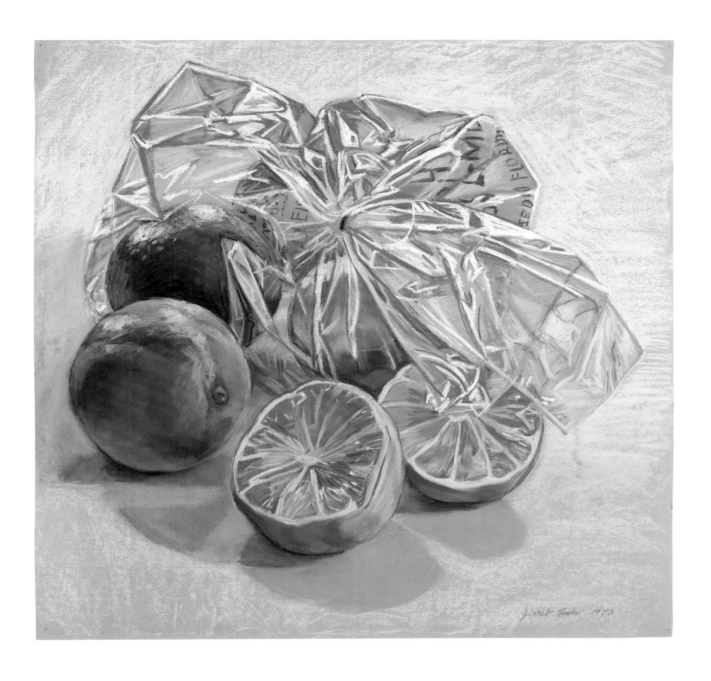

FIG. 2. Janet Fish, *Cut Limes*, 1973. Pastel on paper, 22 × 22⅝ in. (55.9 × 57.5 cm).
The Susan Morse Hilles Fund, 1974.3

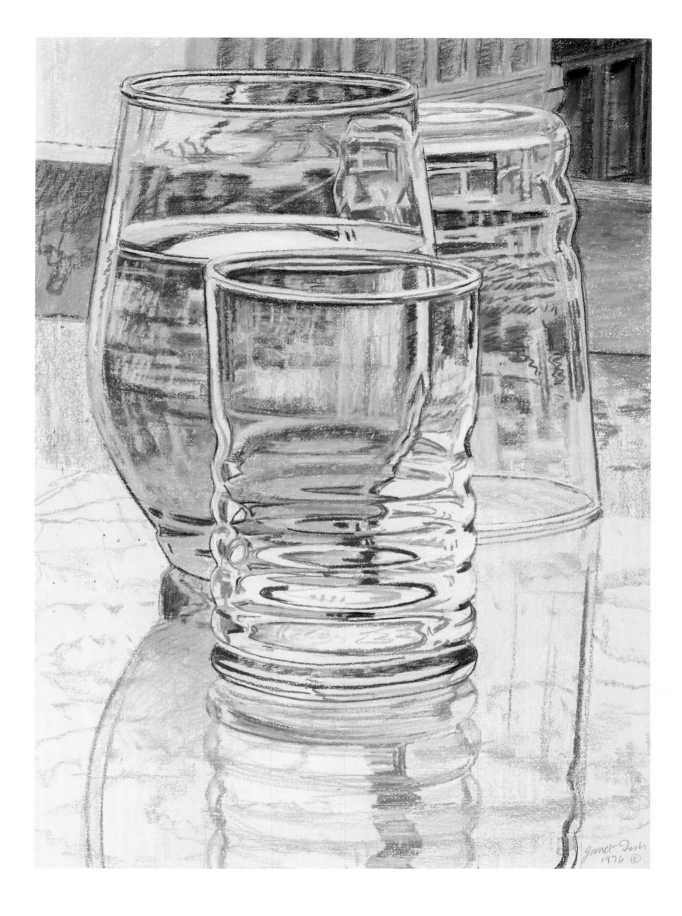

FIG. 3. Janet Fish, *Three Glasses*, 1976. Pastel on paper, 31¼ × 22³⁄₁₆ in. (79.3 × 56.3 cm). Gift of Robert Mangold, B.F.A. 1961, M.F.A. 1963, and Sylvia Plimack Mangold, B.F.A. 1961, 2014.115.3

IN 1969 NANCY GRAVES BECAME THE YOUNGEST female artist to have a solo exhibition at the Whitney Museum of American Art, in New York (see Kramer essay, fig. 13). This was a mere eight years after she had graduated from Vassar College, in Poughkeepsie, New York, and five years after she had received a Master of Fine Arts from the Yale School of Art and Architecture. While at Yale, she studied with Neil Welliver and Sewell "Si" Sillman, and her classmates included Chuck Close, Rackstraw Downes, Janet Fish (cat. 16), and Richard Serra, to whom Graves was married from 1965 to 1970. Although then dean Jack Tworkov actively tried to dissuade her from becoming an artist, suggesting it was too hard a field for women, Graves pursued a Fulbright-Hays grant and went to Paris to study painting.[1] She and Serra then moved to Florence, where she encountered the wax anatomical models made by the late eighteenth-century sculptor Clemente Susini. The models "prompted [Graves] to think of introducing a form from natural history into an art context," and she began an austere and exacting body of work depicting the bones and bodies of camels.[2] Her copious exploratory notes became the *Camel Research Typescripts*, and this rigorous practice of gathering and assembling material—both intellectual and physical—became the backbone of her work.[3]

In 1970 Graves returned to painting and also created her first of five films, pioneering a multimedia approach to art making long before it was common practice. Her paintings, prints, and drawings blend elements of mapmaking, astronomy, natural science, and history. By the end of the decade she had begun making paintings and sculptures that expressed her interest in fragmentary and layered imagery. The fragments were sometimes drawn from her own work: in *Calegli* (fig. 1), the bonelike shapes painted in blue and magenta quote her early camel sculptures.

Graves continually embraced new techniques for print-making and sculpting. As an artist in residence at the Pilchuck Glass School, in Stanwood, Washington, she created a series of monotypes using only glass plates and local vegetation. At Tallix, the foundry established by Dick Polich in the Hudson River Valley, in New York, Graves learned direct casting (in which the source material is destroyed in the process of making a unique cast) and indirect casting (in which a reusable mold can produce multiples). Polich has fondly recalled Graves arriving with baskets of seedpods, leaves, dried pasta, tortilla chips—anything with a shape or texture that caught her eye.[4] She worked with the Tallix crew to transform these items into bronze, aluminum, or sterling silver, which she then soldered together and hand-patinated. *A–Z* (fig. 2), for example, uses a mix of direct- and indirect-cast elements, including a hupa fern, a citrus, segments of rope, a ram's head seedpod, and a folding fan, along with irregularly shaped spills of molten bronze. Graves's assemblage seems to invert gravity, with the visually weighty fan supported on the delicate tendrils of the fern. Many of Graves's patinas were developed especially for her, and their bold colors—as in *Exangulous* (fig. 3)—allow her gestural sculptures to function as three-dimensional paintings.     JSG

1. Nancy Graves and Thomas Padon, "Interview with Thomas Padon," in *Nancy Graves: Excavations in Print, a Catalogue Raisonné* (New York: Harry N. Abrams, 1996), 35.
2. Ibid., 37.
3. The author thanks Christina Hunter, Director of the Nancy Graves Foundation, for accompanying him in paging through the *Camel Research Typescripts*.
4. Dick Polich, conversation with author, November 25, 2002.

Nancy Graves   CAT. 17                                          American, 1939–1995, B.F.A. 1962, M.F.A. 1964     1960s

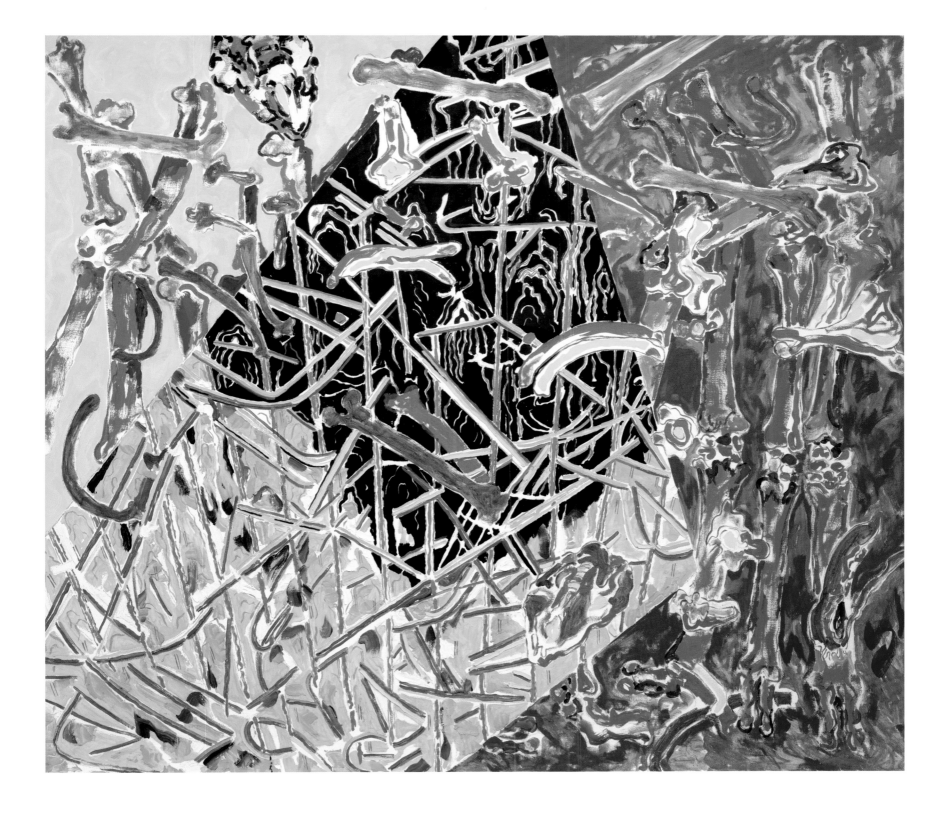

FIG. 1.  Nancy Graves, *Calegli*, ca. 1980. Oil on canvas, 64 × 72 in. (162.6 × 182.9 cm).
Bequest from the Estate of Nancy Graves, 1996.18.1

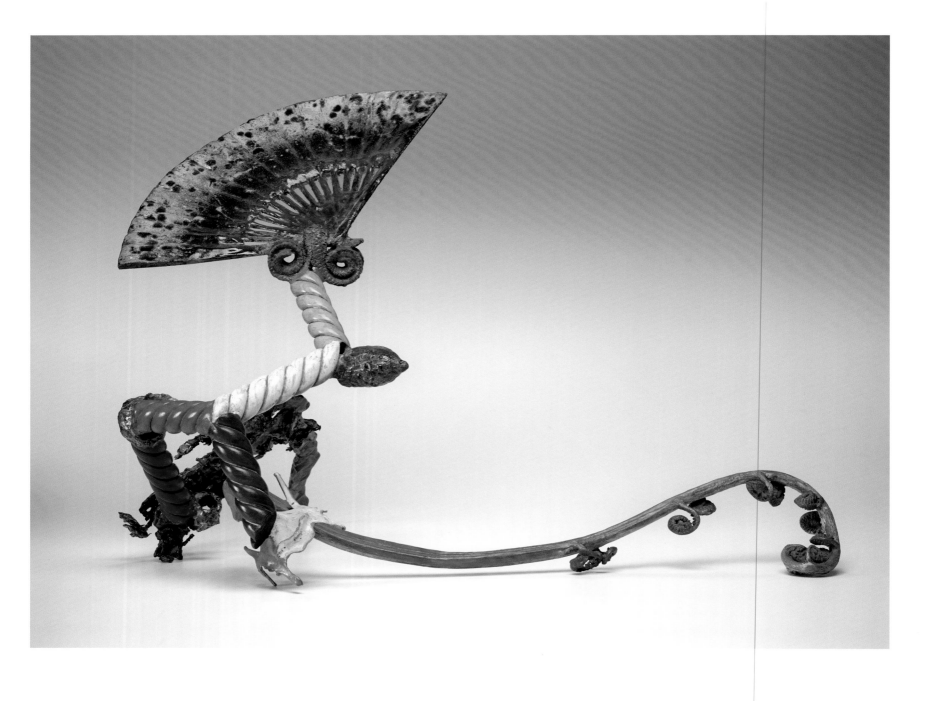

FIG. 2.  Nancy Graves, *A–Z*, 1984. Painted bronze, 22 × 29 × 21 in. (55.9 × 73.7 ×
53.3 cm). The Twigg-Smith Collection, Gift of Thurston Twigg-Smith, B.E. 1942,
2001.148.115a–b

FIG. 1. Howardena Pindell, *Free, White and 21*, 1980. Video with color and sound, 12 minutes, 15 seconds. A. Conger Goodyear, B.A. 1899, Fund, 1990.10.1

FIG. 2. Howardena Pindell, *Kyoto: Positive/Negative*, 1980. Etching, lithography, and chine-collé with hole-punched paper additions, image/sheet: 26⁵⁄₁₆ × 20³⁄₈ in. (66.8 × 51.8 cm). Purchased with the aid of funds from the National Endowment for the Arts and the Susan Morse Hilles Matching Fund, 1981.17.2

FIG. 3. Howardena Pindell, Untitled, from *The Peterdi Years: Alumni Portfolio*,
1976. Screenprint and chine-collé, image/sheet: 22½ × 29¹⁵⁄₁₆ in. (57.1 × 76.1 cm).
Art School Transfer, 1987.12.76

FIG. 4. Howardena Pindell, *Katrina Footprint*, 2005–7. Color lithograph, 21³⁄₁₆ ×
26¹⁵⁄₁₆ in. (53.8 × 68.4 cm). Gift of Jean and Robert E. Steele, M.P.H. 1971, M.S. 1974,
PH.D. 1975, 2009.82.15

125

# 1969 to Present

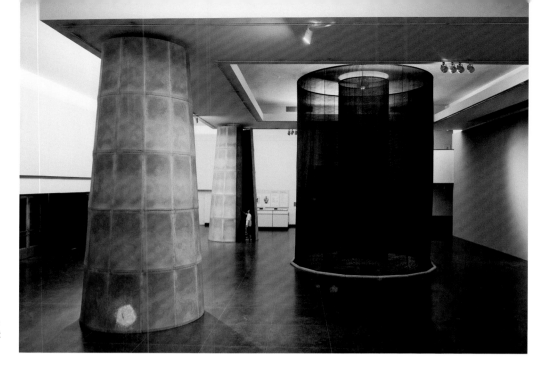

FIG. 4. Winifred Lutz, *Ago/Anon*, 1990. Black screen cloth, flax paper, wood, aluminum, sand, stone, silver Mylar architectural ornament, paint, chalk, and light, overall 23 ft. 6 in. × 60 ft. × 80 ft. (7.2 × 18.3 × 24.4 m). Sited at the Brooklyn Museum

members hired between 1971 and 1983—including Halaby, Campbell, Druckrey, and Lutz—was promoted by the School's all-male governance to a longer-term position with tenure. Though Lutz (fig. 4) was promoted from Assistant to Associate Professor, she was denied reappointment in 1982. According to Lutz, she was told that "Yale had a quota on how many tenured faculty there could be in any year and . . . [she] could not apply because the quota was full."[11] While no documentation of such a policy is known to exist, relevant aspects of Yale's system of tenure and appointment procedures, which remained customary and informal at that time, were reviewed in 2005 and revised in 2007 with publication of "The Report of the Faculty of Arts and Sciences Tenure and Appointments Policy Committee." Lutz cites the leadership of the School, composed solely of male senior faculty members from the Department of Painting, who attempted to parlay their influence within Sculpture, remarking, "They would insist on coming over [uninvited] to Hammond Hall [where the Sculpture department was then housed] to critique what the graduate students in Sculpture were doing . . . which we eventually diffused by creating Open Studios at Sculpture as a completely massive [event]," followed by several days of sanctioned critiques.[12] Although she did not receive tenure and was not reappointed, Lutz successfully demanded a seat on the selection committee for her successor, which resulted in the hiring of Ursula von Rydingsvard.

Halaby, who had a yearslong engagement with the Department of Painting, initially as a visiting lecturer, then as an associate professor, and later as an adjunct associate professor, was also denied tenure and not reappointed, following a vote cast by an all-male faculty in the spring of 1981. Druckrey recalls that Halaby was asked to leave, "although a reappointment was supported by a cohort of junior faculty and by all the women faculty members."[13] In response to Halaby's departure, many School of Art graduates, ex-faculty, and students, as well as Yale College students and alumni and Yale clerical and technical workers striving for unionization in Local 31, organized as "aesthetic dissidents," forming a coalition called the "Committee for Art." The committee curated *On Trial: Yale School of Art* at 22 Wooster Gallery in New York in 1982, citing two basic grievances: that the School held a rigidly "Eurocentric" approach to art, and that it practiced institutionalized racism and sexism.[14] In a *Yale Daily News* article, Dean Andrew Forge was quoted as conceding the first point, saying, "This art school concerns itself with the art of Western culture. It makes no pretense of teaching Oriental art, African art, or any such thing."[15]

## WOMEN GRADUATES IN THE POST-E.R.A. DECADE

When Joyce Owens entered the M.F.A. program in 1971, women graduates made up approximately one-quarter of the student body. Owens, M.F.A. 1973, was among the even fewer people of color and was the only Black graduate student in her class (fig. 5). She had been an undergraduate at Howard University, in Washington, D.C., where Leo Robinson encouraged her to major in Painting.[16] As an applicant to Yale, she was concerned

about the cost of attendance, but she recalls that the administration was supportive, pledging that, "If we accept you, we will help you figure out a way to go."[17] She worked at a local elementary school in New Haven while enrolled at Yale, and she found the environment of the city peaceful and friendly, despite the turbulence and activism on campus in the preceding years: "I came from Howard University in the 1960s. My mother took me to my first civil rights marches. My uncle, Jack T. Franklin, was an acclaimed photographer of the civil rights movement for the *Philadelphia Tribune* and *Ebony*. . . . New Haven was quiet compared to D.C. . . . The only thing that upset me was that I was the only Black person in my class."[18] Seeking community, Owens attended classes in the broader University and cites as influential one at the School of Music on the migration of African polyrhythms, taught by the renowned jazz musician Willie Ruff.

Owens's female classmates included Nancy D. Lasar, who left the program before graduating, Louise L. Luthi, M.F.A. 1973, and Judy Pfaff (cat. 21). Owens forged important and lasting relationships with these peers, as well as with others beyond the School:

> [Judy Pfaff and I] would go out for walks around New Haven and pick up trash as material for our work. I suppose they might call this "found materials" now, but then, it was trash. . . . I considered myself a figurative artist, and I enjoyed life-drawing classes. Outside of school, I spent a lot of time at the Studio Museum in Harlem, as I was interested in Charles White and in

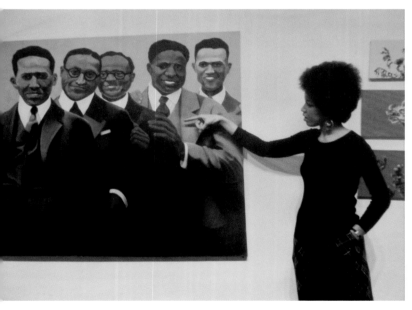

FIG. 5. Joyce Owens with *Writers on the Roof* (completed 2006), Thesis Exhibition, Yale School of Art, New Haven, 1973

Elizabeth Catlett. I just wasn't interested in Minimalism or Conceptual art. I had stories that I thought needed to be told, and I wanted to try to do that visually.[19]

Pfaff had decided to apply to the Yale M.F.A. program on the recommendation of Robert Reed, then Assistant Professor of Art in the Department of Painting and Printmaking, after having attended the Yale Summer School of Music and Art in 1970, where Reed had been her instructor.[20] She recalls that there were very few women in the program and that the climate was polarized in other ways as well: "My mentor throughout my graduate studies had been the painter Al Held, at a time when the painting program was dominated by the ruling opposites of William Bailey versus Al Held. The abstract painters [like Held] were on one side, and the figurative painters [like Bailey] on the other. They held positions like the Democrats and Republicans do today."[21]

Pfaff has said that she believes the process-oriented approach to painting prevalent in the graduate program at the time was rooted in a very practical matter—the arrival of fifty-five gallons of Rhoplex, a binder critical in paint formulations and a component of all acrylic paint, given to the School for free by the Philadelphia-based paint company Rohm and Haas. "Process was a big deal," she recalls. "After all, we inherited the School of Art after the attempted burning down of the Rudolph building, after the Black Panther trials, the campus-wide student protests and strikes. And, so, the School of Art tucked itself back in and righted itself. There were no theory classes. Al wasn't going to think or talk about that, and Bill Bailey certainly wasn't."[22]

By the time Pfaff arrived at the School, reluctance among graduate students in Painting toward "pit crits" was already legendary (fig. 6). Pfaff shares in this historical disdain for the critiques held in the atrium space between the third and fourth floors (the "pit") of the Rudolph building. She believes her very resistance to engage in those sessions motivated her venture into the so-called installation format:

> I anchored all my work into the wall so it was not possible to bring the work downstairs. I was very uncomfortable with the nature of these crits, a panel looking and talking amongst themselves with the thumbs up, thumbs down approach. I decided that I wasn't going to . . . be part of that. . . . That panel was made up of all men, though Samia Halaby was there for a little while. . . . The artist-student was not allowed to speak, and the members of the faculty referred to the format as a way to take up old fights. It wasn't really about focusing on the work of the particular

FIG. 6. Pit Crit, Yale School of Art, late 1980s. Yale University Art Gallery Archives, New Haven

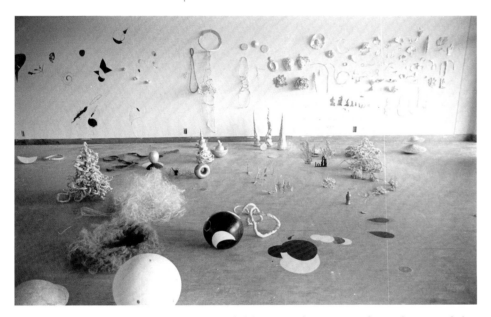

FIG. 7. Judy Pfaff, *La Ciudad de Los Angeles*, 1977. Styrofoam, aluminum foil, seed lamps, and papier-mâché, dimensions variable. Sited at the School of Art and Design, California Institute of the Arts, Valencia

student. Rather, it was about the fight with one another. I never found it interesting, and, actually, I found it sort of scary. I asked myself, "This is the greatest [art] education in America, and this is what's going on?[23]

Pfaff, like many other graduates, speaks of the isolation of the School's studio-based graduate studies from the rest of the University's academic offerings and the absence of an institutional system to promote interdisciplinary exchange. She recalls,

however, a "very prescient show" that opened in April 1973: *Options and Alternatives: Some Directions in Recent Art*, held at the Yale University Art Gallery, was curated by the film critic and art writer Annette Michelson and the critic Klaus Kertess and was produced in cooperation with undergraduate students who had been assigned to interview participating artists contributing to the show. An initiative of the art historian Anne Coffin Hanson, the first woman to be hired as a fully tenured professor at the University, the exhibition, Pfaff says, was intended to "reflect on the many ways of collective thinking and feeling, which are not restricted to the arts, but extend to the many aspects of modern life."[24]

Pfaff graduated in 1973, during an economic downturn, and although she quickly began exhibiting at museums and galleries (fig. 7), she struggled financially. About a solo exhibition at Artists Space, in New York, Pfaff recalls, "It was scheduled to open in twenty-four hours, and I had no money. I was not eating. It was, and I was, a mess. Al Held came to visit and lent me $200, and that's how I did the show."[25] After the exhibition at Artists Space, Pfaff participated in the 1975 Whitney Biennial, cocurated by John Hanhardt, Barbara Haskell, James Monte, Elke Solomon, and Marcia Tucker. While accepting many more exhibition invitations, Pfaff also took on various teaching engagements, at Ohio State University, in Columbus; Queens College, City University of New York; the Tyler School of Art (now the Tyler School of Art and Architecture), Temple University, in Philadelphia; California Institute of the Arts (CalArts), in Valencia; and, beginning in 1979, Yale.[26] Teaching would provide her, and many other women artists, with a way in which to sustain her artistic practice. She credits the sudden nationwide demand for her as a teacher to the lack of professional women educators at the time and the significance of the Title IX movement. "I was among the few women graduating from my class at Yale," she says. "I became a commodity out of necessity. That degree rocketed me out of poverty and enabled me to get jobs because, before that, I had no legitimacy as a woman artist."[27] In fact, despite the challenges women artists faced within the School throughout the 1970s, women graduates who, like Pfaff, went on to important careers as not only practicing artists but also educators—a key role that is often overlooked— are too numerous for any one essay to mention.

## THE FOUNDING OF THE DEPARTMENT OF PHOTOGRAPHY

The Department of Photography at the Yale School of Art was not formally established until 1979, though a handful of students, including several women, received M.F.A. degrees in

Photography before that date from a nascent program housed within Graphic Design. There, photography had long been part of the curriculum established by Herbert Matter, a Swiss-born photographer and graphic designer who had joined the School in the early 1950s with Josef Albers. In 1965 Matter and Alvin Eisenman, the typographer from Yale University Press who was also brought on by Albers, invited the photographer and photojournalist Walker Evans to teach, in part because they were inspired by his approach to images as information. As Eisenman recounts, Evans maintained that "one thing everybody needs to learn about is to read images, what information is contained in them. Learn about photography as information, use it as triable evidence, a universal and reliable kind of information."[28]

Christine Osinski, M.F.A. 1974, who entered the School of Art in 1972, was among the first graduates to receive a degree in Photography.[29] Osinski was motivated to apply to Yale after attending a lecture that Evans gave while she was studying at the School of the Art Institute of Chicago. She submitted a portfolio of photographs taken in a campground in Old Lyme, Connecticut, which was occupied by teenagers hanging out among pinball machines. The images surprised the review committee, who accepted Osinski's application based on what they felt was a refreshing take on Old Lyme, the town in which Evans lived while working at Yale.

Osinski approached the prospect of attending Yale with some trepidation: "I came from a working-class background from the South Side of Chicago, and Yale represented such power, prestige, money, and tradition. [This] led me to develop a crisis of confidence with respect to navigating around the School and the University."[30] She recalls the program as highly unstructured, without assigned advisors, although "education in art at this juncture—not just at Yale but elsewhere—was like learning through osmosis."[31] She became interested in photographing a New Haven beauty parlor called the Artistic Salon—a place "where women went in looking one way and came back out looking altogether different. It was a project about . . . [women's] ideas around beauty and transformation" (fig. 8). She was "met with reactions from male students and faculty who could not relate to the material. In the absence of female faculty members and peers, I moved away from photographing women to focusing on shooting interior domestic life devoid of figures."[32] Struggling to find the space within the School of Art for experimentation, she enrolled in classes at the University, including a course that read photography from a cultural perspective taught by Michael Lesy in the Department of American Studies; a literature class on William Faulkner taught by Cleanth Brooks; and a weekly film class taught by

Annette Michelson in the Department of the History of Art, which was a particularly important resource for Osinski.[33]

Joyce Baronio, M.F.A. 1976, who enrolled in 1974, was among the last students to study under Evans before his death in 1975. "Walker was interested in women," she remembers. "Looking for subjects to photograph with his SX-70 Polaroid, he asked me to sit for him in his studio. I saw him most days—he liked to drink a glass of white wine and to chat."[34] As an undergraduate, Baronio had been a Psychology student with a concentration in Behavioral Science:

I was focused on fantasy, and I felt this [was] more a realm of women. . . . At some point, I went to a nude beauty contest in New Jersey somewhere, and I found out that many of the contestants worked in a variety of jobs in Times Square in New York City. Once I graduated in 1976, I went to New York and located this building called the Show World Center that served as the headquarters for the Miss All Bare Beauty Contest. I promised those who modeled for me prints. I did not exactly blend in—I was in this "Yale" outfit with a long-sleeve shirt and Abercrombie and Fitch pants, Walker Evans style. . . . I was able to keep my studio at Show World for $75 per month for rent. They

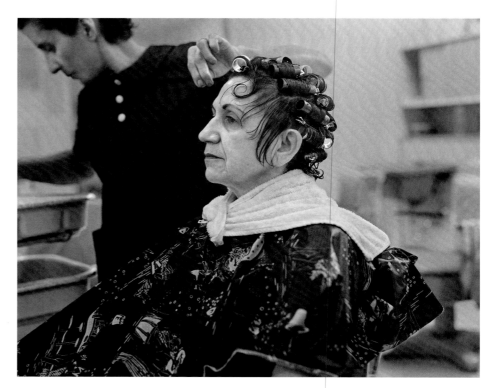

FIG. 8. Christine Osinski, *Woman in Curlers*, 1972. Gelatin silver print, 11 × 14 in. (27.9 × 35.6 cm). Courtesy the artist

called me J. J. and always kept an eye out for me. . . . I was asked if I could post my photographs of sex workers in the ground-floor window cases [of Show World]. The other places had tacky pictures of nude women with nipples covered over with XXX. . . . Those places got busted.[35]

After their installation in the storefront windows of Show World, Baronio's photographs drew the attention of the American novelist and essayist Edmund White, who featured the images in the *Village Voice* with the header "Joyce Baronio on 42nd Street—Tripping the Light Fantastic."[36] Baronio eventually published the series, called *42nd Street Studio*, as a book of portraits of erotic entertainers, including famous porn actors Beth Ann, Sharon Mitchell, Vanessa del Rio, Candida Royalle, and Joey Silvera (figs. 9–10). The book, released in 1980, included a lengthy introductory essay by Linda Nochlin, who wrote that "Baronio is working with sex entertainers, not with prostitutes, and this seems to be a distinction that is as important to her as to her subjects. But even more important, Baronio is a woman photographing other women: her grasp of the subject may have more to do with empathy and identification than with capturing visual prey, no matter how delicately. . . . Baronio, however, focuses not on the universality of the erotic imagination but rather on the individuality and uniqueness of its manifestations in each of her subjects."[37]

By the late 1970s, the broader art world was gripped by a revised approach to the medium of photography, which hinged on questions of representation. In 1977 Douglas Crimp curated the influential exhibition *Pictures* at Artists Space, in which he identified a generation of artists pursuing a crucial shift in perspective regarding the relationship between "illusionism" and representation. In the catalogue for the show, Crimp wrote that representation "does not achieve signification in relation to what is represented, but in relation to other representations," thus illuminating "something absent to the condition of our apprehension of what is present."[38] That same year, Susan Sontag, by then already a well-known public intellectual, published a collection of essays, *On Photography*, as a reminder that "to photograph is to appropriate the thing photographed. It means putting oneself into a certain relation to the world that feels like knowledge—and therefore, like power."[39]

Following Evans's death in 1975, the School created a Department of Photography, which led to the eventual appointment of Tod Papageorge in 1979 as the department's first Director of Graduate Studies. Papageorge's approach countered photography's "straightforward relationship to things in the world" with "young photographic artists as makers of visual fictions."[40]

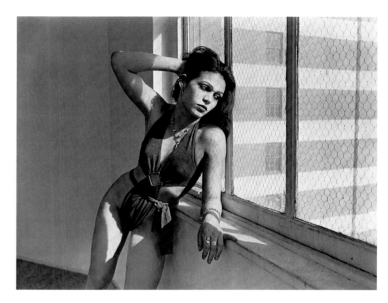

FIG. 9. Joyce Baronio, Untitled, from the series *42nd Street Studio*, ca. 1980. Gelatin silver print, dimensions unknown. Courtesy the artist

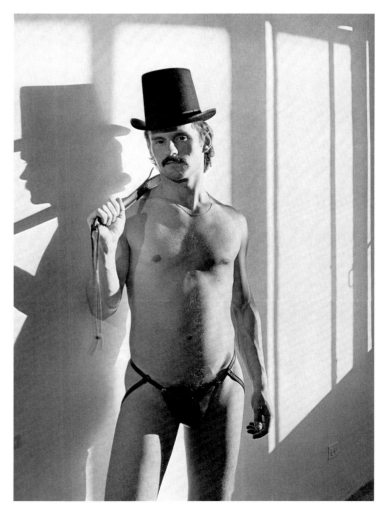

FIG. 10. Joyce Baronio, Untitled, from the series *42nd Street Studio*, 1980. Gelatin silver print, dimensions unknown. Courtesy the artist

During Papageorge's thirty-five-year tenure, more than thirty-three graduates of the program earned Guggenheim Fellowships—twenty of them women, including Marion Belanger (cat. 41), Lois Conner (cat. 30), and Tanya Marcuse (cat. 42).[41] Two of those Guggenheim Fellows, Dawoud Bey and An-My Lê (cat. 49), also received MacArthur Fellowships.

## THEORY AND PRACTICE: THE RISE OF CRITICAL AND CULTURAL STUDIES

By the late 1970s, the concept of "criticality" had emerged as a primary framework for the interpretation and evaluation of the visual arts. Over the following decades, debate ensued within the field over art's "relation to the world"—more specifically, its relation to knowledge and power, as Sontag had alluded to. Concurrently, the Departments of French and English at Yale were earning a reputation as "a metonym for theory,"[42] where literary critics, theorists, and philosophers, including Paul de Man, Jacques Derrida, and, later, Fredric Jameson, set forth aesthetic education as a way of questioning historical objects and objectification itself. While the School of Art remained insulated from these developments, these influential theorists' ideas, particularly regarding the ongoing construction of power through common social forms such as language, nevertheless constituted a foundation of cultural scholarship that profoundly affected art criticism, especially in its less market-bound reaches. *October*, for example, a break-off academic journal founded in 1976 by Annette Michelson and the art historian and critic Rosalind E. Krauss, commissioned in-depth essays of art criticism steeped in poststructural theory, deconstructivist theory, psychoanalysis, and feminism, thus presenting an alternative perspective to *Artforum*, which had been the primary monthly art publication of the era. In the United Kingdom, the cultural theorist Stuart Hall contributed to the conceptualization of "cultural studies," which entailed transdisciplinary critical analysis of contemporary conditions. "Critical studies," "critical practice," and "critical issues" had arrived in the art world, as critics and theorists began taking into consideration the social transformations of a multicultural society to address wide-ranging perspectives—feminist, queer, postcolonial, and more.

During the 1980s, as a neoliberal economic agenda proliferated in the United States and Europe, governmental protections for health, employment, and the environment were steadily eroded. Against this backdrop, the art market boomed, consecrating what the art historian and curator Paul Ardenne described in his paper "The Art Market of the 1980s" as a "marriage" between art and the market, one that "established a new type of businessperson collector who used the market as a stock exchange . . . [and for whom] contemporary art was simultaneously a cultural alibi and a portfolio of stocks."[43] Critical studies and what came to be known as "research-based artistic practice" were attempts to distinguish art from the market and from the culture industry at large. Theorists demanded that the political resonance of all cultural artifacts be acknowledged. As Jameson wrote in *The Political Unconscious: Narrative as a Socially Symbolic Act*, "The convenient working distinction between cultural texts that are social and political and those that are not becomes something worse than an error: namely, a symptom and a reinforcement of the reification and privatization of contemporary life."[44] Such a perspective, however, did not enter the School of Art, despite having been formulated literally right around the corner and despite Jameson's work having served as a primary touchstone for critical thought within the field of art from the 1980s onward.

Debates over criticality and the relationship of critique to the visual arts grew in tandem with the rise of feminism and the ascent of women to positions of authority beginning in the 1970s. Gloria Jean Watkins, better known by her pen name, bell hooks, was Assistant Professor in the Departments of Afro-American Studies and English from 1985 to 1988. During this time, she began laying the groundwork for feminist theory by providing historical evidence of the sexism endured by Black female slaves and its effect on contemporary Black womanhood, publishing her pivotal works *Ain't I a Woman: Black Women and Feminism* in 1981 and *Feminist Theory: From Margin to Center* in 1984. In her essay "The Oppositional Gaze: Black Female Spectators," she wrote, "Given the context of class exploitation, and racist and sexist domination, it has only been through resistance, struggle, reading, and looking 'against the grain,' that black women have been able to value our process of looking enough to publicly name it,"[45] emphasizing the importance of "engaged pedagogy" as a mode of critical practice enabling the transformation of dominant narratives and the valuation of multiple, previously unacknowledged experiences.[46]

At the School of Art, graduate students, particularly those in the Department of Painting, contested what they felt to be the department's dominant concern with figuration and its formalist approaches to art as well as its marginalization of other conceptual frameworks—including the intersectionality that professors like hooks were exploring. They demanded that the curriculum be revised and new faculty added. As a result, students were granted the right to invite three outside lecturers, among them the American conceptual artist Mel Bochner, who arrived in 1979 as Visiting Professor in Painting and who continued to

FIG. 11. Roni Horn on Motorbike, Iceland, 1979

School was requiring applicants to supply written statements along with their work the reviewers were obliged to read those statements—at which point the group commenced to read Horn's text regarding the ambiguity inherent in any photographic depiction. Lutz's call for a consideration of Horn's work in the context of the artist's own writing led to the reevaluation and acceptance of her application.[47] While at Yale, Horn says she felt alienated as an artist who was both gay and androgynous. She used this experience to develop a visual language around identity and difference and to explore the aesthetic function of language—work that evolved into her *Pair Object* series, which reflected her ongoing concern with doubling.[48] Horn's sexuality was not an explicit component of this work; nevertheless, she notes, "I don't know if I would have done those *Pair Objects* if I were a straight girl."[49] Upon graduation, Horn received the Alice Kimball English Travel Fellowship—Yale's oldest and largest endowed fellowship—and used the $5,000 grant to purchase and ship a motorbike to Iceland, where her travels through the country led to a long body of work exploring geology, spirituality, and indeterminacy (fig. 11).

teach at the School as a part-time faculty member through 2008. Bochner introduced the "Critical Issues" seminar in Painting, which was organized as close readings of critical perspectives on works of art, including, for example, Martin Heidegger's *The Origin of the Work of Art* (1935) and Derrida's *Restitutions of the Truth in Pointing* (1978). Bochner continued to lead seminars at the School over the following decades, with courses such as "When Language Enters Studio," in which students investigated the relationship of language to contemporary art practice, both as a system of signs and as a social system.

Though discussions of poststructuralist theory did not pervade the art school, some artists began to engage with related concepts in their work. Roni Horn (cat. 28), for example, did not attend the courses at Yale given by either de Man or Derrida, but her practice evolved around the aesthetic function of language and the capacity of language to challenge the privileging of visual and haptic perception in aesthetic experience. When Horn applied to Yale in 1976, the selection jury for incoming students, according to Winifred Lutz, consisted of faculty and enrolled students, mostly male, who partook in a communal review of applicants' work. Lutz vividly remembers Horn's submission, which consisted of two sets of slides—one addressing the identity of objects perceived in light, the other, those same objects perceived in darkness. The reviewers responded raucously and dismissively to Horn's minimalist presentation. Lutz interrupted to contest, noting that if the

## THE EMERGENCE OF RESEARCH-DRIVEN PRACTICE

Lorraine Wild, M.F.A. 1982 (fig. 12), entered the School of Art as a Graphic Design student after studying at Cranbrook Academy of Art, in Bloomfield Hills, Michigan, under Katherine McCoy, in a program that was later considered a bastion of deconstructivist and poststructuralist thought. Wild's interest in pursuing graduate studies grew from a desire to explore the history of teaching within the field, specifically that which had been canonized at Germany's Bauhaus in the 1920s and 1930s. Bauhaus faculty later immigrated to the United States, where they became influential pedagogues, seeking to dissolve hierarchies between the fine and applied arts while also focusing on function in design. By the time Wild arrived at Yale, the Bauhaus curriculum established by Josef Albers had been adapted by the faculty, including the American graphic designer Paul Rand according to a modernism that Rand had imported from the Kunstgewerbeschule, in Basel, Switzerland, and had applied to corporate commissions. Wild perceived the Rand curriculum as calculated and prescriptive in comparison with the earlier, more experimental style of working and thinking typified by Albers and Herbert Matter.[50]

Wild approached Rand and Bradbury Thompson—an American designer known for influential and often highly graphic typography that commented on the legacies of printing—as "historical artifacts," who, by the time she arrived at Yale,

"represented a stultified formalist practice with no inclination to revisit some of the foundations of their earlier teaching." She says Rand was "rudely resistant" and Thompson "passive-aggressive" in their adherence to the idea that modernism is timeless, noting, "The very philosophy of design that they had embodied was part of the reason they resisted speaking about how the work really came together or how they communicated their ideas to their clients."[51] After all, if a work is timeless and universal, then it needs no explanation, and, by the same token, if a work needs no explanation, it must be timeless and universal. The tools of critical discourse are anathema to such truisms.

Despite resistance from the faculty toward her research, which amounted to abandonment of supervision, Wild committed to writing an essay for her thesis project—an unconventional approach. Eventually, Dean Andrew Forge intervened on Wild's behalf, arguing that her proposed research was legitimate and helping to locate readers outside the design department.[52]

FIG. 12. Lorraine Wild, Self-Portrait Assignment from Visiting Artist Shigeo Fukuda, Yale School of Art, New Haven, fall 1981

Wild also found inspiration in areas beyond the School, noting the "electricity" within the Departments of Comparative Literature and English, and adding that American Studies was a department with "many material culture people who were interested in speaking about visual culture and visual studies in an alternative way—ways." She continues, "They were not driven by those grand old men . . . in the art and art history department[s]." In looking back on her graduate studies, Wild recalls that sexism was prevalent and went unquestioned, that "it was just there, and women kind of laughed about it, but there was no critical mass to somehow deal with it. . . . It was always around the issue of feeling somehow not taken seriously and not treated as equal. That was the struggle one had to deal with."[53]

Wild was commissioned after graduation to design the four-hundred-page monograph of the American architect John Hejduk, who directed the Architecture program at Cooper Union, in New York. An article she wrote during this time, titled "More Than a Few Questions about Design Education" and published in the Society of Typographic Art's *Design Journal*, captured the attention of Catherine Lord, the dean of the School of Art at CalArts. Lord turned CalArts' Graphic Design department over to Wild in 1985, when Wild was just thirty-two years old. Wild consolidated the faculty, built a curriculum, and revived the graduate program. After Wild's graduation from Yale, it was still another eight years before Sheila Levrant de Bretteville became the first woman appointed as Director of Graduate Studies and tenured Professor of Graphic Design at the Yale School of Art.

### OCCUPYING SPACE AS AN ACT OF AGENCY

National and international recognition of women graduates and undergraduates from and affiliated with the School of Art continued to grow as their enrollment increased and they developed networks of mutual support both within and beyond the School. The 1982 commission of Maya Lin's winning proposal for the Vietnam Veterans Memorial in Washington, D.C. (fig. 13; see also cat. 31, fig. 1), granted while she was still an undergraduate at Yale, marked a milestone achievement for women in the fields of art, architecture, and design. Selected during her senior year of studies as the winner of a national competition, Lin became not only the creator of one of the most significant monuments in the nation's history but also the first woman to design a federal monument for the National Mall.

The requirements for the D.C. memorial indicated that all fifty-seven thousand names of those missing and killed be included in the final design, and that the design be apolitical.[54] In thinking about her proposal, Lin recalled that in the rotunda

FIG. 13. Maya Lin and Final Design for Vietnam Veterans Memorial, Washington, D.C., with Jan C. Scruggs (left), President of the Vietnam Veterans Memorial Fund, and Bob Doubek (right), Project Director, 1981

at Yale's Memorial Hall are engravings of all the names of the Yale alumni killed in previous wars, inviting those passing by to "feel" the individual inscriptions. Lin visited the site where the memorial would be erected and imagined "taking a knife and cutting into the earth, opening it up, an initial violence that in time would heal."[55] The remaining challenge was to "find the chronology for the names of the dead." She recalls, "Between the first and second crit, my professor [Andy Burr] advised me that the apex was very important, at which point I switched the chronology from starting on the left side."[56] On the finished memorial, the names are in chronological order from left to right beginning at the apex of the wall, then circling back to the far-left end and rejoining the apex.[57]

Lin, an Architecture major, aspired to study art as well and had applied for a double major in Architecture and Photography, but her request was denied by the senior faculty of the School of Art. The committee used Lin's request to spend part of her undergraduate studies abroad as justification for its denial. As she explains, the committee believed that "if you were serious about entering a double major—the Art major—you would not be going away. And if you [decided] to go away, you [would] never amount to anything more than a second-rate draftsman."[58]

Despite this, Lin attended courses led by Richard Benson and Tod Papageorge, pursuing what she considered an "obsessional" interest in photography. "I might have double-majored in Photography," she says, "but if I had, I wouldn't have designed the Vietnam Memorial."[59]

Lin spent a year in Washington, battling for the validity of the monument before a Senate subcommittee while working to complete it. Later, she returned to Yale for her master's degree in Architecture. Of her postgraduate studies at Yale, she recalls, "I arrived labeled within Architecture, when I felt myself more an artist. So, I drifted over to the art department." She continues, "I was hanging out in Hammond Hall [where the Department of Sculpture was housed after the 1969 fire]. Ursula von Rydingsvard was amazing. She was very supportive, and I started making art." At Hammond Hall, Lin noticed that "the boys got enormous studios." She adds, "They just decided, 'Well, these artists are working on a bigger scale, and so they require the bigger space.' It opens the question then, if we as women had been given a bigger space, would our work have been different?"[60]

While the dearth of women among tenured faculty at the School of Art persisted through the 1980s, von Rydingsvard

(figs. 14–15) has been referred to by many graduates of that period as a revered mentor. Von Rydingsvard had been hired to join the Sculpture department under the direction of David von Schlegell. She was promoted to Associate Professor in 1985 but eventually left to pursue a full-time practice as an artist, noting that the School's leadership seemed to have "a narrow idea with respect to the fact that good educators could and should be active practicing artists."[61] She describes her teaching methodology as "looking at and following a student's work carefully as to what could be added or substituted, or how one could go about one's work to carry more depth."[62] She was mentor to, among others, Jessica Stockholder (cat. 36), saying of Stockholder, "I loved her sense of humor, which was not at all humorous."[63] She also mentored Ann Hamilton (cat. 35), who, she says, "took things that no one else did to reach into places that were psychologically oriented, such as putting her head through a hole in a table."[64] She recalls teaching Beverly Semmes (cat. 39) and Meg Webster, M.F.A. 1983, who she notes "held a special relationship to nature, to earth," as well as Ritsuko Taho, M.F.A. 1985, whose work "spared nothing and was so labor oriented."[65]

Scale figured into the work of many Sculpture students as a direct effect of their studios being located in Hammond Hall (fig. 16), a remote building on the edge of campus some fifteen minutes' walk from the rest of the School. By virtue of its vast size and informal relationship to codes and regulations, the building fostered a sense of experimentation. "It was spectacular," von Rydingsvard notes of the building. "We could screw up the floors, studios were plentiful, the ceilings were forty feet in height. It was a building made entirely of stone [and] had once been used for ROTC."[66] Semmes, who entered the M.F.A. program in 1985—and credits it with creating synergy around an intense work ethic, an emphasis on production, energetic

FIG. 14. Allen Rokach, *Ursula von Rydingsvard in Her Studio, New York*, 1988

critiques, and a close peer structure—feels similarly. Of the experience of working in a space like Hammond Hall, she says, "It was a provocation to my own feelings about scale, it served as an invitation to make pieces that take up a room. That impulse to take up space conveyed a sense of strength and empowerment, and for me, represented a feminist gesture."[67] Many graduates felt the location of Hammond Hall contributed to the "outsider" status of the School in relation to the larger University. Pfaff says, "As no one cared very much about the School within the University, it was left up to us to be accepted

FIG. 15. Ursula von Rydingsvard, *Saint Martin's Dream*, 1980. Cedar, 35 × 260 × 20 ft. (10.7 × 79.3 × 6.1 m). Sited at Battery Park City Landfill, New York

and regarded by the art world and by those who graduated from it, to help uphold it . . . to recognize the long history of challenge that women faced within the School, either as graduates or as leaders and teachers."[68]

Stockholder entered the M.F.A. program at Yale as a Painting student in 1983, having studied with Mowry Baden, who, according to the artist, "was very involved with thinking about how art objects function politically within the economy."[69] She recalls that some of the faculty in Painting were suspicious of her practice because she did not work with materials or processes that had traditionally been accepted within that department. Regarding the structure of group critique in Painting, Stockholder felt that some faculty members had a disrespectful approach, recalling Lester Johnson commenting, "Well, you look lovely standing there, but beyond that, I have nothing else to add to your work."[70] So, she frequented Sculpture critiques at Hammond Hall instead, eventually transferring to that department in 1984 with the assistance of painter David Pease, who was dean at that time.[71] After moving to the Sculpture department, Stockholder found that von Rydingsvard and Pfaff had a significant impact on her evolving practice, one routed through painting but with a spatial sensibility that aimed to include "an experience of material, objects, and environment"—something Pfaff herself had pursued in the early 1970s, before installation art arrived as a category. She notes that Jake Berthot, a visiting professor in the Department of Painting, continued to support her work after she transferred to Sculpture. Stockholder maintains that the "most important aspect of my education had been the processing of ideas through conversation with my peers—with artist-classmates Ann Hamilton, Carolyn Ginsberg [M.F.A. 1985], Jan Cunningham [cat. 34], Mark Holmes, and Jack Risley."[72] She supplemented her studio-based education by attending the lectures of the art historians Vincent Scully, Jr., and Karsten Harries and the philosopher George Schrader. Within the School, she says, there were "few mechanisms to bring people together from other departments," but there were some all-School critiques.[73] Though Stockholder does not consider her work to have been influenced by the community of theorists at Yale, her artistic practice addresses controlled chaos, fragmentation, and ideas related to the parergon—a detachable part not quite separate from the whole—which had been discussed by Derrida. As Hamilton notes, "I don't think we were consciously aware of the theoretical debates going on in the University, but, perhaps, it's like growing up in a context where you might not go to church, but it is in the culture and you absorb its customs and values."[74]

When interviewed for a place in the Yale Sculpture department, Hamilton was asked, "You don't do this weaving stuff

FIG. 16. Hammond Hall, Yale School of Art, late 1980s. Yale University Art Gallery Archives, New Haven

anymore, do you?"—a question that disarmed the artist, whose practice included woven elements and was informed by the medium of textiles.[75] "It was such a different time, with a different attitude toward what [weaving] might even mean socially, and the judgment around those histories, with a much more hierarchical attitude about the relationship between what is art and what is craft," she says.[76] The denigration of a process intrinsic to Hamilton's work—one that she considered related to some understanding of women's bodies—negated what she felt was "the meaning of the processes fundamental to textiles. Weaving, sewing, knitting, and netting are constructions in which individual elements forge a mutual whole and, in their coordination, become metaphors for social structures and relations."[77] In discussing her time at Yale, Hamilton emphasizes the tremendous

importance of strong, female professors like von Rydingsvard, Pfaff, and others.[78] Lauren Ewing, for instance, a critic in the Department of Sculpture at the time, "was perceptive and articulate in leading the conversation in group critiques." She continues, "Rydingsvard, Pfaff, and Ewing were faculty members I really admired and respected. . . . They made a life in art seem possible and were incredibly generous to us as students."[79]

Hamilton has noted how much the architecture of Hammond Hall helped to create a culture around space, inspiring a sense of freedom as well as a spatial broadening of one's work (fig. 17): "Hammond Hall had beautiful, tall windows and light, and it served as a studio as well as a forum and a conversation for the presentation of work during twice-a-semester open studios. . . . I started to place my own body into the work, and without the context of the open studios in a former industrial building I probably wouldn't have had a forum for these early experiments."[80] Hamilton's project *tropos* (1993), a genre-breaking work that blanketed a five-thousand-square-foot floor of the original Dia Art Foundation in Chelsea with horsehair, followed a direct line from Hammond Hall. "Working in response to the architecture began at Yale," she says. "The duration of the several-hour open houses raised, for me, the question of time. Were these performances, are these live works, is this a tableau, is this meant to be photographed? I really didn't know what to call it, but the impulse to make the work live came from my interest in

carrying forward the attention, focus, and energy of *making* into the ongoing life of the work, instead of thinking about presenting the work as the funeral when [the making is] over."[81]

Hamilton actively drew from resources offered by the larger University, recalling, "What I loved about the program was that I felt we could venture into other areas and study other disciplines. . . . It's an incredible university to do that within."[82] She adds that she longed for more theoretical conversation, which she felt was lacking in the program, and she notes this desire was shared by her peers, who also recognized there was no structure for it within the School. In American Studies, however, Hamilton discovered Leslie Rado, who taught a class on the cultural construction of the body called "The Body: Gender, Symbol, and Society," with topics including "the language of dress and style, body expressiveness, cultural images of the body, and body stigma, including illness and aging."[83] Rado made a point of supporting Hamilton's thinking as an artist, and her mentorship became a foundation of Hamilton's education. Of Rado's class, Hamilton says,

> It helped give me a vocabulary to think about what I was doing. I made a suit covered in a dense hide of toothpicks painted black with white tips. I was thinking about camouflage, surface, and skin, and the ways in which a membrane can be protective in one context but make one vulnerable and exposed in another. I didn't know what to do with it or how to present the suit. A fellow Sculpture student, Melinda Hunt [M.F.A. 1985], looked at the work and said to me, "Ann, you are an armature. Why don't you just wear it?" It was a casual comment, but it was like the bells went off. And, of course, I wore it, and the experience of wearing it changed everything. . . . Leslie's class helped me to think about the experience of standing still as an active experience. . . . Her class was the most important class I took as a student.[84]

FIG. 17. Ann Hamilton, *the lids of unknown positions*, 1984. Installation tableau, two versions: live (two figures), duration of the tableau, approx. two hours; and static (without figures). Wall, mussel shells, lawn roller, lifeguard chair, ceiling hole, wood table, wood chair, and pile of sand, dimensions variable. Sited at Open House, Department of Sculpture, Yale School of Art, New Haven

### WOMEN ASCEND TO LEADERSHIP IN THE YALE SCHOOL OF ART

From the late 1980s into the 1990s, as the AIDS crisis accelerated, a conservative U.S. government led a campaign to censor the arts, provoking what came to be known as the "culture wars." Funding for the National Endowment for the Arts was drastically cut as public controversy ensued around various exhibitions, including Nan Goldin's group show *Witnesses: Against Our Vanishing* at Artists Space, in New York (1989), and Robert Mapplethorpe's *Perfect Moment* at the Corcoran Gallery of Art, in Washington, D.C. (1989). Craig Owens, a visiting

professor in the Department of the History of Art at Yale and author of *The Allegorical Impulse: Toward a Theory of Postmodernism* (1980), *The Discourse of Others: Feminists and Postmodernism* (1983), and *Outlaws: Gay Men in Feminism* (1987), spoke at a conference on campus in March 1987 titled "Postmodernisms: Politics, Practices, Performance." The conference included the artist Barbara Kruger, the philosopher Edward Said, the choreographer and filmmaker Jo Andres, the performance artist John Kelly, and the choreographer Yvonne Rainer.[85] The following year, Owens worked with an undergraduate student, Richard Meyer, now an art historian, to organize a film series called *Visualizing AIDS*, which included work by Gregg Bordowitz and Maria Maggenti, core members of the AIDS Coalition to Unleash Power (ACT UP).[86] Owens succumbed to AIDS in 1990 at age thirty-nine.

Critical discourse evolved further during the 1990s and directly impacted the School, making its continued isolation untenable. The 1993 Whitney Biennial, curated by Thelma Golden, John G. Hanhardt, Lisa Phillips, and Elisabeth Sussman, engaged head-on with some of the most divisive issues in U.S. cultural politics, including racism, the AIDS crisis, feminism, and economic inequality. It was famously the first Whitney Biennial exhibition in which white male artists were in the minority (a fact memorialized by a poster by the artist group the Guerilla Girls), and it introduced to the world a new generation of artists who had not previously been shown in major museums, some of whom began to arrive at the School as influential critics and lecturers.[87] The fall of the Berlin Wall, the collapse of historical Communism in Eastern Europe, the dissolution of the former East–West divide, the emergence of global capitalism—these, too, were important developments impacting discussions around art. In 1995 the first Johannesburg Biennale was held in postapartheid South Africa, and in 1997 Documenta X, in Kassel, Germany, was curated for the first time by a woman, Catherine David. David presented an expansive international project that included critical and political perspectives toward neoliberalism, global capitalism, privatization, global migrations, and the rise of populism.

Within this context, the School of Art's all-male governance, which structurally privileged white male perspectives, was soon challenged. In the twenty years since the arrival of feminism's second wave, the School had not yet integrated tenured women faculty. This changed in 1990, when Dean David Pease recruited and appointed Sheila Levrant de Bretteville (fig. 18), B.F.A. 1963, M.F.A. 1964, a pioneer in the field of feminist design, as Director of Graduate Studies in Graphic Design and tenured Professor, making her the first woman with tenure in the School's 120-year history. This appointment came nearly two decades after de Bretteville founded CalArts' first feminist design program.[88] She recalls her interview with Yale's all-male review committee and teaching staff, who asked what she felt the School of Art had not yet done that they should do. "Bring more women!," she answered.[89]

Significantly influenced by the Brazilian philosopher Paulo Freire's critical pedagogy, de Bretteville endeavored to rethink the Graphic Design curriculum, revising that which had been adopted nearly forty years earlier to instead reflect an explicitly feminist pedagogical agenda, with the idea that feminist design respects forms of public life rather than privileging a corporate client. She introduced a "person-centric" curriculum, in which students, for the first time, were asked to pull ideas and inspiration from their own experiences—a radical shift from the standard "design-as-problem-solving" model championed by her predecessors, who had conceived of design education as preparation for corporate vocations. De Bretteville remembers feeling that some of the men who preceded her at the School were worried that she was going to let the outside world in, which of course was exactly what she planned to do. "Feminist design," she stated at the start of her tenure, "is an effort to bring the values of the domestic sphere into the public sphere; feminist design is about letting diverse voices be heard through caring, relational strategies of working and designing. Until social and

FIG. 18. Special Edition of the Feminist Newspaper *Everywoman*, Designed by Sheila Levrant de Bretteville (pictured), 1970

economic inequalities are changed, I am going to call good design feminist design."[90]

As a result of the autonomy with which de Bretteville set out to revise the department, the beginning of her tenure was characterized by a rally of dissent from other tenured faculty. Her inclusive definition of design and her leadership of the department enraged Paul Rand, in particular. A member of the School's faculty since the 1950s, Rand felt himself very much the embodiment of the Yale graphic design profile. In his essay "From Cassandre to Chaos," which appeared in his 1993 book *Design, Form, and Chaos*, Rand directly criticized de Bretteville's approach to the department: "Both in education and in business graphic design is often a case of the blind leading the blind. To make the classroom a perpetual forum for political and social issues, for instance, is wrong; and to see *aesthetics as sociology*, is grossly misleading. A student whose mind is cluttered with matters that have nothing directly to do with design, whose goal is to learn *doing* and *making*, . . . and who is overwhelmed with social problems and political issues is a bewildered student. This is not what he or she bargained for nor, indeed, paid for."[91] De Bretteville's pedagogy shifted the direction of a Graphic Design department that, as Lorraine Wild notes, had become stultified.[92] In the three decades since de Bretteville's arrival at the School, the Graphic Design program has generated a cadre of successful women designers.[93]

De Bretteville's appointment in 1990 as the School's first female tenured professor under Pease's deanship was followed by Pease's appointment of Alice Aycock (fig. 19) to Director of

Graduate Studies in Sculpture and tenured Professor in 1991, making Aycock the second woman with tenure in the School's history. Aycock assumed the directorship after David von Schlegell, who had served nearly twenty years, retired from the position. An internationally recognized artist who had participated in Documenta VI and VII, Aycock had arrived at the School in 1989 as Senior Critic in Sculpture, becoming an important mentor to Matthew Barney, Rachel Berwick, M.F.A. 1991, and Leo Villareal. As director, Aycock introduced the "Critical Studies" course in the department. She notes, "I had wanted to make a think tank. If I was going to do it, then let's all let our guard down, let's have a great graduate moment where we are all exchanging ideas, we're talking about our work, we're experimenting, and we are not worried whether we are going to be famous or not."[94] Her attempts to widen the conversation around artistic practice were resisted by a group of students who were only "interested in meeting whatever critic was hot at the moment" and who she felt prioritized career building over experimentation. She decided to leave the School after just one year as director, citing the death of a student from AIDS as a determining factor: "The [AIDS] crisis was full-blown, and it was hitting really young people. There were three graduate students in my class, all from Kansas City, and each of them gay. . . . Each got AIDS, and each was dying. I remember it was in February that I went to visit Greg Cabrera in the hospital, where he was comatose. I watched this young man die while other kids in his class were acting privileged. I think it was a kind of coup de grâce for me."[95]

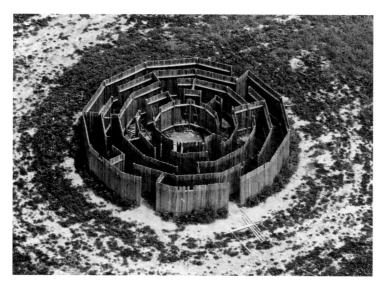

FIG. 19. Alice Aycock, *Maze*, 1972. 12-sided wooden structure of 5 concentric dodecagonal rings, broken by 19 points of entry and 17 barriers, H. 6 × DIAM. 32 ft. (182.9 × 975.4 cm). Sited at Gibney Farm, near New Kingston, Penn.

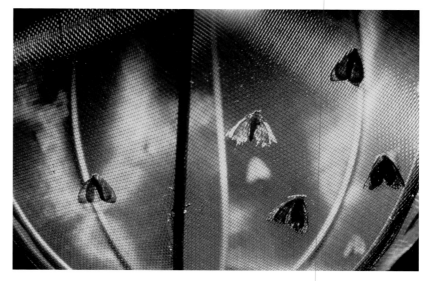

FIG. 20. Rachel Berwick, *The Economy of Desire* (detail), 1990. Live male and female moths, brass screen, steel, light, and shadow, DIAM. 9 ft. (274.3 cm). Courtesy the artist

Aycock's former student Rachel Berwick (fig. 20), who had recently graduated, was hired as a lecturer in 1991, under the temporary directorship of John Newman, with the expectation that she would oversee the day-to-day operations of the department. Berwick's hire was intended as a two-year engagement, but after von Schlegell's retirement and Aycock's quick departure left the Sculpture department with no director and with two main faculty members—Newman and Ronald Jones—who both lived two hours away in New York, she stayed on, becoming Critic in 1996 and Acting Director of Sculpture in 1998, following the departures of Newman and Jones. According to Berwick, she was an equal partner for the duration of her time as faculty, "selecting, inviting, and interacting with the visiting lecturers, visiting faculty, and visiting critics year to year." She "taught both undergraduate and graduate students and participated, along with [her] colleagues, in the admissions process and in critiques of all graduate student work, without exception."[96] Like Pfaff ten years earlier, Berwick notes that there had been an economic downturn at the time she began teaching; students moved toward immersive installations that explored metaphors aligning personal experiences and perspectives. She recalls that Trisha Donnelly, M.F.A. 2000, brought a trampoline into her studio, on which she performed as an artwork.

Following a national search, Pease appointed Rochelle Feinstein as Director in Printmaking and tenured Associate Professor of Painting and Printmaking in 1994, making her the third woman in the School's history to serve in a full-time tenured faculty and leadership position. Feinstein was a highly accomplished artist whose practice extended beyond painting and drawing into photography and video and related to the legacy of a largely male-dominated modernist tradition through works characterized by vibrant color fields, bold brushstrokes, and fragmented slogans that conveyed a slapstick feminist sensibility (fig. 21). She had fourteen years of experience teaching at Bennington College, in Vermont—where she had also held tenure. Despite this, her appointment at Yale was contested by the all-male faculty, who challenged her credentials. During her third interview, she says, William Bailey asserted that she was "not a part of painting culture."[97] At the time, Feinstein perceived Bailey's motive as protecting the Painting program from everything other than formalist discourse. She became the singular woman in a traditionally paternalistic and conventional Painting and Printmaking department. Once at Yale, she worked within what she found to be a "toxic" environment, requiring "a rope to pull through the trenches."[98]

Feinstein continued to teach at the School for twenty-three years, offering diverse perspectives on painting and printmaking.

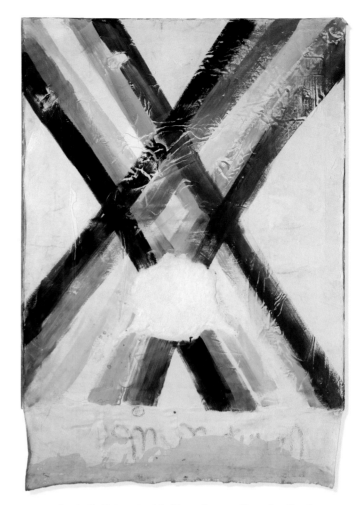

FIG. 21. Rochelle Feinstein, *Mr. Natural*, 2009. Crystal, reflective glass powder, oil, and charcoal on drop cloth, 72 × 50 in. (177.8 × 127 cm). Collection of S. J. Weiler

In her later role as Director of Graduate Studies in Painting and Printmaking, she revised the graduate curriculum and implemented a rotating program of "Core Critics" to bring emerging, diverse, and urgent conversations to the School. When the School moved from Rudolph's Art and Architecture Building to its current location in Holcombe T. Green, Jr., Hall (on Chapel and Crown Streets) in 2000, Feinstein designed an expanded printmaking area that not only embraced traditional media but also made room for the new. In 2004 she introduced "LABoratory," a graduate seminar focused on contemporaneous artworks, periodicals, essays, reviews, and criticism, to encourage students to engage with new work outside their individual studio practices. The objective was "to think through a problem, discover capacities not yet unearthed, and understand the historical context that informs how objects are made and what they might have meant in relation to their own moment of making."[99]

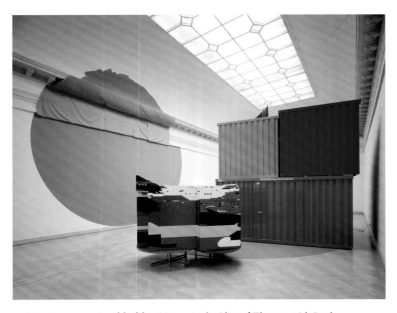

FIG. 22. Jessica Stockholder, *Vortex in the Play of Theater with Real Passion: In Memory of Kay Stockholder*, 2000. Duplo, theater curtain, work site containers, bench, theater light, linoleum, tables, fur, newspaper, fabric, and paint, dimensions variable. Sited at Kunstmuseum St. Gallen, Switzerland

In 1999, following Berwick's departure from the Sculpture program, Jessica Stockholder (fig. 22 and cat. 36) was appointed Director of Graduate Studies in Sculpture and a tenured associate professor. "When I came into the School as faculty," Stockholder notes, "I understood that to arrive with tenure was a very privileged and secure position. Yet I realized that those who had retired into emeritus positions—such as William Bailey, Lester Johnson, David Pease—continued to put pressure on Chip [Dean Richard Benson] and still seemed to have some influence."[100] Stockholder built upon the structure David von Schlegell had established for the Sculpture program, appointing faculty who she believed balanced an interest in conceptual, political, racial, and gender issues with an emphasis on how processes and forms of making generate meaning. During Stockholder's tenure, the department moved from Hammond Hall, where it had resided for almost forty years, to a newly constructed building at 36 Edgewood Avenue. The building was considerably closer than Hammond Hall to the rest of the School, but the departments remained fairly siloed, though students were able to attend critiques in other departments. Conversations, often fraught, ensued over the possibility of establishing more formal channels for cross-disciplinary encounters, as well as exchanges within the larger University. Stockholder, attempting to address the disconnection, proposed a collaboration with the Yale Law School, but it was not met

with support by the School's leadership. After a twelve-year engagement with the School, she decided to leave her tenured position in 2011.[101] It would be another seventeen years after Stockholder's 1999 appointment before a female faculty member would again enter the School's governance—with the appointment in 2016 of the present author as the first woman dean in the School's 150-year history.

## CRITIQUE AS A MODE OF REFLEXIVITY AND REFLECTION

In 2016 the School's "Critical Practice" course was revised to a weekly lecture and seminar called "Diving into the Wreck: Revisiting Critical Practice"—a title borrowed from a 1972 poem by the American writer and feminist Adrienne Rich—thus formalizing critical study as part of the curriculum and expressing a decanal perspective in direct contrast with that of the preceding deans who maintained that artists should be makers, not thinkers. As a Hayden Distinguished Speaker addressing the "Diving into the Wreck" course in the fall of 2020, the scholar and activist Angela Y. Davis cited the description of the course, noting its stated intent to provide "space for a cultivation of consciousness that extends self-knowledge outwards into a sense of community, through the act of critical reflection."[102] In her lecture, Davis emphasized that creative existence is based on the ability to hold contradictions, "to form new knowledges, to critically engage with the world."[103] Yet, over several decades, the sequestration of critical practice within the domain of theory, rather than its integration into a system of inquiry endemic to artistic practice, had largely come to characterize education at the School of Art; both students and faculty mused over the issue, expressing a wish to transcend the format of group critiques.

During her tenure as Director of Graduate Studies in Sculpture, Stockholder had introduced her own structure for group critiques, one that aimed to place viewers and artists on equal footing in a process of generating dialogue about a work:

The student was asked to present their work and everything that they felt was important for us to know about the work. After that, they were asked not to speak for the first half of the critique. The onus was on the rest of us, faculty and students, to put words to the work and to articulate where our questions came from. Midway through their crit, we brought the student into the conversation. This mode of critique privileged the work over language, and proposed that as viewers, our reception of the work, and how we articulate what we care about, is of equal importance to the subjectivity of the artist who made the work.

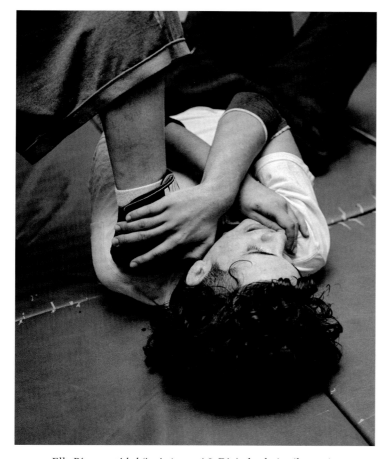

FIG. 28. Elle Pérez, *untitled (junior)*, 2014/18. Digital gelatin silver print, 34 × 28 in. (86.4 × 71.1 cm). Courtesy the artist

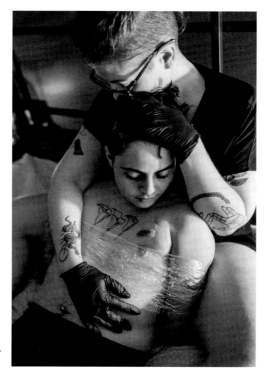

FIG. 29. Elle Pérez, *Wilding and Charles*, 2019. Digital gelatin silver print, 56½ × 40 in. (143.5 × 101.6 cm). Courtesy the artist

interlocutors and mentors who can perceive the stakes in one's work and foster its development: "As a student, it's always so hard, because you are always in this mental space of wanting something so badly that is difficult to actualize. I remember being in a crit, and I gave some vague introductory statement about resilience in relation to a series of images of wrestlers in Baltimore. Someone in the crit shouted out, 'Did anyone understand what they meant?' and Roni Horn, who had been on the review panel that day answered, 'Yes, I understood what they meant'—an affirmation that stayed with me."[125] Pérez continues:

> I guess what I've been trying to figure out for myself in returning . . . [is] where the line between an external and internal conflict lies [for those who are] existing in these spaces. As a student, I think I brought my own baggage or my own expectations to the space that had to do with what I thought was possible for me there, or how I thought I was going to be treated [as a person of color who is gender nonconforming]. I saw what I wanted to see in a way. Now that I'm back in the space in a different way, at a different time, in a different role, and watching people go through [similar situations], I'm teaching myself how to recognize that struggle.[126]

## A FORTHCOMING HISTORY OF INCLUSIVITY

While any essay that attempts to distill a fifty-year period of an institution as intricate as a school of art into a singular narrative will only succeed in broaching the vast complex of stories that make up a full history, a landmark anniversary provides an important opportunity to revise and enrich existing legacies, to fill in oral histories not previously told, and to bring to light materials not already known or cited. This essay has depicted the Yale School of Art since around 1969 from the perspective of an author whose understanding of that period has been informed by avidly listening to exemplary women associated with the School during this time, as students, faculty, or both. The aim has been to acknowledge and reflect a constellation of individuals, events, and experiences that historically have been peripheralized, while admitting that too many individuals will still be overlooked, and many more stories are as yet unfolding. Such a complex, multidimensional, and extensive history asks to be retold many more times, at length, and through counterpositions. Nevertheless, the testimonies gathered here demonstrate that, since 1969, the gender binary that once dominated the School has gradually shifted toward gender nonconformity, profoundly influencing its pedagogical perspective.

The author wishes to acknowledge the generous participation of the interviewees and the research efforts of Edi Dai, M.F.A. 2019, whose dedication to the recovery of this important historical record made its retelling possible, as well as Angela Chen, M.F.A. 2020, Angie Keefer, B.A. 1999, Willis Kingery, M.F.A. 2019, and Beth Lovell, M.F.A. 1991.

1. Abigail Child, telephone conversation with author, February 1, 2020; see Charles C. Meeker, "Leary Praises Youth Hits Old Moral Values," *Yale Daily News* (New Haven), November 18, 1969.

2. Nick Doob, telephone conversation with author, February 5, 2020.

3. Tom Warren, "A and A Protesters Hold Mock Burial," *Yale Daily News* (New Haven), May 5, 1969.

4. Dean Howard Sayre Weaver, memo, September 15, 1969, School of Art and Architecture, Yale University, Records, RU 189, Manuscripts and Archives, Yale University Library, New Haven.

5. Ibid.

6. Three months after the meeting, Weaver submitted a written report to President Brewster with additional thoughts on the M.F.A. program; see Howard Sayre Weaver, "Studies in Visual Arts in the University," report, January 9, 1970, Yale School of Art archives, New Haven.

7. Scott Herhold and Peter Diamond, "750 Join March; Post Five Demands," *Yale Daily News* (New Haven), April 24, 1970.

8. For many of the faculty titles and dates of employment cited in this essay, see copies of the annual School of Art catalogue, Manuscripts and Archives, Yale University Library, New Haven.

9. Halaby is a Palestinian-born U.S. citizen, and Druckrey was born in Germany, not yet a citizen. Inge Druckrey, oral history interview by Laura Luís Worden, April 17, 2019, transcript, Yale University Art Gallery Archives, New Haven.

10. "Time to Tenure," *Faculty Handbook* (New Haven: Yale University, 1978; rev. February 1981), Manuscripts and Archives, Yale University Library, New Haven.

11. Winifred Lutz, email correspondence with author, February 28, 2021.

12. Ibid.

13. Druckrey, oral history interview.

14. The exhibition was on view from December 29, 1982, to January 8, 1983. Jason Friedman, "Rebels Attack Yale School of Art Artists 'Try' Art School," *Yale Daily News* (New Haven), January 21, 1983.

15. Rob Glaser, "Art for Whose Sake?" *Yale Daily News* (New Haven), January 28, 1983.

16. Joyce Owens, telephone conversation with author, January 27, 2020.

17. Ibid.

18. Ibid.

19. Ibid.

20. For more information on the Norfolk summer program, see "Timeline: 1869–1949" in the present volume.

21. Judy Pfaff, conversation with author, January 13, 2020.

22. Ibid.

23. Ibid.

24. Ibid. The exhibition included works by Jo Baer, Lynda Benglis, Hollis Frampton, Yvonne Rainer, Paul Sharits, and Michael Snow, among others. See Anne Coffin Hanson, Klaus Kertess, and Annette Michelson, *Options and Alternatives: Some Directions in Recent Art*, exh. cat. (New Haven: Yale University Art Gallery, 1973).

25. Judy Pfaff, conversation with author, January 13, 2020.

26. Ibid.

27. Ibid.

28. Alvin Eisenman, in Jerry L. Thompson and Alvin Eisenman, "Teaching the Practice of Photography at Yale: A Conversation with Alvin Eisenman, February 2006," *Yale University Art Gallery Bulletin* (2006): 128.

29. The first known woman graduate student to receive an M.F.A. in Photography was Melinda Blauvelt (Wells), M.F.A. 1973; she matriculated in 1971.

30. Christine Osinski, telephone conversation with author, February 9, 2020.

31. Ibid.

32. Ibid.

33. After graduating in 1976, Osinski taught at the Bedford Hills Correctional Facility for Women, in New York State, as well as at CW Post College (now LIU Post), Long Island University, in Brookville, New York; Parsons School of Design, in New York; and Pratt Institute, in Brooklyn and New York, before being appointed Professor at Cooper Union, in New York, where she has taught photography since 1983. Osinski received a Guggenheim Fellowship in 2005.

34. Joyce Baronio, telephone conversation with author, September 15, 2019.

35. Ibid.

36. Edmund White, "Joyce Baronio on 42nd Street—Tripping the Light Fantastic," *Village Voice* (August 6, 1979): 35, 37.

37. Joyce Baronio, *42nd Street Studio* (New York: Pyxidium Press, 1980), n.p. Baronio's *42nd Street Studio* won the American Institute of Graphic Arts Award for Excellence in 1980.

38. Douglas Crimp, *Pictures* (New York: Committee for the Visual Arts, 1977), 5.

39. Susan Sontag, *On Photography* (New York: Picador, 1977), 4.

40. Tod Papageorge, telephone conversation with author, January 16, 2020.

41. Ibid.

42. Marc Redfield, *Theory at Yale: The Strange Case of Deconstruction in America* (New York: Fordham University Press, 2016), 3.

43. Paul Ardenne, "The Art Market of the 1980s," *International Journal of Political Economy* 25, no. 2 (*The Political Economy of Art*) (Summer 1995): 116.

44. Fredric Jameson, *The Political Unconscious: Narrative as a Socially Symbolic Act* (Ithaca, N.Y.: Cornell University Press, 1981), 20.

45. bell hooks, "The Oppositional Gaze: Black Female Spectators," in *Black Looks: Race and Representation* (Boston: South End Press, 1992), 126.

46. bell hooks, *Teaching to Transgress: Education as the Practice of Freedom* (New York: Routledge, 1994), 10.

47. Winifred Lutz, telephone conversation with author, February 11, 2020.

48. Mimi Thompson, "Roni Horn," *BOMB* (July 1, 1989), https://bombmagazine.org/articles/roni-horn/.

49. Roni Horn, in "Roni Horn with Jarrett Earnest," *Brooklyn Rail* (December 2013–January 2014), accessed January 5, 2021, https://brooklynrail.org/2013/12/art/roni-horn-with-jarrett-earnest.

50. Wild also observed that Albers's legacy had migrated beyond the Department of Graphic Design to the Department of Painting. She recalls a daylong symposium toward the end of her studies in honor of the thirtieth anniversary of Albers's arrival at the School, which was organized by and composed almost entirely of painters and sculptors, without the participation of any design students or the remaining faculty members that Albers had originally hired; Lorraine Wild, telephone conversation with author, January 28, 2020. For more on Albers's time at Yale, see the essay by Linda Konheim Kramer in the present volume.

51. Lorraine Wild, telephone conversation with author, January 28, 2020.

52. With no art or design school offering a graduate degree in design history at the time, Wild conducted most of her research in the archives of the New York Public Library. She also recalls that classmate Katy Homans, M.F.A. 1982, chose to write an essay on British designer Robert Brownjohn and encountered the same amount of resistance to her thesis that Wild had. Ibid.

53. Ibid.

54. Maya Lin, *Boundaries* (New York: Simon and Schuster, 2000), 4:10.

55. Ibid., 4:11.

56. Maya Lin, telephone conversation with author, January 20, 2020.

57. "Frequently Asked Questions," National Park Service, Vietnam Veterans Memorial, updated November 9, 2017, https://www.nps.gov/vive/faqs.htm.

58. Maya Lin, telephone conversation with author, January 20, 2020.

59. Ibid.

60. Ibid.

61. Ursula von Rydingsvard, telephone conversation with author, January 31, 2020.

62. Ibid.

63. Ibid.

64. Ibid.

65. Recalling the courses in which she taught Architecture students, including Maya Lin, von Rydingsvard says, "I wanted to push them toward [other] materials instead of concentrating on their usual medium of cardboard. I had them build things with alternative materials uncommon to architectural draftsmanship and model

building, and to build and install around an old defunct railroad in New Haven"; ibid.

66. Ibid.

67. Semmes went on to teach, joining the faculty of New York University in 1995, where she stayed until 2015; Beverly Semmes, telephone conversation with author, February 6, 2020.

68. Judy Pfaff, conversation with author, January 13, 2020.

69. Jessica Stockholder, quoted in "There Are No Words for What I'm Going to Do: An Interview with Jessica Stockholder," Artspace, June 14, 2018, https://www.artspace.com/magazine/interviews_features/qa/there-are-no-words-for-what-im-going-to-do-an-interview-with-jessica-stockholder-55484.

70. Jessica Stockholder, telephone conversation with author, January 8, 2020.

71. Ibid.

72. Ibid. Similarly, Semmes recalls the Sculpture program as being a "functional community," with people who were supportive of one another; Beverly Semmes, telephone conversation with author, February 6, 2020.

73. Jessica Stockholder, telephone conversation with author, January 8, 2020.

74. Ann Hamilton, telephone conversation with author, February 5, 2020.

75. Hamilton had received a B.F.A. in Textile Design from the University of Kansas, in Lawrence, in 1979.

76. Hamilton, telephone conversation with author.

77. Ibid.

78. Ibid.

79. Ibid.

80. Ibid.

81. Ibid.

82. Ibid.

83. "Yale College Programs of Study: Fall and Spring Terms, 1983–84," Bulletin of Yale University, ser. 79, no. 8 (August 15, 1983): 55, Manuscripts and Archives, Yale University Library, New Haven.

84. Ann Hamilton, telephone conversation with author. After graduation, Hamilton was hired by the University of California in Santa Barbara, where she stayed until 1991; she then left teaching to pursue her art-making practice full

time, and soon thereafter produced tropos. In the catalogue for the tropos exhibition, Dia's curator and director, Lynne Cooke, remarked on Hamilton's graduate education at Yale: "Fundamental to Hamilton's fusion of installation and performance modes at this time were the requirements and restrictions attendant on presenting work as a student in a studio situation at the Yale School of Art"; Lynne Cooke and Karen Kelly, eds., Ann Hamilton: tropos (New York: Dia Art Foundation, 1993), 62–63.

85. Richard Meyer, "Postmodernisms at Yale," Yale Daily News (New Haven), February 20, 1987.

86. Stephen Heuser, "Films and Producers Help Visualize AIDS Epidemic," Yale Daily News (New Haven), March 2, 1988. The film series also screened Snow Job: The Media Hysteria of AIDS by Barbara Hammer.

87. These included Donald Moffett (Lecturer in Graphic Design, 1993–95), Fred Wilson (Critic in Sculpture, 1994–95), Gary Simmons (Critic in Sculpture, 1998–99), Suzanne McClelland (Senior Critic in Painting/Printmaking, 1999), and Byron Kim (Senior Critic in Painting/Printmaking, 1999–2000, 2001–2, 2009–10, 2012–present).

88. De Bretteville also cofounded the Woman's Building and the related Women's Graphic Center at CalArts and was a founding member of the first independent feminist art school in the United States, the Feminist Studio Workshop, in Los Angeles.

89. Sheila Levrant de Bretteville, oral history interview by Edi Dai, October 12, 2018, transcript, Yale University Art Gallery Archives, New Haven.

90. Sheila Levrant de Bretteville, in Ellen Lupton, "Reputations: Sheila Levrant de Bretteville," Eye 2, no. 8 (Fall 1993), http://www.eyemagazine.com/feature/article/reputations-sheila-levrant-de-bretteville.

91. Paul Rand, "From Cassandre to Chaos," in Design, Form, and Chaos (New Haven: Yale University Press, 1993), https://www.aaeportal.com/?id=-14897. Italics in the original.

92. Lorraine Wild, telephone conversation with author, January 28, 2020.

93. Since de Bretteville assumed the directorship of the department in 1990, women graduates have included: Lucinda Hitchcock, M.F.A. 1994, head of the undergraduate Graphic Design department at the Rhode Island School of Design, in Providence; Miko McGinty, B.A. 1993, M.F.A. 1998, a book designer whose work includes the present volume; Alicia Cheng, M.F.A. 1999, and Sarah Gephart, M.F.A. 1999, who founded the design studio MGMT; Tamara Maletic, M.F.A. 2001, partner and cofounder with Dan Michaelson of Linked by Air; Juliette Cezzar, M.F.A. 2002, former President of AIGA/NY and former Director of the B.F.A. program in Communication Design at Parsons School of Design, in New York; Sulki Choi, M.F.A. 2002, who runs an independent studio located in her native South Korea; Danielle Aubert, M.F.A. 2005, cofounder of a three-woman studio based in Detroit, as well as a labor activist and board member of Metro Detroit DSA; Yoonjai Choi, M.F.A. 2006, who runs a studio in New York; Rachel Berger, B.A. 2003, M.F.A. 2009, Chair of the Design department at the California College of the Arts, in Oakland and San Francisco; Julia Novitch, B.A. 2006, M.F.A. 2013; and Jessica Svendsen, B.A. 2009, M.F.A. 2013, Design Director, Dropbox, in New York, Lecturer at the Yale School of Art, and Assistant Professor Adjunct at Pratt Institute, in New York.

94. Alice Aycock, telephone conversation with author, September 30, 2020.

95. Ibid.

96. Rachel Berwick, telephone conversation with author, September 9, 2020.

97. Rochelle Feinstein, conversation with author, February 9, 2020.

98. Ibid.

99. Rochelle Feinstein, telephone conversation with Edi Dai, October 18, 2018.

100. Jessica Stockholder, telephone conversation with author, January 8, 2020.

101. Stockholder accepted a tenured professorship in the Department of Visual Arts at the University of Chicago, a position she still holds.

102. Angela Y. Davis, "Diving into the Wreck: Rethinking Critical Practice

(ART 949)" (class lecture), October 27, 2020, Yale School of Art, New Haven, transcript, author's files.

103. Ibid.

104. Jessica Stockholder, telephone conversation with author, January 8, 2020.

105. Sarah Oppenheimer, telephone conversation with author, March 15, 2021.

106. Sarah Oppenheimer, telephone conversation with author, January 9, 2020.

107. Ibid.

108. Ibid.

109. Carol Vogel, "Warhols of Tomorrow Are Dealers' Quarry Today," New York Times, April 15, 2006.

110. Rochelle Feinstein, conversation with author, February 9, 2020.

111. Sarah Oppenheimer, telephone conversation with author, January 9, 2020.

112. Anoka Faruqee, email correspondence with author, February 11, 2020.

113. Sarah Oppenheimer, telephone conversation with author, March 15, 2021.

114. "Yale University Race/Ethnicity, Gender and International Student Enrollment by School 2014–15 to 2020–21," Office of Institutional Research, Yale University, November 2020, accessed February 15, 2021, https://oir.yale.edu/sites/default/files/w010_enroll_race_gender_2021.pdf. Race/ethnicity categories are established by the federal government.

115. An-My Lê, telephone conversation with author, January 16, 2020.

116. Ibid.

117. Tala Madani, telephone conversation with author, January 24, 2020.

118. Ibid.

119. Tala Madani, email correspondence with author, March 22, 2021.

120. Ibid.

121. Wangechi Mutu, telephone conversation with author, January 15, 2020.

122. Ibid.

123. Elle Pérez, conversation with author, January 11, 2020.

124. Ibid.

125. Ibid.

126. Ibid.

## 1969

The Yale School of Art and Architecture informally reorganizes as two separate faculties—Faculties in Art and Faculties in Design and Planning—each with its own dean. Howard Sayre Weaver, previously dean of the Yale School of Art and Architecture, is appointed Dean of Faculties in Art, and Charles Moore, previously chairman of the Department of Architecture, is appointed Dean of Faculties in Design and Planning. Additionally, the programs in Painting, Sculpture, and Graphic Design are each to be coordinated by one faculty member, who assumes the title of Director of Studies.

On May 15, Claes Oldenburg installs *Lipstick (Ascending) on Caterpillar Tracks* in Beinecke Plaza on Yale's campus. The work is a commission led by a group of architecture students taking the name the Colossal Keepsake Corporation of Connecticut.

On June 14, a fire breaks out on the fourth and fifth floors of the Art and Architecture Building, damaging the sixth floor as well. Renovations are delayed by a reappraisal of the School's program and studies of the best future use of the individual spaces. The School is temporarily housed in Weir and Harkness Halls and in several buildings on Temple Street.

On June 28, patrons and neighbors of the Stonewall Inn, a gay bar in New York, form a resistance to a police raid and police harassment of the LGBTQ+ community. Marsha P. Johnson, a Black transgender woman and activist, plays a key role in the uprising.

In September, Yale College coeducates: Of the 278 women offered admission to the class of 1973, 230 enroll, including 26 of the 34 Black women accepted. In addition, 370 women are accepted as transfer students: 212 for the class of 1971 and 158 for the class of 1972.

On October 1, the Task Force on Women's Rights and Responsibilities is appointed by U.S. president Richard Nixon, with the stated goal of "review[ing] the present status of women in our society and recommend[ing] what might be done in the future to further advance their opportunities."

## 1970

In March, Claes Oldenburg removes his *Lipstick (Ascending) on Caterpillar Tracks* from Beinecke Plaza; made of cardboard and plastic, it had begun to fall apart.

In the aftermath of the June 1969 fire, the University offers the use of Hammond Hall, at 14 Mansfield Street (a building formerly used for mechanical engineering) to students and faculty in the Department of Sculpture, since there is no single location with adequate room for Painting, Sculpture, Architecture, and City Planning.

In the early 1970s, Graphic Design is located at 212 York Street (an old Yale fraternity building), and there are classrooms and additional graduate painting studios at 215 Park Street. Street Hall is turned over for the exclusive use of the Department of the History of Art.

Anne Coffin Hanson is hired as a fully tenured professor in the Department of the History of Art—the first woman at Yale to be hired with this distinction, rather than promoted from within.

The M.F.A. program is reduced from three years to two years.

On May Day Weekend (May 1–3), demonstrators from around the country converge on Yale and New Haven to rally in support of Black Panther leaders who were being tried in New Haven on charges ranging from criminal conspiracy to felony murder. Yale women and men provide volunteer staffing to house and feed protesters throughout the tense weekend. State and local police forces are joined by four thousand National Guardsmen, with tanks and tear gas, in anticipation of chaos and violence that does not transpire.

In November, as a result of complaints filed by the Women's Equity Action League and the National Organization for Women, the U.S. Department of Health, Education, and Welfare investigates a number of Ivy League institutions, including Yale, for sexual discrimination in the faculty hiring process.

On December 12–13, the Chubb Conference on the Black Woman is held, featuring Chubb Fellows Maya Angelou, Gwendolyn Brooks, John Henrik Clarke, and Shirley Graham Du Bois. It is the first time the Chubb Fellowship—a visiting lecture program administered by Yale's Timothy Dwight College since 1949—has been awarded to women.

Judy Chicago founds the Feminist Art Program (FAP) at Fresno State College, in California, to address gender inequities in art education and the broader art world. In 1971 Chicago and Miriam Schapiro bring the FAP to the newly formed California Institute of the Arts (CalArts), in Santa Clarita.

## 1971

Alan Shestack, who had served as Curator of Drawings and Prints at the Yale University Art Gallery since 1968, becomes director of the Gallery; he serves in this role until 1985.

David von Schlegell is appointed Director of Studies in Sculpture at the School of Art and Architecture. The Department of Sculpture gradually begins to occupy Hammond Hall, remaining in the building until 2009.

Anne Coffin Hanson, Professor of the History of Art, becomes president of the College Art Association; she serves until 1974.

Anne Coffin Hanson is a plaintiff in a suit to admit women on the Yale faculty to Mory's, an all-male eating club founded in 1849.

In January, the Women's Equity Action League submits a formal charge of sexual discrimination against Yale to the U.S. Department of Health, Education, and Welfare related to its status as a federal contractor, citing the small proportion of women faculty members. According to the *Yale Daily News*, there are only two tenured women teaching in Yale College and three full professors at the University. Only 7 percent of assistant professors—and no associate professors—are women.

In January, art historian Linda Nochlin's essay "Why Have There Been No Great Women Artists?" is published in *Artnews*.

On January 31, the Black Emergency Cultural Coalition (BECC) pickets outside the Whitney Museum of American Art, in New York, with signs featuring demands such as "50% Black Women Artists." The BECC, which includes artists Camille Billops and Faith Ringgold, advocates for the inclusion, elevation, and study of Black artists within museums and cultural institutions.

In fall 1971–72, Pat Adams is Visiting Critic in Painting (she will also be a visiting critic in 1976, 1979, and 1983) and Jane Greenfield is Visiting Lecturer in Bookbinding.

Gloria Steinem starts *Ms.* magazine.

## 1972

In meeting notes dated April 27, the "Report of the Appointments Committee" at Yale includes the following statement: "Mr. [Al] Held [Professor of Art] reported that the Search Committee has been interviewing candidates . . . and that they are primarily looking for a woman artist. However, they are having difficulty finding one with the ideal qualifications who would be willing to move to New Haven."

In April, the Connecticut law banning abortion is struck down.

# TIMELINE

In May, the Yale School of Art and the Yale School of Architecture are formally established as two separate schools by the president and fellows of the University.

Herman Spiegel is appointed dean of the School of Architecture; he serves until 1976.

Samia Halaby joins the School of Art as Visiting Lecturer in Painting.

During the 1972–73 academic year, Michael Roemer begins to direct an experimental program of studies in Film-Making, offering a limited number of M.F.A. degrees.

Inspired by her work to diversify the collections and exhibits of the Wadsworth Atheneum in Hartford, Dollie McLean founds the Artists Collective, a multiarts organization emphasizing Black history and culture. In 2010 First Lady Michelle Obama awards the Artists Collective a national distinction for their efforts.

In June, the U.S. Congress passes the Education Amendments of 1972, which include Title IX (later renamed the Patsy T. Mink Equal Opportunity in Education Act), prohibiting federal funding to educational institutions that discriminate on the basis of sex. One-quarter of Yale's annual budget, or $32 million, comes from federal funding, making the University subject to the new law. The law gives schools seven years to "fully cooperate." U.S. president Richard Nixon signs the law on June 23. Elga Wasserman, J.D. 1976, head of the Women's Advocate Group at the time, expresses doubts about Yale's ability to meet these standards under its current policies.

A.I.R. Gallery—the first nonprofit, artist-directed and -maintained gallery for women artists in the United States—is established in New York. Judith Bernstein (cat. 19) and Howardena Pindell (cat. 20) are among the cofounders.

## 1973

Gretna Campbell joins the faculty of the School of Art as Assistant Professor of Painting; she is appointed Associate Professor in 1979. Campbell holds positions at the School until her death in 1987.

Inge Druckrey joins the faculty as Assistant Professor of Graphic Design; she is appointed Associate Professor in 1979, but never receives tenure. Druckrey continues to teach at the School in various capacities until 1995.

Faith Hubley begins as Lecturer in Film-Making.

Sarah Miller begins as Assistant Instructor in Film-Making.

Samia Halaby joins the faculty as Associate Professor of Painting—becoming the first woman to be appointed a full-time professor at the School of Art; she never receives tenure.

Melinda Blauvelt (Wells) becomes the first woman to receive a Master of Fine Arts degree in Photography from the School of Art.

In January, the U.S. Supreme Court rules on the case of *Roe v. Wade*, protecting a pregnant woman's choice to have an abortion without extensive government restriction, striking down many state abortion laws. Grassroot factions form on both sides of this heated debate.

Artist Judy Chicago, art historian Arlene Raven, and graphic designer Sheila Levrant de Bretteville, B.F.A. 1963, M.F.A. 1964, quit teaching at the male-dominated CalArts to found the Feminist Studio Workshop in Los Angeles, one of the first independent art schools for women.

In September, Hanna Holborn Gray becomes the first woman to be appointed provost at Yale, a position she holds until 1978. Gray then becomes the first woman to serve as acting president of Yale, for thirteen months—the only woman to hold that position to this day.

On September 20, Billie Jean King, American tennis champion, defeats champion player Bobby Riggs in a highly publicized "Battle of the Sexes" match.

## 1974

Anne Coffin Hanson is named chair of the Department of the History of Art; she is the first woman to serve as department chair at Yale.

At the request of President Kingman Brewster, William Bailey, who had been teaching at the School of Art since 1956, agrees to serve as dean of the School of Art while the search for a new dean continues; he serves until 1975.

Claes Oldenburg's refabricated *Lipstick (Ascending) on Caterpillar Tracks* is accessioned by the Yale University Art Gallery and installed in the courtyard of Yale's Morse College, where it remains today.

After the sustained agitation of female faculty, the all-male eating club Mory's begins to admit women.

In November, the former secretary of state and congresswoman Ella T. Grasso becomes Connecticut's first woman governor.

## 1975

The School of Art awards its final B.F.A. degree.

Andrew Forge is appointed dean of the School of Art; he serves until 1983.

The U.S. Department of Health, Education, and Welfare issues the final Title IX regulations. Colleges are given three years to comply.

## 1976

Photography—which, since the mid-1950s, had been taught as a discipline under the umbrella of Graphic Design, first under the direction of Herbert Matter, then Walker Evans—becomes a separate concentration in the School of Art.

Winifred Lutz joins the faculty of the School of Art as Assistant Professor of Sculpture; she is appointed Associate Professor in 1979. She teaches at Yale until 1982.

Edmund P. Pillsbury becomes director of the Yale Center for British Art; he serves until 1981.

In September, twenty of the twenty-one members of the women's crew team march into the office of Joni Barnett, Director of Women's Activities, strip, and stand with the words "Title IX" written across their chests and backs, while their captain reads a statement protesting the lack of locker room facilities for women at Yale's boathouse. A headline in the *Yale Daily News* reads, "Oarswomen bare all." The immediately infamous "Title IX strip" results in not only a trailer with four showers but also national press coverage.

## 1977

The Yale Center for British Art, designed by Louis Kahn and located across Chapel Street from the Yale University Art Gallery, opens to the public. It holds the largest collection of British art outside the United Kingdom.

Cesar Pelli is appointed dean of the School of Architecture; he serves until 1984.

*Alexander v. Yale*, the first national case to argue sexual harassment as a form of gender discrimination in education, arises from Yale. Plaintiffs include Ronni Alexander, B.A. 1977, Ann Olivarius, B.A. 1977, J.D. 1987, M.B.A. 1986, Pamela Price, B.A. 1978, Margery Reifler (Kimbrough), B.A. 1980, and Lisa E. Stone, B.A. 1978, M.P.H. 1982.

## 1978

In February, the Dean's Office at Yale College forms an advisory committee on sexual-harassment grievance procedures to consider ways in which to deal with student complaints.

In December, the *Yale Daily News* editorial board rejects a *Playboy* ad soliciting women to appear in the September 1979 magazine's "Girls of the Ivy League" issue. Two days later, the business board decides to run the ad when the publisher of the *Yale Daily News* says the paper cannot deny *Playboy* the freedom they allow other advertisers. The editorial board discourages female students from modeling for the magazine and encourages Yale students to boycott the Ivy League issue. Later, the Women's Caucus holds a demonstration to protest the *Playboy* solicitation of campus models. Ultimately, nine Yale women are chosen to pose from over one hundred applicants nationwide, resulting in national news coverage—including the appearance of four of the women on the cover of *Time* magazine.

Ellen Ash Peters, LL.B. 1954, becomes the first woman appointed to the Connecticut Supreme Court; she is appointed Chief Justice in 1984.

## 1979

Natalie Charkow begins as Visiting Professor in Painting and Printmaking; she continues in the role until 1989, then serves as Senior Critic from 1990 to 1995.

In January, the *Yale Daily News* runs an article on new abortion services at University Health Services, citing a positive, supportive atmosphere.

Also in January, Pamela Price is the only plaintiff to proceed to trial in the Yale sexual-harassment case in the U.S. District Court in New Haven. In June, the court renders a verdict in favor of Yale University. In September, the Second Circuit affirms the District Court's decision in favor of Yale. Nonetheless, *Alexander v. Yale* establishes the use of Title IX in sexual-harassment cases. Price goes on to become a prominent Bay Area civil rights litigator.

In April, the Yale faculty unanimously approves Associate Dean of Yale College Judith Brandenburg's grievance-procedure committee proposal to establish a formal procedure to handle sexual-harassment complaints. A Sexual Harassment Grievance Board is established on campus the following year.

Rhetaugh Dumas, PH.D., R.N., M.S.N. 1961, becomes the first woman, first Black person, and first nurse to serve as the Deputy Director of the National Institute of Mental Health, a position she holds until 1981.

## 1980

Helen A. Cooper, M.A. 1975, PH.D. 1986, becomes the first woman to be appointed Curator of American Paintings and Sculpture at the Yale University Art Gallery, a position she holds until 2014; she then becomes Curator Emeritus of American Paintings and Sculpture.

Katharine Ordway bequeaths her collection of 150 twentieth-century paintings, sculptures, prints, and drawings to the Yale University Art Gallery, along with an endowment for the publication and conservation of the collection and generous purchase funds for the acquisition of twentieth-century art.

## 1981

From January 29 to March 29, the exhibition *20 Artists: Yale School of Art, 1950–1970*, curated by the art critic and historian Irving Sandler, is on view at the Yale University Art Gallery. Of the twenty Yale artist-graduates included, seven are women: Jennifer Bartlett (cat. 18), Janet Fish (cat. 16), Audrey Flack (cat. 9), Nancy Graves (cat. 17), Eva Hesse (cat. 12), Howardena Pindell (cat. 20), and Sylvia Plimack Mangold (cat. 14).

In May, after competing in a national contest entered by hundreds of artists, including several of her professors from the School of Architecture, Yale College senior Maya Lin (cat. 31) is chosen as the designer of the Vietnam Veterans Memorial in Washington, D.C.

Michaela A. Murphy joins the faculty of the School of Art as Assistant Professor of Photography.

Mary Miller, M.A. 1978, PH.D. 1981, joins the Yale faculty as Professor of the History of Art.

Duncan Robinson begins as director of the Yale Center for British Art; he serves until 1995.

On September 25, Sandra Day O'Connor becomes the first woman appointed to the U.S. Supreme Court.

## 1982

In response to her contract with the School of Art having not been renewed in May 1981, Samia Halaby along with many School of Art graduates, former faculty, and students, as well as Yale College students, alumni, and others organize an exhibition, *On Trial: Yale School of Art*, at 22 Wooster Gallery, in New York. On view from December 29, 1982, to January 8, 1983, the exhibition features work by students, staff, and alumni of the School of Art who are critical of the faculty and administration of the School.

In April, the Gay and Lesbian Cooperative, a political action group on campus, launches GLAD (Gay and Lesbian Awareness Days), a week of lectures, films, discussions, and more.

In May, poet and cultural advocate Elizabeth Alexander, B.A. 1984, chastises the *Yale Daily News* for neglecting to cover the Black Women Writer's Conference, whose panelists included Alice Walker. Alexander goes on to become a professor at Yale for more than fifteen years.

## 1983

David Pease is appointed dean of the School of Art; he serves until 1996.

Ursula von Rydingsvard joins the faculty of the School of Art as Assistant Professor of Sculpture, a position she holds until 1987.

In April, Yale hosts Women's Week—a program designed to explore the role of women in labor, academia, athletics, and law. Panelists include Congresswoman Bella Abzug, chemist Maxine Singer, and the *Ms.* magazine editorial board.

Betty Friedan, the feminist activist and author of *The Feminine Mystique* (1963), is chosen as Yale College's Senior Class Day Speaker.

On June 18, the astronaut Sally Ride becomes the first woman in space.

## 1984

Frances Barth joins the faculty of the School of Art as Professor of Painting, Drawing, and Critical Issues, a position she holds until 2004.

In April, Yale's Faculty of Arts and Sciences Advisory Committee on the Education of Women (Donald Crothers, Chairman) releases an eighty-six-page report on the status of women faculty on campus, including the number of tenured versus nontenured women faculty, salary issues, maternity and parenting leave, and recommendations for moving forward.

## 1985

Thomas Beeby is appointed dean of the School of Architecture; he serves until 1992.

In April, Provost William Brainard announces that Yale hopes to have thirty tenured women on the faculty by 1990, as recommended by the 1984 Crothers Report.

The Guerrilla Girls, a group of feminist activist artists, forms in New York.

## 1986

Following the departure in 1985 of Alan Shestack as director of the Yale University Art Gallery, Anne Coffin Hanson serves as acting director, a position she holds until 1987.

In January, the first Rape Awareness Week at Yale offers information, holds a vigil, and places a large "X" on campus in locations where women are known to have been sexually assaulted.

In April, the Yale Corporation votes to include "sexual orientation" in Yale's equal-opportunity clause.

In September, *Playboy* again comes to Yale's campus to recruit models, and several undergraduate women are selected to pose for the October 1986 issue. Unlike in 1978, there is minimal controversy.

## 1987

Mary "Mimi" Gardner Neill (Gates), PH.D. 1981, Curator of Asian Art at the Gallery, becomes the first woman to be appointed director of the Yale University Art Gallery.

Deborah Berke begins as Professor Adjunct at the Yale School of Architecture. Although women had served as visiting critics at the School, Berke is one of the first women to become an adjunct faculty member, preceded by Diana Agrest (fall 1983), Ada Karmi-Melamede (fall 1985), and Elizabeth Plater-Zyberk (spring 1987).

Artspace, a contemporary art gallery and nonprofit arts organization, opens at 70 Audubon Street, in New Haven, with a mission to catalyze artistic activities in the Greater New Haven area, support emerging artists, and foster appreciation for the visual arts. Artspace will move to 50 Orange Street in 2002.

In the spring, the National Museum of Women in the Arts opens in Washington, D.C.

## 1988

Sylvia Ardyn Boone, M.A. 1974, M.PHIL. 1975, PH.D. 1979, Associate Professor of the History of Art and Afro-American Studies, becomes the first Black woman to receive tenure at Yale; she had joined the faculty in 1979, after having been a visiting lecturer since 1970.

From November 28 to December 16, *Gretna Campbell: A Memorial Retrospective Exhibition* is on view at the Art and Architecture Gallery in Yale's Art and Architecture Building.

Maria Colón Sánchez, an advocate for Connecticut's Puerto Rican community who is known affectionately as "La Madrina" (The Godmother), becomes the first Latina elected to the Connecticut General Assembly.

## 1989

In April, approximately four hundred Yale students join over three hundred thousand demonstrators in Washington, D.C., to "Mobilize for Women's Lives." Yale marchers carry signs reading "Skull and Bones for Choice" and "For God, for Country, for Yale, and for Choice," referencing, respectively, one of the most famous secret societies on campus (which at the time was still all male) and Yale's motto. Seven hundred women and one hundred men also march to "Take Back the Night" after a seven-hour speak-out on Old Campus against sexual assault and harassment.

Also in April, Nancy Cott and Margaret Homans, B.A. 1974, PH.D. 1978, Professors of American Studies and English, respectively, collect forty faculty signatures and send a letter to Yale president Benno C. Schmidt, Jr., urging a goal of parity between men and women on the faculty.

## 1990

Sheila Levrant de Bretteville joins the School of Art faculty as the first woman to be appointed tenured Professor and Director of Graduate Studies in Graphic Design; in 2010 she will become the Caroline M. Street Professor of Graphic Design, a position she continues to hold.

## 1991

In April, Judith Rodin becomes the first woman to be appointed dean of Yale's Graduate School of Arts and Sciences, a position she holds until 1992. From 1992 to 1994, she serves as provost.

On October 11, Anita Hill, J.D. 1980, testifies before the all-white, all-male Senate Judiciary Committee of the U.S. Congress at the nomination hearing of Supreme Court nominee Clarence Thomas. Her testimony claims that Thomas, her former supervisor at the Department of Education, sexually harassed her multiple times in the workplace—a testimony that catalyzes the third-wave feminist movement.

Alice Aycock is appointed tenured Professor and Director of Graduate Studies in Sculpture; she is the second woman and the first sculptor to obtain tenure in the School's history. She leaves the following year.

The Riot Grrrl movement, a feminist and punk political subculture, forms in both Washington State and Washington, D.C., and subsequently spreads across the country.

## 1992

Yale School of Architecture dean Thomas Beeby is keen to increase the visibility of women architecture students and encourages Debra Coleman, M.E.D. 1990, Elizabeth Danze, M.ARCH. 1990, and Carol Henderson, M.ARCH. 1989, to found the *Yale Journal of Architecture and Feminism* "to advance a feminist perspective in architectural scholarship, criticism, and practice." Deborah Berke serves as faculty advisor. The first issue is published this year; the journal eventually leads to a book, *Architecture and Feminism*, published in 1996.

## 1993

From April 30 through July 31, the exhibition *Yale Collects Yale* is on view at the Yale University Art Gallery. Of the seventy-six Yale artist-graduates included, eighteen are women: Jennifer Bartlett (cat. 18), Louisa Chase (cat. 22), Janet Fish (cat. 16), Audrey Flack (cat. 9), Barbara Gallucci (M.F.A. 1987), Nancy Graves (cat. 17), Nancy Hagin (M.F.A. 1964), Eva Hesse (cat. 12), Roni Horn (cat. 28), Lois Lane (M.F.A. 1971), Patty Martori (M.F.A. 1983), Judy Pfaff (cat. 21), Howardena Pindell (cat. 20), Sylvia Plimack Mangold (cat. 14), Rona Pondick (cat. 26), Beverly Semmes (cat. 39), Jessica Stockholder (cat. 36), and Lisa Yuskavage (cat. 38).

*The Women's Table* is installed in front of Yale's Sterling Memorial Library. Designed by Maya Lin (cat. 31), the granite slab is engraved with the number of women in each Yale class from the founding of Yale College in 1701 until the time of its installation in 1993.

Fred Koetter is appointed dean of the School of Architecture; he serves until 1998.

## 1994

Rochelle Feinstein becomes the first woman to be appointed tenured Associate Professor of Painting and Printmaking. In 1998 she will be promoted to Professor of Painting and Printmaking, a position she holds until 2017.

The U.S. Congress passes the Violence against Women Act.

## 1995

On January 1, Susan Mullin Vogel becomes the second woman to be appointed director of the Yale University Art Gallery; she serves until November 1997. She had previously served as founder and director of the Museum for African Art, in New York.

Women outnumber men for the first time in the freshman class of Yale College: 694 to 675.

## 1996

Richard Benson is appointed dean of the School of Art; he serves until 2006.

Patrick McCaughey becomes director of the Yale Center for British Art; he serves until 2001.

Anne Calabresi, Jean Handley, and Roslyn Meyer found the International Festival of Arts and Ideas in New Haven, with the goal of bringing world-class artists and thinkers from around the globe to the city and showcasing both the city and the state as a major arts destination.

## 1998

Jock Reynolds becomes director of the Yale University Art Gallery; he serves until 2018.

Robert A. M. Stern is appointed dean of the School of Architecture; he serves until 2016.

Three New Haven–based women—Marianne Bernstein, Helen Kauder, and Linn Meyers—cofound New Haven's City-Wide Open Studios festival, an annual celebration of contemporary art that remains Connecticut's leading visual-arts festival.

## 1999

Jessica Stockholder (cat. 36) is appointed Director of Graduate Studies in Sculpture and tenured Associate Professor; she is later appointed Professor and serves until 2011. She is just the fourth woman in the School's 130-year history to receive tenure, and the second woman sculptor to do so.

## 2000

On October 27, Yale president Richard C. Levin and the deans of the Schools of Art and Drama dedicate Holcombe T. Green, Jr., Hall (on Chapel and Crown Streets), renovated by Deborah Berke, Professor Adjunct at the School of Architecture, to house almost all School of Art programs, which had been spread among the Art and Architecture Building, Hammond Hall, several facilities on Park Street, and one on Wall Street.

## 2001

In September, the Women Faculty Forum is established; members are women faculty across the University who seek to advocate for gender equality at Yale. It is inaugurated with a two-day conference titled "Gender Matters," featuring the artist Maya Lin (cat. 31) and the novelist Gloria Naylor, M.A. 1983, as keynote speakers.

Following the September 11 terrorist attacks on the United States, for which Osama bin Laden, the leader of Al-Qaeda, claimed responsibility, the War in Afghanistan begins with an invasion of Afghanistan by American and allied troops on October 7. The war continues to be fought this day, with over one hundred thousand documented Afghan casualties and over two thousand U.S. casualties to date.

## 2002

Amy Meyers, M.A. 1979, PH.D. 1985, becomes the first woman to be appointed director of the Yale Center for British Art; she serves until 2019.

In January, a group of women architects convene a panel at Yale, "Women, Family, and the Practice of Architecture," with speakers Peggy Deamer, Deborah Berke, Lise Anne Couture, M.ARCH. 1986, Audrey Matlock, Susan Rodriguez, and Alan Plattus, to discuss issues of gender equity in the field of architecture.

In May, Maya Lin (cat. 31) is elected as both the first artist and first Asian American woman to serve on the Yale Corporation.

## 2004

The Yale University Art Gallery begins renovations of its three historic buildings: Street Hall, the Old Yale Art Gallery, and the Louis Kahn building.

In September, the U.S. Department of Education investigates claims that Yale has been underreporting crimes on campus, particularly incidents of sexual harassment and rape.

## 2005

Yale Women in Architecture (YWA)—a student support network and forum for the examination of gender in architecture education and practice—is founded. At one of the opening events, Carol Burns, B.A. 1980, M.ARCH. 1983, states, "You have to be smarter to be considered as smart. You have to work harder to be considered as hardworking."

## 2006

Robert Storr is appointed dean of the School of Art; he serves until 2016.

In September, women make up 31 percent of the Yale faculty and just 20 percent of tenured faculty. News outlets report that women are paid less than their male counterparts at every professional rank.

Also in September, Yale announces its intention to open an on-campus center for sexual assault. This announcement eventually gives rise to the Sexual Harassment and Assault Response and Education (SHARE) Center, which opens in the academic year of 2007–8.

In October, the Yale Corporation expands its official equal opportunity and employment policy—which protects against discrimination based on "race, color, religion, age, sex, sexual orientation, disability, national or ethnic origin, veteran status"—to include "gender identity or expression."

In December, the Yale University Art Gallery's Louis Kahn building reopens following a complete renovation.

## 2007

Nancy Pelosi becomes the first woman to be appointed Speaker of the U.S. House of Representatives.

## 2008

In January, a photograph is circulated that depicts members of the Yale chapter of the Zeta Psi fraternity in front of the Yale Women's Center, holding a sexist and derogatory sign. In response, the Women's Center produces a report encouraging the improvement of Yale's sexual-harassment and education policies. Dean of Yale College Peter Salovey creates two committees to address the center's requests.

In April, the *Yale Daily News* covers the senior thesis of Aliza Shvarts, B.A. 2008, whose *Untitled (Senior Thesis)* performance work engages the subject of abortion and incites critical attention from mass media. The work provokes national debate, which becomes known as the "Yale student abortion art controversy."

In October, Mary Miller, Professor of the History of Art and Master of Yale's Saybrook College, becomes the first woman to be appointed dean of Yale College; she serves until 2014.

In November, following an extensive restoration by Charles Gwathmey, the School of Architecture moves back into Paul Rudolph's Art and Architecture Building, which is renamed and dedicated Rudolph Hall on November 8.

Also in November, Yale College receives 2,281 more applications from women than men, but 68 more men than women are offered a place in the class of 2012—representing an admission rate of 9.8 percent for men and 7.5 percent for women. When released, these statistics raise doubts about Yale's "gender-blind" admissions policy.

## 2009

The Department of Sculpture moves from Hammond Hall, which it had fully occupied since 1973, to the new Sculpture Building at 36 Edgewood Avenue, designed by Kieran Timberlake.

In November, the Yale policies on Sexual Harassment and Teacher-Student Consensual Relations are amended to expressly forbid amorous or sexual relations between teachers and undergraduate students.

## 2012

In December, the School of Architecture holds a "Yale Women in Architecture" symposium to discuss issues of gender equity in the field.

On December 12, the Yale University Art Gallery reopens Street Hall and the Old Yale Art Gallery building, following complete renovations.

## 2013

Patrisse Cullors, Alicia Garza, and Opal Tometi create the #BlackLivesMatter movement to fight racism and anti-Black violence, especially police brutality.

## 2015

Anoka Faruqee, B.A. 1994, who had served as Associate Professor of Painting and Printmaking at the School of Art since 2011, receives tenure and is appointed Director of Graduate Studies in Painting and Printmaking.

## 2016

Marta Kuzma becomes the first woman to be appointed dean of the School of Art, a position she holds until June 2021.

Deborah Berke, who had served as Professor Adjunct of Architecture since 1987, becomes the first woman to be appointed dean of the School of Architecture, a position she continues to hold.

On April 5, a portrait of the first seven women awarded PH.D.s at Yale is unveiled at Sterling Memorial Library. The portrait project had been initiated in 2009 by the Women Faculty Forum. Following a national competition, New Haven–raised, Brooklyn-based artist Brenda Zlamany was chosen for the project.

## 2017

On January 21, various campus organizations provide bus transportation and carpools for hundreds of Yale students to attend the Women's March in Washington, D.C. The march draws over five hundred thousand protesters, with millions more marching in other cities.

Yale names one of its new residential colleges after Pauli Murray, J.S.D. 1965, HON. 1979. Calhoun College, originally named for John C. Calhoun, the seventh vice president of the United States and a vocal supporter of slavery, is renamed after computer scientist Grace Murray Hopper, M.A. 1930, PH.D. 1934.

In March, Nasty Women Connecticut, a platform of inclusion and community-building through the arts, holds its first art exhibition at the Institute Library on Chapel Street, in New Haven. The show features over three hundred feminist artworks from throughout the state.

In October, the #MeToo hashtag—inspired by the activist Tarana Burke's coining of the phrase in 2006—goes viral. The movement inspires a public discourse around gender and power, especially sexism, sexual harassment, and sexual violence.

## 2018

Stephanie Wiles is appointed director of the Yale University Art Gallery; she is the third woman to serve in this position, which she continues to hold.

On September 27, Christine Blasey Ford publicly testifies before U.S. Congress that, while in high school, she was sexually assaulted by U.S. Supreme Court nominee Brett Kavanaugh. A few days earlier, another woman had accused Kavanaugh of sexual assault while they were both freshmen at Yale. Kavanaugh denies both women's allegations and, after testifying before the Senate, is confirmed as Supreme Court Justice.

## 2019

Courtney J. Martin, PH.D. 2009, is appointed director of the Yale Center for British Art; she is the second woman to serve in this position, which she continues to hold.

In the fall, Dr. Nancy J. Brown, a dedicated teacher and internationally renowned investigator and clinician, becomes the first woman to be appointed dean of the Yale School of Medicine.

Jahana Hayes becomes the first Black woman to represent Connecticut in the U.S. Congress.

## 2020

In the spring, NXTHVN begins a phased opening. The brainchild of Titus Kaphar, Jason Price, and Jonathan Brand, NXTHVN is an intergenerational mentorship and professional development community space located in the Dixwell neighborhood of New Haven that fosters collaboration among artists, art professionals, and local entrepreneurs within New Haven's creative community. The organization hosts a robust roster of artist residencies and paid high-school apprenticeships.

In June, a landmark decision by the U.S. Supreme Court rules that Title VII of the Civil Rights Act of 1964, which makes it illegal for employers to discriminate on the basis of a person's sex, also covers sexual orientation and transgender status—upholding lower court rulings that sexual orientation discrimination is a form of sex discrimination.

On November 7—after a protracted vote count—Kamala Harris, running on the Biden-Harris ticket, becomes the first woman, first Indian American, and first Black American to attain the vice presidency of the United States, making her the highest-ranking woman in U.S. history.

## 2021

In July, Kymberly Pinder succeeds Marta Kuzma as dean of the School of Art. She is the second woman to hold the position and the first person of color.

JUDY PFAFF IS KNOWN FOR HER LARGE-SCALE installations constructed with a variety of materials, from the everyday to the industrial. Pfaff was born in London in 1946, and as a child she moved to New York with her family. As an undergraduate, she attended Wayne State University, in Detroit, and Southern Illinois University, in Edwardsville, before graduating from Washington University, in Saint Louis, in 1971.[1] Later that year, Pfaff began graduate school at Yale, and in 1972 she served as an assistant printmaker at the Yale Summer School of Music and Art, which she had attended as an undergraduate student in 1970.[2] In 1973 she worked as a teaching assistant with Al Held, and his mentorship encouraged her to see how seemingly simple questions about material decisions could become larger questions about meaning and content.[3] She received her Master of Fine Arts that year and later became a resident faculty member in both the Painting and Sculpture departments at the School of Art.

In 1985 Pfaff went to the Aoyama district of Toyko. She noticed that the youth would hang out at Yoyogi Park, playing music and dancing in 1950s American attire, which she saw as a moment of freedom for them. She made the print *Yoyogi II* (fig. 1) while in Japan.[4]

Pfaff made *Straw into Gold* (fig. 2) in 1990 while living in Brooklyn. Near her studio, she discovered a lot full of the burnt remains of furniture, beds, and cars. Struck by what had been discarded, she began to pull pieces out of the rubbish.[5] Spiral shapes are a recurring motif in her work, so she was particularly attracted to some bedsprings. Back in her studio, she aimed to give these materials new life, removing soot from the springs, for instance, as an act of cleansing before painting them in silver and gold.[6] She suspended the bedsprings on the wall and intertwined them with wire, tin cans, and blown glass. Near the bottom, three metal elements in the shape of wheels hang from the springs, drawing attention to the floor. Although it can be easy to overlook the discarded and devalued, Pfaff sees the beauty in them and allows them to shine.    ED

1. Judy Pfaff, oral history interview by Judith Olch Richards, January 27–February 4, 2010, transcript, Archives of American Art, Smithsonian Institution, Washington, D.C.
2. Judy Pfaff, oral history interview by author, April 19, 2019, transcript, Yale University Art Gallery Archives, New Haven.
3. Ibid.
4. Ibid.
5. Ibid.
6. Ibid.

Judy Pfaff  CAT. 21

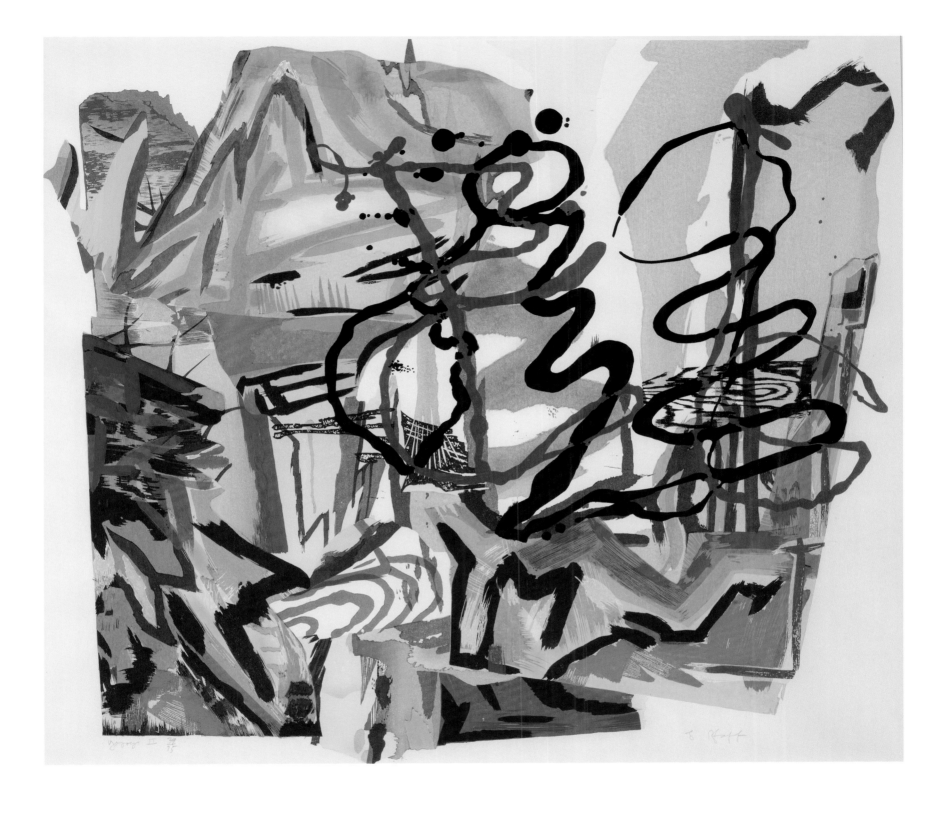

FIG. 1. Judy Pfaff, *Yoyogi II*, 1985. Color woodblock print, 31⅞ × 36 in.
(81 × 91.5 cm). Katharine Ordway Fund, 1986.7.1

FIG. 2.  Judy Pfaff, *Straw into Gold*, 1990. Steel wire with paint, tin cans, bed-springs, and blown glass, 9 ft. 6 in. × 9 ft. 10 in. × 8 ft. 4 in. (289.6 × 299.7 × 254 cm). Janet and Simeon Braguin Fund and Charles B. Benenson, B.A. 1933, Fund, 2011.204.1

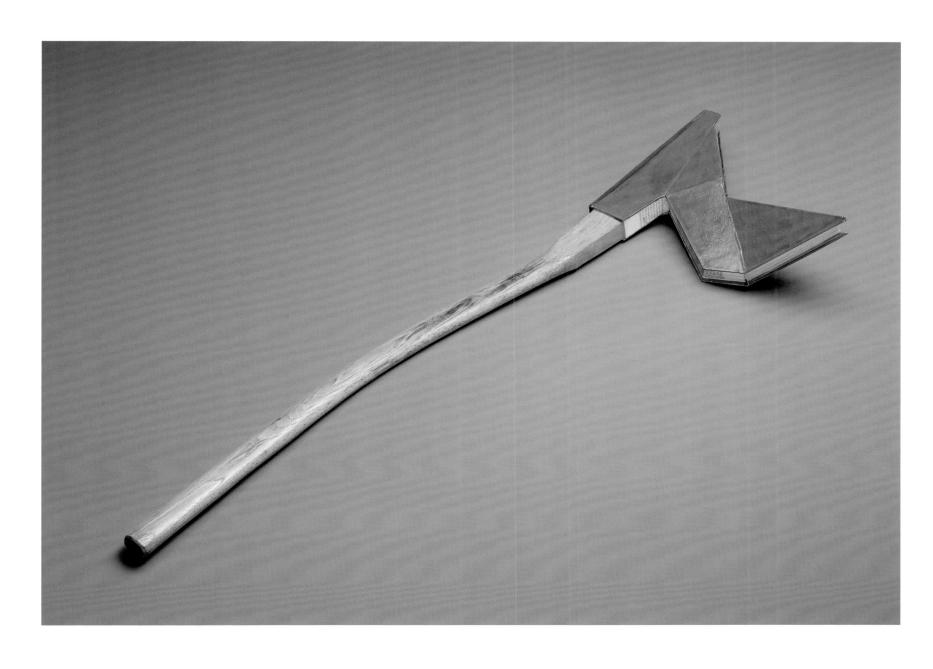

FIG. I. Maria Porges, *Implement of Knowledge*, 1992. Found and altered book with
oil paint and a wooden handle, 13¹³⁄₁₆ × 41⁹⁄₁₆ × 5⅛ in. (35 × 105.5 × 13 cm). The
Allan Chasanoff, B.A. 1961, Book Art Collection, curated with Doug Beube,
2014.58.222

AFTER HER UNDERGRADUATE STUDIES IN PAINTING at the Rhode Island School of Design, in Providence (which did not offer a Printmaking major at the time), Rosalyn Richards worked in independent print workshops, including the Experimental Etching Studio (now the Full Tilt Print Studio), in Boston, to gain experience with the medium.[1] When she arrived at the Yale School of Art in 1973 to pursue an M.F.A., Richards was urged to reconsider her artistic process, in which she was using many different techniques and colors. She says, "Distilling my work down to some of the simplest means of image making . . . was a pivotal turning point for me." Her newfound style, which included the elimination of color, is apparent in her woodcut *Excavation*, from *The Peterdi Years: Alumni Portfolio* (fig. 1). This portfolio celebrated Richards's mentor Gabor Peterdi and his influence on an entire generation of artists who studied printmaking with him at Yale from 1960 to 1987.[2] Richards recalls that Peterdi was supportive and encouraging but also challenged his students. The Painting faculty often joined the Printmaking students' critiques and were tough on them, in part, Richards thinks, because there was still a perception that printmakers were technicians, not fine artists.

To supplement Peterdi's focus on intaglio techniques, visiting critics offered coursework in silkscreen, lithography, and new photo-based processes. Andrew Stasik, then Director of Exhibitions at the Pratt Institute, in Brooklyn, had a particularly strong influence on Richards. One of her favorite courses was a seminar on the history of prints taught in the Yale University Art Gallery study room by James Burke, then Curator of Prints, Drawings, and Photographs. A drawing course with Gretna Campbell also strongly influenced her, as did several courses outside the Art program, including ones on contemporary film and writing poetry.

The broad range of courses that Richards took at Yale played a role in shaping the breadth of her artistic practice. To this day, she works in various media, and her work frequently incorporates lines and patterns that bridge the diagrammatic and the calligraphic. Color has reentered Richards's visual vocabulary as an essential way to differentiate forms and elucidate their relationships with one another and to the background. In her drawing *Borderlands* (fig. 2), the artist conceptualized space as a network of geometric forms. Working in water-soluble gouache on top of gesso and acrylic grounds, Richards was able to wipe away the gouache in some places and then go over the resulting semi-erased brushwork with more gouache and graphite. The layering of materials creates a texture and physicality that animate the surface and symbolically evoke the role of memory and the imagination in reconstructing that which is, in the artist's words, "covered, faded away, or scraped out." The dynamism of *Borderlands*—its tension and cohesion—speaks to the way in which political, geographical, ideological, and other borders can act as sites of both division and reunion.    EW

1. All biographical information and quotations by the artist are from Rosalyn Richards, oral history interview by author, April 22, 2019, transcript, Yale University Art Gallery Archives, New Haven.

2. The current printmaking studio at the Yale School of Art is named after Peterdi, in honor of his long tenure and passion for the medium: the Gabor Peterdi Print Studio. For other works from *The Peterdi Years: Alumni Portfolio*, see cat. 19, fig. 1; cat. 20, fig. 3; cat. 29, fig. 1; and cat. 38, fig. 2.

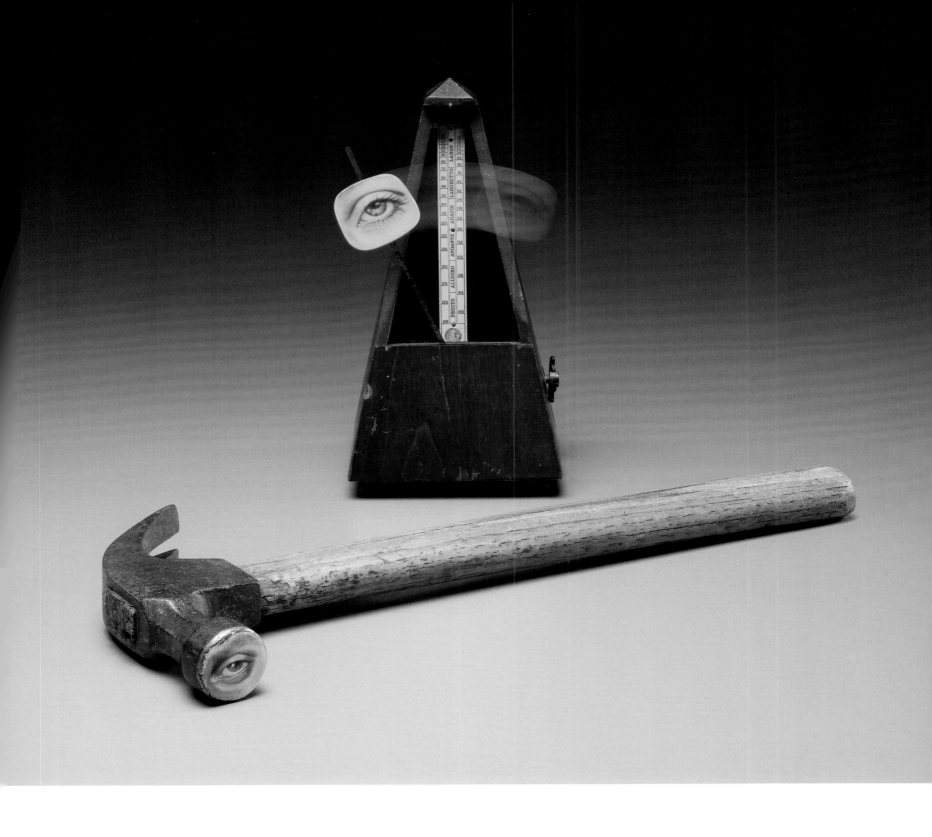

FIG. 1. Tabitha Vevers, *CHECKMATE (Lee + Man)*, 2008. Oil on ivorine with a
metronome and a hammer, 9¼ × 4½ × 4½ in. (23.5 × 11.4 × 11.4 cm). Gift of Peggy
and Richard M. Danziger, LL.B. 1963, 2008.162.1

BORN IN NEW YORK IN 1955, RONI HORN GREW UP androgynous. She has said, "It started with my name which is not male or female. It seems to me, retrospectively, that my entire identity formed around this, around not being this or that: a man or a woman. I don't fit in with these kinds of singular identities."[1] Horn bristles at being named a woman or being categorized as a woman artist because, in her view, identifying the gender of an artist dilutes their identity.[2] Likewise, her work evades clear categorization, moving between the observable qualities of form, material, and space, and the metaphoric realm of literature and poetry. Horn received her B.F.A. from the Rhode Island School of Design, in Providence, in 1975 and her M.F.A. from the Yale School of Art in 1978, and she has worked in a diverse range of media. She splits her time between New York and Iceland, which she began visiting in 1975.

Horn became well known for work that deployed the material strategies of Minimalism—especially the use of precisely machined and standardized objects—to investigate complex issues of identity, memory, and history. The poet Emily Dickinson is one of the literary figures with whom Horn has engaged deeply. In the 1990s, she created several sculpture groups that draw from the *Index of First Lines* (1924), a catalogue of the opening lines of Dickinson's 1,775 untitled poems. Horn's *Untitled (Gun)* (fig. 1) spells out the opening salvo of Dickinson's poem 754, "My Life had stood—a Loaded Gun—," in plastic, sans-serif letters embedded in aluminum blocks that are stacked precariously in a corner. The narrator of the poem likens herself to a rifle leaning in a corner, ready to fire when needed—a potent metaphor for the power of art.

Horn's work often engages with doubling, as in the twinned figures in her pigment drawing *The XIII* (fig. 2). To make pigment drawings like this, she applies powdered color to a sheet of paper, using as little binder as possible, and fixes the drawings with small amounts of varnish. She then cuts out shapes from the colored sheet and collages them on a new sheet of paper, where they create a remarkable sense of dimensionality. Horn has explained, "I think of drawing as how one establishes a relationship between the view and the viewer. It's not just about the description of something. My drawings are really about composing relationships."[3] Relationships—whether among objects, concepts, or people—are central to Horn's work, which invites viewers to examine their own positions in space, time, and society.

Questions about identity have led Horn to engage with notions of amorphousness and ambiguity in much of her photographic work. An untitled work from 2003 (fig. 3)—one in a series of long-exposure portraits of a clown with a powdered-white head and blood-red nose and mouth—confronts the viewer with a blurred and contorted image of a familiar symbol. This work upends expectations about the genre of portrait photography by reveling in the viewer's discomfort in struggling to see and identify its subject.   SSS

1. Roni Horn, quoted in Claudia Spinelli, "Interview with Roni Horn," *Journal of Contemporary Art* (1995), http://www.jca-online.com /horn.html.
2. Ibid. See also Barbara Garrie, "Roni Horn's Watery Surfaces: Identity, Excess and the Sublime," *Australian and New Zealand Journal of Art* 18, no. 2 (2018): 195–97.
3. Roni Horn, quoted in James Lingwood, "From the South of England to the North of Iceland: Interview with Roni Horn," in *Roni Horn*, ed. Ingvild Goetz, Larissa Michelberger, and Rainald Schumacher (Munich: Sammlung Goetz, 2012), 161.

Roni Horn CAT. 28

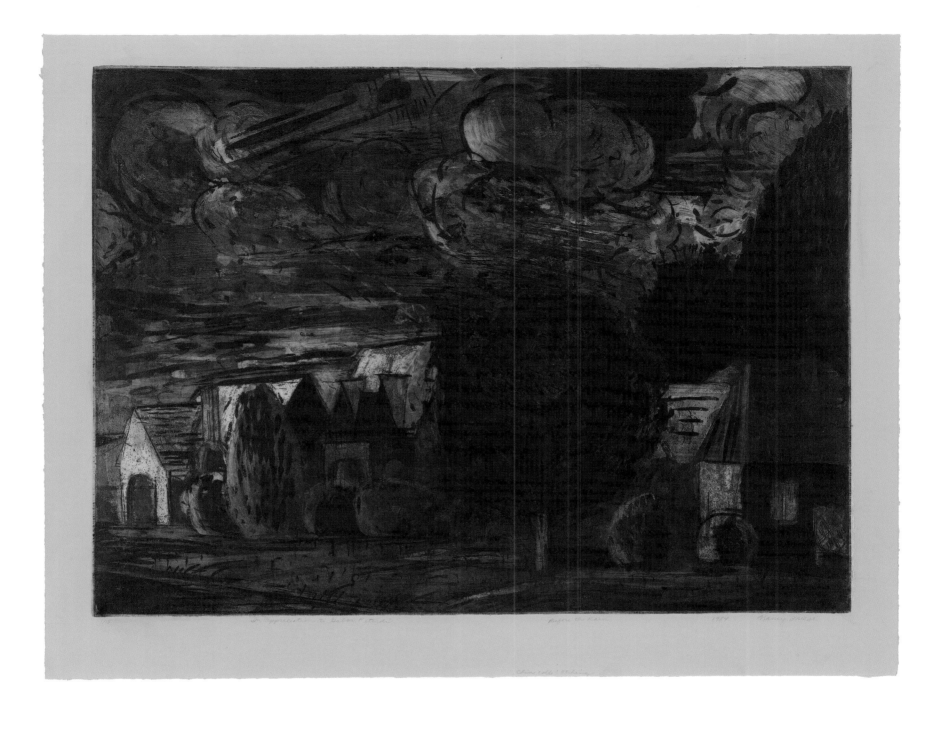

FIG. 1. Nancy Friese, *Before the Rain*, from *The Peterdi Years: Alumni Portfolio*, 1984.
Color etching, sugar-lift, and aquatint with chine-collé, 17¹¹⁄₁₆ × 23¹¹⁄₁₆ in. (45 ×
60.2 cm). Art School Transfer, 1987.12.37

LOIS CONNER ENTERED THE YALE SCHOOL OF
Art in 1979 as one of the first women to join the program in
Photography, which had only begun regularly admitting
students three years earlier. Since earning her M.F.A. in 1981,
Conner has been a pioneering figure at Yale and beyond. In
1991 she became the first female Director of Undergraduate
Studies in Photography, a position she held until 2000. It is
her unique approach to photography, however, that truly sets
her apart as a trailblazer. Conner is known for making platinum
prints using a large-format banquet camera that produces
oblong, 7-by-17-inch negatives. Platinum printing, which
requires coating individual sheets of paper with photographic
chemicals by hand, yields a richer tonal range than conven-
tional silver printing. Conner's labor-intensive process imbues
her prints with a refined aesthetic that captures a sense of
history emanating from the landscape.

Conner has photographed throughout the world, but the
landscapes of China and the American West have figured most
prominently in her work. She first visited China in 1984 with
the support of a Guggenheim Foundation grant. A class on
Ming-dynasty landscape painting that she took at Yale had
sparked her interest in the country's diverse topographies, from
the western Tibetan plateau to the scenic lakes and waterways
along the eastern coast (figs. 1–2).[1] The Huangshan mountain
range, with its distinctive granite spires and twisted pine trees,
has been a popular subject among Chinese landscape painters
for centuries. In Conner's *Huangshan, Anhui, China (CH85426)*
(fig. 3), the tall, narrow format of the print coupled with the
delicate platinum tones forms a strong formal affinity to
traditional Chinese ink-wash painting.

In a similar way, Conner's photographs of the American
West (figs. 4–5) conjure the monumental views of the American
frontier by nineteenth-century artists like Timothy O'Sullivan
and Carleton Watkins. Conner, whose maternal grandmother
was Cree, is steadfast in her attentiveness to the particular ways
in which culture and history lend special meaning to a place.
She has focused on landscapes with long human histories,
such as Bryce Canyon, in Utah, a region of dramatic, red-rock
formations that was first inhabited by Indigenous people over
ten thousand years ago. Taken together, Conner's works reveal
enduring traces of history and culture in the landscape.   CF

1.  Lois Conner, oral history interview
    by author, May 14, 2019, transcript,
    Yale University Art Gallery
    Archives, New Haven.

# Lois Conner   CAT. 30

FIG. 1. Lois Conner, *Da Fu, Le Shan, Szechuan, China*, from the series *Tibet*, 1986. Platinum print, 16¾ × 5¹⁵⁄₁₆ in. (42.6 × 15 cm). Janet and Simeon Braguin Fund, 1999.36.2

FIG. 2. Lois Conner, *Hangzhou, China*, 1984. Platinum print, 6⁵⁄₁₆ × 16⅞ in. (16 × 42.8 cm). Gift of Margaret and Neale M. Albert, J.D. 1961, 2012.150.8

FIG. 3. Lois Conner, *Huangshan, Anhui, China (CH85426)*, 1985, printed 1995. Platinum print, 18½ × 7¼ in. (47 × 18.4 cm). Gift from Robinson A. Grover, B.A. 1958, M.S.L. 1975, and Nancy D. Grover, 2016.26.31

FIG. 4. Lois Conner, *Bryce Canyon National Park, Utah*, 1989. Platinum print, 16½ × 7 in. (41.9 × 17.8 cm). Janet and Simeon Braguin Fund, 2013.50.1.1

FIG. 5. Lois Conner, *Mammoth Hot Springs, Yellowstone National Park, Wyoming*, 1990. Platinum print, 6½ × 16½ in. (16.5 × 41.9 cm). Janet and Simeon Braguin Fund, 2012.109.3

BORN IN ATHENS, OHIO, IN 1959, MAYA LIN GARNERED national recognition while she was an undergraduate at Yale College. She had come to New Haven intending to study science and become a zoologist; instead, she realized that a career in architecture could combine her interests in science, art, and mathematics. In her senior year, she proposed the winning design for a memorial dedicated to veterans of the Vietnam War for the National Mall, in Washington, D.C. (see Kuzma essay, fig. 13). Installed in 1982, the memorial—a black granite wall engraved with the names of over fifty-eight thousand individuals who lost their lives in service or remain missing—is a powerful, emotional site for honoring and mourning the dead. In a series of four collaged pastel studies for the memorial (fig. 1), Lin presented sculptural, architectural, and topographical perspectives of the V-shaped form that would be carved into the landscape.

Lin went to Harvard University, in Cambridge, Massachusetts, for a year of graduate school then returned to New Haven to finish her master's degree at the Yale School of Architecture in 1986. She divides her practice into three interrelated parts: art, architecture, and memorials, considering the latter a hybrid of the first two. Her lifelong commitment to the environment informs all aspects of her work.

In 1989 Lin was commissioned to design a memorial to honor the women who have studied at Yale, in celebration of the twentieth anniversary of coeducation at Yale College. *The Women's Table*, installed in front of Yale's Sterling Memorial Library, is inscribed with the number of female students registered at Yale each year, from its founding in 1701 to the completion of the work in 1993. These numbers spiral outward from the center of the elliptical granite tabletop—as seen in a collaged study for the memorial (fig. 2)—and a fountain pours water across the surface of the table and over its edges. Zeroes mark the first 172 years of Yale's history, until 1873—the first year, it was thought, that women registered at the Yale School of the

Fine Arts. (Subsequent research has shown that women were registered when the School first opened, in 1869.) Over the years, *The Women's Table* has become an important gathering place and site of protest; in 2018, for example, as the Yale Law School graduate Brett Kavanaugh—who had been accused of sexual assault—was being confirmed as a U.S. Supreme Court Justice, students adorned the table with flowers and messages of solidarity with sexual-assault survivors.

Lin has devoted much of her work to exploring the earth's geology, ecology, and topography, as well as the human means of measuring and mapping them. *Silver Housatonic (Benefit Edition)* (fig. 3) is in the shape of an aerial view of the Housatonic River, which runs from western Massachusetts through Connecticut into the Long Island Sound. Lin knew the river well from her time on the Yale women's crew team. The delicate, wall-mounted sculpture belongs to a larger project that seeks to give positive form to waterways, which often appear as negative spaces or absences on maps. Cast in recycled silver that appears to flow down the wall, the sculpture calls attention to the power and precariousness of water. Lin has explained,

In my work I am constantly focused on and inspired by the
    natural world—
revealing things that we may not be thinking about—
because they're hidden below the surface—
under the ocean—
under a lake—
the scale of rivers and seeing them in their entirety—
revealing things that we may not be thinking about.[1]

sss

1.   Maya Lin, "Here and There," in *Maya Lin: Here and There*, exh. cat. (New York: Pace, 2013), 12.

Maya Lin   CAT. 31        American, born 1959, B.A. 1981, M.ARCH. 1986     1980s

FIG. 1. Maya Lin, Four Studies for the *Vietnam Veterans Memorial*, 1980. Pastel on paper, each 23½ × 17¾ in. (59.7 × 45.1 cm). Promised gift of Maya Lin, B.A. 1981, M.ARCH. 1986, in honor of Jock Reynolds, the Henry J. Heinz II Director, 1988–2018, and Vincent J. Scully, Jr., B.A. 1940, M.A. 1947, PH.D. 1949

FIG. 2. Maya Lin, Study for *The Women's Table*, 1993. Collage, porous-point pen, and graphite on tracing paper, 18 × 27⁷⁄₁₆ in. (45.7 × 69.7 cm). Gift of Richard Levin, PH.D. 1974, and Jane Levin, M.PHIL. 1972, PH.D. 1975, 2016.50.1

FIG. 3. Maya Lin, *Silver Housatonic (Benefit Edition)*, 2011. Recycled silver, 1 × 28 × 8 in. (2.5 × 71.1 × 20.3 cm). Gift of Yale University President Richard C. Levin, PH.D. 1974, 2013.144.1

WHILE AN UNDERGRADUATE ART MAJOR AT YALE College, Amy Klein Reichert studied graphic design with the Swiss-trained professors Philip Burton, Inge Druckrey, and Armin Hofmann, who had all been hired by the influential Swiss-American photographer and designer Herbert Matter.[1] Following her graduation in 1981, Reichert practiced graphic design in Japan and became intrigued by how Japanese design and architecture often relied on flat planes to create volumes, thus uniting two- and three-dimensional space. She returned to the United States and worked in New York before enrolling at the Yale School of Architecture in 1984. Reichert appreciated the eclecticism of the curriculum at the School of Architecture and was drawn to established instructors like Alexander Purves and visiting professors like the Bay Area architect William Turnbull, Jr. Shortly after graduating in 1987, Reichert entered private practice as an architect in Williamstown, Massachusetts, where she also taught at Williams College. She then relocated to Chicago, where she taught for a time at the Illinois Institute of Technology and is now a lecturer at the School of the Art Institute of Chicago.

In 1996 Reichert expanded into exhibition design with *Drawn from the Source: The Travel Sketches of Louis I. Kahn* at the Williams College Museum of Art. Since then, she has created installations for the Jewish Museum, in New York; the Berkshire Museum, in Pittsfield, Massachusetts; the Jane Addams Hull-House Museum, in Chicago; and the Albany Institute of History and Art, among others. To Reichert, using color, text, and form to convey a narrative on an intimate scale without being hindered by the complexities of plumbing or electrical systems has proven a satisfying synthesis of her training in architecture and graphic design.

The desire to create narratives also informs Reichert's Judaica. She designed her first piece of Judaica, a Seder plate (fig. 1), for the 1996 Spertus Judaica Prize competition hosted by the Spertus Museum, in Chicago (now part of the Spertus Institute for Jewish Learning and Leadership). Wanting to create an object that stood apart on the dining table and that visually signaled its ceremonial function, Reichert designed a rectangular mahogany box outfitted with silver compartments, some of which are indented with the shape of the food they are intended to contain. As Reichert has explained: "The Seder plate is not supposed to be a plate at all, but a symbolic landscape. Ordinary plates, when wiped clean, leave no hint of their previous use. In contrast, the seder plate must bear a trace of what has been there, and point toward what will be there again."[2] Her design won second place and was fabricated in an edition of ten by the Massachusetts silversmith Steve Smithers. Reichert continues to produce intellectually rigorous and elegant Judaica, often engaging the same craftsmen she relies upon to manufacture elements of her architectural and exhibition designs, thus uniting the three aspects of her career. JSG

1. Unless otherwise noted, all biographical information is from Amy Klein Reichert, oral history interview by author, June 5, 2019, transcript, Yale University Art Gallery Archives, New Haven. Matter had retired by the time Reichert entered Yale, but he served on her final review panel.

2. Amy Klein Reichert, artist statement, February 16, 1995, curatorial files, Department of American Decorative Arts, Yale University Art Gallery, New Haven.

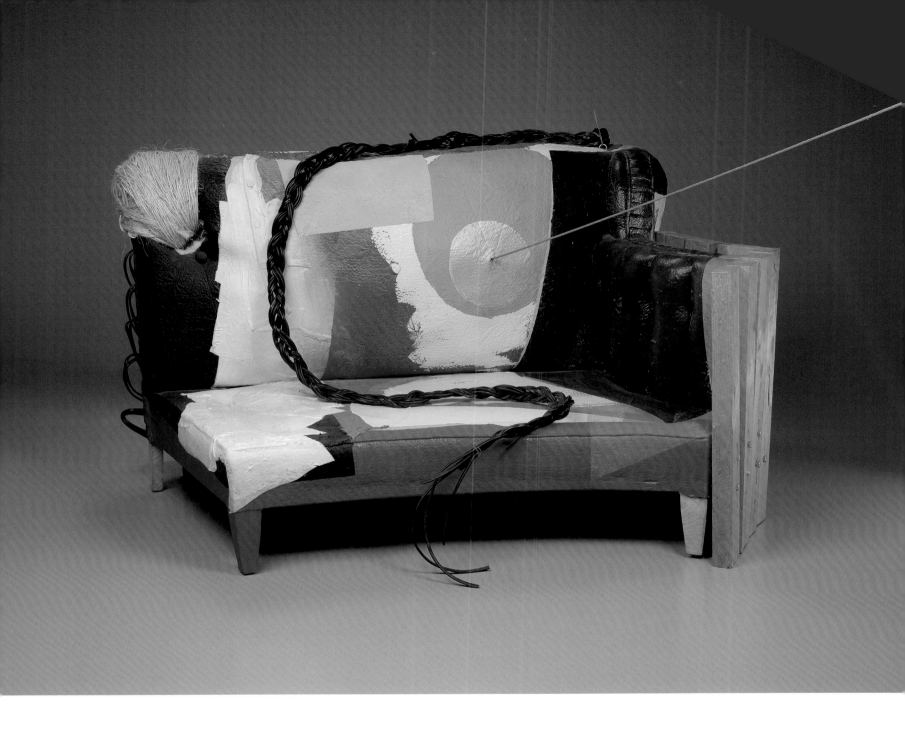

FIG. 1. Jessica Stockholder, *JS Inventory #241*, 1994. Pink couch, oil and acrylic paint, wood, hardware, electric wiring, newspaper maché, plastic, twine, clothing, string, and nail, 34 × 61 × 46 in. (86.4 × 154.9 × 116.8 cm). Gift of Eileen and Michael Cohen, 2007.85.1

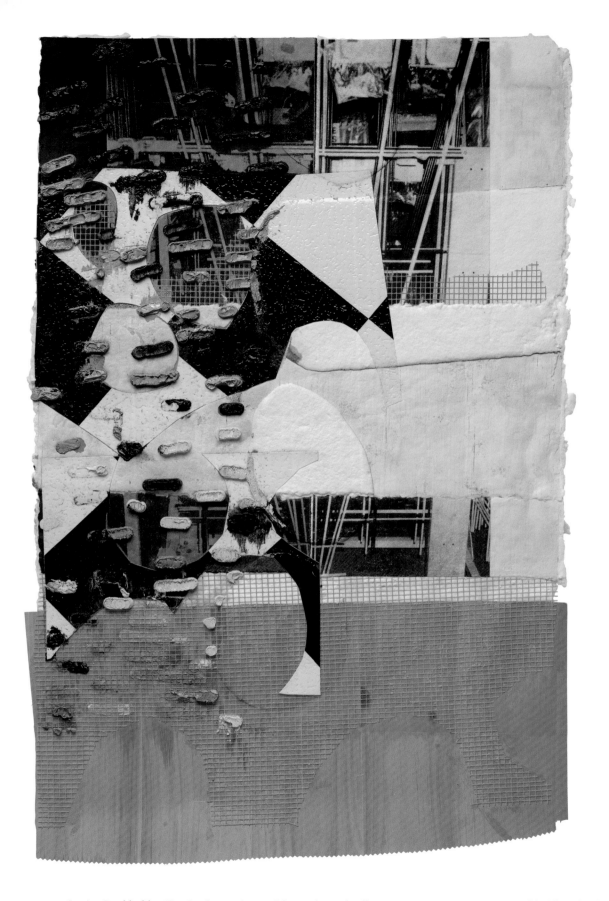

FIG. 2. Jessica Stockholder, *Turning Paper #61*, 1997. Monoprint and collage; linoleum, screenprint, wood veneer, plastic mesh, wood engraving, and embossing on handmade paper, 35¼ × 22¾ in. (89.5 × 57.8 cm). Janet and Simeon Braguin Fund, 1999.87.1

FIG. 3. Jessica Stockholder, *Thank You, Anthony Caro*, 1994. Basket, acrylic yarn, silicone caulking, plastic car part, cable, plastic orange, acrylic paint, and green plastic spot, 16 × 19 × 13 in. (40.6 × 48.3 × 33 cm). Janet and Simeon Braguin Fund, 2005.47.1

208

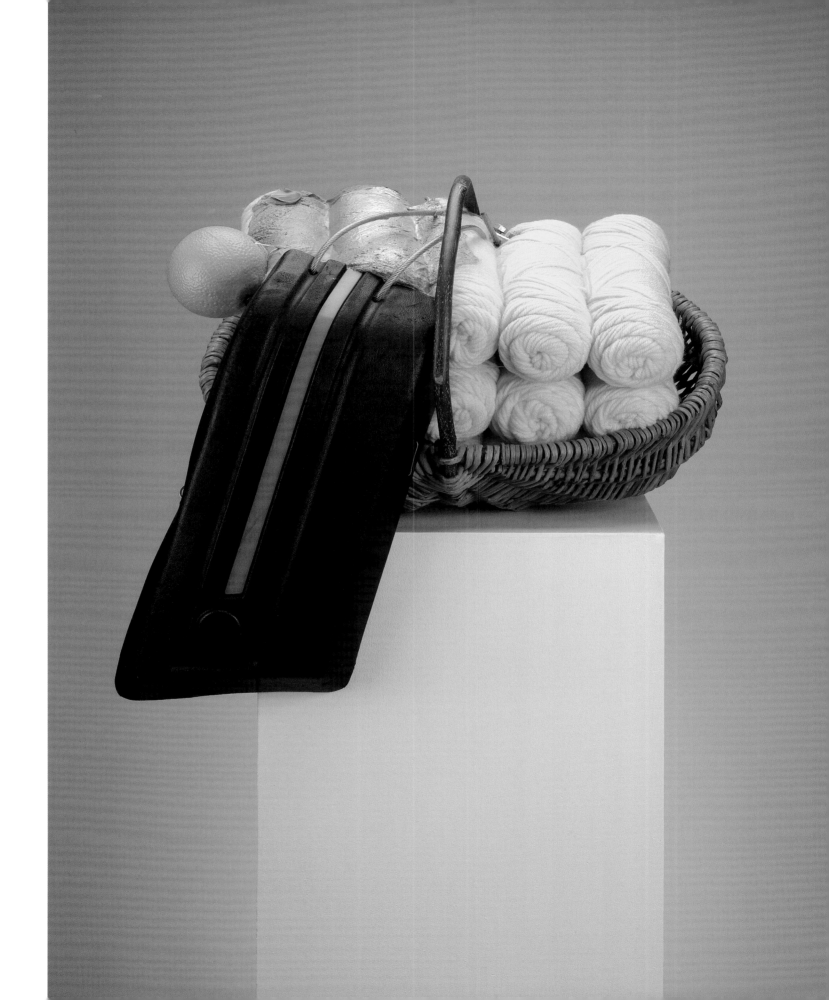

JOCELYN LEE'S SERIES *CHILDREN'S GAMES* EXPRESSES the artist's ongoing interest in "psychological portraiture."[1] In one of the untitled gelatin silver prints from the series, a young child sits inside a glass aquarium brimming with water (fig. 1). The tank rests in a shaded yard and the child, looking away from the camera, guides the nozzle of a tangled hose. In another, similar image, two children play in the water from a lawn sprinkler (fig. 2). The works show not only the physical transitions of youth but also the emotional and intellectual complexities that accompany this life phase.

In 1982, when Lee arrived at Yale College as an undergraduate transfer student from Colgate University, in Hamilton, New York, she decided to pursue a double major in Art and Philosophy. She had been exploring photography since her senior year of high school, and her time in the Department of Photography at Yale furthered her passion for the medium and helped her hone her technical skills. "I would go to the graduate critiques all the time and just sit like a sponge," the artist recalls.[2] Street photography dominated the discourse at Yale at the time, but Lee photographed personal subjects and revealed intimate histories. She photographed her mother, feeding a nascent interest in creating portraits of women, and began working with subjects with whom she would build relationships and would photograph for decades to come.

Away from the camera, Lee danced in the Annie Sailer Dance Company, in New Haven, and connected with mixed-media sculptors and performance artists at the Yale School of Art. Her philosophy courses prompted her existential inquiries, and she used photography as a means to meditate on questions she had about the world. Photography is "a poetic, passionate way of making meaning of the world around you," she states.[3] Through her work, Lee is able to study the arc of human life, following her subjects through liminal moments such as pregnancy and death. Capturing individualized stages of being, she creates expressive images that present the psychological dimensions of her subjects.

After she graduated from Yale, Lee completed her M.F.A. in Photography in 1992 at Hunter College, in New York. In the early 1990s, when she made the images in her *Children's Games* series, Lee was focusing on the concept of youth in her work. But, looking to make images that went beyond innocence and simplicity—qualities more often presented in images of children—she sought to explore play and the symbolic meanings that accompany it. Describing her young subjects, Lee has said, "The developing consciousness of children is fertile ground to explore a wide range of human impulses: from the desire to nurture and love, to the darker imperatives of control, dominance, and anger."[4]     LLW

1. "Exhibition: *Children's Games (1990–1994)*, Jocelyn Lee," Institute, accessed June 14, 2021, http://www.instituteartist.com/exhibition-Children-s-Games-1990-1994-Jocelyn-Lee.

2. Jocelyn Lee, oral history interview by author, July 20, 2019, transcript, Yale University Art Gallery Archives, New Haven.

3. Ibid.

4. "Feature: *Children's Games*."

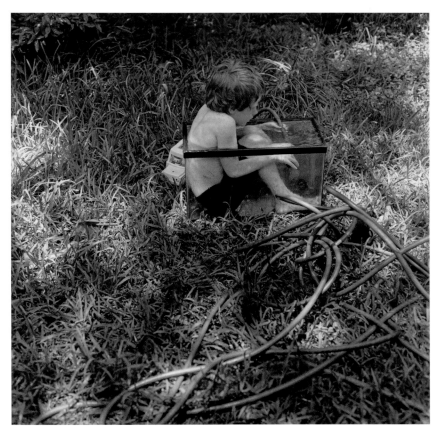

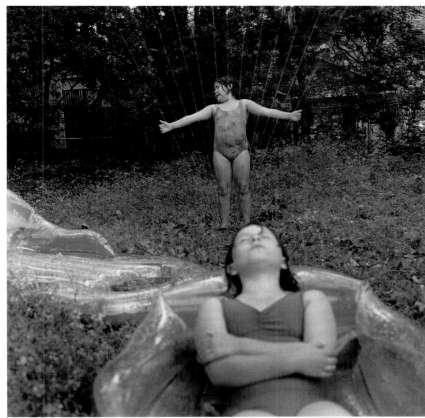

FIG. 1. Jocelyn Lee, *Untitled (Boy in Aquarium)*, from the series *Children's Games*, 1990–93. Gelatin silver print, 8 × 7⅞ in. (20.3 × 20 cm). Janet and Simeon Braguin Fund, 2009.201.2

FIG. 2. Jocelyn Lee, *Untitled (Arms Open and Closed in Water Spray)*, from the series *Children's Games*, 1990–93. Gelatin silver print, 8 × 8 in. (20.3 × 20.3 cm). Janet and Simeon Braguin Fund, 2009.201.1

THE BULBOUS BREASTS, DISTENDED BELLY, AND PERT nose and lips of Lisa Yuskavage's *Foodeater* (fig. 1) are at once repulsive and vaguely alluring. As a character in the artist's series *Bad Habits* (1996–98), which includes other allegorical types such as *Asspicking*, *Headshrinking*, *Socialclimbing*, and *Motherfucker*, *Foodeater* exemplifies Yuskavage's defiant and eroticized depictions of the female figure. The artist has garnered both acclaim and notoriety for her images of young women, which blur the lines between the formal tradition of the classical nude and bawdy sexuality.

As a student at the Tyler School of Art, Temple University, in Philadelphia, and at the Yale School of Art, Yuskavage learned how to draw figures in the style of the Old Masters and absorbed a wide range of influences, from Pontormo to Jan Vermeer to Philip Guston. Yuskavage often iterates conventions and characters, such as *Foodeater*, in myriad sketches and drawings in preparation for her paintings. She is also a skilled printmaker and employs a range of techniques—from intaglio etching to monotype—as she revisits and works through imagery. *Philadelphia* (fig. 2), a monotype that the artist printed the year she graduated from Yale, reflects her longtime fascination with Edgar Degas's experiments in that medium.[1] Like Degas, Yuskavage uses prints as a way to play with form, anatomy, and space, and to rework the aesthetic and psychological effects of a motif.

In the 1990s, Yuskavage (along with other artists like Elizabeth Peyton and Yuskavage's Yale classmate John Currin) committed to a new mode of figuration that was distinctly rooted in contemporary ideas of sexuality, beauty, and identity, despite the ubiquitous debates at the time around cultural politics and the "death of painting." At first, she constructed her subjects entirely from her imagination, but soon she began to use source materials like *Penthouse* magazine photographs and, eventually, her friends as models. For *Bad Habits*, Yuskavage made a set of maquettes out of Sculpey clay, inspired by the sixteenth-century Venetian artist Tintoretto's practice of producing small wax figures from which to paint. The figure of *Foodeater*, with her bulging buttocks and bouffant hairdo, exploits and exaggerates the female form through light and ominous shadow. In some depictions she is monumental and intimidating, and in others, childlike and vulnerable.

The art critic Roberta Smith has written of Yuskavage, "Her distortions exaggerate the way women are objectified both by society and by themselves. But her real subject is, I think, the inside, the female soul and psyche."[2] The artist herself has noted, "I am interested in making work about how things are rather than how they should be. I exploit what's dangerous and what scares me about myself: misogyny, self-deprecation, social climbing, the constant longing for perfection. My work has always been about things in myself that I feel incredibly uncomfortable with and embarrassed by."[3] Through her provocative subjects and virtuosic imagery, Yuskavage coaxes viewers into that uneasy space between intimacy and estrangement.    EA

1. Katy Siegel wrote of Yuskavage's fascination: "Degas's images of women (which she loved) seemed suspect, even a bit kitschy. Somehow, like forbidden sex, the fact that they were in questionable taste (at least in terms of art-school fashion) just reinforced their desirability; the pastels and monotypes and drawings of bathing women were beautiful and masterfully realized, and now they were naughty, too." Katy Siegel, "Blonde Ambition: The Art of Lisa Yuskavage," *Artforum* 38, no. 9 (May 2000): 157.

2. Roberta Smith, "A Painter Who Loads the Gun and Lets the Viewer Fire It," *New York Times*, January 12, 2001.

3. Lisa Yuskavage, quoted in "Interview: Chuck Close Talks with Lisa Yuskavage," in *Lisa Yuskavage*, ed. Faye Hirsch (Santa Monica, Calif.: Smart Art Press, 1996), 26.

# Lisa Yuskavage CAT. 38

American, born 1962, M.F.A. 1986

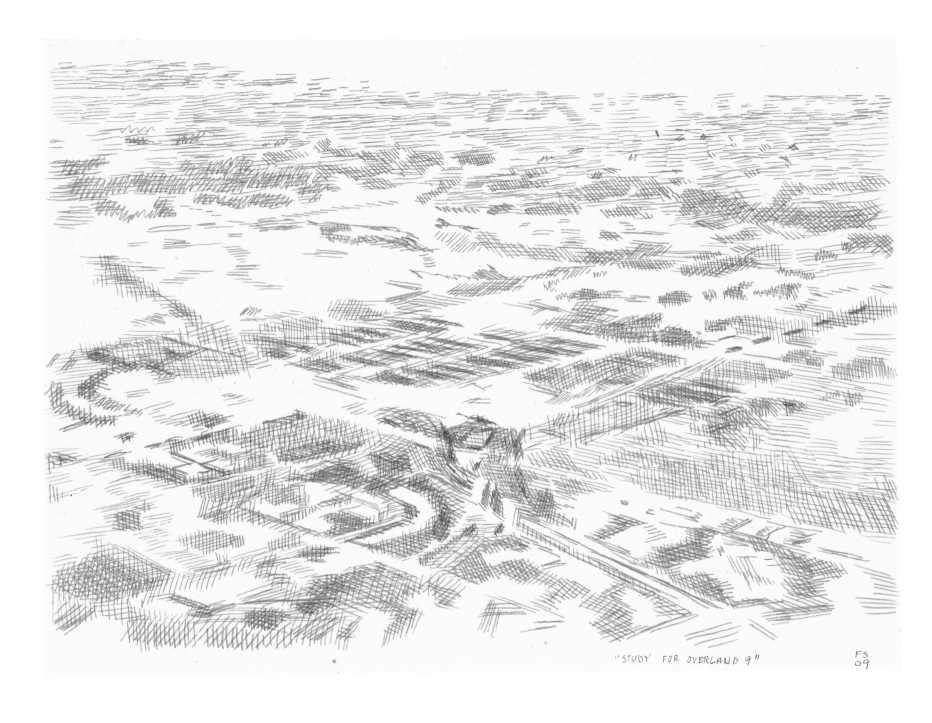

"STUDY FOR OVERLAND 9"

FS
09

FIG. 1. Fran Siegel, Study for *Overland 9*, 2009. Silverpoint on paper, image/
sheet: 9¾ × 12⅝ in. (24.7 × 32 cm). Gift of Werner H. and Sarah-Ann Kramarsky,
2016.150.13

FIG. 2. Fran Siegel, *Overland 8*, 2009. Ink, graphite, and pigment on cut paper, 90 × 134 in. (228.6 × 340.4 cm). Purchased with a gift from Werner H. and Sarah-Ann Kramarsky, 2011.98.1

the Metropolitan Museum of Art, in New York, Marcuse began to scrutinize the skeletal structure that gave it its form. Beneath the dress were crude, industrial, sculptural undergarments that shaped the gown, upholding the characterization of femininity. The armor component of the series evolved when, on a walk through the museum, Marcuse noticed the intricate attention to detail in the ornamentation of the armor that was on display. Exploring and highlighting the polarities between these ideas—masculine and feminine, hard and soft, inside and outside—became integral to her project.   MDM

1. Tanya Marcuse and Valerie Steele, *Tanya Marcuse: Undergarments and Armor* (Tucson, Ariz.: Nazraeli, 2005). *Undergarments and Armor* was supported by a 2002–3 Guggenheim Fellowship and a 2003 John Anson Kittredge Grant.

FIG. 1.  Tanya Marcuse, *Tea Gown*, from the series *Undergarments and Armor*, 2002. Platinum-palladium print, 4¾ × 3¾ in. (12 × 9.5 cm). The Richard S. Field Fund for Contemporary Photography and Works on Paper, 2004.15.1

FIG. 2.  Tanya Marcuse, *Bustle (Wire and Muslin)*, from the series *Undergarments and Armor*, 2002. Platinum-palladium print, 4¾ × 3¾ in. (12 × 9.5 cm). Gift of the artist, 2004.16.1

FIG. 3.  Tanya Marcuse, *Medieval Helmet*, from the series *Undergarments and Armor*, 2002. Platinum-palladium print, 4¾ × 3¾ in. (12 × 9.5 cm). The Richard S. Field Fund for Contemporary Photography and Works on Paper, 2004.15.2

FIG. 4.  Tanya Marcuse, *Bronze Cuirass*, from the series *Undergarments and Armor*, 2002. Platinum-palladium print, 4¾ × 3¾ in. (12 × 9.5 cm). Gift of the artist, 2004.16.2

MARY BERRIDGE'S *SPORTIVNAYA* (FIG. 1), WHICH depicts young people outside an annual concert festival in Moscow, almost did not exist. Moments after the photograph was taken in 1998, a group of skinheads picked up the fallen branches seen in the foreground of the image and began beating people with them. Berridge continued snapping photographs as the fighting ensued and the police intervened. Her camera was confiscated; she was lucky to have it returned to her later with her film unscathed. Berridge had joined her husband, Clark Troy, in Moscow in the summer of that year, where he was working on his PH.D. in Russian literature. She was wandering the streets of Moscow with a limited Russian vocabulary, taking photographs as part of a four-month-long John Simon Guggenheim Fellowship. It was during this trip that she first seriously took up street photography.[1]

The resulting series, *On the Eve, Moscow, 1998*, documents a near-dystopian, post-Soviet city at the tail end of the presidency of Boris Yeltsin. The promise of a utopian society had not materialized, yet the city and its people persevered and resiliently found their own way. The title is a reference to Ivan Turgenev's 1859 novel *On the Eve*. The photographs were all taken just prior to the Russian government's bond default and the subsequent stock market collapse, in August 1998.[2]

The people captured in *Sportivnaya* are part of the overflow from the concert, those who did not make it into the venue but stuck around outside to hear the music. A young girl sips on a canned gin and tonic, easily purchased from street vending machines for the cost of a ruble, and grasps the string of a bright yellow balloon, a counterpoint to what the artist has described as the "wasteland" in which the scene is set.[3] It floats like a sun in the colorless sky, a reminder of the one constant in life: there will always be tomorrow.    MDM

1.  Mary Berridge, oral history interview by author, May 28, 2019, transcript, Yale University Art Gallery Archives, New Haven.

2.  The series was published in Mary Berridge and Clark Troy, *On the Eve: Mary Berridge* (Portland, Ore.: Blue Sky Books, 2014).

3.  Berridge, oral history interview.

FIG. 1. Donnamaria Bruton, *Personalities Are Portable*, from the series *Daze Work*, ca. 1995. Acrylic, graphite, crayon, ink, tape, fabric, and cut-and-pasted paper on panel, 24 × 48 in. (61 × 121.9 cm). Gift of the Estate of Donnamaria Bruton and Cade Tompkins Projects, 2019.8.1

EVE FOWLER GREW UP OUTSIDE PHILADELPHIA AND studied journalism and photography as an undergraduate at Temple University. After college, she worked as a photojournalist for about five years before enrolling in the Yale School of Art to study photography and, in her words, "transition from being an illustrator of other people's ideas as a photojournalist to an artist with my own point of view."[1] At Yale, classes in drawing, documentary filmmaking, art history, and the history of sexuality in ancient cultures, as well as conversations with faculty members Richard Benson and Lois Conner (cat. 30), informed her artistic practice. Regular trips to New York—which included visits to the Museum of Modern Art, where the curator and Yale photography critic Susan Kismaric generously showed Fowler prints by the pioneering portrait photographers Hugo Erfurth and Helmar Lerski—further shaped her work.[2]

After graduating with an M.F.A. in 1992, Fowler began photographing male prostitutes she met on the street or through friends in New York and Los Angeles. The vulnerable and performative anonymous portraits in her series *Hustlers* (1993–98) were intentionally familiar and accessible. Fowler made *Hustlers* concurrent with her coming out and against the backdrop of the HIV/AIDS crisis. Like much of her work since then, *Hustlers* deals with stereotypes and issues of identity and power, and constitutes an empathetic documentation driven by collaboration and an effort to bear witness. The result is a typological cataloguing in the spirit of the German photographer August Sander. During this period, Fowler also created two other photographic series, one of women athletes and another of objects in her Bleecker Street apartment. Each of the three series can be read as part of the artist's exploration of her own identity.

Fowler's untitled work from the latter group of photographs (fig. 1) captures the edges of somewhat worn magazines, which the artist had tightly packed in a wooden cube.[3] This full-bleed chromogenic print is sharply focused at the center with a shallow depth of field. The limited range of tones, from off-white to dark brown, makes the magazines read as organic matter; the edges are almost hairlike. Fowler recalls this period as one in which she had a difficult time caring for and maintaining all of her belongings in a tiny apartment. Photographing these objects allowed her to catalogue them and regain a sense of control over her environment. The magazines cannot be identified, but they likely include issues of those Fowler photographed for, including the interior design magazine *Nest* and the music and entertainment magazine *Vibe*.

During a critique toward the end of Fowler's time at Yale, Benson, who would later become the dean of the School of Art, remarked that he could imagine Fowler's work in an activist mode, displayed outdoors like political posters.[4] Though at the time Fowler disagreed with Benson's assessment, she has more recently started making work for that very context, moving from photography to collage and using words as her medium. Since 2010 she has worked with Gertrude Stein's writings, appropriating phrases from the author's experimental book of poems *Tender Buttons* (1914)—which has been seen as a window into Stein's intimate relationship with her life partner, Alice B. Toklas—and printing them on posters she distributes around Los Angeles.[5] Fowler has continued to work with language, both inside and outside of the gallery. She now runs Artist Curated Projects, in Los Angeles, supporting fellow artists by organizing exhibitions, and she has created two films focused on women artists.[6]    MT

1. Eve Fowler, oral history interview by author, May 22, 2019, transcript, Yale University Art Gallery Archives, New Haven.
2. Ibid.
3. Ibid.
4. Ibid.
5. Michael Slenske, "L.A. Women: Eve Fowler," *Cultured*, October 7, 2016, https://www.culturedmag.com /eve-fowler/.
6. Fowler's film *with it which it as it if it is to be, Part I* (2016) was included in a 2016 exhibition at Participant Inc., in New York, and was screened at the Museum of Contemporary Art, Los Angeles, in 2017. Her film *with it which it as it if it is to be, Part II* (2019) was included in her 2019 exhibition at Morán Morán, in Los Angeles, and was screened remotely at the San Francisco Museum of Modern Art in 2020. The audio track in both films is a recording of artists reading Gertrude Stein's story "Many Many Women." Eve Fowler, email correspondence with author, February 11 and 26, 2020.

# Eve Fowler CAT. 48

FIG. 1. Eve Fowler, Untitled, 1998. Chromogenic print, 24 × 20 in. (61 × 50.8 cm).
The Allan Chasanoff, B.A. 1961, Photography Collection, 2004.130.36

AN-MY LÊ'S PHOTOGRAPHS EXAMINE THE IMPACTS of war and its representation. In both her black-and-white and color work, Lê captures the effects—physical, environmental, and sociocultural—generated by the violent transformation of the natural landscape into a battlefield. Her work displays an interest in ambiguity rather than documentary truth, and a desire to blur the boundaries between fact and fiction, and between the genres of war and landscape photography. Since the mid-1990s, Lê has used a cumbersome, large-format camera in the tradition of nineteenth-century landscape and Civil War photographers such as Mathew Brady, Alexander Gardner, and Timothy O'Sullivan. War photography has always been associated with a certain degree of artifice: unable to capture a battle in progress due to the technical limitations of the medium, Civil War photographers often arranged the scenes for dramatic effect when they pictured the aftermath.

Lê was born in Saigon in 1960. She and her family fled in 1975 during the final year of the Vietnam War and came to the United States as political refugees. Her first trip back to Vietnam was in 1994, shortly after she completed her M.F.A. at the Yale School of Art. Lê initially traveled with her friend and former professor Lois Conner (cat. 30), whose use of the large-format camera and approach to landscape resonated strongly with Lê.[1] Over a period of several years, she returned to photograph the people and landscape. In the resulting series, *Viêt Nam* (1994–98; see Kuzma essay, fig. 25), the war is present only obliquely, as Lê grappled with the gaps between her memories and a now-unfamiliar country.[2]

Upon her return to the United States, Lê embarked on a project that would become the series *Small Wars* (1999–2002; figs. 1–3), which examines the legacy and impacts of the Vietnam War from an American perspective. For this project, she photographed battlefield reenactments organized by a group of Vietnam War re-creation societies in Virginia and North Carolina. To gain permission to photograph, she agreed to participate in the reenactments, making pictures over the course of the events. Lê is a keen observer of the natural environment. Although the subjects' costumes and gear appear to be period specific, and Lê's black-and-white photographs seem to depict combat, the landscape betrays the fiction: the North American pine and oak forest stands in contrast to the dense tropical jungle that plays a key role in the visual record of the war, in both photographic documentation and Hollywood films. Lê's photographs destabilize conventional expectations of war photography and highlight the incongruity between the ostensible realism of photography and the constructed nature of the image.    JD

1. An-My Lê, oral history interview by Gabriella Svenningsen, September 20, 2019, transcript, Yale University Art Gallery Archives, New Haven.

2. One work from this series, *Untitled, Ho Chi Minh City, Mekong Delta* (1998, printed 2006), is in the collection of the Yale University Art Gallery, New Haven; see inv. no. 2006.229.1.

FIG. 1.  An-My Lê, *Rescue*, from the series *Small Wars*, 1999–2002. Gelatin silver
print, 26½ × 38 in. (67.3 × 96.5 cm). Janet and Simeon Braguin Fund, 2006.118.1

FIG. 2. An-My Lê, *Ambush II*, from the series *Small Wars*, 1999–2002. Gelatin silver print, 26 × 37½ in. (66 × 95.3 cm). Janet and Simeon Braguin Fund, 2006.120.2

FIG. 3. An-My Lê, *Explosion*, from the series *Small Wars*, 1999–2002. Gelatin silver print, 26 × 37½ in. (66 × 95.3 cm). Janet and Simeon Braguin Fund, 2006.120.1

ERICA BAUM CAME TO PHOTOGRAPHY WITH AN anthropologist's eye, developed during her studies at Barnard College, in New York, where she received her B.A. in 1984. After graduation, while working at City Arts, a small, nonprofit arts organization in New York, Baum found role models in the women artists whom she encountered, and she decided to pursue graduate studies in photography—a medium she thought best suited her interest in "the visual aspects of anthropology."[1] She enrolled in the Yale School of Art in 1992. There, Baum was strongly influenced by full-time faculty members Lois Conner (the only full-time female faculty member in Photography at that time; cat. 30), Richard Benson, and Zeke Berman, and by the visiting critics Joel Sternfeld and Barbara Ess.

In the middle of her first year, Baum applied for and received a fellowship at Silliman College (one of Yale's residential colleges) that would allow her to explore campus life and take the undergraduate student body as her primary subject. The experience led to the series *Blackboards*, one of the final projects of her M.F.A. work, in which she photographed the words, equations, and other marks left on blackboards after classes. For Baum, *Blackboards* was a pivotal project. When she arrived at Yale, she had been using a 35-millimeter point-and-shoot camera, but by the end of her second year, she was using a large-format view camera that allowed her to capture the material qualities of chalk on a blackboard. Moreover, it was with this series that Baum felt she had found her artistic voice.

Materiality, chance, and language have remained central aspects of Baum's artistic practice since *Blackboards*. In making her *Dog Ear* series (2009–10), Baum turned down the corners of pages of various books to create visually and verbally evocative arrangements of text. She then scanned these pages on a 2008 Epson printer-scanner, cropped the resulting images to a square format, and printed them as pigmented inkjet prints. In these works, such as *Differently* (fig. 1), horizontal and vertical text creates visually dynamic patterns that offer numerous interpretive possibilities, depending on the order in which one chooses to read them. By decontextualizing the printed words from the rest of the book and rearranging them in relation to one another, Baum emphasizes the pictorial quality and physical dimensionality of both the words and the yellowing, roughly textured paper on which they are printed.    EW

1.  All biographical information and quotations by the artist are from Erica Baum, oral history interview by author, April 19, 2019, transcript, Yale University Art Gallery Archives, New Haven.

FIG. 1. Erica Baum, *Differently*, from the series *Dog Ear*, 2009. Pigmented inkjet print, 9 × 9 in. (22.9 × 22.9 cm). The Richard S. Field Fund for Contemporary Photography and Works on Paper, 2010.135.4

A QUIET, PIOUS ATMOSPHERE PERVADES THE IMAGES in *Bare Handed*, a series Holly Lynton began in 2007 that documents traditional agrarian practices that are quickly vanishing from the American landscape. Instead of wrapping these disappearing folkways in a layer of nostalgia, Lynton depicts her subjects' shared sense of purpose gained from working in harmony with the land. Many of Lynton's compositions recall the Depression-era works of Farm Security Administration photographers, such as Walker Evans and Dorothea Lange, who drew inspiration from the conventions of religious painting to frame their sympathetic representations of rural hardship. But whereas Evans and Lange sought to portray their subjects as victims of circumstance, Lynton emphasizes the enduring feeling of community and responsibility that arises from embracing these forms of labor. Her depictions of traditions like preparing sheep for judging at a local fair suggest a kind of spiritual calm rarely seen, much less felt, in modern life (fig. 1).

For Lynton, who majored in Psychology as an undergraduate at Yale College, these labor-intensive practices—from sheep-shearing and beekeeping to more regionally specific traditions

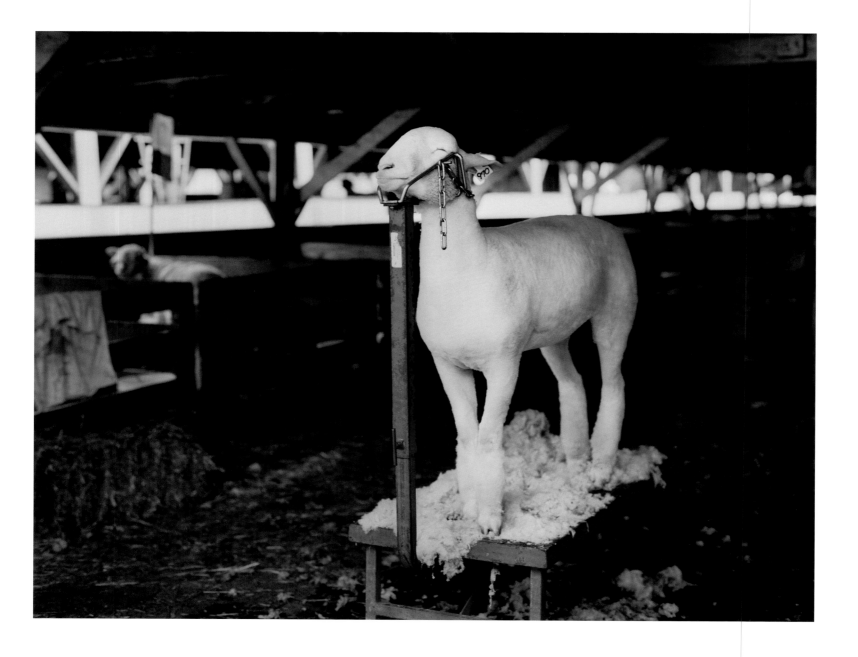

# Holly Lynton CAT. 51

American, born 1972, B.A. 1994    1990s

like beaverslide hay stacking and catfish noodling—join body and mind in a state of intense focus and surrender. Lynton shares a connection with her subjects through her own working process, shooting with color film and making chromogenic prints—technologies that are becoming obsolete in the face of more efficient alternatives.

In 2008 Lynton moved from New York to the Pioneer Valley in Massachusetts in a conscious effort to live out her ethical ideals closer to the land. Her enigmatic *Burst, Deerfield,* *Massachusetts* (fig. 2) depicts one of the region's once-thriving industries—shade tobacco, which farmers grow under tents using a method that has persisted largely unchanged since the early 1900s. The tobacco producers that still remain in operation rely largely on seasonal migrant labor. In Lynton's image, three workers from Jamaica are faintly visible, pulling down the tobacco after it had been moistened in a barn. These figures, shrouded in steam, hint at the complex cultural dynamics of the modern regional economy.    CF

FIG. 1.  Holly Lynton, *Fairest, Cummington Fair, Massachusetts*, from the series *Bare Handed*, 2010. Digital chromogenic print, 20 × 25¾ in. (50.8 × 65.4 cm). Richard Brown Baker, B.A. 1935, Fund, 2013.82.3

FIG. 2.  Holly Lynton, *Burst, Deerfield, Massachusetts*, from the series *Bare Handed*, 2010. Chromogenic print, 20 × 26 in. (50.8 × 66 cm). Richard Brown Baker, B.A. 1935, Fund, 2013.82.2

RINA BANERJEE WAS BORN IN CALCUTTA, INDIA, and grew up in London and New York.[1] Before attending the Yale School of Art, she earned her bachelor's degree in Polymer Engineering from Case Western Reserve University, in Cleveland, and worked as a research consultant at Pennsylvania State University, in University Park. While she was there, she decided to take a painting class with artist Santa Barraza. Banerjee realized that art making was much more multifaceted than what she had imagined; it included learning, researching, and communicating with others.[2] She decided to pursue art and applied to graduate school.

During her time at Yale, she took a course titled "Photography and Images of the Body" with Laura Wexler, HON. 2002, which examined photography archives of archaeological and anthropological materials.[3] As a result, Banerjee realized that globalization has not only brought people together but also made them more aware of the shared aspects of human culture. Globalization was essential to considering diaspora.[4] In her sculptures, she uses artifacts from different societies to explore the impact of globalization. At first glance, an artifact may be representative of a single culture; but upon further consideration of its assembly, the methods used to source it, or the memories with which it is imbued, the artifact exhibits a multiplicity of associations.

In *Dangerous World* (fig. 1), Banerjee used both imagery and materials to create meaning. The scene has a quality of fantasy and otherworldliness. In the bottom center of the work are three humanoid figures, one of whom, with a skeleton-like form underneath her body, represents the artist. The figures stand in what appears to be a flow of lava, which neither engulfs them nor allows them to find their footing. Hovering ominously in the air are menacing creatures that represent a period of poor health in Banerjee's life and serve as a reminder of the transition from life to death.[5] The durable printmaking paper she chose accommodates many media; it also allows for better absorption and for the inks to bleed, creating a liminal relationship between the paper and ink, thus reinforcing the idea of the thin boundary between life and death. Like the artifacts she uses in her sculptures, Banerjee's printmaking materials and techniques enhance the themes she addresses.   ED

1. Rina Banerjee, "Rina Banerjee," *Artforum*, June 22, 2011, https://www.artforum.com/interviews/rina-banerjee-discusses-her-exhibition-at-musee-guimet-28485#.

2. Rina Banerjee, oral history interview by author, March 25, 2019, transcript, Yale University Art Gallery Archives, New Haven.

3. Ibid.
4. Ibid.
5. Ibid.

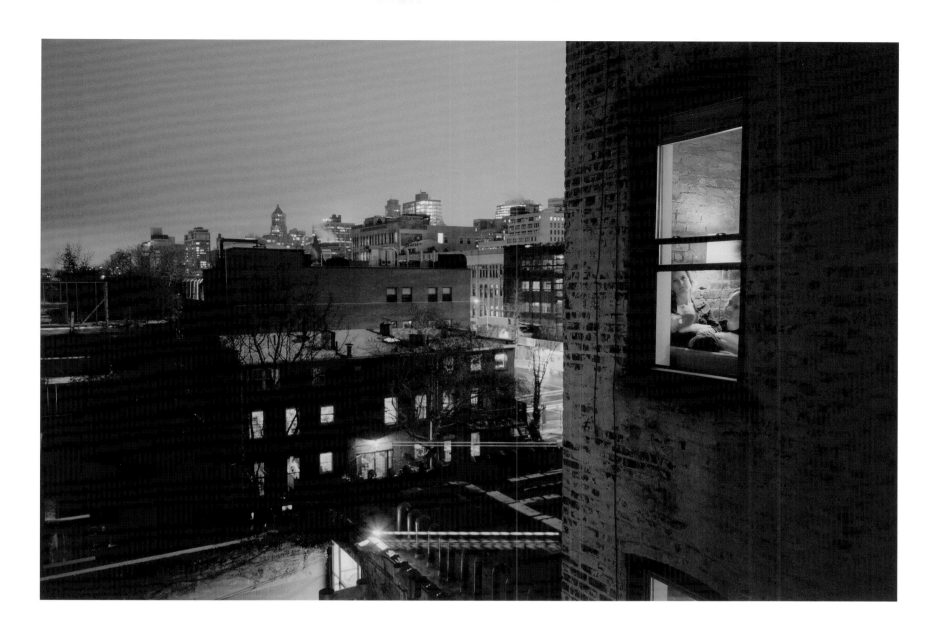

FIG. 1. Gail Albert Halaban, *Out My Window, Brooklyn, Snow*, from the series *Out My Window*, 2007. Pigmented inkjet print mounted on foam core, 14⅞ × 22 in. (37.8 × 55.9 cm). Gift of Carol Ballock, 2010.178.1

IN HER SERIES *EARLY AMERICAN*, SHARON CORE reimagines the nineteenth-century still-life paintings of Raphaelle Peale as contemporary photographs. Peale, the son of the prominent Philadelphia painter and naturalist Charles Willson Peale, stood apart among artists of the Early Republic for his embrace of still life. His sensuous compositions celebrated the natural abundance of the young nation while symbolically reflecting on the values and character of its citizens. According to former Yale University professor Alexander Nemerov, whose groundbreaking monograph on Peale influenced Core's project, the objects in Peale's paintings assume an uncanny, almost sentient quality through the subtle ways in which their tactile surfaces touch each other and seem to emanate beyond the picture plane.[1]

In making *Early American*, Core drew both from her training as a painter—she had studied painting as an undergraduate at the University of Georgia, in Athens, prior to entering the Yale School of Art to study photography—as well as from her work as an assistant food stylist. She also tracked down heirloom varieties of produce and antique dishes and glassware to match those in Peale's still lifes. While she copied some of the paintings directly, more often her photographs borrow or combine elements from multiple works. *Still Life with Oranges* (fig. 1) takes cues from two Peale paintings: *A Dessert* (National Gallery of Art, Washington, D.C.) and *Still Life with Liqueur and Fruit* (Nelson-Atkins Museum of Art, Kansas City, Mo.), both of which date to 1814 and feature an enticing array of citrus, nuts, raisins, and sherry.

The mimetic accuracy of Core's photographs belies a conceptual sophistication that elevates them above mere homage. Whereas Peale's paintings are remarkable for their trompe-l'oeil effects, Core's photographs introduce an additional layer of deception by resembling a painting at first glance. In this way, Core not only reproduces the illusionism in Peale's work with remarkable skill but simultaneously, and conversely, situates photography as a mode of picture making with no greater claim to visual truth than more traditional artistic media.   CF

1. See Alexander Nemerov, *The Body of Raphaelle Peale: Still Life and Selfhood, 1812–1824* (Berkeley: University of California Press, 2001).

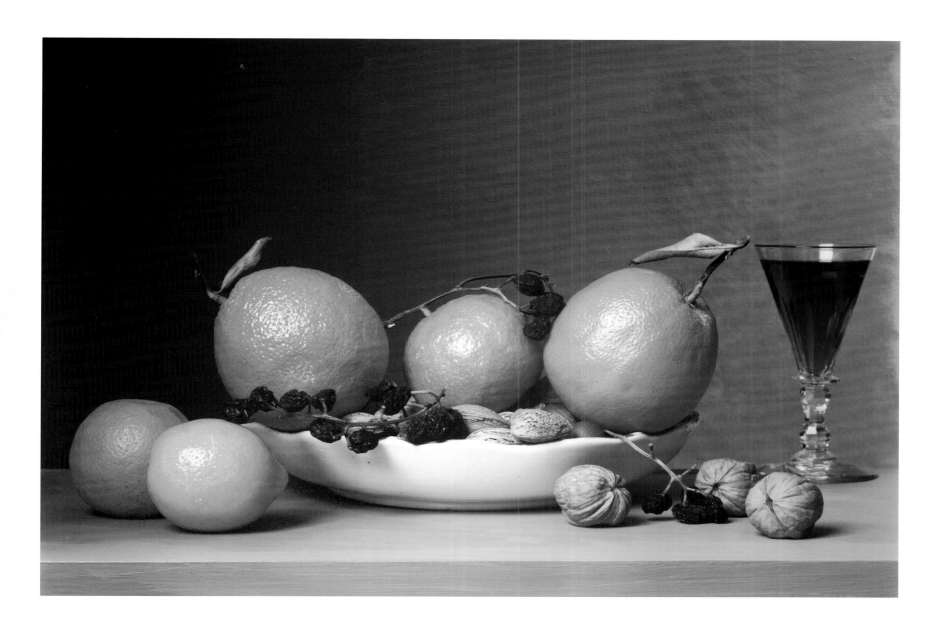

FIG. 1. Sharon Core, *Still Life with Oranges*, from the series *Early American*, 2008. Chromogenic print, 13⅜ × 19⅞ in. (34 × 50.5 cm). Promised gift of Nancy D. Grover

KNOWN FOR HER BOLD DEPICTIONS OF THE NUDE figure in staged settings, Malerie Marder performs all roles in her work: director, photographer, audience, and sometimes subject. "People give different things,"[1] Marder says, referring to both her models, who may be friends or family, and her professors and visiting critics at the Yale School of Art in the 1990s, of whom she speaks fondly: Richard Benson, Gregory Crewdson, Philip-Lorca diCorcia, Nan Goldin, Laurie Simmons, Judith Joy Ross, and John Szarkowski.[2]

By its very nature, nude photography—its voyeuristic quality, its implied truth—has always been a charged genre. It is one to which Marder has committed her twenty-year career, which has spanned a period that has witnessed the advent and dizzying growth of the Internet—and with it, a radical reconsideration of the concepts of privacy and personal space. When she received her M.F.A. in 1998, Marder never could have imagined the impact the Internet would have on photography. She is horrified at the increasing lack of protection it has brought, both professionally, in terms of the rampant online appropriation of a photographer's images, and on a personal level: as a photographer of nude subjects, she must consider the privacy of her models.[3] In this age of social media, Marder's work also points a spotlight on an incongruity in American culture: on the one hand, America's perennial priggishness at seeing still photographs of unidealized nude bodies framed on a wall, and, on the other, the new normal manifest in the unbridled online posting of naked or half-naked selfies for "private" consumption on a handheld digital device.

A 1998 work from Marder's series *Carnal Knowledge* pictures a young girl adrift on a raft at the implied edge of a body of placid water at night (fig. 1). The viewer stands above her and vicariously partakes in her reverie. Marder, who works in both color and black and white, purposefully chose black and white for this image, and for much of the work she was doing at the time, because she likes its "nostalgic" quality and generally finds it "more beautiful" than color. The artist took this photograph while on a trip to Arkansas with her boyfriend at the time and was at least in part inspired by a recent talk that the photographer O. Winston Link had given at Yale, in which Link described his process of creating complicated lighting setups for his night photographs. Moved, Marder bought numerous cheap tungsten lights and extension cords to create the elaborate staged lighting by which this image was taken. The photograph necessitated a long exposure (she did not use strobes), so despite the girl remaining very still, the image is slightly blurred, adding to its seductive, film-noir mood. As Crewdson has said of Marder's work, "There are secrets brooding in the shadows. What we don't see is as important as what we do."[4]    EH

1.  All quotations by the artist are from Malerie Marder, oral history interview by author, July 9, 2019, transcript, Yale University Art Gallery Archives, New Haven.
2.  Just one year after Marder received her M.F.A., Crewdson included her in the pathbreaking exhibition *Another Girl, Another Planet* at Lawrence Rubin Greenberg Van Doren Fine Art, in New York, a show that also included her classmates Justine Kurland (cat. 57) and Katy Grannan (cat. 59).
3.  For both reasons, Marder is careful to keep the images on her website small and low resolution.
4.  Gregory Crewdson, foreword to *Malerie Marder: Carnal Knowledge* (London: Violette Editions, 2011), 7.

Malerie Marder CAT. 56

American, born 1971, M.F.A. 1998

1990s

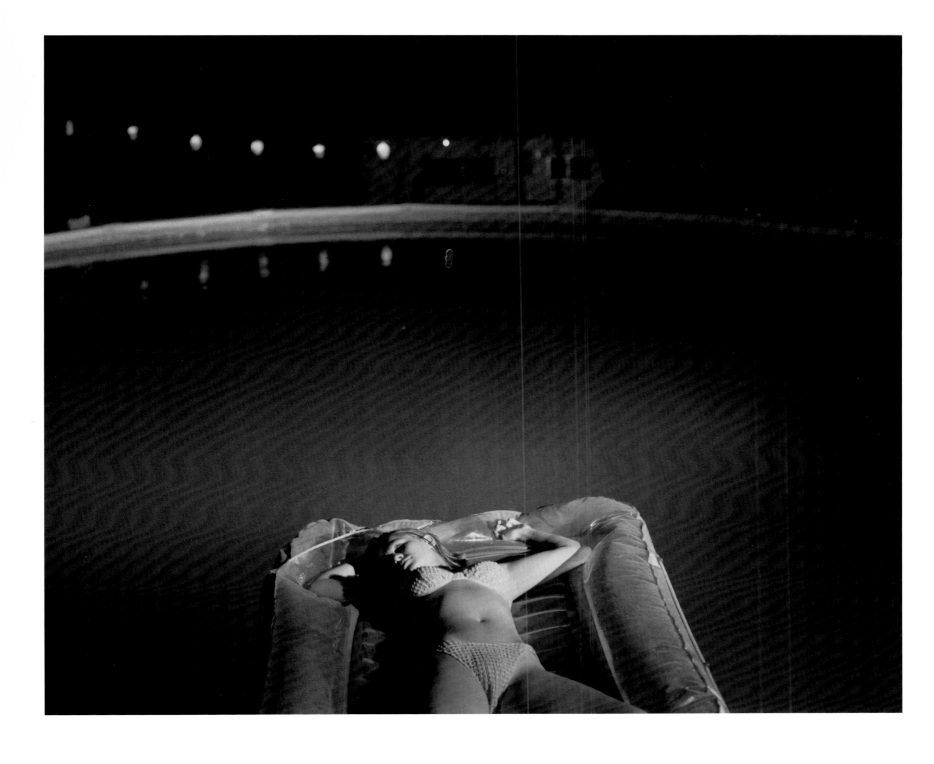

FIG. 1. Malerie Marder, Untitled, from the series *Carnal Knowledge*, 1998. Gelatin
silver print, 18⅜ × 22⁹⁄₁₆ in. (46.7 × 57.3 cm). Gift of Pamela and Arthur Sanders,
2008.121.7

JUSTINE KURLAND LOOKS TO THE EDGES OF THE American social landscape—the places just off the grid, where civilization and wilderness touch—to find surviving expressions of freedom and self-reliance, those flagging ideals on which American identity was built. In her first major photographic series, *Girl Pictures*, which she began in 1997 as a graduate student at the Yale School of Art and completed in 2002, Kurland conjured scenes of adolescent girls living together on the run, finding kinship and acting out fantasies with youthful abandon in riverside encampments and highway underpasses. The staged vignettes were inspired by her own teenage experience of running away from her rural hometown in eastern New York to New York City, where she resolved to become an artist. Shortly after she graduated from Yale, her photographs were included in *Another Girl, Another Planet*, a landmark exhibition at Lawrence Rubin Greenberg Van Doren Fine Art, in New York City, which was coorganized by Yale photography instructor Gregory Crewdson. This exhibition positioned her within a group of photographers—which included fellow School of Art graduates Malerie Marder (cat. 56) and Katy Grannan (cat. 59)—known for creating works that blend elements of narrative fiction and documentary realism.

In her subsequent work, Kurland has continued to explore unconventional, nomadic lifestyles that preserve some vestige of the frontier spirit. Her subjects range from real-life train hoppers, drifters, and members of utopian communities to her own son, who was her constant travel companion throughout his childhood. While Kurland continues to blur the line between truth and fantasy, she has increasingly referenced the real world, with her subjects expressing versions of their own identities rather than wholly imagined roles. *The Burned Down Forest, Twisted Limbs* (fig. 1) marks this shift toward the real in her work. Unlike most of her images, the scene contains no human figures; it simply depicts a gnarled mass of charred tree remains. Kurland has noted that the work was created concurrently with bombing campaigns led by the U.S. military in the Middle East.[1] Viewed in this light, the "twisted limbs" take on a dark, symbolic significance, situating Kurland within a long tradition of American artists dating back to Thomas Cole who have used landscape elements as symbols of both the promise and pitfalls of American idealism.   CF

1.   Justine Kurland, in "ICP Lecture Series: Justine Kurland," lecture, November 19, 2014, International Center of Photography, video, 58:17, May 28, 2015, https://www.youtube .com/watch?v=m6YPqeNMZYE. See 26:21 for the relevant comment.

# Justine Kurland   CAT. 57

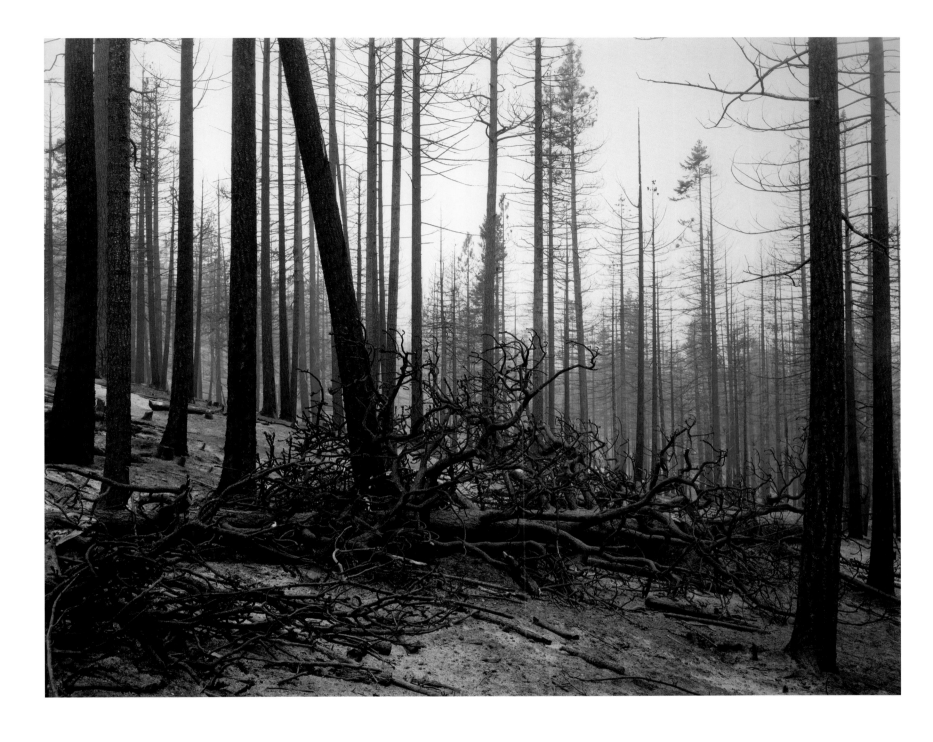

FIG. 1. Justine Kurland, *The Burned Down Forest, Twisted Limbs*, 2004. Chromo-genic print, 39⁷⁄₁₆ × 49⁷⁄₁₆ in. (100.2 × 125.5 cm). Promised gift of Nancy D. Grover

FOR THE LAST TWO DECADES, STARTING SHORTLY after her graduation from the Yale School of Art, Victoria Sambunaris has been traversing the United States. She spends between three and seven months each year on the road, equipped with maps, books on regional history and geology, camping gear, and a 5 × 7 wooden field camera. Sambunaris follows a tradition of American landscape photography that traces back to Timothy O'Sullivan and the photographers of the U.S. geological surveys in the mid-nineteenth century. Her large-format color photographs bear witness to the ways in which natural forces and human industry alike have shaped the land over time, giving equal treatment to a massive open-pit gold mine in Fairbanks, Alaska (fig. 1), and a monumental volcanic crater on the island of Maui, Hawaii (fig. 2). Like O'Sullivan and his peers, Sambunaris maintains a neutral posture, foregoing either reflexive adulation or overt critique, and instead allowing the landscape to speak for itself.

From 2009 to 2011, Sambunaris made photographs along the two-thousand-mile border that separates the United States and Mexico. Following a road primarily used by U.S. Border Patrol agents, she traced the ways in which the border can shift between a geologically defined boundary and a man-made divide marked by a fence. In some places, the line appears invisible or arbitrary, while in others, dramatic contrasts in land use on either side underscore the material impact of the political dividing line. Her photograph of a large-scale agricultural operation in Jacumba, California, shows how industry has adapted along the border (fig. 3). The small, makeshift fence in the foreground creates a sense of ambiguity; at first it appears to be the border fence, but it merely serves to mark the edge of a farm. Meanwhile, the actual border fence—which enters the picture on the right and recedes up into the distance— abruptly terminates halfway up the hill. The scene probes how the border moves from abstraction to everyday reality and back again.    CF

# Victoria Sambunaris    CAT. 58

American, born 1964, M.F.A. 1999

# 1990s

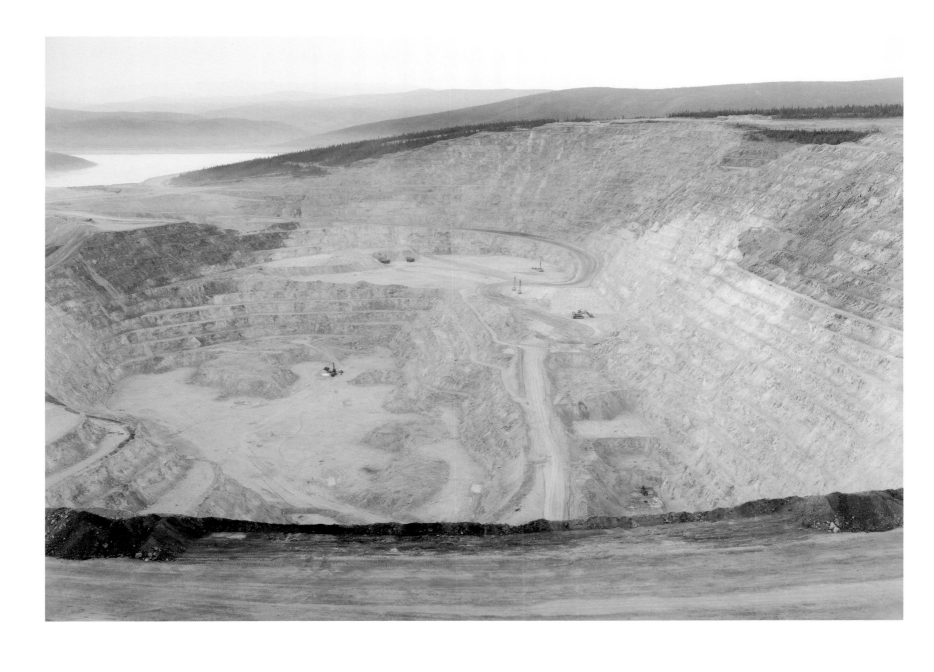

FIG. 1. Victoria Sambunaris, *Untitled (Fort Knox Gold Mine), Fairbanks, Alaska,*
2003. Chromogenic print mounted on aluminum, 39 × 55 in. (99.1 × 139.7 cm).
Gift of the artist in honor of Richard Benson, 2006.85.1

FIG. 2. Victoria Sambunaris, *Untitled (Haleakalā Crater), Maui, Hawaii*, 2005.
Chromogenic print, 39⁹⁄₁₆ × 55⁷⁄₈ in. (100.5 × 142 cm). Gift of Susan and Arthur
Fleischer, Jr., B.A. 1953, LL.B. 1958, 2017.34.15

FIG. 3.  Victoria Sambunaris, *Untitled (Farm with Workers), Jacumba, CA*, 2010.
Chromogenic print, 39 × 55 in. (99 × 139.7 cm). Purchased with a gift from the
Arthur and Constance Zeckendorf Foundation, 2011.112.1

FROM 2008 TO 2010, KATY GRANNAN TRANSFORMED the urban environment into an impromptu studio, photographing strangers on the streets of Los Angeles and San Francisco. She positioned her subjects in front of white stucco walls and in strong, midday light (figs. 1–2). Having been raised in Massachusetts and having studied at the University of Pennsylvania, in Philadelphia, and the Yale School of Art, when Grannan moved to the West Coast she was struck by how the California "light is so seductive and comforting, and at the same time it kills everything—nothing stays green very long—[it] can be relentless and indiscriminate."[1] The light casts over her subjects a western promise of a better tomorrow and the sobering reality of life's crude past.[2]

Each of the street portraits in Grannan's *Boulevard* series was an impromptu collaboration between the subject and photographer. Contrary to the typical process of street photography, nobody was caught unaware by the camera's lens. Grannan was able to capture what appear to be spontaneous moments by shooting the images immediately after meeting her subjects and quickly developing a rapport with them to put them at ease.[3] While Grannan's subjects are often members of marginalized communities who are undervalued and overlooked, she is careful to point out the presumptiveness of that statement in its application to her *Boulevard* works.[4] They are everyday people on the streets of Los Angeles and San Francisco who are generally passed by with little to no notice. By photographing her subjects on the streets outside, in harsh daylight and against a plain white background absent of ancillary details, and by using a large-format camera, Grannan ensures that they are seen. She maintains their anonymity in the titles of the works, each of which is simply called *Anonymous*, followed by the city in which the portrait was taken. Grannan's unpolished portraits capture life's indeterminate and messy nature. She does not purport to show the entire essence of an individual in her *Boulevard* series; instead, she considers each portrait a short vignette of the subject's life, one that includes the narrative of her time with them.[5]

Grannan continued making street portraits in her series *99*, for which she traveled along Highway 99 photographing the undervalued landscapes and inhabitants of, as Joan Didion has described it, California's "trail of an intention gone haywire."[6] Her more recent project, a feature-length film titled *The Nine* (2016), follows the lives of individuals in the marginalized community of Modesto's South Ninth Street, in the Central Valley.  MDM

1. Katy Grannan, in Seth Curcio, "Boulevard: An Interview with Katy Grannan," *Daily Serving*, January 20, 2011, https://www.dailyserving.com /2011/01/boulevard-an-interview -with-katy-grannan/.
2. On this idea, see "Katy Grannan," Fraenkel Gallery, accessed March 2, 2020, https://fraenkelgallery.com /artists/katy-grannan.
3. "Katy Grannan: Boulevard," Museum of Modern Art, video, 3:21, February 10, 2016, https:// www.youtube.com/watch?v =BOef03Sy3x0.
4. Ibid.
5. Maria Lokke, "On the Boulevard" *New Yorker*, April 12, 2011, https:// www.newyorker.com/culture /photo-booth/on-the-boulevard -with-katy-grannan.
6. Joan Didion, "Some Dreamers of the Golden Dream, 1961," in *A Route 66 Companion*, ed. David King Dunaway (Austin: University of Texas Press, 2012), 150–52.

consumption by stripping them of their social context, Kereszi manages a lighter touch, revealing the human desires preserved in the places, which are cast in a mood somewhere between deadpan and mildly melancholic. In works like *Ball Toss, Coney Island, Brooklyn* (fig. 2), she inherits the rich tradition of photographers like Eugène Atget and Walker Evans, who refigured the modern cultural landscape as a matrix of signs and symbols. Since 2004, Kereszi has been on the faculty of the Yale School of Art, and she has served as Director of Undergraduate Studies in Photography since 2013.    CF

FIG. 1.  Lisa Kereszi, *Disco Ball in a Cardboard Box,* from the series *The Party's Over,* 2008. Chromogenic print, 18⅝ × 23⁵⁄₁₆ in. (47.3 × 59.2 cm). Promised gift of Nancy D. Grover

FIG. 2.  Lisa Kereszi, *Ball Toss, Coney Island, Brooklyn,* 2001. Chromogenic print, 28⅜ × 35¼ in. (72 × 89.5 cm). Gift of the artist, 2004.58.1

WANGECHI MUTU, ONE OF THE MOST ACCLAIMED contemporary artists working on a global scale, is constantly innovating in her work, which critically questions social and cultural practices. Mutu's exposure to other countries began at an early age: born and raised in Nairobi, Kenya, she attended high school in Wales, earned a B.F.A. in 1996 from Cooper Union, in New York, and graduated from the Yale School of Art in 2000 with an M.F.A. in Sculpture. At Yale she had the opportunity to experiment with different media and hone her multidisciplinary artistic voice.[1]

Since then, Mutu has traveled back and forth between Kenya and North America, a physical mobility that deeply informs her art. In her practice, she engages with issues of femininity, the sexualization of the female body, ecopolitics, ecology, and racial stereotypes. She draws from various sources, notably her native Kenyan culture, to create a varied body of work that reflects on and reacts to contemporary society. Her works include collages, sculptures, installations, and video art. Mutu uses popular imagery taken from wide-ranging areas—fashion magazines, pornography, anthropological and botanical writings, and traditional African arts—to create haunting figures of eccentric beauty that call out racial and gender stereotypes, as well as oppression.[2]

Mutu gained early recognition for her collages that explore a duality of beauty and violence by conveying an image of otherworldly places inhabited by strange and hybrid creatures, with embellished surfaces that are both beautiful and slightly off-putting. These collages show recomposed or mutilated female bodies and disfigured faces, addressing violence against women, especially Black women. Mutu constructs the collages using Mylar polyester film, ink, and acrylic paint. She also incorporates unusual materials, such as synthetic hair, feathers, pearls, and sand, into her works. Through the process of reconfiguring and altering, she frees the collaged images from their traditional cultural associations, such as physical beauty and wealth, and offers a new perspective.

In her work overall, Mutu uses the female figure as a springboard to investigate universal issues of displacement, persecution, and cultural rituals.[3] In recent sculptures, such as *Sentinel I* (fig. 1), the artist combines natural and manufactured materials to create hybrid female forms that poignantly evoke nature as the source of all life and simultaneously convey concern about its destruction by humankind. Her practice of drawing from multiple sources, ranging from her native culture to ecological and social issues, is powerfully illustrated by the series of prints *The Original Nine Daughters* (fig. 2). This series refers to a legend of the founding of the Kikuyu Tribe, the largest ethnic tribe in Kenya, from which Mutu descends. The legend tells the story of Gikuyu, the founder of the tribe, who with his wife had nine daughters, each of whom founded one of the nine Kikuyu clans. Mutu's own name derives from one of the daughters' names—Wangeci.    FVJ

1. Wangechi Mutu and Trevor Schoonmaker, "A Conversation: Wangechi Mutu and Trevor Schoonmaker," in *Wangechi Mutu: A Fantastic Journey*, ed. Trevor Schoonmaker, exh. cat. (Durham, N.C.: Nasher Museum of Art at Duke University, 2013), 98.

2. Okwui Enwezor, "Weird Beauty: Ritual Violence and Archaeology of Mass Media in Wangechi Mutu's Work," in *Wangechi Mutu, Artist of the Year 2010: My Dirty Little Heaven*, exh. cat. (Ostfildern, Germany: Hatje Cantz, 2010), 28.

3. Trevor Schoonmaker, "A Fantastic Journey," in Schoonmaker, *Wangechi Mutu*, 21.

FIG. 1. Leslie Hewitt, *Untitled (Constant Emotion)*, from the series *Midday Studies*, 2010. Chromogenic print, 30 × 40 in. (76.2 × 101.6 cm). Purchased with a gift from the Arthur and Constance Zeckendorf Foundation, 2011.32.1

AN ENCOUNTER WITH ERIN SHIRREFF'S WORK "needs time to unfold."[1] She is interested in how an experience with a work of art can be mediated by technology, the viewer's physical proximity, or even the weather. In her practice, Shirreff investigates the discrepancy between seeing a depiction of a three-dimensional object in a photograph or video and encountering the object in person, which essentially activates it in time and space—and considers the different meanings evoked by each experience.

Shirreff was born in British Columbia, Canada, and earned a B.F.A. at the University of Victoria before enrolling in the Sculpture program at the Yale School of Art. According to Shirreff, Jessica Stockholder (cat. 36), then Director of Graduate Studies in Sculpture, believed in "unmonitored, devoted studio time,"[2] which afforded Shirreff the space to figure out what kind of artist she wanted to be and to engage in an organic and intuitive approach to making work. In addition to sculpture, she studied poetry and literature, exploring the intellectual histories that would guide her practice.

Since graduating in 2005, Shirreff has continued to develop a patient, hands-on studio practice; even when she is creating on a large scale, she is engaged in all aspects of the work. She explains, "The actual doing of it is where you get the ideas of how to take a next step. . . . It's really the doing that creates the making."[3] In 2006, after looking at photographs of large-scale outdoor sculptures from the 1960s by the artist Tony Smith, Shirreff pondered the continued psychological and physical power of the works, and wondered whether the viewer could still access Smith's artistic intentions when not viewing the original works of art. With photographs of Smith's sculptures as her guide, Shirreff made small cardboard maquettes of various works by Smith that were accurate only from the viewpoint presented in the photograph. Then, she filmed the maquettes in an invented landscape in her studio. From this investigation came her early video work *Sculpture Park (Tony Smith)* (fig. 1).

In the video, the sculptures are seen amid falling snow—in the form of shaved Styrofoam sifted through a horizontal window screen—which clings to her maquettes and reveals their forms out of darkness.

In 2010 Shirreff was approached by the Public Art Fund, in New York, to create an outdoor sculpture that would be installed for one year at MetroTech Center, in Brooklyn. Realizing that the work would have to survive the elements, including the snowstorms of a New York winter, Shirreff recalled her video and found the maquettes she had made. She created a hollowed-out, frontal version of the maquette she had originally modeled after (an image of) Smith's *Amaryllis* (1965/68; Walker Art Center, Minneapolis), and then she had it fabricated to the actual dimensions of Smith's work. Like Smith's *Amaryllis*, Shirreff's *Sculpture for Snow* (fig. 2) is eleven feet tall and is made of black painted aluminum, but in other ways, Shirreff's work functions at a remove from Smith's. In *Sculpture for Snow*, a thin, rectangular form rises from the ground, then dynamically turns upward in a different direction. Oscillating between volume and line, the work has stability but also playfulness, as if it were casually folded into its shape. Shirreff's title plays with the idea that almost any experience of the work is incomplete—if it is not snowing when the viewer sees the sculpture, they must contend with the idea that their experience of it is limited. As the viewer circumambulates the monumental sculpture, their process of discovery unfolds.   MT

1. Erin Shirreff, "A Roundtable Discussion Hosted by Chris Wiley, with Lucas Blalock, Sara Cwynar, and Erin Shirreff," in *You Are Looking at Something That Never Occurred*, ed. Paul Luckraft, exh. cat. (London: Zabludowicz Collection, 2017), 19.

2. Erin Shirreff, oral history interview by author, May 20, 2019, transcript, Yale University Art Gallery Archives, New Haven.

3. Ibid.

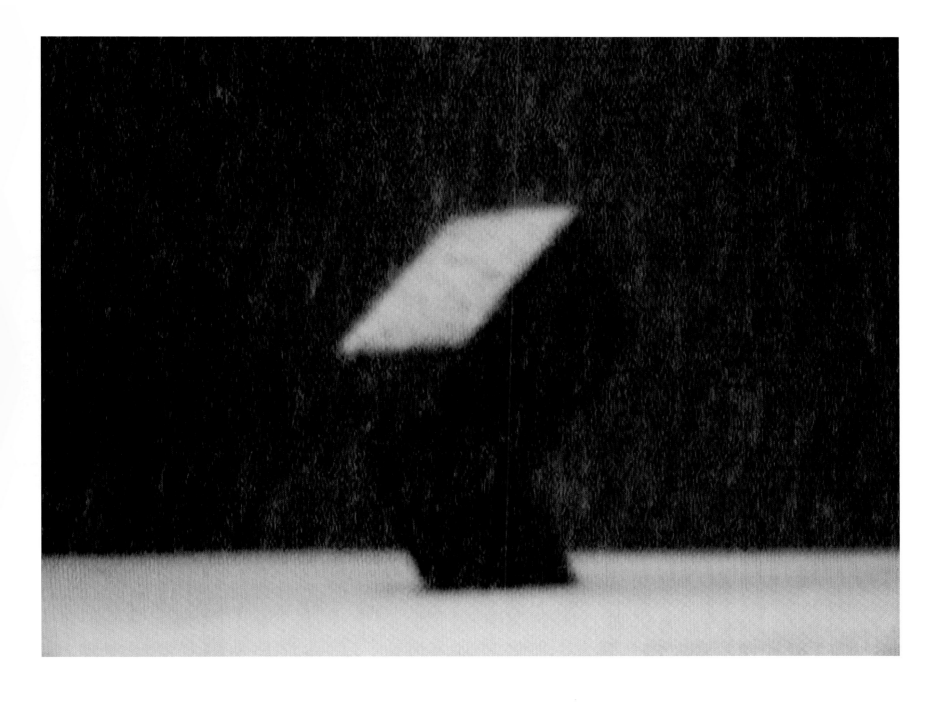

FIG. 1. Erin Shirreff, *Sculpture Park (Tony Smith)*, 2006. Single-channel video with color, 37 minutes. Purchased with a gift from the Arthur and Constance Zeckendorf Foundation, 2013.89.2

FIG. 2. Erin Shirreff, *Sculpture for Snow*, 2011. Painted aluminum, 9 ft. 7½ in. ×
4 ft. 6 in. × 11 ft. 4½ in. (293.4 × 137.2 × 346.7 cm). Purchased with a gift from the
Arthur and Constance Zeckendorf Foundation, 2013.89.1

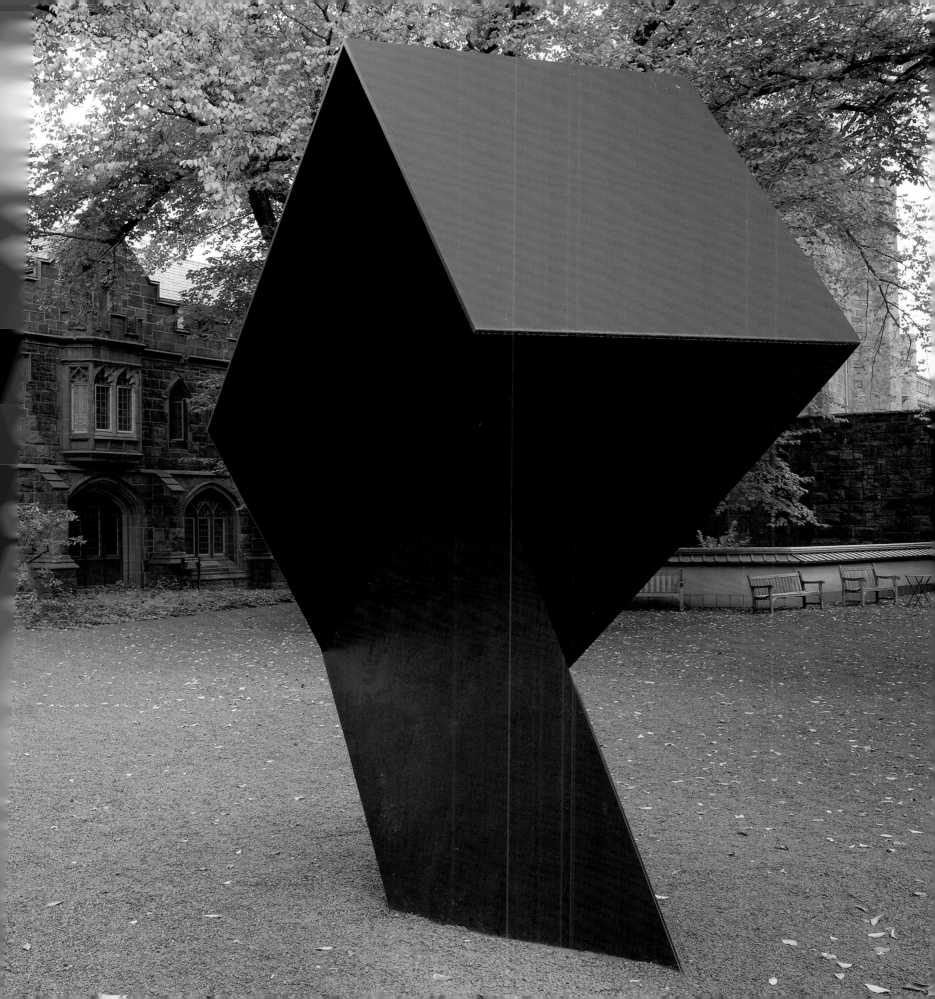

TALA MADANI BECAME INTERESTED IN ART AT A
young age, while she was growing up in her hometown of
Tehran, Iran. As a child, she studied calligraphy, which helped
develop her artistic sensibilities. At age fifteen, Madani moved
with her mother to Oregon, and she later took classes in
political science and the visual arts at Oregon State University,
in Corvallis.[1] In 2004 she enrolled at the Yale School of Art with
a focus in Painting, and she received a Master of Fine Arts in
2006. Soon after, she was a visiting artist at Yale and the Yale
Summer School of Music and Art. From 2013 to 2016, she taught
at the University of Southern California, in Los Angeles.

Madani creates videos using the stop-motion-animation
technique, in which objects or images are physically manipu-
lated in small increments to suggest motion as they are photo-
graphed over time. Madani paints on a single board, takes a
picture of it, then adds to and edits the painting before taking
the next picture. It is a painstaking process in comparison to
making a stand-alone painting, and she completes just one or
two stop-motion videos each year.[2]

*Chit Chat* (fig. 1)—a silent, stop-motion-animation video
made of more than two thousand images per minute—depicts
two figures in conversation. As their lips move, their attitudes
change; over time, they become increasingly agitated as their
attempts to communicate only lead to confusion. Eventually, the
figures projectile vomit on each other as a last-ditch effort to
express themselves. Madani has stated that the "vomit trajectory
is very much a reference to language."[3] Much like the physiolog-
ical function of vomiting, the figures feel an overpowering need
to express something that they cannot keep inside. For Madani,
painting is a form of expulsion by which she can freely address
the societally inappropriate things we cannot get out in every-
day life.[4] This is why much of her art explores subjects seen as
repressed, impolite, or vulgar.   ED

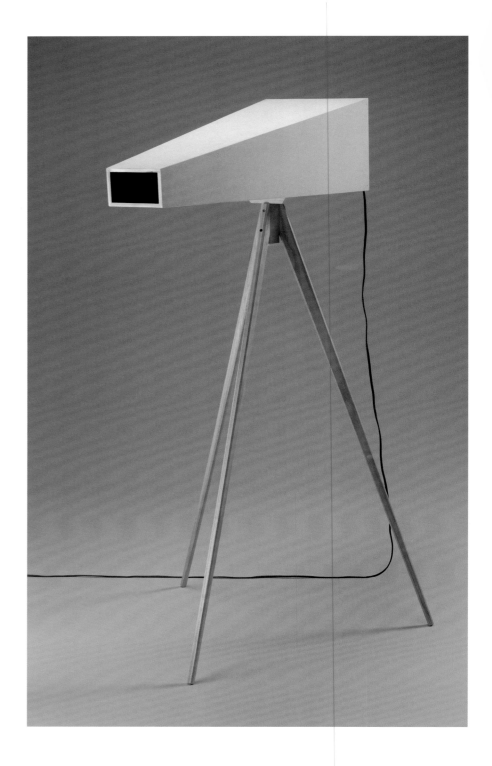

1.  Robert Shore, "Tala Madani,"
    *Elephant* 18 (Spring 2014): 128–33.
2.  Ibid., 127.

3.  Tala Madani, in "Tala Madani:
    I Really Laugh When I Paint,"
    interview by Synne Rifbjerg, 2013,
    Louisiana Channel, video, 9:08,
    March 10, 2016, https://www
    .youtube.com/watch?v
    =vocCwTsVz3s.
4.  Ibid.

Tala Madani   CAT. 72       Iranian, active in the United States, born 1981, M.F.A. 2006   2000s

FIG. 1. Tala Madani, *Chit Chat*, 2007. Mixed media and single-channel video animation, 66 × 48 × 34 in. (167.6 × 121.9 × 86.4 cm), 2 minutes, 35 seconds. Stephen Carlton Clark, B.A. 1903, Fund, 2008.87.1

IN A DANGEROUS DEMONSTRATION OF VIRILITY, local teenagers are poised to jump eighty feet into a narrow ravine surrounded by rocky terrain in Rebecca Soderholm's *Bridge, Lake Luzerne, New York* (fig. 1). The scene depicts a spot on the Hudson River, south of Rockwell Falls and north of the place where the Sacandaga River meets the Hudson. This location is a hot spot for teenagers and young men and women to congregate, cool off on hot summer days, and show off to their peers. In the image, the exhibition of masculinity is reinforced by the boys' engagement with the rugged, dynamic environment. Soderholm grew up in a small town in central New York and frequently revisited the surrounding areas in search of subjects for this series, called *The League of Peace and Power*, focusing her lens on landscapes and the ways in which people interact with them.

When developing the series, Soderholm documented her progress by pinning on a map the places where she intended to work and the places where she had already been successful in making work. Her map marked small villages in Upstate New York, including Hadley, Fort Plain, and Canajoharie, with populations ranging from 750 to 3,664; Ogdensburg, just across the Canadian border, with a population of 11,000, seems to be the largest settlement included in her series.[1] The pins coincidentally corresponded to the lands of the Onondaga Nation, so Soderholm felt that her work was in some way connected, and she named her series to honor this fact.[2] Her title, *The League of Peace and Power*, derives from the colloquial name for the fifteenth-century Iroquois Confederacy, which initially consisted of five Indigenous nations: the Cayuga, Mohawk, Oneida, Onondaga, and Seneca.[3] *The League of Peace and Power* was the subject of Soderholm's 2015 solo exhibition at 511 Gallery, in New York.

In addition to holding teaching positions at the Yale School of Art, Soderholm was the Marcia Brady Tucker Fellow in the Department of Prints, Drawings, and Photographs at the Yale University Art Gallery from 2008 to 2010. She also participated in the Gallery's Happy and Bob Doran Artist-in-Residence Program in Praiano, Italy, supported by Carol LeWitt.[4]   MDM

1. "The League of Peace and Power: New Photographs by Rebecca Soderholm, 23 October 2014– 6 November 2014," 511 Gallery, accessed February 29, 2020, http://www.511gallery.net /peace-and-power.
2. Rebecca Soderholm, oral history interview by author, April 10, 2019, transcript, Yale University Art Gallery Archives, New Haven.
3. A sixth nation, the Tuscarora, joined after the initial confederacy was formed.
4. For an example of her resulting work from this residency, see *Couple, Naples, Italy* (2013); Yale University Art Gallery, New Haven, inv. no. 2014.39.2.

# Rebecca Soderholm CAT. 73

FIG. 1. Rebecca Soderholm, *Bridge, Lake Luzerne, New York*, from the series *The League of Peace and Power*, 2011. Pigmented inkjet print, 16 × 24 in. (40.6 × 61 cm). Janet and Simeon Braguin Fund, 2014.39.1

CALIFORNIA-BASED PHOTOGRAPHER SAM CONTIS makes work that quietly resists convention. She is sensitive to photographic tradition, yet her images are refreshingly unbeholden to its constraints, moving fluidly between land-scape and portraiture genres, or between documentary and overtly formalist modes, challenging the distinctions among them. Contis's project *Between Rivers and Roads* took shape during a cross-country road trip she took in 2007 while on summer break from the Yale School of Art. The unidentified yet unmistakably suburban American cul-de-sac in the fore-ground of *Grain Elevators* (fig. 1) shrinks under the towering white structures that rise amid the trees in the background, resulting in a scene suspended between residential and indus-trial scales. The striking composition reveals an interest in thresholds and liminal states, which has emerged as a unifying theme in Contis's subsequent work.

Her recent series *Deep Springs*—published as a book in 2017—advances this conceptual engagement by wedding form to content. Contis investigated life at Deep Springs College, in California, one of the last all-male colleges in the United States prior to its shift to coeducation in 2018. The one-hundred-year-old school continues to embody the vision of its Progressive Era founders, combining academic rigor with strenuous labor aimed at self-sufficiency: alongside their studies, students devote nearly half of their time to farming and cattle ranching. Contis creatively interweaves her own images of student life at Deep Springs with archival photographs from the early years of the school, blurring the boundary between made and found work. The image that emerges subverts the tropes of masculinity tied to the Western landscape, instead modeling a less-restrictive and unusually tender expression of youthful male identity.   CF

# Sam Contis   CAT. 74

FIG. 1. Sam Contis, *Grain Elevators*, from the series *Between Rivers and Roads*, 2007.
Chromogenic print, 30 × 38 in. (76.2 × 96.5 cm). Gift of Nancy D. Grover, 2019.103.1

VETERANS OFTEN RETURN HOME CHANGED BY THE terror of war. The mundanity of everyday life may be unsettling for those who have borne witness to wartime atrocities, and they may find they are without the support needed to reintegrate into their communities. The disconnect and loneliness that some veterans feel upon their return from war are the subject of Suyeon Yun's *Homecoming* series.

From 2006 to 2008, Yun documented an American landscape that has been shaped by wars abroad. In her portrayals of common places and everyday situations, she conveys the sustained emotional trauma experienced by many veterans, who may no longer feel at home in the country they fought to protect. *Homecoming* traces the postwar experiences of hundreds of soldiers and their families, from forty-two states and from conflicts ranging from World War II to the Iraq War. A veteran walking down the quiet street in *Garbage Bag, Harrisburg, Pennsylvania* (fig. 1) could be confronted with posttraumatic stress triggers at every step: The wind flapping through the banner commemorating a local war hero could sound like an attack from above. Lurking behind every corner, hidden in every vehicle—even the couple walking at a distance—could be potential threats.

*Homecoming* is just one of several series by Yun that document communities impacted by war. In *Incomplete Journey* (2003–6), for instance, she captured the lives of exiled North Koreans who had resettled in her birth country of South Korea. In *New Haven, No Haven* (2008–9), she followed the resettlement of Iraqi war refugees in New Haven.[1] Since 2010, she has been working on *The Rest Is History*. The bitter aftertaste of displacement—whether physical, as in *Incomplete Journey* and *New Haven, No Haven*, or psychological, as in *Homecoming*—connects all of these bodies of work.    MDM

1.  Suyeon Yun, Youngmi Park, and Robert Pledge, *New Haven, No Haven* (Seoul: Parkgeonhi Foundation, 2009).

# Suyeon Yun CAT. 75

FIG. 1.  Suyeon Yun, *Garbage Bag, Harrisburg, Pennsylvania*, from the series
*Homecoming*, 2008. Chromogenic print, 50 × 37⅝ in. (127 × 95.5 cm). Promised gift
of Nancy D. Grover

MADE DURING HER YEARS AS A STUDENT AT THE Yale School of Art, Jen Davis's *Steve and I* (fig. 1) is an image strained with longing. Aching to make a connection, the female subject staring through the camera lens, out toward the viewer, is the photographer herself. This is not an intimate glimpse into the bedroom of two lovers; Steve is merely a friend of a friend who had agreed to play Davis's inamorato for the camera. They share a bed, but Steve is turned away from Davis, who sits at his feet, wrapped in a blanket, the only element of warmth and closeness in the photograph. The anesthetic coolness of the image underscores the fractured relationship it depicts.

Davis has been the subject of her work since 2002, when she first photographed herself on the beach with friends because she was curious to see how others saw her. She continued documenting herself over a span of eleven years, a period she demarcated with a monograph bearing that timeframe as its name, *Eleven Years*.[1] The number eleven (or 1-1) also symbolically represents the one-to-one connections that she sought and created in her work. *Steve and I* illustrates a turning point, one in which she refocused her self-portraits on the notions of desire and intimacy.[2]

When Davis came to the School of Art in 2006, she began taking risks with her self-portraits, using the photographic process to negotiate with her longings. By 2007, she had begun developing a sense of self-love, as seen in another work from *Eleven Years*, *New Haven Bedroom* (2007), in which she explores her sensuality, the image awash in a warm glow.[3] At Yale, she learned to articulate her artistic intentions in critiques with Tod Papageorge, John Pilson, and Collier Schorr, among others.[4] Newly adept at engaging in dialogue about her work, Davis started approaching strangers in bars and asking them to model for her. Using the camera as an intermediary tool, she created a connection with her subjects—albeit a short-lived, synthetic one. These mediations are intrinsic in both her *I Ask in Exchange* and *Webcam* series. The first work in *I Ask in Exchange*, *Mike, New Orleans, LA* (2007), was included in her M.F.A. thesis at Yale and in the second volume of Papageorge's *A Yale Portfolio, 1979–2013*.[5]

In an effort to turn her camera outward, Davis's current series, *First Call Out*, engages with the hyperreal world of bodybuilders. Her subjects are shown in moments of transition, in between being "on"—getting a spray tan, for instance—working hard to refine and transform their bodies into models of perfection, and encouraging scrutiny as a means of garnering acceptance.    MDM

1. Jen Davis, Anne Tucker, and John Pilson, *Eleven Years* (Heildelberg: Kehrer, 2014).
2. Jen Davis, oral history interview by author, May 10, 2019, transcript, Yale University Art Gallery Archives, New Haven.
3. See Yale University Art Gallery, New Haven, inv. no. 2018.158.1.
4. Davis, oral history interview.
5. See Yale University Art Gallery, New Haven, inv. nos. 2014.106.2.1–.135.

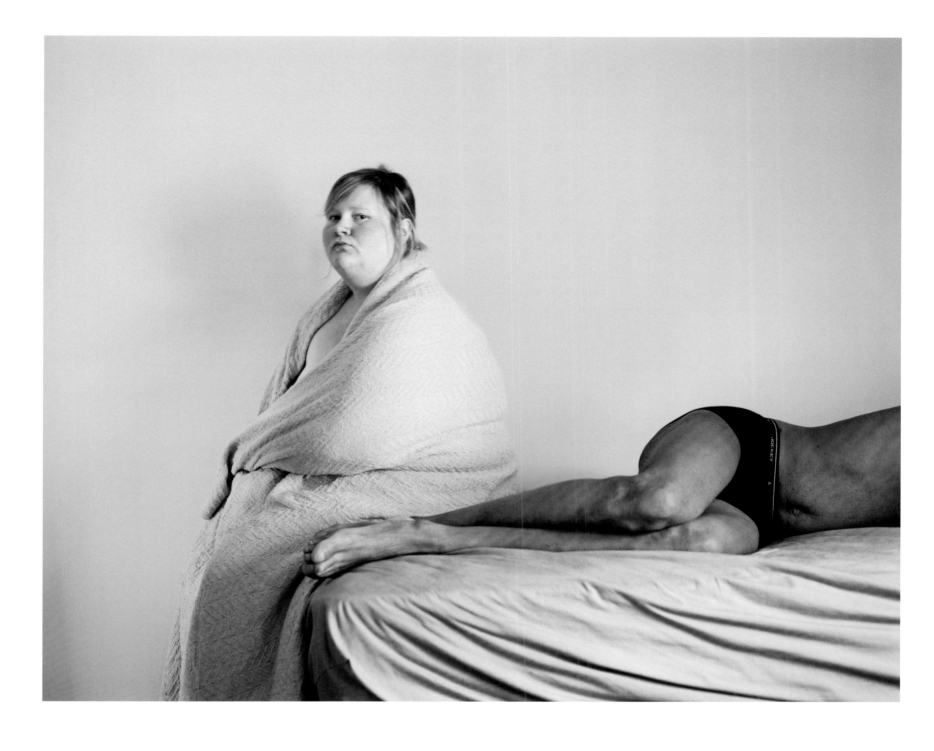

FIG. 1. Jen Davis, *Steve and I*, from the series *Eleven Years*, 2006. Pigmented inkjet print, 17¾ × 22 in. (45.1 × 55.9 cm). Gift of Lee Marks and John C. DePrez, Jr., in honor of Richard Benson, 2018.158.2

TAKEN YEARS AFTER THE 1991 COLLAPSE OF THE U.S.S.R., Sasha Rudensky's photographs of life in post-Soviet Russia reveal a country in transition—one still reliant on functional Soviet goods such as Tambov refrigerators, yet increasingly obsessed with the acquisition of flashy Western products such as Range Rovers. Rudensky recalls, "I saw the creation of this new identity as a form of playacting. It was also the way 'The East' read 'The West,' or filtered it . . . which is exactly what excited me most as an artist—the seductions and the incongruities."[1] Rudensky was raised in the Soviet Union until 1990, when, at age eleven, she immigrated with her family to the United States. In this way, hers is also a world-between story, an identity that straddles countries and cultures. Rudensky received her B.A. from Wesleyan University, in Middletown, Connecticut, in 2001 and—after her first return trip to Russia to take photographs (2004–5)—came to the Yale School of Art in 2006 to pursue her M.F.A. in Photography.[2]

*Game Room* (fig. 1) represents a specific subset of Rudensky's Russia-, Georgia-, and Ukraine-based work: her wish to capture on film the surge of orthodoxy that she witnessed on her visits to those countries—a cultural reembracing of religion that had been suppressed in the "godless Soviet past." She explains that she was trying to bring that post-Soviet spirituality into the work without going into a church to photograph. *Game Room* pictures a Catholic boy in choir robes posed at a ping-pong table and illuminated from behind by an otherworldly light bursting from a basement window. The boy's pureness and innocence are accentuated by the glowing whiteness of his robes and the virginal blue of the ping-pong table and carpet that surround him.

Rudensky speaks of the rigor of her graduate education at Yale, and in particular of Tod Papageorge, then Director of Graduate Studies, whose passionate, eloquent, and emotional lectures directly engaged the "poetics" of photography, a concept that was formative in the development of her style. Rudensky's autographic exploitation of color, light, and setting are touchstones of her practice. In her work about post-Soviet life, the vibrant and peculiar palette is an essential compositional element. "The color of that world is fundamentally different. It's like a different set of paints," she says. Light is another element that distinguishes Rudensky's work; she only shoots with natural light, which is her "not-so-secret secret." And, setting—perhaps more than any other element—plays an essential role. "If the setting was not right, there would be no picture."   EH

1.  All quotations by the artist are from Sasha Rudensky, oral history interview by author, June 10, 2019, transcript, Yale University Art Gallery Archives, New Haven.

2.  This was a time when photography was also in transition, from film to digital. Students were still shooting film but printing digitally; by the time Rudensky left Yale, almost no students were using the darkroom.

Sasha Rudensky   CAT. 77          Russian and American, born U.S.S.R. (Russia) 1979, M.F.A. 2008          2000s

Every effort has been made to credit the artists and the sources; if there are errors or omissions, please contact the Yale University Art Gallery so that corrections can be made in any subsequent editions. All images courtesy Visual Resources Department, Yale University Art Gallery, unless otherwise noted.

Courtesy Njideka Akunyili Crosby, Victoria Miro, and David Zwirner: cat. 79, fig. 1

Courtesy The Josef and Anni Albers Foundation: p. 61; Kramer essay, figs. 4–6

© The Josef and Anni Albers Foundation/Artists Rights Society (ARS), New York 2021: Kramer essay, fig. 2

© Gail Albert Halaban: cat. 54, fig. 1

Photo: Jim Alexander. The Jim Alexander Collection: Kuzma essay, fig. 5

© Estate of Anna Held Audette: cat. 15, fig. 1

Photo: Alice Aycock: Kuzma essay, fig. 19

© The Estate of William Bailey/Artists Rights Society (ARS), New York 2021: Kramer essay, fig. 10

© Kristin Baker: cat. 63, fig. 1; p. 306

© Rina Banerjee. Courtesy the artist: p. 18; cat. 52, fig. 1

© Joyce Baronio: Kuzma essay, figs. 9–10

© Jennifer Bartlett. Courtesy Marianne Boesky Gallery, New York and Aspen, Paula Cooper Gallery, New York, and the Jennifer Bartlett 2013 Trust. Courtesy Locks Gallery: cat. 18, figs. 1–3

Copyright Erica Baum. Courtesy the artist and Bureau, New York: cat. 50, fig. 1

© Marion Belanger: cat. 41, fig. 1

© Judith Bernstein: cat. 19, fig. 1

© Mary Berridge: cat. 43, fig. 1

Image courtesy Rachel Berwick: Kuzma essay, fig. 20

Bettmann/Bettmann/Getty Images: Kuzma essay, fig. 13

© Elisheva Biernoff: cat. 65, fig. 1

Courtesy Francesca Borgatta, Mia Borgatta, and Paolo Borgatta: cat. 7, fig. 1

© Peter de Bretteville: Kuzma essay, fig. 18

Courtesy the Estate of Donnamaria Bruton and Cade Tompkins Projects: cat. 47, fig. 1

Courtesy the Estate of Nicolas Carone: Kramer essay, fig. 11

© Bernard R. Chaet Estate/Fred Giampietro Gallery: Kramer essay, fig. 9

Courtesy the Estate of Louisa Chase and Hirschl & Adler Modern, New York: cat. 22, figs. 1–2

© Barbara Chase-Riboud; Courtesy Michael Rosenfeld Gallery LLC, New York, N.Y.: cat. 13, figs. 1–2

© Susanna Coffey: cat. 33, figs. 1–2

© Anna Collette: cat. 68, fig. 1

© Lois Conner: cat. 30, figs. 1–5

Courtesy Sam Contis and Klaus von Nichtssagend Gallery, N.Y.: cat. 74, fig. 1

© Sharon Core: cat. 55, fig. 1

© Jan Cunningham: cat. 34, fig. 1

Courtesy Jen Davis and Lee Marks Fine Art, IN, and ClampArt, New York: cat. 76, fig. 1

© Jane Davis Doggett: Kramer essay, fig. 3

© Nick Doob and Josh Morton: Kuzma essay, fig. 3

Courtesy Shannon Ebner and Kaufmann Repetto, New York/Milan: cat. 60, fig. 1

© Anoka Faruqee. Photo: Clarissa Tossin: Kuzma essay, fig. 24

© Rochelle Feinstein. Photo: Adam Reich: Kuzma essay, fig. 21

Photo: David Fenton/Getty Images: Kuzma essay, fig. 2

© 2021 Janet Fish/Licensed by VAGA at Artists Rights Society (ARS), New York: cat. 16, figs. 1–3

© Audrey Flack: cat. 9, figs. 1–2

© Eve Fowler: cat. 48, fig. 1

© Nancy Friese. Courtesy Cade Tompkins Projects: cat. 29, fig. 1

Courtesy the George J. Mitchell Department of Special Collections & Archives, Bowdoin College Library, Brunswick, Maine: Cooper essay, fig. 14

© Katy Grannan, courtesy Fraenkel Gallery, San Francisco: cat. 59, figs. 1–2

Photograph collection of the Nancy Graves Foundation: Kramer essay, fig. 12

© Nancy Graves Foundation, Inc./Licensed by Artists Rights Society (ARS), N.Y.: cat. 17, figs. 1–3

© Nancy Graves Foundation, Inc./Licensed by Artists Rights Society (ARS), N.Y. Image courtesy the photograph collection of the Nancy Graves Foundation: Kramer essay, fig. 13

Copyright Ann Hamilton: cat. 35, figs. 1–2

Courtesy Ann Hamilton Studio. Photo: Bob McMurty: Kuzma essay, fig. 17

© The Estate of Eva Hesse. Courtesy Hauser & Wirth: cat. 12, figs. 1–4

Courtesy Leslie Hewitt and Perrotin: cat. 70, fig. 1

© Sheila Hicks. Alison Jacques Gallery, London: p. 60; cat. 11, figs. 1–2

© Roni Horn. Courtesy the artist and Hauser & Wirth: cat. 28, figs. 1–3

© Sarah Anne Johnson, Courtesy Yossi Milo Gallery, New York: cat. 69, figs. 1–4

Courtesy Lisa Kereszi and Yancey Richardson Gallery: cat. 61, figs. 1–2

© Justine Kurland. Courtesy the artist and Mitchell-Innes & Nash, New York: cat. 57, fig. 1

Copyright Estate of Jennett Lam: cat. 10, fig. 1

© An-My Lê. Courtesy the Artist and Marian Goodman Gallery: Kuzma essay, fig. 25; cat. 49, figs. 1–3

All photographs Copyright Jocelyn Lee: cat. 37, figs. 1–2

© Laura Letinsky. Courtesy the artist and Yancey Richardson, New York: cat. 44, figs. 1–2

Photo: Harry Lieberman: Kuzma essay, fig. 11

© Maya Lin Studio: cover; cat. 31, figs. 1–3

© Winifred Lutz. Photo: Gregory Benson: Kuzma essay, fig. 4

© Holly Lynton: cat. 51, figs. 1–2

© Tala Madani, courtesy David Kordansky Gallery: Kuzma essay, fig. 26; cat. 72, fig. 1

Manuscripts and Archives, Yale University Library: Cooper essay, figs. 3–11, 13; Kramer essay, fig. 16

© Tanya Marcuse: cat. 42, figs. 1–4

© Malerie Marder: cat. 56, fig. 1

Copyright Estate of Ellen Carley McNally: cat. 8, fig. 1

© Wangechi Mutu. Courtesy the artist and Gladstone Gallery, New York and Brussels: cat. 62, figs. 1–2

© Wangechi Mutu. Photo courtesy San Francisco Museum of Modern Art. Photo: Ben Blackwell: Kuzma essay, fig. 27

Courtesy Sarah Oppenheimer and the Baltimore Museum of Art. Photo: James Ewing: Kuzma essay, fig. 23

© Christine Osinski: Kuzma essay, fig. 8

© Elizabeth Peak: cat. 25, fig. 1

Image courtesy Elle Pérez and 47 Canal, New York: Kuzma essay, figs. 28–29

© 2021 Judy Pfaff: Kuzma essay, fig. 7

© 2021 Judy Pfaff/Licensed by VAGA at Artists Rights Society (ARS), New York: frontispiece; cat. 21, figs. 1–2

Courtesy Howardena Pindell and Garth Greenan Gallery, New York: cat. 20, figs. 1–4

Courtesy Howardena Pindell and Garth Greenan Gallery, New York. Image © The Metropolitan Museum of Art. Image source: Art Resource: Kramer essay, fig. 18

© Sylvia Plimack Mangold, courtesy Alexander and Bonin, New York: Kramer essay, fig. 7; cat. 14, figs. 1–5

© Rona Pondick: cat. 26, figs. 1–2

© Maria Porges: cat. 23, fig. 1

© Amy Klein Reichert: cat. 32, fig. 1

© Mary Reid Kelley: cat. 78, fig. 1

© Rosalyn Richards: cat. 24, figs. 1–2

© Allen Rokach: Kuzma essay, fig. 14

© Sasha Rudensky: cat. 77, fig. 1

© Ursula von Rydingsvard. Courtesy Ursula von Rydingsvard Studio: Kuzma essay, fig. 15

Image courtesy Salon 94 and Natalie Frank: cat. 64, figs. 1–2

© Victoria Sambunaris. Courtesy the artist and Yancey Richardson Gallery: p. 126, cat. 58, figs. 1–3

Copyright Beverly Semmes. Courtesy the Artist and Susan Inglett Gallery, N.Y.C.: cat. 39, fig. 1

© Erin Shirreff: cat. 71, figs. 1–2

© Fran Siegel: cat. 40, figs. 1–2

© Rebecca Soderholm: cat. 73, fig. 1

© Jessica Stockholder/Courtesy the artist; Kunstmuseum St. Gallen and Mitchell-Innes & Nash, New York: Kuzma essay, fig. 22

© Jessica Stockholder/Courtesy the artist and Mitchell-Innes & Nash, New York: cat. 36, figs. 1–3

© Angela Strassheim: cat. 67, fig. 1

© Sarah Sze: cat. 46, fig. 1

© Mickalene Thomas/Artists Rights Society (ARS), New York: cat. 66, fig. 1

© Tabitha Vevers: cat. 27, fig. 1

© Marie Watt: cat. 53, fig. 1

© Lorraine Wild: Kuzma essay, fig. 12

Copyright Estate of Jennette Williams: cat. 45, fig. 1

Courtesy Yale University Art Gallery Archives: Cooper essay, figs. 12, 15–17; Kramer essay, figs. 1, 8, 15, 17; p. 127; Kuzma essay, figs. 1, 6, 16

© Suyeon Yun: cat. 75, fig. 1

© Lisa Yuskavage. Courtesy the artist and David Zwirner: cat. 38, figs. 1–2

# PHOTO CREDITS

Publication made possible by Nancy D. Grover, the Janet and Simeon Braguin Fund, the Katharine Ordway Exhibition and Publication Fund, the Raymond and Helen Runnells DuBois Publication Fund, and the Wolfe Family Exhibition and Publication Fund.

First published in 2021 by the
YALE UNIVERSITY ART GALLERY
1111 Chapel Street
P.O. Box 208271
New Haven, CT 06520-8271
artgallery.yale.edu/publications

and distributed by
YALE UNIVERSITY PRESS
302 Temple Street
P.O. Box 209040
New Haven, CT 06520-9040
yalebooks.com/art

Published in conjunction with the exhibition *On the Basis of Art: 150 Years of Women at Yale*, organized by the Yale University Art Gallery.

September 10, 2021–January 9, 2022

Produced by the Yale University Art Gallery

Tiffany Sprague, Director of Publications and
    Editorial Services
Copyeditors: Zsofia Jilling, Madeline Kloss Johnson,
    and Stacey A. Wujcik
Proofreaders: Jennifer Lu, Tamara Schechter, and
    Stacey A. Wujcik
Rights and Reproductions Coordinator: Kathleen
    Mylen-Coulombe
Designers: Miko McGinty and Rebecca Sylvers
Typesetter: Tina Henderson

Set in Empirica and Athelas

Printed at Meridian Printing, East Greenwich, R.I.

ISBN 978-0-300-25424-2
Library of Congress Control Number: 2019956723

10 9 8 7 6 5 4 3 2 1

Cover illustration: Maya Lin, *Silver Housatonic (Benefit Edition)*, 2011 (cat. 31, fig. 3)
Frontispiece: Detail of Judy Pfaff, *Straw into Gold*, 1990 (cat. 21, fig. 2)
p. 18: Detail of Rina Banerjee, *Dangerous World*, from the Exit Art portfolio *Ecstasy*, 2010 (cat. 52, fig. 1)
p. 20: Detail of Irene Weir, *The Noon Hour, Chinon, France*, ca. 1923 (cat. 5, fig. 2)
p. 21: Detail of Cooper essay, fig. 12
p. 60: Detail of Sheila Hicks, *Observatoire*, 2018 (cat. 11, fig. 1)
p. 61: Detail of Kramer essay, fig. 5
p. 126: Detail of Victoria Sambunaris, *Untitled (Fort Knox Gold Mine), Fairbanks, Alaska*, 2003 (cat. 58, fig. 1)
p. 127: Detail of Kuzma essay, fig. 1
p. 306: Detail of Kristin Baker, *Revolving Control*, 2005 (cat. 63, fig. 1)